LIFE World War 2

History's Greatest Conflict in Pictures

EDITED BY RICHARD B. STOLLEY

A Bulfinch Press Book

LITTLE, BROWN AND COMPANY · BOSTON NEW YORK LONDON

LIFE World War 2

U.S. Task Group 38.3, led by the carrier *Langley*, steams toward an anchorage after attacking Japanese forces in the Philippines, 1944.

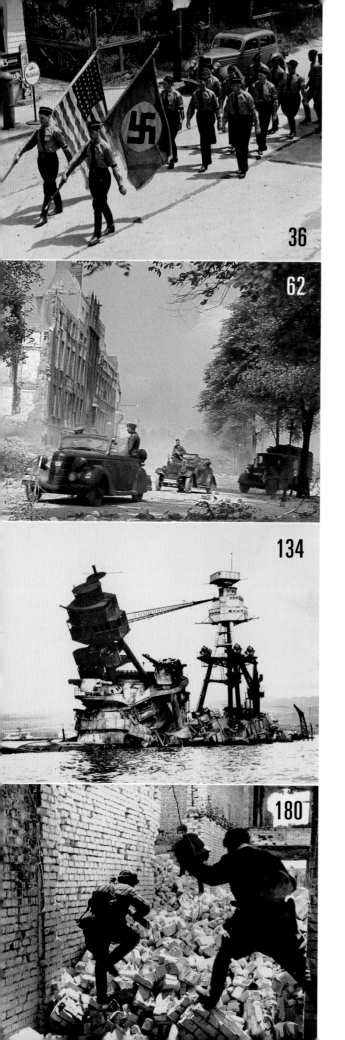

36

62

134

180

Contents

244

278

336

342

It Was America's Finest Hour Too

by Richard B. Stolley, Editor

THE START OF World War 2 woke me up early on the morning of September 1, 1939. A newsboy in the street below was squawking, "Extra, Extra!" My twin brother, Jim, and I leaned out the dormer windows of our upstairs bedroom in Pekin, Illinois (halfway between Chicago and St. Louis), and learned the news that would shape the world — and, 62 years later, this book.

Fascination with the war has reached a peak of sorts this year. It seems to have started in 1998 with *Saving Private Ryan* and Tom Brokaw's *Greatest Generation* books. And now the war is being celebrated, if that is the word, by other movies (*Pearl Harbor*, etc.), other books, an HBO television series, a new museum in New Orleans and an unseemly quarrel over the location of a World War 2 monument in Washington, D.C.

I seem to have been preparing myself to edit this book for most of my life. I remember precisely where I was at the critical moments of the war: listening intently to the radio on December 7, 1941, after asking the question so many Americans asked: "Where is Pearl Harbor?" In 1944, at the age of 15, I went to work for a daily newspaper and followed D-Day, VE-Day and VJ-Day — and everything in between — on the United Press Teletype in our office. We were alerted to breaking stories by a bell in the machine: one ding for a bulletin, five dings for a flash (D-Day). The entire staff hurried to read

the story when that bell sounded (a very Pavlovian reaction).

In fact, only staff members were allowed near the Teletype, according to a sign on the wall nearby. It was a War Department regulation. Advance notice of military developments was sometimes sent to help editors plan their editions, and this was inside news that visiting "civilians" weren't supposed to know.

Whatever self-importance that gave me quickly evaporated, however, when I occasionally was assigned to write a story about a Pekin boy who had been killed. It meant calling the family, asking a mother or father about their dead son, wondering if they had a photograph. The courage of those families, the clear conviction that he had died in a noble cause, has stayed with me ever since.

After the war, I (and my twin) enlisted in the Navy, and I spent 18 months on a light cruiser, the USS *Dayton* (CL-105), mostly in the Mediterranean. The shooting was still going on in a few places: We were fired on by Greek Communists in the hills outside Athens, and one of our Sixth Fleet destroyers rammed an unswept World War 2 mine in the Adriatic, killing several sailors.

What impressed me most, however, was the appalling residue of war: the ruined villages of Italy and France and North Africa, with only a single lane of the main street cleared of rubble; the sad, sunken ships in the harbor of Alexandria, Egypt; the acres of

temporary cemeteries at what seemed like every turn of the road. Many years later, after all those villages had long been rebuilt and the dead sent home, I was stationed as a journalist in Europe and marveled at buildings in cities like Leningrad and Munich that still carried shrapnel gouges from the war.

All of these impressions and memories were stored up inside me when we began work on this book. Our search for photographs, under the direction of picture editor Christina Lieberman, covered the globe. We found amazing coverage of the Soviet war in a collection in London, where the Imperial War Museum was also a treasure trove. The Australians turned out to have fine photographs, unfamiliar to us, of the South Pacific. The Germans were cooperative; the Japanese less so, but that attitude is consistent with their minimal acknowledgment of the events of the period. The *Life* archive at home yielded great pictures that were part of the magazine's superlative but, back then, routine weekly coverage.

The bravery of the photographers who created this book is impossible to exaggerate. Readers should constantly remind themselves that when many of these pictures were made, the air was filled with the deadly buzz of bullets, the boom of incoming artillery, the screams of the wounded. And yet the photographers poked up their heads or, at the very least, their cameras to do their jobs. I have been in combat (with the Israeli Army), and I confess with no embarrassment that when mortar rounds landed nearby, I thought only of self-preservation and dove into a bunker. The photographer with me stayed aboveground to document the pandemonium.

In addition to the 665 photographs, our book offers eight original essays on the war, its origins and its aftermath. The authors are eminent historians. I was struck by some of their personal memories of the war. John Eisenhower, who writes on 1945, inquired first about 1944 as a possible subject. When I explained that the year had already been assigned,

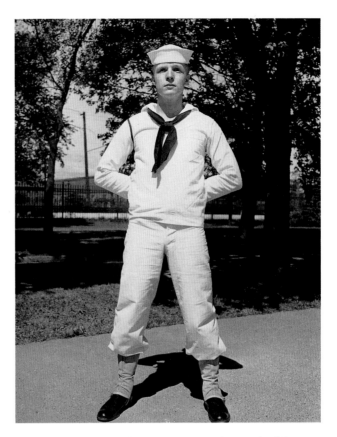

Editor Dick Stolley went to boot camp at Great Lakes Naval Training Station in 1946 (above), then served at sea for 18 months, mostly in the Mediterranean, on a light cruiser.

he genially remarked: "Well, it's just as well. I guess I shouldn't do 1944 because then I'd have to write about Dad." Dad, I realized after a moment's reflection, was Supreme Commander (and later President) Dwight D. Eisenhower, and it was a shock to hear this mythic historical figure referred to in such a simple, loving way. The author who accepted the 1944 chapter, Sir John Keegan, recalled to me in vivid terms the awesome roar of American planes flying low over his home in southeastern England on D-Day.

If there is any lesson in this book, for America at least, it is one you've heard before but which bears repeating: the astounding way the country rallied, from farm to factory to kitchen to battlefield, to help subdue a monstrous tyranny. It was *our* finest hour too. Now, what can we do in the 21st century to reignite that feeling of purpose and dedication and triumph?

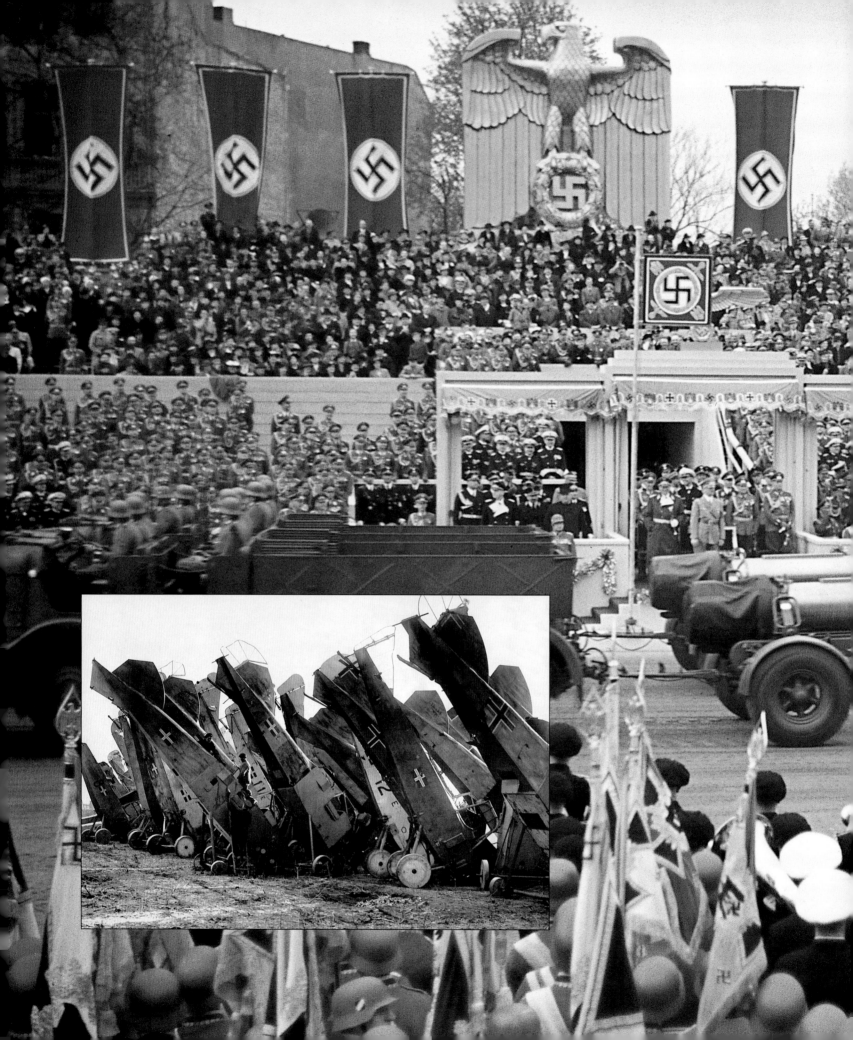

1919
1939

ALL ROADS LED TO WAR

The most dramatic evidence possible of the transformation of the world in the 20 years between the wars was the rearming of Germany. In 1919, the Treaty of Versailles required Germany to junk its Air Force, and the defeated country's planes were stacked up like abandoned toys (inset). After Hitler came to power, in 1933, he began to rebuild the military, in defiance of the Treaty. The frightening result is seen in this 1939 Berlin parade (left), where the most modern artillery and armor were shown — to foster German pride and caution the rest of Europe.

HUGO JAEGER / TIMEPIX
INSET: FPG / ARCHIVE PHOTOS

Four Blunders That Doomed the World

by Robert Edwin Herzstein

O N NOVEMBER 11, 1918, the bloodiest war in human history ended. But in the aftermath of that Great War, the seeds of a more horrific struggle were sown. In more than four years (1914–1918) of bloodshed, 10 million men had died in the trenches and killing fields of Europe. Another 20 million were wounded. Now, millions of men and women hoped that a new world order would prevent the outbreak of another, more terrible conflict.

A diverse cast of characters would propose different remedies.

From war-ravaged Russia, V. I. Lenin called for a European revolution, led by Communists in the name of workers and peasants of the world. End imperialist wars, he declared, and Socialism would inaugurate an era of human happiness.

From the United States came President Woodrow Wilson. For the first time, his country had determined the outcome of a general European war. Before cheering crowds, he offered the world "Fourteen Points" toward a just peace and a League of Nations under American leadership. He had called the recent conflict the war to end all wars; now, he insisted, "the world must be made safe for democracy."

Both Wilson and Lenin would die in 1924, their dreams unfulfilled.

The Treaty of Versailles, signed in the summer of 1919, required Germany to give up its colonies and

drastically reduce the size of its Army and Navy, admit responsibility for the war and pay the Allies reparations. It left the German people feeling humiliated, "stabbed in the back" by the countries that defeated them and by pacifists, Jews and Communists. Proving prophetic, Marshal Ferdinand Foch, an Allied commander, said of the Treaty of Versailles, "This is not peace. It is an armistice for 20 years."

Broken and ill, Wilson retired from the fray in 1921, a shattered relic of idealistic hopes that were long gone. The United States had refused to guarantee the borders of France, ratify the Treaty of Versailles or join the League of Nations. America quickly dismantled the Army that had only recently defeated the Germans.

Britain and France, though victors, had lost the cream of a young generation. They had prevailed only because of their alliances with Russia, the United States and Italy. But Russia was suffering through a revolution followed by a civil war; it was barred from participation in the postwar global order. Given Russian isolation and American withdrawal, the coalition that had defeated mighty Germany became a thing of the past.

Benito Mussolini would come to power in Italy. As a Fascist, he would have scant sympathy for the democracies. A resurgent Germany could clearly profit from this disintegration of the wartime alliances.

In 1920, a charismatic, Austrian-born war hero

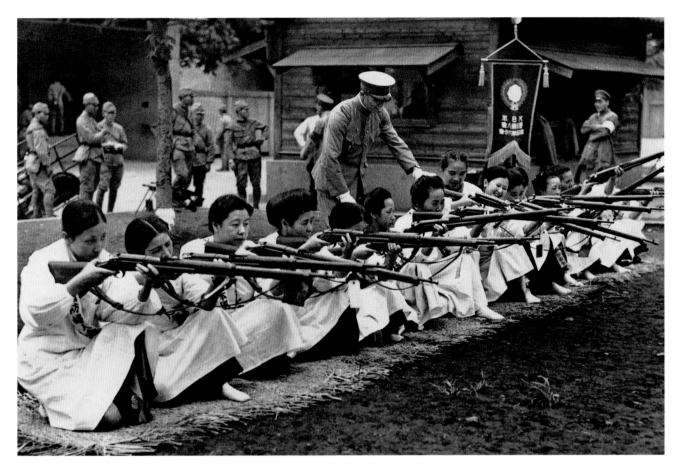

As early as 1937, Japan was training its citizens for the possibility of war at home. These members of the National Defense Women's Association learned how to handle a rifle from an Army Reserve officer in Tokyo.
WIDE WORLD

named Adolf Hitler founded the National Socialist German Workers' Party. Unscrupulous but gifted, Hitler would mobilize the middle classes against Communism, against the hated Treaty of Versailles, against the Jews. A Third Reich, he reasoned, could avenge Germany's defeat and dominate Europe, perhaps the world.

Hitler was a ruthless and cunning demagogue, and his hate-filled oratory soon inspired millions of bitter Germans. A master propagandist, the self-proclaimed "Führer" (leader) flew from rally to rally ("Hitler over Germany") and made clever use of movies, art and other media. By 1929 more than 100,000 Germans had joined the Nazi party. Armed gangs of Nazi storm troopers began to intimidate and even murder Hitler's political opponents. At the same

time, some German industrialists, alarmed at their country's deterioration, were starting to support him.

In the late Twenties, global disruptions, occasioned by protectionism, reparations, war loans and overspeculation in stocks, wrought general havoc. The West had no common policy on tariffs, trade and currencies. By 1933, both Europe and the United States suffered from curtailed production and staggering unemployment.

The Great Depression would be the prelude to political catastrophe.

In Germany, with five million or more unemployed, Adolf Hitler seized power, becoming chancellor in 1933. There was no order in Europe, he declared, only domination or submission. He resolved to rearm the German Reich. In America, President Franklin D. Roosevelt, concentrating on the Depression, treated Europe as a secondary problem; the United States maintained an Army smaller than that of Poland. The Congress passed, and the Presi-

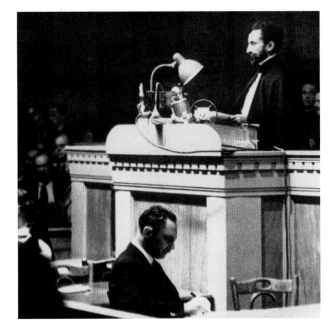

dent signed, a series of neutrality acts. Americans did not wish to be drawn into a new European war.

Fearing no retribution, the Nazis robbed and persecuted the Jews. Illegally, Germany began to build a modern Air Force and enlarged the small Army allowed them under the Treaty of Versailles.

Britain and France were at best reluctant guarantors of the peace treaties they had created. Leaders like Socialist writer Léon Blum and Premier Edouard Daladier in Paris and statesman Stanley Baldwin and Prime Minister Neville Chamberlain in London feared that a new war would lead to another massacre of their young men as well as to Communist expansion. They let events mold their policy and felt compelled to appease Hitler and Mussolini, while holding Stalin at bay.

In 1935 Mussolini invaded and later conquered Ethiopia, a member of the League. No one intervened against him. Hitler remilitarized the Rhineland; in 1938 he annexed Austria and threatened to dismember the Czech Republic. Chamberlain flew to Munich, conferred with Hitler, accepted his dismemberment of Czecho-Slovakia (as it was then called) and returned home, promising "peace in our time." The frightened democracies had bought off Germany at the expense of their Czech ally. But Chamberlain had only strengthened the Third Reich without securing peace. A few months after Munich, Hitler seized the rest of Czecho-Slovakia.

In Spain, Hitler and Mussolini helped General Francisco Franco lead an uprising against the freely elected government of the Spanish Republic. The pilots and crews of the German Condor Legion used the country as a testing ground; Hitler's Luftwaffe thereby learned some of the aerial tactics that later served it well in a bigger war. The democracies did little for the other side, and Franco won. Once again, aggression fed upon democratic indecision. Hitler began to formulate new demands, this time against Poland.

But among the World War 1 Allies, signs pointed to a changing constellation of forces. Hesitantly, Britain and France began to rearm. In Britain, a politician derided as an overage has-been warned Chamberlain against appeasing Hitler, but in vain. By 1939, however, Winston Churchill was gaining a broader audience.

FDR, viewing German aggression with growing concern, hinted that Britain, France and Poland might receive American help if they resisted Hitler. But though Roosevelt was an articulate and persuasive — some would say devious — politician, he faced an enormous challenge: How could he push a recalcitrant public toward rearmament short of war?

Hitler, meanwhile, bragged that he had "freed [Germany] from the death sentence of Versailles." He had created a Greater Germany, enlisted Mussolini as his cowed ally and now threatened further expansion by preparing to attack Poland. Belatedly, the West turned to Stalin, hoping for his support in defense of Poland. But Stalin mistrusted Britain and France for their years of hostility and wanted to forestall any Ger-

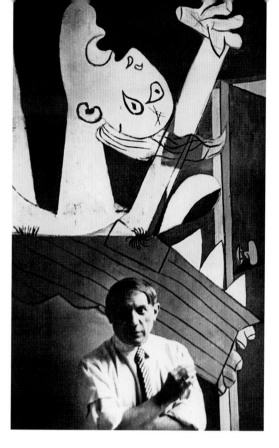

When the Spanish city of Guernica was devastated by German air raids, in 1937, Spanish-born Pablo Picasso, then 55, commemorated the attack with a huge, dramatic black-and-white painting (*Guernica*, a partial view at right, with artist) that became world famous.

DAVID SEYMOUR / MAGNUM

man threats to his western border. He also had expansionist plans of his own. He and Hitler entered into secret consultations and agreed to divide Poland and much of Eastern Europe between them.

After signing his pact with Stalin late in August, on September 1 Hitler invaded helpless Poland from the west. Two days later, Britain and France declared war on Germany. On September 17 Stalin attacked Poland from the east. The country quickly fell, but the first few months of "phony war" in the West were indecisive. Britain had a small Army; France hid behind the Maginot Line. Soon, Hitler's plans for a "lightning war" would threaten to overrun France and the Low Countries.

In the Far East, Hitler's friend Japan was ever more aggressive. By 1939 Americans, shocked by Japanese brutality against hapless China, were willing to support measures that curtailed and ultimately suppressed U.S. trade with Japan. This was a critical decision, since the Japanese war machine had to import crucial fuels and raw materials from the United States.

Amidst the gloom Prime Minister Chamberlain and Premier Daladier saw one ray of hope: FDR would try to help them. The President was soon working to ship arms and munitions to Britain and France. Stalin was an uncertain ally of Hitler's, at best. If the West could hold out, with American help the global empires of Britain and France might prove decisive. Hitler needed a quick series of vic-

tories, and he knew it. Still, the future looked grim for the West in this first winter of World War 2.

How had the world come to the state it was in? Four factors made the new war possible, even likely:

Russia and America had turned their backs on the alliance that had defeated Germany in World War 1.

The Germans had never accepted the peace that ended the war, and they blindly followed a leader who promised revenge and greatness.

The West, lacking the leadership that Wilson had promised, failed to support the treaty system that it had created in 1919.

Appeasement born of demoralization and fear permitted Germany to prepare for war, expand and, finally, attack. Churchill put it well when he wrote that "the English-speaking peoples through their unwisdom, carelessness and good nature allowed the wicked to rearm."

America's attempt to isolate itself from Europe's troubles had backfired disastrously. As a result of enemy blunders and weakness, the Germans appeared to hold the higher cards. Yet, once before, Britain, France, Russia and the United States had joined to prevent German domination of Europe. Would they, could they, do so again, and save the West?

Robert Edwin Herzstein, Ph.D., is Carolina Distinguished Professor at the University of South Carolina. He is the author of seven books, including Roosevelt and Hitler: Prelude to War, The War That Hitler Won *and* Waldheim: The Missing Years.

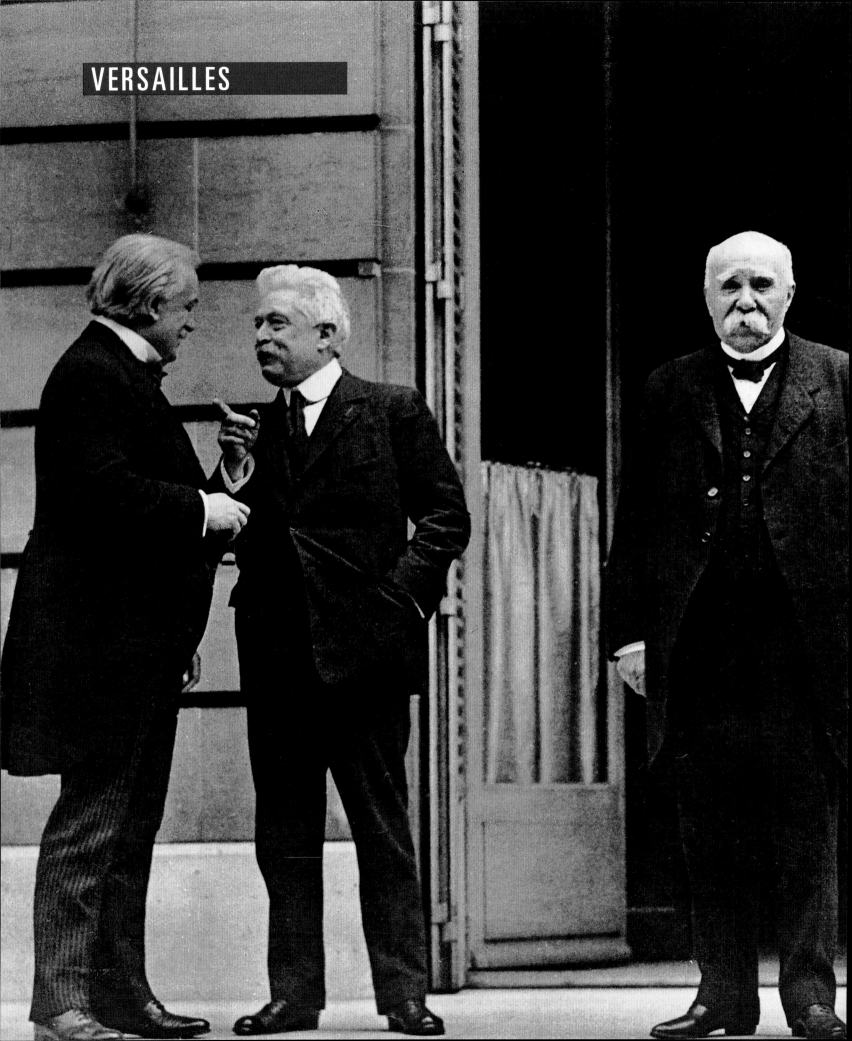

< >
THE VICTORS

At the end of World War 1, diplomats from 32 nations attended the Paris Peace Conference, but the aging men at left dominated it: (l. to r.) British Prime Minister David Lloyd George, Italian Premier Vittorio Orlando, French Premier Georges Clemenceau and U.S. President Woodrow Wilson. They rewarded friends, penalized enemies and redrew the boundaries of Europe. On June 28, 1919, as aides stood on chairs to watch (right top), the Treaty was signed in the Hall of Mirrors in the Palace of Versailles. Germany learned for the first time that it would have to surrender all its colonies and occupied territory and pay $33 billion in reparations. Absent from Paris: the civil war–wracked Soviet Union, which had made its own peace with Germany the year before.

LEFT: BROWN BROTHERS
RIGHT TOP: HULTON / ARCHIVE

THE VANQUISHED

Germany's economy collapsed in the Twenties, drained by the long war and reparations. Its coal and iron reserves had been given to France. Its industry was forbidden to build submarines and planes, and the Army was limited to a paltry 100,000. Unemployment was rising; national morale was shattered. In desperation, these Berliners (right) collected tin cans and sold them for scrap.

GRANGER COLLECTION

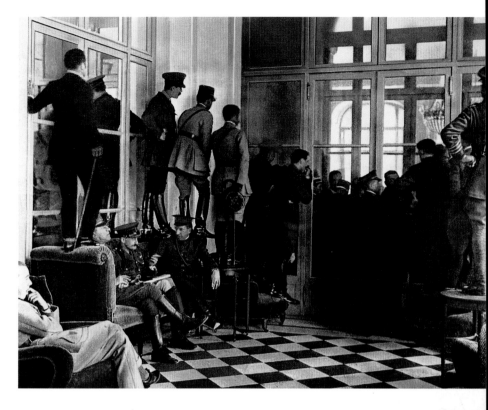

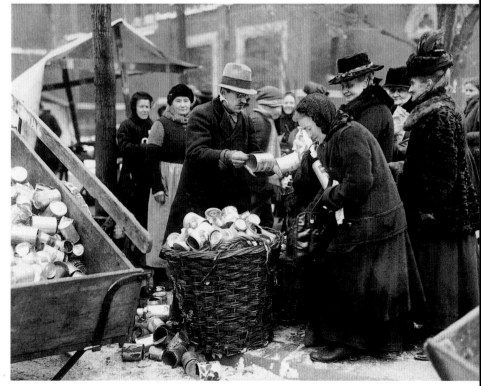

GERMANY

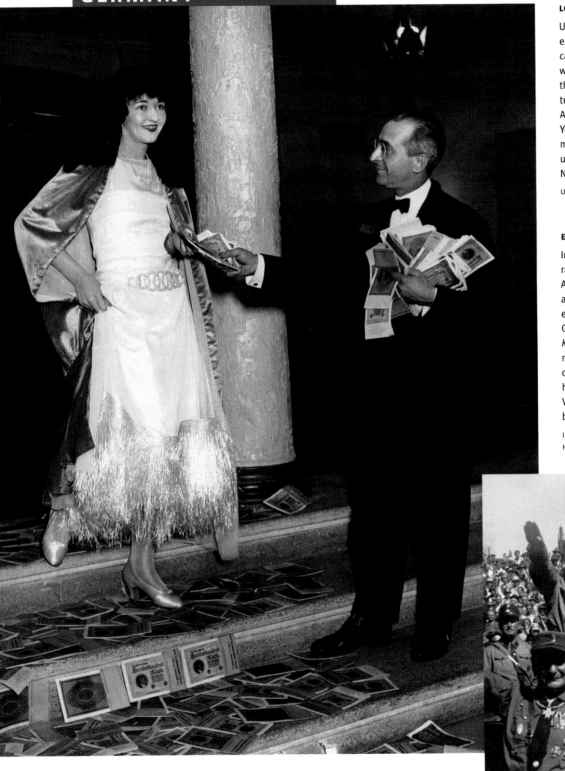

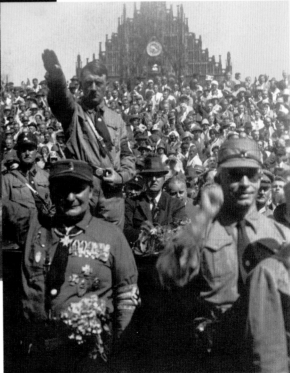

LOWEST MARKS

Unable to cover government expenses, Berlin issued more cash. The resultant inflation wiped out the savings of the thrifty. By 1923, the mark was trading at four trillion to the American dollar, and one New York City restaurant (left) mocked German misery by using its devalued currency as New Year's Eve confetti.

UNDERWOOD PHOTO ARCHIVES

ENTER EIN FUHRER

Into the breach stepped a deco-rated war hero from Austria, Adolf Hitler. Jailed after an abortive 1923 coup, he emerged with his blueprint for German renascence (*Mein Kampf*) and a growing national reputation. In rallies like this one at Nuremberg (below), he demonized the Treaty of Versailles and Jews, and slowly built his power base.

INSET: NATIONAL ARCHIVES,
HEINRICH HOFFMANN COLLECTION

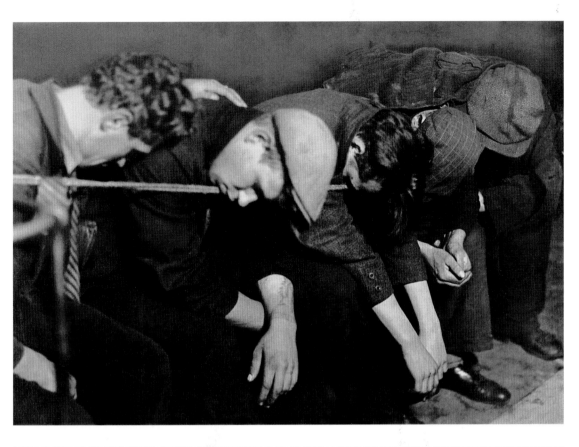

CALL IT SLEEP

German men, many of them disgruntled war veterans, searched in vain for work. By 1933, the army of unemployed had grown to six million. Shelters were jammed. These unfortunates in Hamburg (right) were forced to sleep while seated shoulder to shoulder on a bench because there was no room for them to lie down. The rope suspended at chest level allowed them to doze without pitching onto the floor.

FPG / ARCHIVE PHOTOS

PROTECTING LUNCH

Although German reparation payments had been lowered and rescheduled, the lot of most ordinary citizens had worsened. The Depression gripping much of the world had tied up international bank loans that might have eased the crisis. In this grim climate, any display of food invited theft, so Army troops were assigned to this outdoor Berlin soup kitchen (right) to maintain order.

CORBIS / BETTMANN

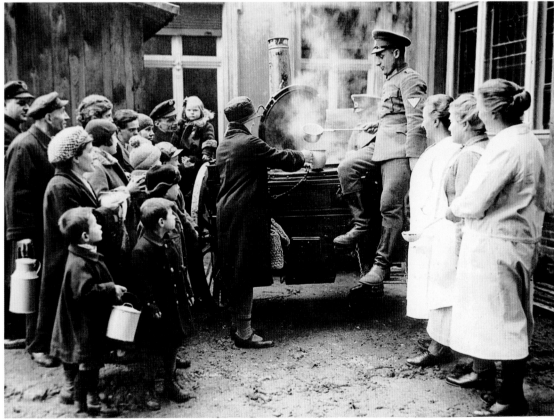

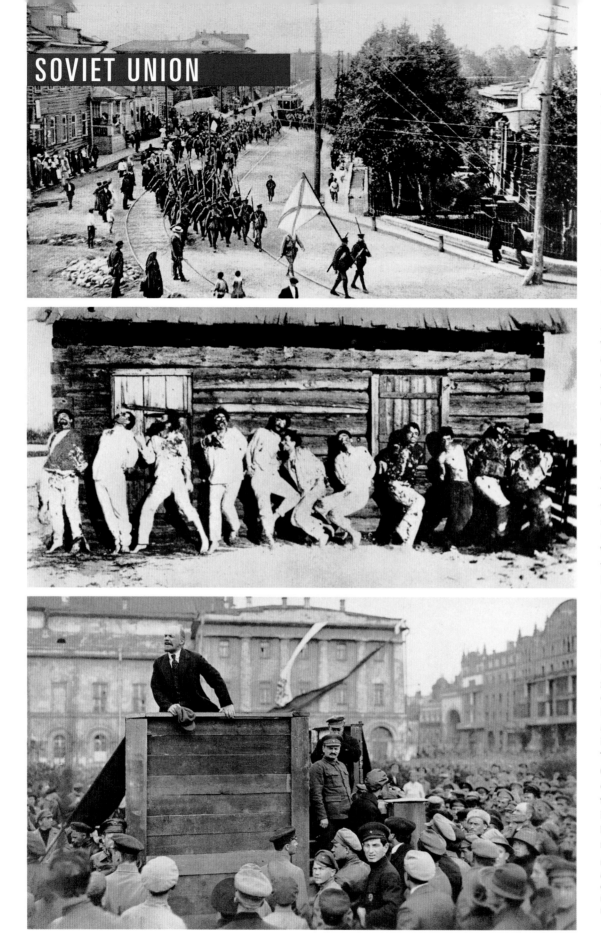

SOVIET UNION

A NATION IN CHAOS

The March 1917 revolution that deposed Czar Nicholas II left the Soviet Union rudderless until November, when the Bolsheviks, the most radical of competing left-wing parties, took over. They promptly signed an armistice with Germany, leaving citizens free to turn their guns on one another. By May 1918, a full-scale civil war had erupted, pitting the Reds against the counterrevolutionary Whites. Fearing the spread of Communism, Allied countries sent 100,000 troops to bolster the ex-Czarists, and actually occupied Archangel, in the polar north. But despite White recruitment parades there (left top), the city eventually fell to the Reds. The fighting between the two sides was particularly savage; prisoners were routinely shot, like these White captives in Kazan at the moment of their death by firing squad (left middle). The body count had begun when Vladimir Ilyich Ulyanov, better known as Lenin (left bottom), the 48-year-old leader of the new Soviet government, ordered the execution of the Czar and his family in July 1918. Meanwhile, starvation took its toll on the population. These refugee children (right), their bellies distended from malnutrition, gave mute testimony in 1921 to the famine that killed as many as six million people.

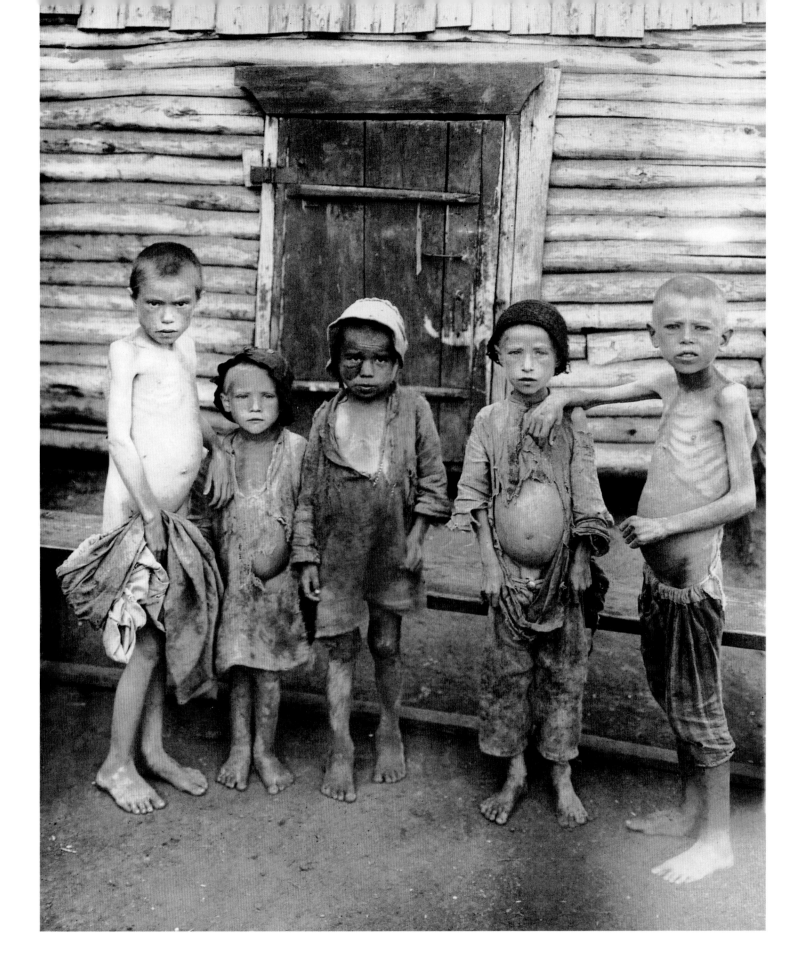

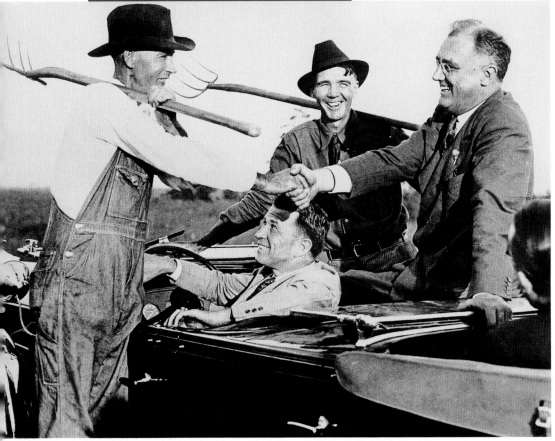

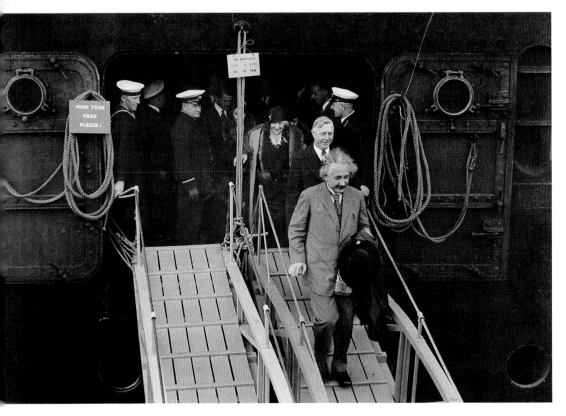

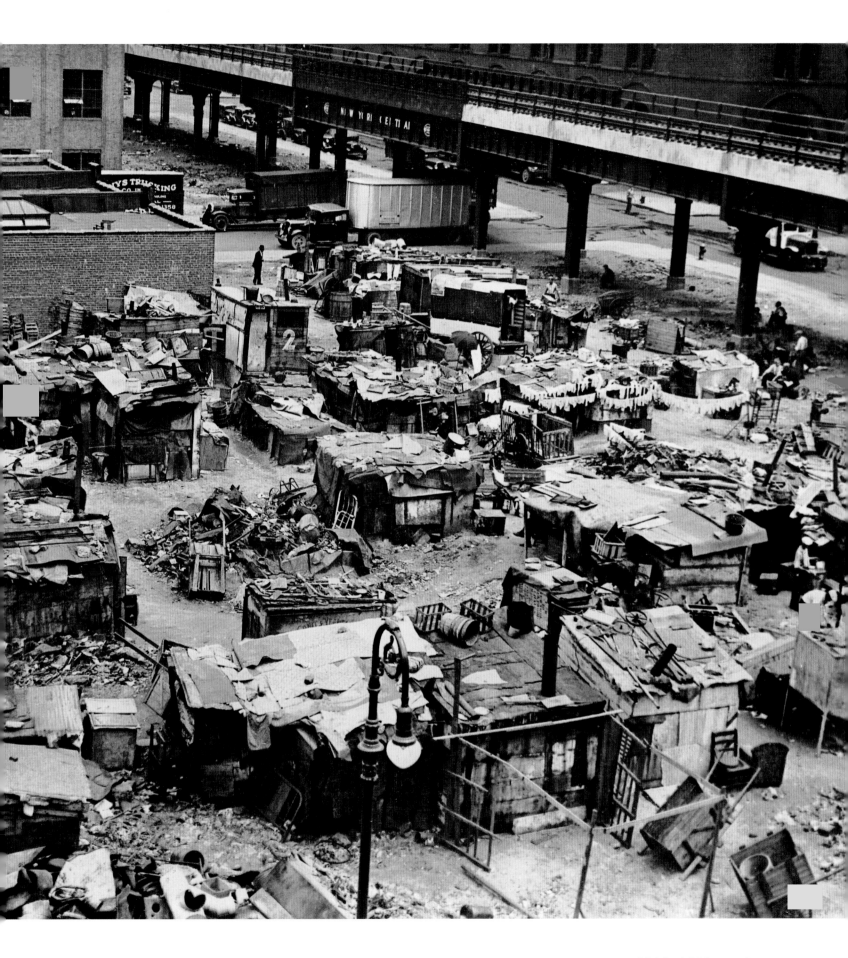

CHINA

THE HIGH GROUND

The Great Wall provided visibility for Chinese troops (right) but not much protection against the invading Japanese. Japan had been nibbling at China since the late nineteenth century. When civil war between the Chinese Nationalists and Communists in the Thirties left much of the country undefended, Japan advanced.

BROWN BROTHERS

MANCHURIA FIRST

Charging sabotage in September 1931, Japan sent cavalry into Manchuria (below) to protect its rail line. (Japanese agents actually set the dynamite.) Six months later, the iron ore-rich Chinese province became a Japanese puppet state with its own emperor. The hapless League of Nations condemned Japan for its aggression. Tokyo then quit the League.

UNDERWOOD PHOTO ARCHIVES

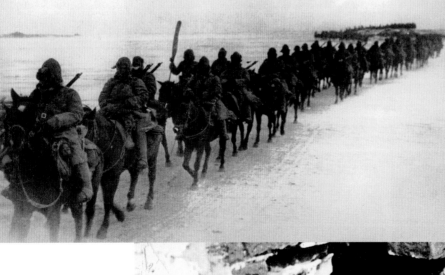

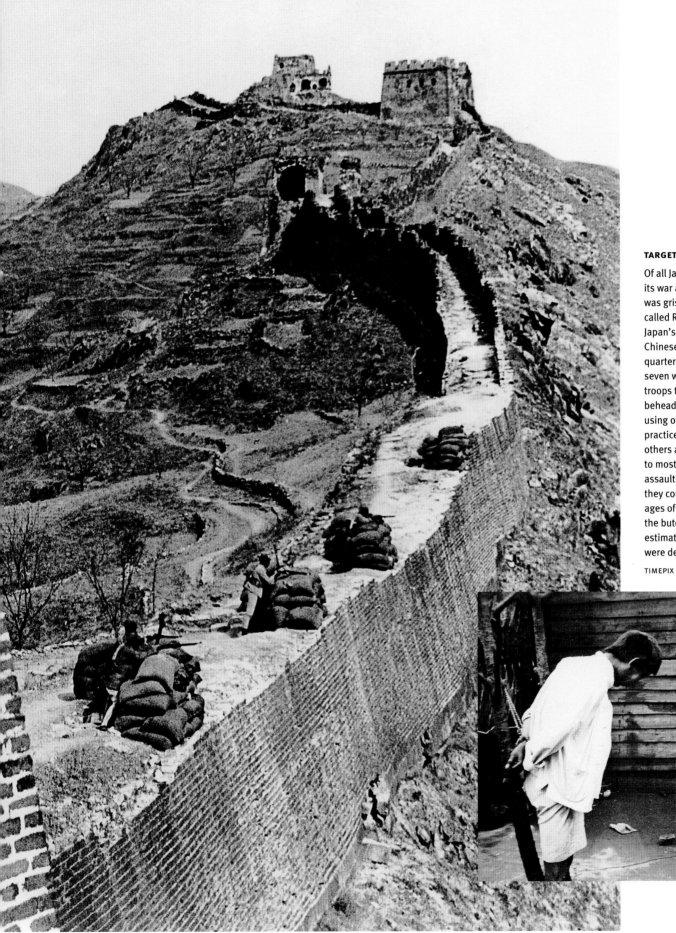

TARGET: NANKING

Of all Japanese atrocities in its war against China, none was grislier than the so-called Rape of Nanking, Japan's attack on the Chinese Nationalist head-quarters city in 1937. For seven weeks, Japanese troops tortured civilians, beheading some (below), using others for bayonet practice, burying still others alive and, according to most accounts, sexually assaulting every female they could find between the ages of 10 and 70. When the butchery ended, an estimated 42,000 Chinese were dead.

TIMEPIX

CHINA

THE LITTLEST VICTIMS

Shortly after war broke out, in July 1937, Japanese planes bombed and strafed large areas of North China. Mourning was a luxury its victims could hardly afford. This dead child (left) was unsentimentally carried to a common grave. Yet the capriciousness of war was demonstrated on the streets of Shanghai, where a Japanese soldier (below) genially shared his candy with grateful youngsters. As food-supply chains were destroyed, Chinese families fell apart. Parents who could not care for their children often abandoned or sold them — especially girls, who were considered burdensome. A common Chinese phrase for "Hello" actually meant "Have you eaten today?"

PICTURES INC. / TIMEPIX
INSET BELOW: MANSELL
COLLECTION / TIMEPIX

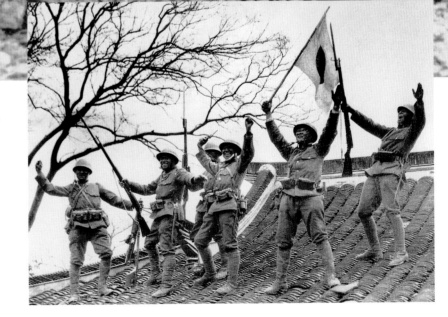

AN ASIAN BLITZKRIEG

Japan's well trained and equipped infantry devoured one city after another. In the first month of hostilities, these troopers (right) celebrated their triumph on a rooftop in Tianjin (formerly Tientsin). Three weeks later, despite barbed wire and artillery fire (above), they charged into Beijing. Short of everything but manpower and largely ignored by the rest of the world (though the U.S. was sympathetic), China desperately signed a nonaggression pact with the Soviet Union, which secretly agreed to furnish weapons to its new ally.

TOP: WIDE WORLD
RIGHT: CORBIS / BETTMANN

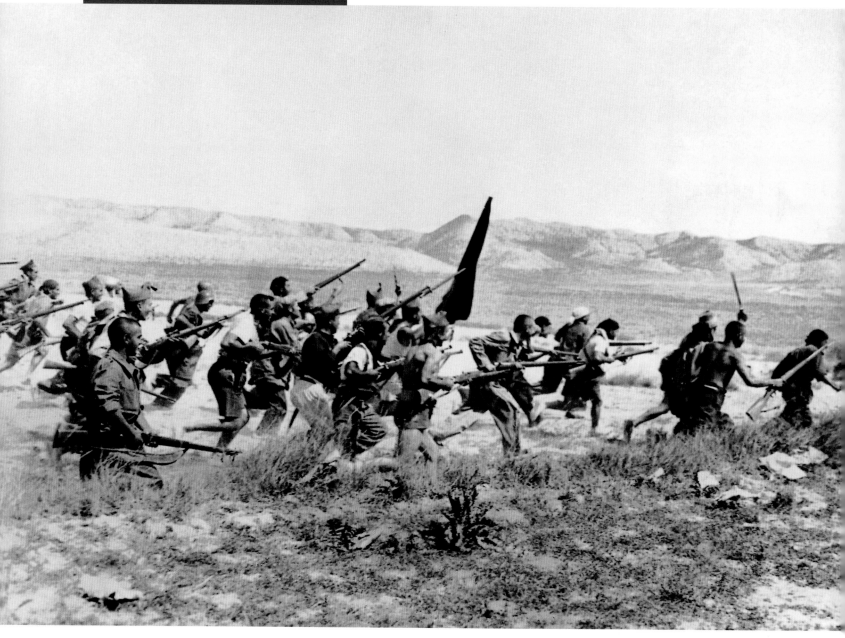

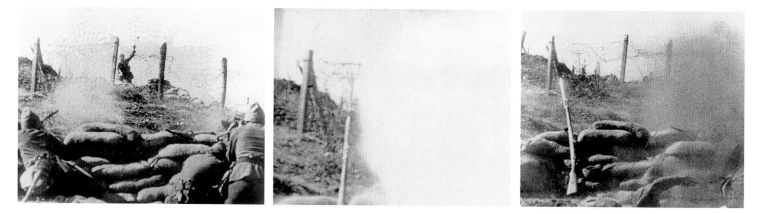

ANOTHER CIVIL WAR

In 1936, five years after its first elections, Spain was polarized between the Left and the Right. Then the latter suffered a defeat at the polls and the assassination of its parliamentary leader. Outraged supporters urged the military to revolt, and it did. Civil war engulfed the country. The right-wing rebels, or Nationalists, occupied the provincial capital of Saragossa, in the northeast, but were driven out by hard-charging government Loyalists (left).

BROWN BROTHERS

NOWHERE TO HIDE

Without leaves for camouflage, this tree in Teruel became a death trap for a Loyalist soldier stringing field-telephone wires. Among the Loyalist forces: 40,000 largely Communist volunteers of the International Brigade from Europe, Canada and the U.S, including 3,000 Americans in the Abraham Lincoln Brigade.

ROBERT CAPA / MAGNUM

A FATAL SKIRMISH

Spain's civil war was a brutal conflict that lasted only 33 months but killed 600,000. An example of the fratricidal fighting near the city of Burgos is seen in the remarkable sequence at lower left: Heedless of his safety, a Nationalist soldier flings a grenade at Loyalist machine gunners, who fire back; the grenade explodes in a flash of smoke; after it clears, all the men involved are found dead.

WIDE WORLD

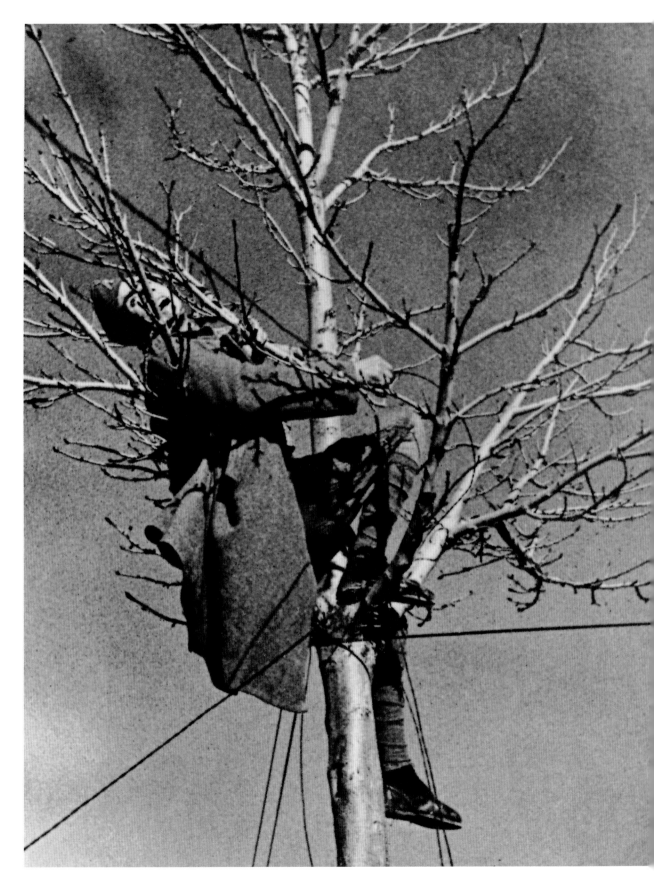

FLIGHT OVER FIGHT

After Barcelona, seat of the Republican government, fell, in January 1939, many Loyalists fled across the border to France. They included government officials and these miserable refugees (left). An estimated 500,000 people managed to escape before Spain closed its border in February 1939. That same month, London and Paris recognized Franco as the leader of Spain, a position he held for 36 years.

HULTON / ARCHIVE

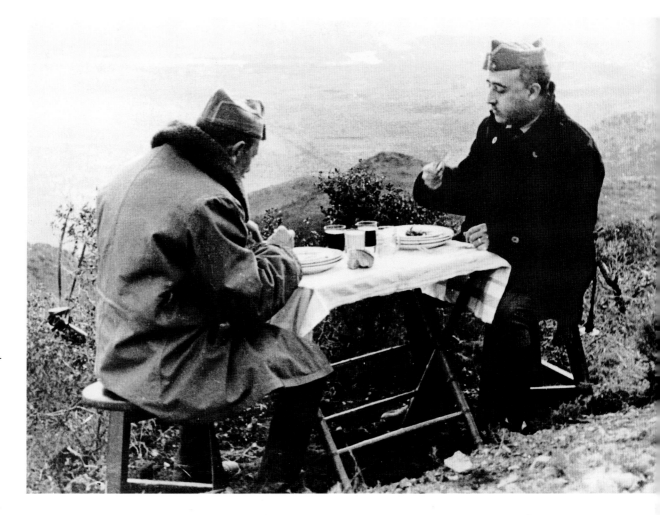

A DICTATOR DINES

The war pauses as Generalissimo Francisco Franco (right) and his Minister of War, General Fidel Dávila, share an alfresco supper. One of the key military plotters against the government, Franco laid siege to a stubbornly defended Madrid for two years. When the capital surrendered, in March 1939, the civil war was over.

FPG / ARCHIVE PHOTOS

THE CONDOR RETURNS

In June 1939, the Condor Legion, German air and ground forces who fought with Franco, returned to Berlin — their dead commemorated by wreaths. (Franco was not overly grateful; when Hitler asked him to join the Axis in World War 2, he refused.) Italian Fascists also supported the Nationalist side. The Soviet Union sent the Loyalists a few men, planes, guns and tanks. The U.S. and Britain officially supplied only food and clothing.

HUGO JAEGER / TIMEPIX

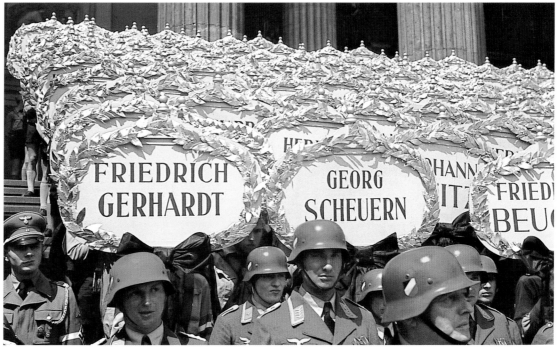

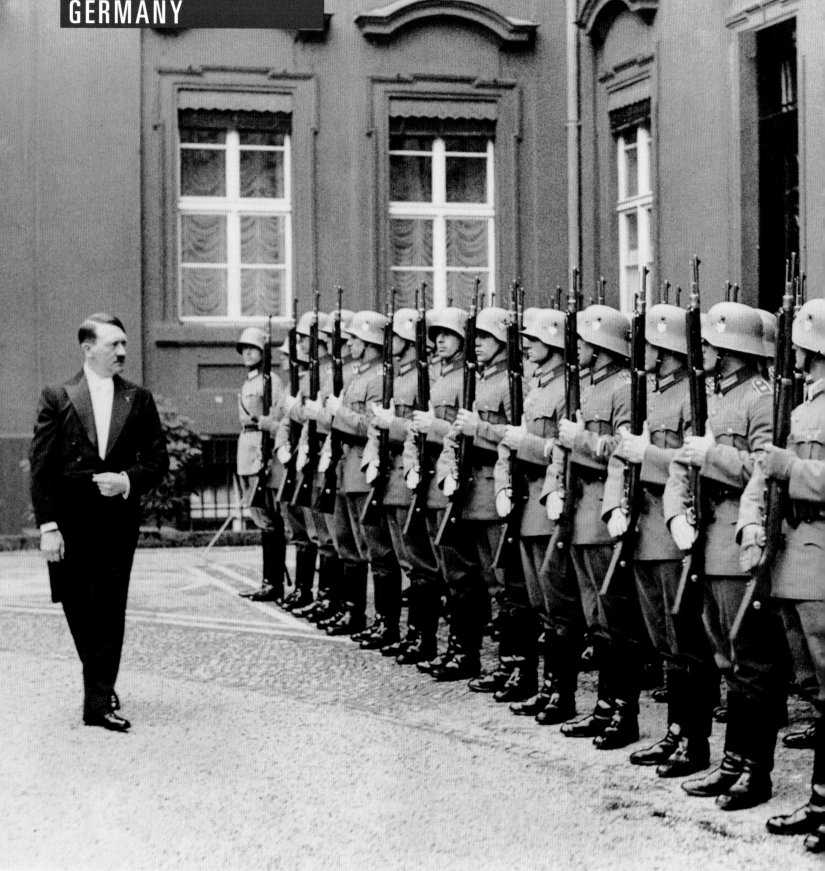

A PREENING HITLER

Dressed up in tails, the Führer, 45, inspects an honor guard after receiving the new Polish ambassador, Josef Lipski, in March 1935. It was, of course, the country he would invade in four years. The Napoleonic pose was hardly accidental; Hitler was a vain man who studied a series of portraits of himself, taken by his personal photographer, so as to polish his gestures and bearing while speaking in public.

HULTON / ARCHIVE

>

A REVERENTIAL HITLER

Mindful of President Paul von Hindenburg's reputation, Hitler always showed the World War 1 hero great public deference (right top). Their private relationship was another story. On January 30, 1933, the older politician appointed his rival chancellor in hopes of containing the Nazi movement. Two months later, Hitler demanded, and got, unlimited powers.

HULTON / ARCHIVE

>

A PLOTTING HITLER

The first, fateful meeting of Hitler and Mussolini was in Venice, in June 1934, to discuss the fate of Austria. Mussolini was dressed as Commander of the Fascist Militia, a favorite self-proclaimed title. He had ruled Italy since 1922 — a career the German leader followed with admiration. During the war, Hitler faithfully supported Mussolini, although he was often vexed at the Italian dictator's inept military strategies.

ALFRED EISENSTAEDT/ LIFE / TIMEPIX

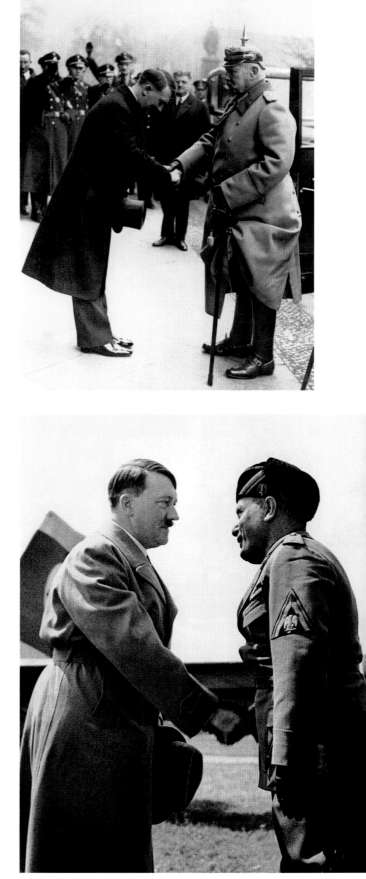

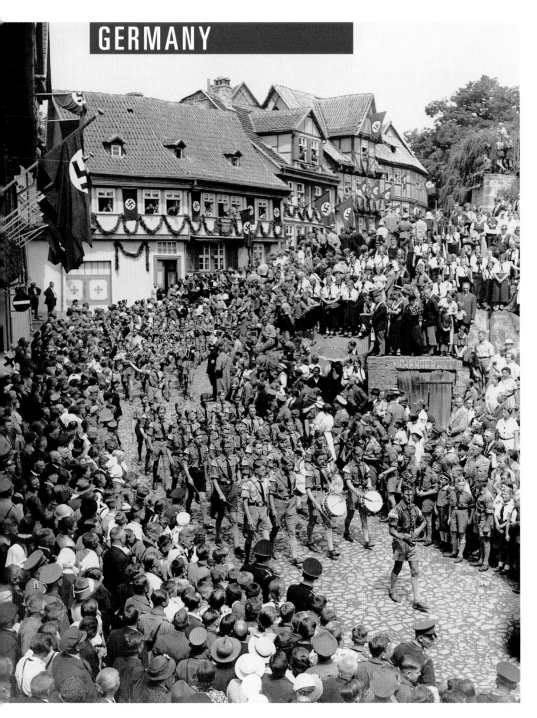

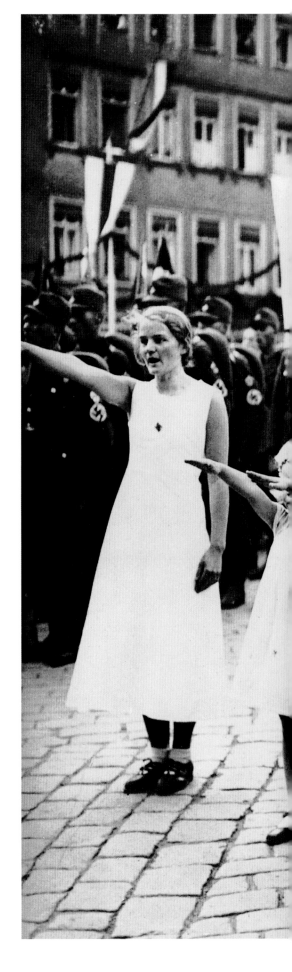

HEIL TO THE CHIEF

Enthusiasm for Hitler's regime was generated — for both internal and international audiences — by an endless schedule of public events. Above, Weimar turns out in July 1936 to cheer a youthful march through the cobblestone streets to celebrate the tenth anniversary of Nazi Party Day. In Coburg (right), indoctrination began early. Little schoolgirls, garlanded like Aryan goddesses, and their teachers salute a political rally. In class the curriculum was nazified; the morning greeting, "Heil Hitler."

ABOVE: NATIONAL ARCHIVES / FOREIGN RECORDS SEIZED, 1941
RIGHT: IMPERIAL WAR MUSEUM

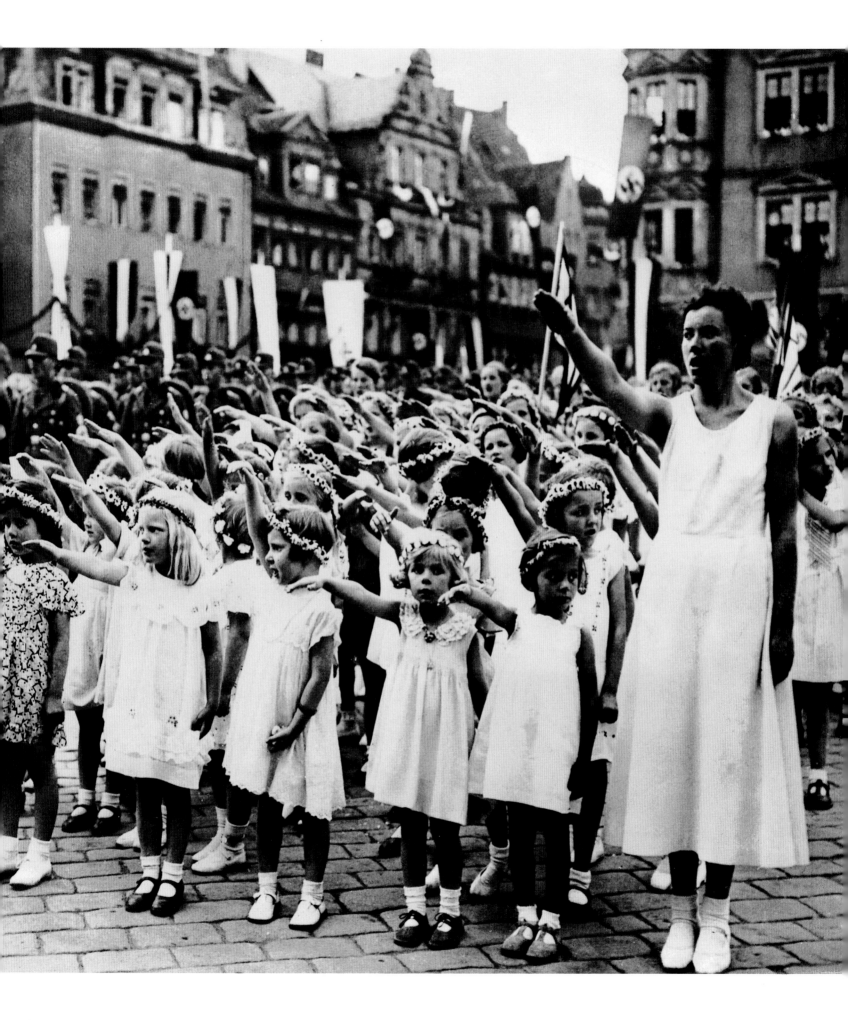

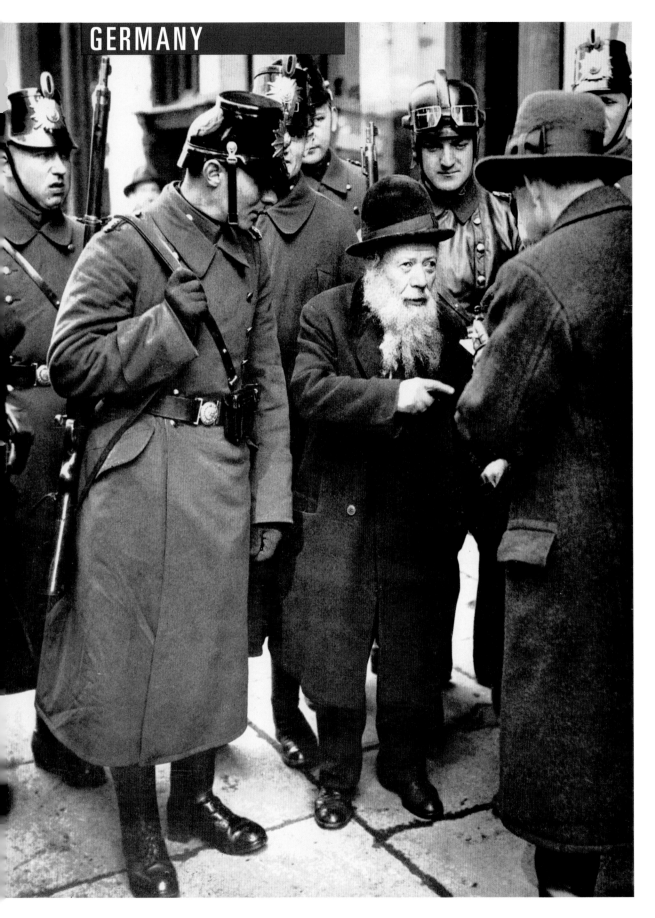

GERMANY

< >

ATTACKING A PEOPLE . . .

Under Nazi ideology, non-Aryans were members of inferior "races." Jews were held in particular contempt and were increasingly harassed by police, especially the Orthodox, whose distinctive hairstyles and clothing made them obvious targets — like this elderly man in 1939. But many German Jews had grown away from tradition and assimilated into their communities, considering their country tolerant and civilized. They learned otherwise. To ferret out Jews, likely "suspects" were subjected to humiliating inspection by pseudo-scientists who measured such physical features as the size of a nose (right).

LEFT: WIDE WORLD
RIGHT TOP: HULTON / ARCHIVE

. . . AND A CULTURE

Two anti-Jewish events in the Thirties shocked the world. The first, in 1933, was the burning of thousands of books (near right) by "racially alien" authors (some non-Jews too), from Sigmund Freud to Thomas Mann, by students at the University of Berlin. Five years later, in retaliation for the assassination of a German diplomat by a Polish Jew in Paris, some 7,500 Jewish-owned shops and 200 synagogues were destroyed. So much broken glass covered Berlin streets (far right) that the evening of November 9 went down in history as Kristallnacht. The luckier victims lost mere property — 91 Jews were also killed and thousands arrested.

NEAR RIGHT: STEFAN LORANT
COLLECTION
FAR RIGHT: WIDE WORLD

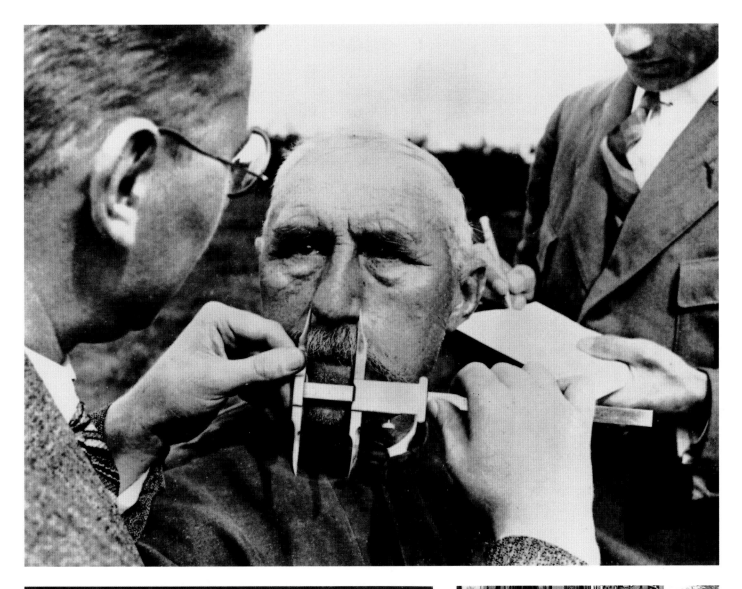

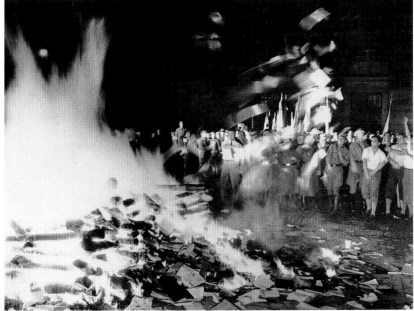

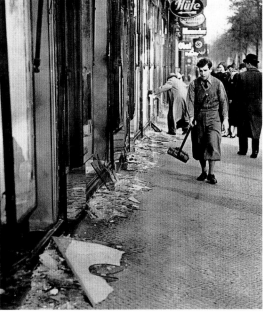

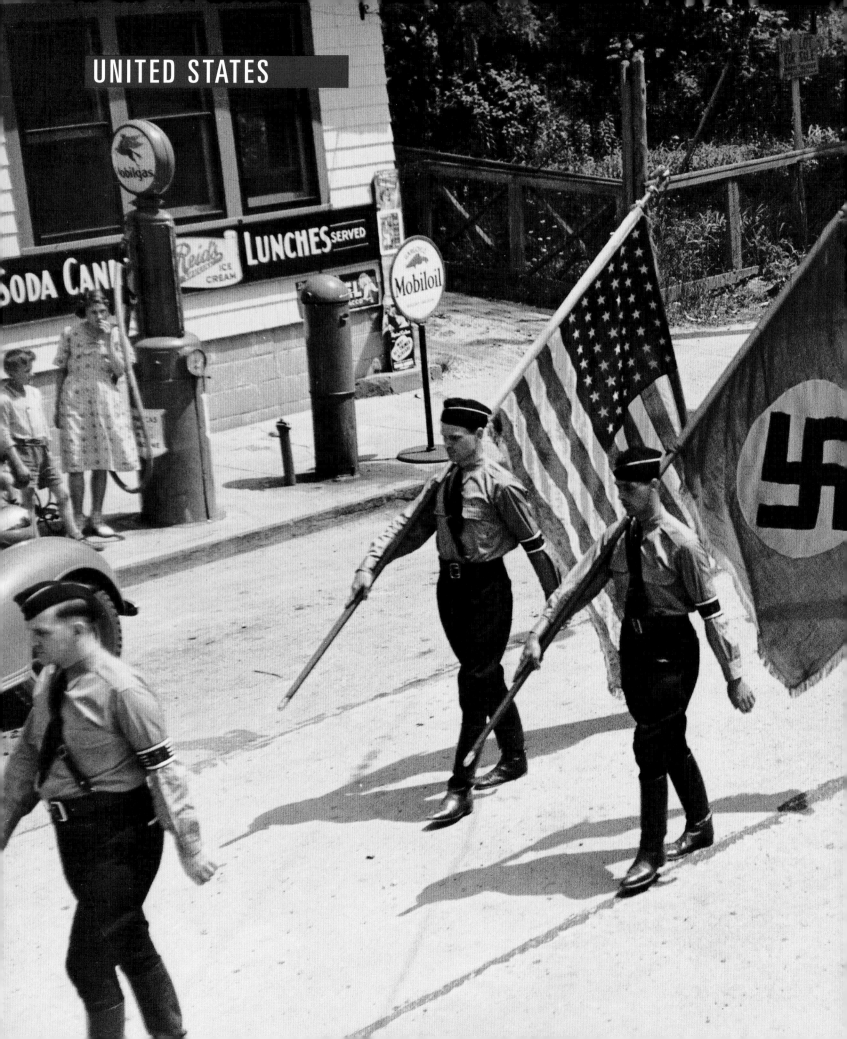

EIN, ZWEI, DREI — FEAR

Feeling ran high in Depression-stricken America against getting involved in Europe's worrisome political turmoil. In some areas, this "noninterventionist" sentiment escalated into outright sympathy for the Germans. One such place was Yaphank, Long Island. There, a quasi-military camp called Siegfried was set up by the pro-Nazi German-American Bund, a domestic organization that received covert financial support from Berlin. In the summer of 1937, jackbooted Bundsmen from Camp Siegfried carried the Nazi flag alongside Old Glory through downtown Yaphank.

REX HARDY / LIFE / TIMEPIX

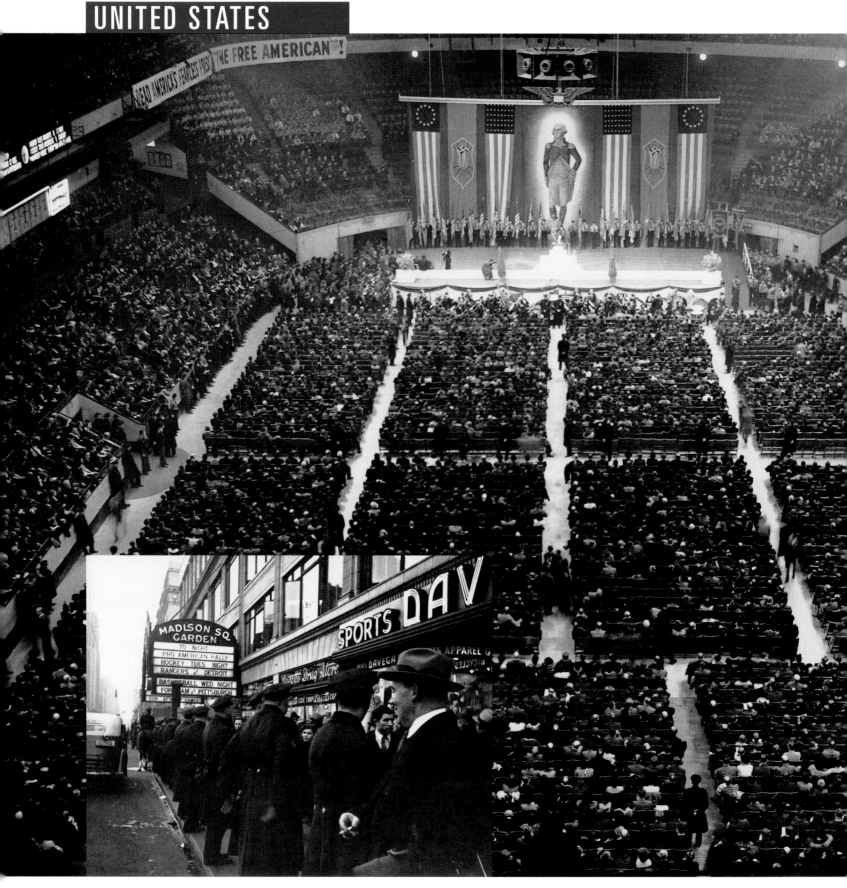

LEFT FACE

German sympathizers faced rising opposition in major urban areas. These women (right) were among 40,000 marchers who clogged traffic in New York City to promote peace and liberal causes. The occasion was May Day 1936, a workers' holiday in Socialist countries. The sign Never Again! refers to war. After 1945, the words, of course, meant Jewish determination to prevent another Holocaust.

BROWN BROTHERS

<

THE GARDEN PATH

Sharing the Madison Square Garden marquee with mainstream sports events, the German-American Bund drew an SRO crowd to a rally in 1939 celebrating George Washington's birthday (left). Because of a bomb threat and the expectation of protests, 1,700 New York City policemen were assigned to peacekeeping duty (inset). By early 1940 a city investigation of the Bund had sent two of its leaders to jail.

LEFT: CORBIS / BETTMANN
INSET: OTTO HAGEL

>

RIGHT WING

The most prominent member of America First, a group demanding U.S. neutrality, was Charles Lindbergh. His reputation plummeted in 1938, when Lindy, 36 (right, at extreme left), accepted a medal from Hitler's Air Force chief, Hermann Goering (in center). After Pearl Harbor, Lindbergh about-faced and flew combat missions in the Pacific — but never returned the Nazi medal.

CULVER

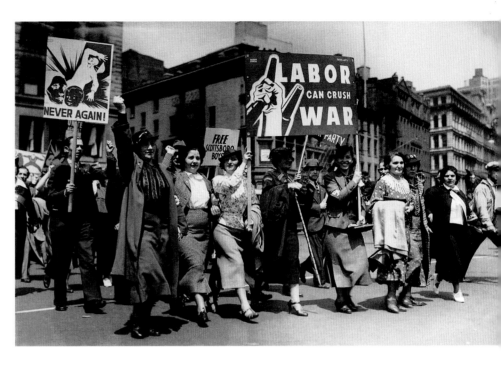

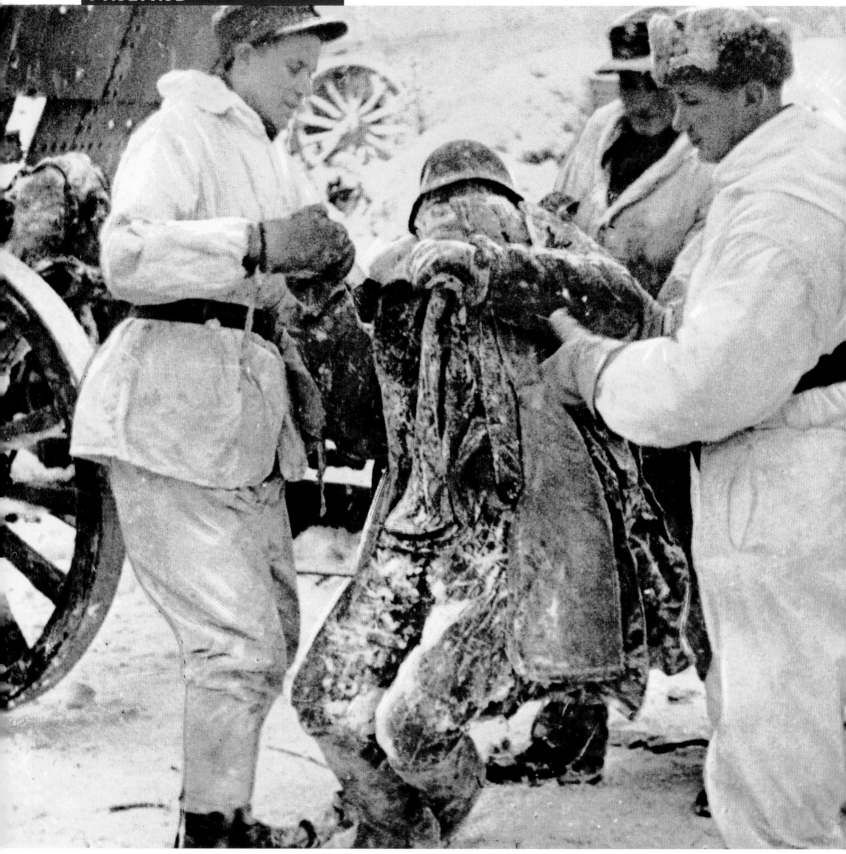

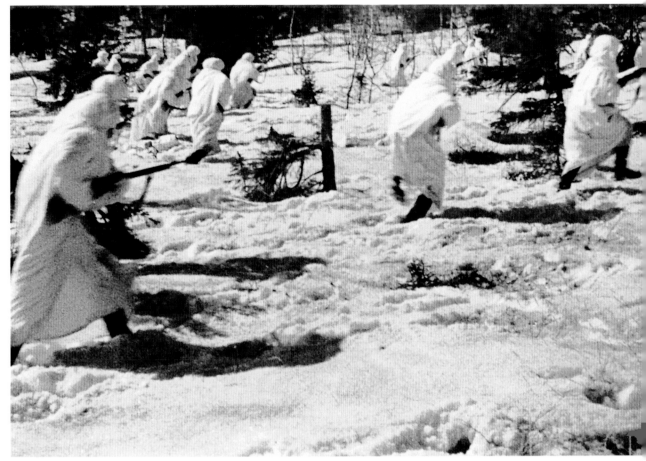

COLD COMFORT

A nonaggression pact with the Nazis in summer 1939 allowed the Soviet Union to absorb its Baltic neighbors within the year. But when it attacked Finland in November, a real, if one-sided, winter war ensued. Soviet battle deaths were high — a frozen corpse is carried off by Finnish soldiers (left). When the Soviets attacked (above), the Finns slipped away, then counterattacked. But civilians were bombed, like this mother and child (right), and in March 1940 Helsinki surrendered. For the Soviets it was a humiliating victory.

LEFT: WIDE WORLD
TOP: TRIANGLE PICTURES
RIGHT: CARL MYDANS / LIFE / TIMEPIX

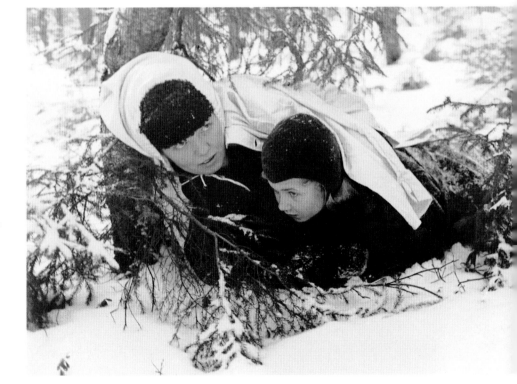

HITLER TURNS 50

On April 20, 1939, Adolf Hitler celebrated his 50th birthday. He had a lot to celebrate. Germany was enjoying economic prosperity. His political grip on the country was unchallenged. His troops had annexed Austria and moved into Czechoslovakia. And in four months, they would invade Poland. His grateful fatherland showered its Führer with all manner of gifts, ranging from a bowl of fresh eggs (right top) to a new Volkswagen convertible (left) handed over by the famous carmaker Ferdinand Porsche (in suit, next to Hitler). A whole room in the Reichs Chancellory in Berlin was devoted to lavish presents of art and books (above). The highlight of the day was a four-and-a-half-hour military parade (right). Among the most unusual gifts: 30 baby carriages from citizens hoping Hitler would marry and have children.

ALL: HUGO JAEGER / TIMEPIX

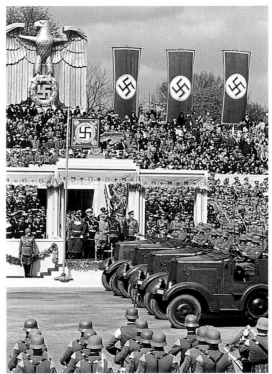

WORKING LUNCH

The setting was grotesquely peaceful. Hitler played host to his key advisers — Goering, von Ribbentrop, et al. — at his Berchtesgaden retreat, in the Bavarian Alps, on August 22, 1939. The main course was Poland. It had rebuffed Nazi demands for the return of the seaport Danzig, lost after World War 1. Final plans were laid for an invasion in 10 days.

TOP: IMPERIAL WAR MUSEUM, HU 75345

LICENSE TO KILL

When Germany and the Soviet Union, sworn political enemies, signed a nonaggression pact in August 1939, Europe was stunned. Joseph Stalin (at right, shaking hands with Nazi foreign minister Joachim von Ribbentrop) was cynically buying time. Undisclosed terms also divided Poland between its powerful neighbors to the east and to the west.

RIGHT: FPG / ARCHIVE PHOTOS

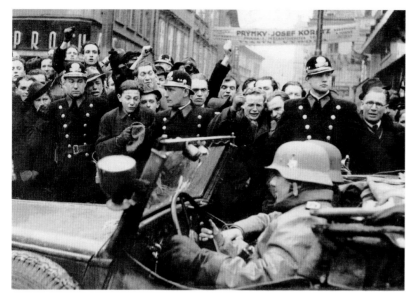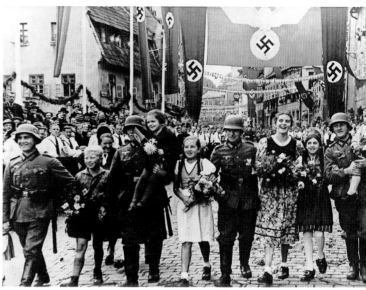

CZECH-MATE

Prague residents (above) could only weep and shake their fists when the German Army arrived in March 1939, ending the country's 20 years of independence. Its allies, England and France, had declined to intervene. Five months earlier, the Nazis had taken back the formerly Austrian Sudeten-land from Czechoslovakia; there the Teutonic population hailed the Wehrmacht as liberators (top right).

TOP LEFT: SUDDEUTSCHER
VERLAG BILDERDIENST
TOP RIGHT: BIBLIOTHEQUE
NATIONALE

SIGN-OFF

Four years after he was shot and allowed to bleed to death in a Nazi coup that failed, former Austrian chancellor Engelbert Doll-fuss suffered insult after fatal injury. As part of their peaceful annexation of the country, in 1938, the Nazis removed the martyred leader's name from a Vienna square and replaced it with the name of their own chancellor.

IMPERIAL WAR MUSEUM,
HU 50097

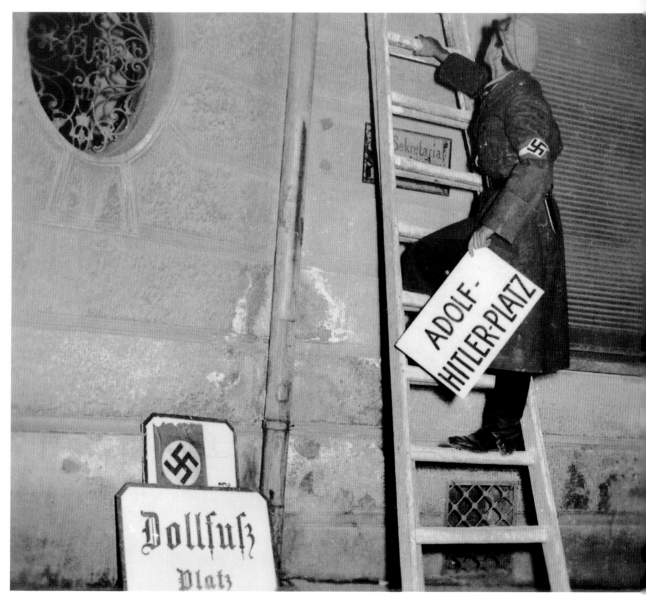

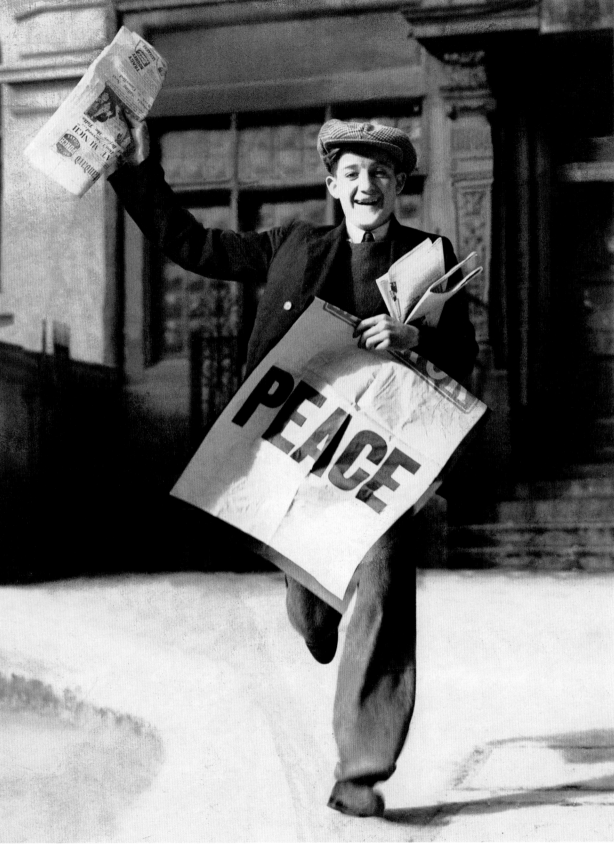

APOCALYPSE NOW

History was approaching on the run. Like this paperboy, England rejoiced in September 1938 at news of an Anglo-German pact that agreed the two countries should avoid war with each other. Prime Minister Neville Chamberlain had returned from a meeting with Hitler proclaiming "peace in our time." The price of that peace was to endorse Germany's move into part of Czechoslovakia. It was an acceptable compromise to some, craven appeasement to others. The others were right. Hitler and Mussolini already had designs on all of Europe, including Great Britain. The first step was to conquer Poland. On September 1, 1939, German soldiers raced across the border, shooting and throwing grenades (right). Two days later, England and France honored their commitment to Warsaw and offered military support. Twenty years, nine months and twenty-three days after World War 1 ended, World War 2 began.

LEFT: WIDE WORLD
RIGHT: ULLSTEIN BILDERDIENST

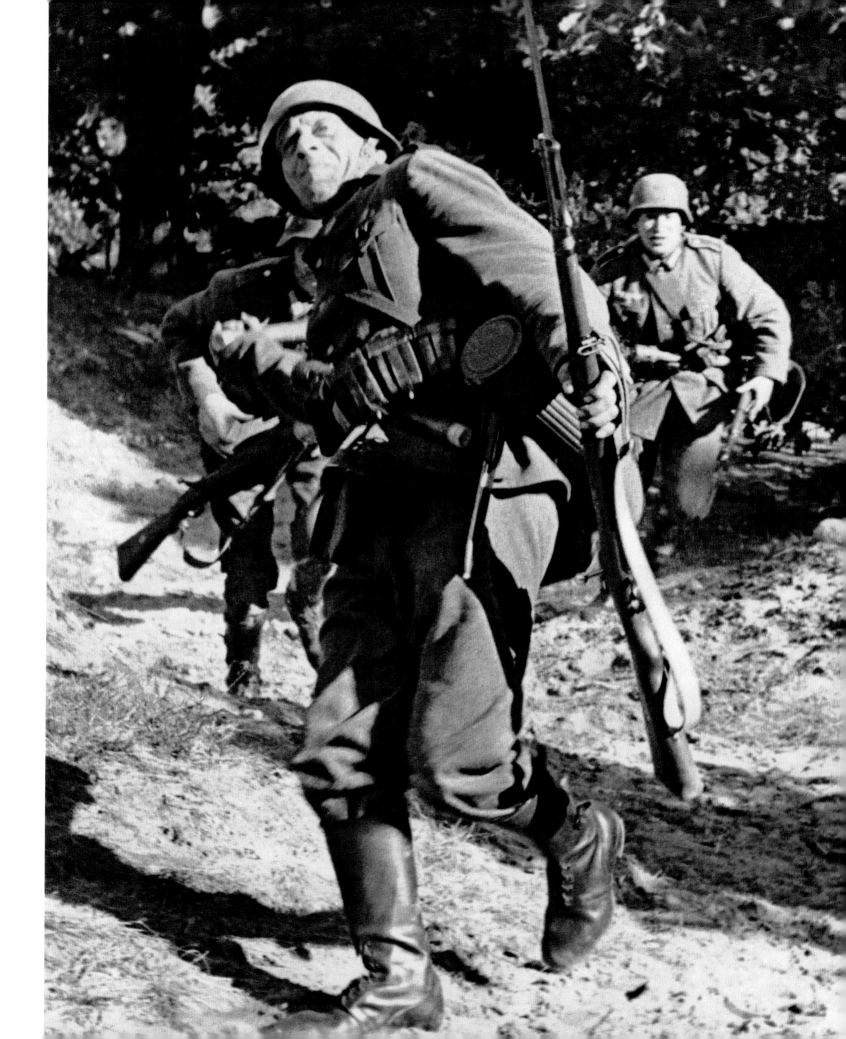

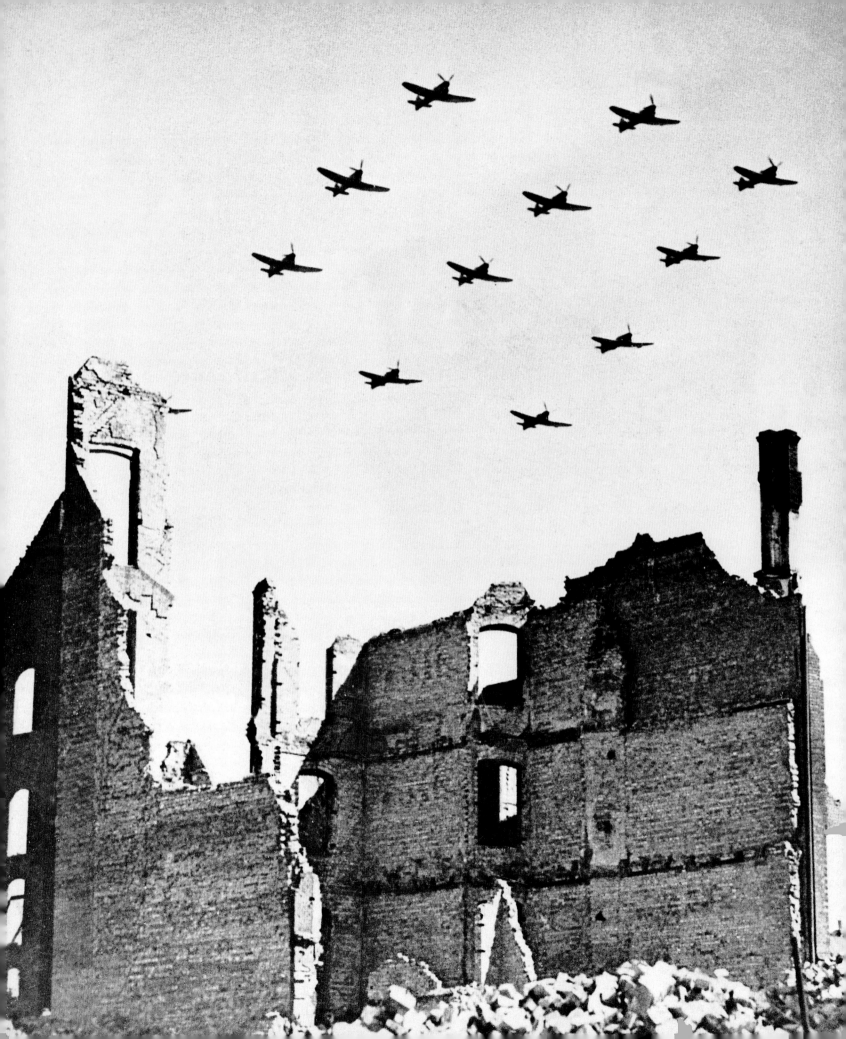

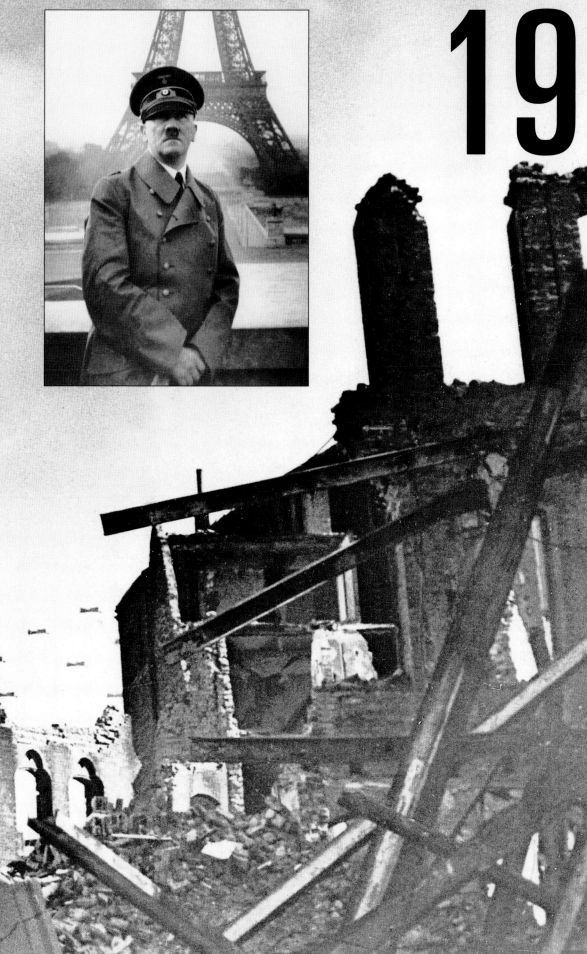

1940

FRANCE FALLS AND BRITAIN TEETERS

In Western Europe the German Army accomplished in six weeks what it could not in four years of World War 1: the conquest of France. In late June, Hitler triumphantly toured Paris and, like an ordinary tourist, had his picture snapped at the Eiffel Tower (inset). The next month, the Luftwaffe began bombing England to prepare for a planned invasion. Only the pilots of the Royal Air Force (at left, a British fighter squadron flies over London ruins) stood in Hitler's path.

Hitler's Generals Are Astounded

by Alistair Horne

POSSIBLY THE MOST climacteric year of the Second World War, 1940 presented Western civilization with an unprecedented catastrophe — the fall of France. In all four bloody years of World War 1, nothing like this had occurred to challenge the cause of Western civilization. It was also the year of the refugee, with millions driven from their homes, trudging forlornly down the highways of Europe. Yet 1940 would also end on a note of hope over experience in the triumph of Britain's survival in the face of Hitler's Blitz.

After Germany destroyed Poland, in the fall of 1939, with France and Britain locked paralytically into the "phony war," 1940 began on a note of false optimism. No attack in the West had materialized. Allied spin doctors came to believe their own propaganda about the apparent weakness of Hitler; "We Shall Win Because We Are Stronger" proclaimed the placards displayed everywhere in France. The much vaunted Maginot Line, which had consumed so many billions in French defense funds, would keep the *Boche sale* (dirty Hun) at bay while France and Britain built up their strength. During that time, Hitler and his generals evolved the brilliant Manstein Plan, aimed at striking at the Achilles' heel in France's defenses, where the Maginot Line was incomplete.

For the Allies 1940 also nearly began with an error of horrendous proportions; they came within an inch of rushing to the support of Finland, invaded by the Soviet behemoth. This would have involved Britain and France in war simultaneously with Hitler and Stalin. Fortunately for the Allies, "brave little Finland" collapsed just in time.

In April, however, Hitler — moving in the face of British naval supremacy — marched northward into Denmark and across the Baltic into Norway. It was clear that the long-awaited offensive in the West could not be far off.

Nevertheless, as May arrived in Paris, lovers continued to linger in the sidewalk cafés, listening to the strains of "J'Attendrai" and dreaming nostalgically of last year's holidays-with-pay given them by the left-wing Front Populaire. Seldom had there been a more marvelous spring.

There were art shows in the Grand Palais, horse racing at Auteuil (temporarily suspended at the outbreak of war) and soccer matches between Tommies and poilus in the suburbs. About the only difference from the previous year was that traffic was agreeably light.

On May 10 Hitler struck in the West, across the board. Neutral Holland capitulated on the fourteenth, the Belgians two weeks later. The first bad news of the machine bearing down on France came with the fall of Belgium's Fort Eben Emael, supposedly the world's strongest and the linchpin of the Belgian defenses. It was taken in 24 hours by a handful of Germans who landed atop the

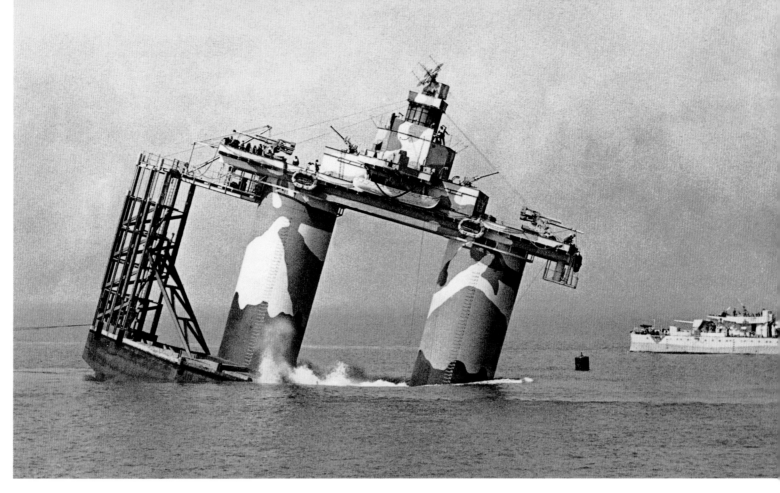

No, it's not another victim of Luftwaffe bombers. This armed sea fort was meant to defend against German air and sea attack. It was sunk into place in the Thames River estuary outside London.

IMPERIAL WAR MUSEUM, A26877

fort in gliders and knocked it out with hollow-charge explosives.

The French Army, 97 divisions strong, was powerful — at least on paper. It had more tanks than the Germans, and some that were better, but it had no conception of massing them in the way the Germans had demonstrated in Poland. Instead they were spread out thinly and ineffectually — ready, like a lot of small corks, to plug holes in the line. But it was in the air that the Allies were at their greatest disadvantage, generally outclassed and heavily outnumbered.

Nor was it any help that "Goering's weather" (as British pilots called it), so essential to the success of Blitzkrieg in the West, would continue virtually without a break over the next three critical weeks.

By May 13 the Panzers — seven elite armored divisions strong — had burst through the supposedly "impassable" Ardennes forests on the Belgian frontier and across the Meuse River at the French city of Sedan. Not covered by the Maginot Line, the sector was held only by two second-grade divisions of reservists. The Panzers moved into the open country of eastern France. May 15, in effect, was the day that the campaign was decided. On the sixteenth, Winston Churchill, who had been prime minister for less than a week, flew to Paris to find out what was happening. The French chief of staff, General Maurice Gamelin, dumbfounded him with the admission that he had no reserves left to counterattack the Panzers.

Premier Paul Reynaud declared that the battle was lost, while outside the French foreign ministry Churchill could see officials stoking bonfires of diplomatic archives. Nothing could have been more

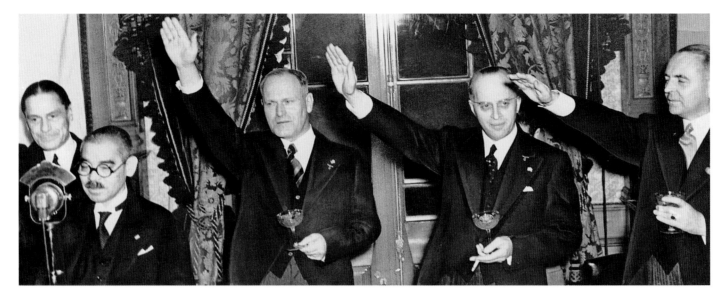

The official addition of Japan as a member of the Axis was celebrated in September in Tokyo by Japanese foreign minister Yosuke Matsuoka (at microphone) and Italian and German diplomats.

demonstrative of defeat than the scene he witnessed of warm air filled with whirling scraps of charred paper — state secrets intermingled with meaningless interdepartmental memos.

Though the Germans were now little more than 100 air miles from Paris, it was remarkable how long nothing but disquieting rumors reached the capital. Outside government circles, life went on as usual. The outdoor stamp market functioned on the Champs Elysées; children watched *Punch and Judy* shows there; theaters remained open; restaurants were filled.

In good part the lack of alarm was because Paris had been spared the ruthless bombing that had flattened Rotterdam.

Then came the tide of refugees; first by car from Belgium and the invaded provinces in the East, then pathetic families on foot, pushing their few possessions in battered baby carriages. On May 20 the Germans reached the English Channel near Abbeville, having advanced 200 miles in 10 days. They had effectively split the Allied forces and trapped the British Expeditionary Force (BEF) and the French armies in the North in a deadly pocket with their backs to the sea. The BEF Commanding General, Lord Gort, now concentrated on evacuation from Dunkirk.

Momentarily Hitler seemed to lose his nerve and issued — in a profound error of judgment — his controversial "halt order," which was to save the BEF. The "Miracle of Dunkirk" came to pass; 338,000 men, including 110,000 French, were evacuated by the Royal Navy. After Dunkirk, the German campaign became largely a matter of marching. Paris was declared an open city, and on June 22 France was forced to agree to a humiliating armistice.

Contrary to received opinion, the French forces fought — or some did — losing 100,000 killed in six weeks to Germany's 27,074. But in retrospect, there never was a battle that looked quite so lost in advance: France internally demoralized, her generals out-of-date and too politically minded; Britain unprepared; and for Germany the Manstein Plan, to which the Panzers marched in an almost perfect military blueprint for victory. Like Napoleon's Austerlitz, in 1805, it was Hitler's most brilliant campaign. Its one flaw lay in not subsequently defeating Britain, and that was to send Hitler, like Napoleon, to his ultimate doom in Russia.

To Hitler's fury and the world's astonished admiration, Britain would not give in. Led by Winston

Churchill's bulldog determination, it would "fight on the beaches," the fields, the streets — and on to the very end until Germany was defeated. To England in those dark days after the fall of France there also came a 50-year-old French Brigadier General, tall like a beanpole, Reynaud's newly appointed Undersecretary of State for War, Charles de Gaulle. Around him he collected his tiny troop of Free French who refused to submit.

That August, Hitler failed to bring off Operation Sea Lion; there would be no invasion of Britain. Instead, he would force the country to its knees by saturation bombing — its culmination, the Blitz on the civilians of London.

In the course of World War 2, Hitler committed at least five decisive strategic errors that would save the world from Nazi domination. One was Barbarossa, his attack on the Soviet Union, and a second his declaration of war on the United States — both in 1941. But he committed the first three of his fundamental blunders in 1940:

First, he should never have allowed the British to escape at Dunkirk.

Secondly, he failed to have any contingency plan immediately after the French surrender. This reflected the fears of his generals, who, having all fought through the costly, stalemate battles of 1914–1918, constantly doubted that the mighty French Army could really be smashed by one single stroke. They were left gasping at their own success. Had there been a follow-up strategy, in July or August, with vessels prepared for an instant invasion of Britain still reeling from Dunkirk, it is hard to see how it could have failed. Instead, while the Germans gorged themselves on their triumph and the delights of Paris, the Royal Air Force spent the unexpected respite bracing itself for the coming Battle of Britain.

Hitler committed his third gigantic error in switching resources from an invasion to the area bombing of civilian targets in the Blitz. Grievously

Sweden nervously sat out the war as a neutral, selling iron ore to the Germans, taking in European Jews. Buildings were sandbagged and windows fortified, however, as Stockholm prepared for the worst.
K.W. GULLERS, STOCKHOLM

damaging as it was to London, this last strategic miscalculation cost Germany any chance of defeating Britain — or, eventually, of winning the war. Allied reprisals would pulverize the cities of the Third Reich.

The year 1940 was to change the world balance of power. The struggle against Hitler could now only be fought with Soviet and American involvement. France's capitulation made inevitable the eventual participation of the United States in the war, while Britain's air victory meant that American and British forces would have a base from which to fight — the "unsinkable aircraft carrier." Churchill's defiance and the Battle of Britain ensured that the war would be won; but the road would be painfully long and hard.

Alistair Horne (CBE) was awarded the French Légion d'Honneur for his works on French history, which include The Price of Glory: Verdun 1916 *and* To Lose a Battle: France 1940. *His* Seven Ages of Paris *will be published in spring 2002.*

DENMARK/NORWAY

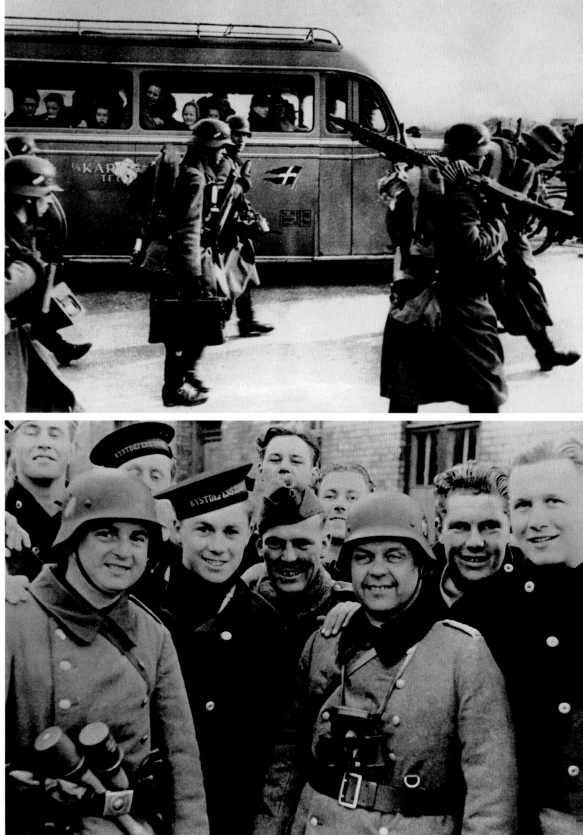

DENMARK COLLAPSES

Germany reached north in April, overrunning Denmark in a day with hardly a shot fired. Danish schoolchildren giggled at the sight of passing Nazi troops (left), and Danish sailors fraternized openly with their conquerers (below). German occupation was benign at first. But in August 1943, after Hitler ordered martial law and dissolved parliament, Danish guerrillas resisted and were harshly suppressed. Thousands were arrested and sent to concentration camps. The little country had a final trick up its sleeve: That same year it snuck 7,000 Jews marked for death into fishing boats at night and ferried them to safety in Sweden.

TOP LEFT: HULTON / ARCHIVE
LEFT: CORBIS / BETTMANN

NORWAY IS NEXT

On the same day Germany invaded Denmark, it landed troops in Norway. For the first time, parachutists (right) were deployed in an airborne assault. Hitler wanted air and naval bases in Norway — and Swedish iron-ore exports shipped through the northern port of Narvik. German scientists also coveted Norway's ability to produce "heavy water," essential for the development of nuclear weapons.

SUEDDEUTSCHER VERLAG,
BILDERDIENST

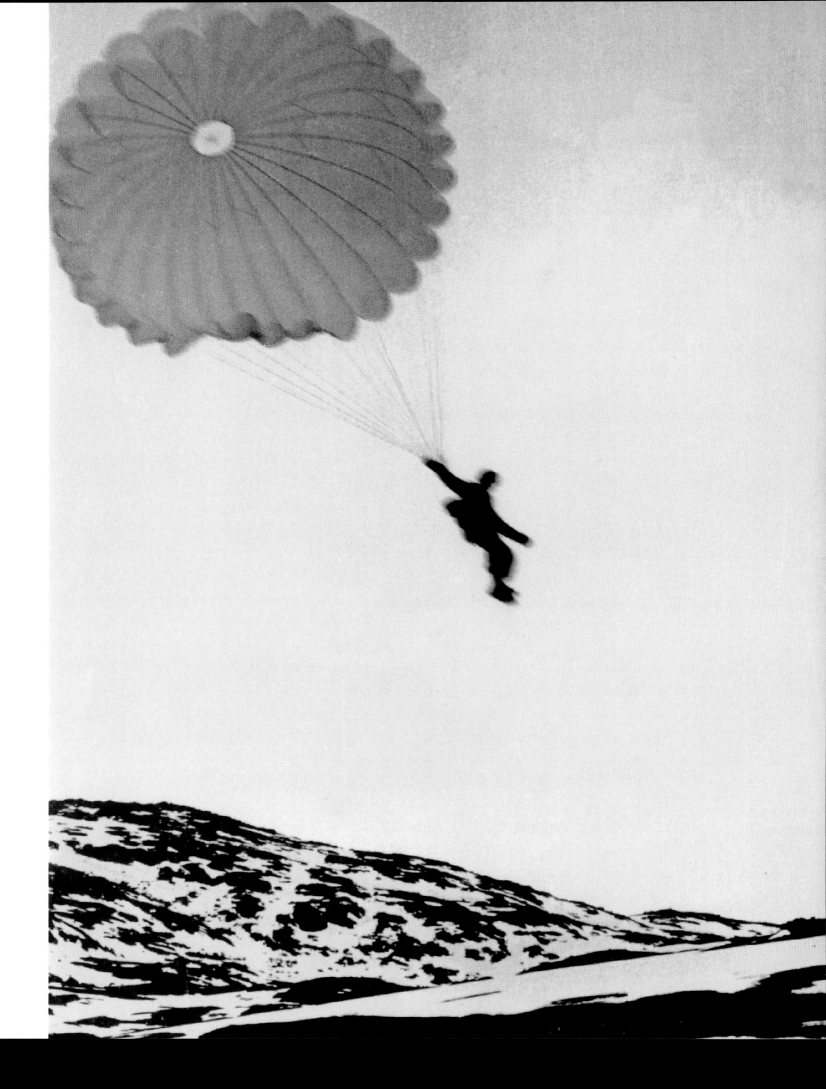

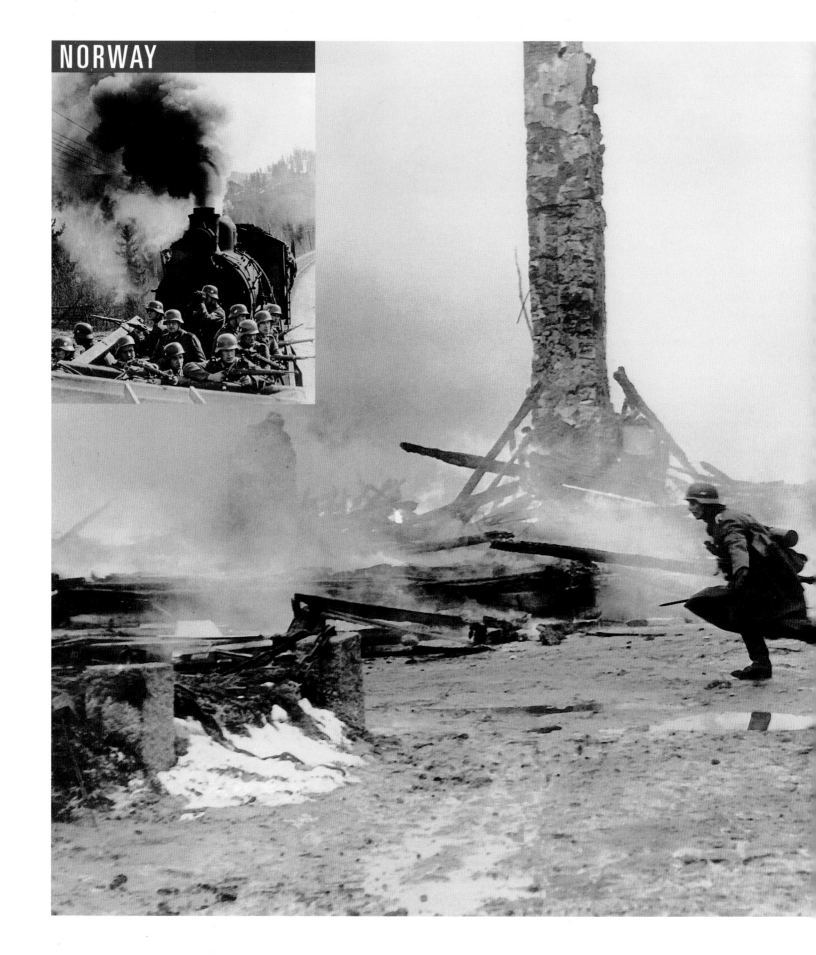

NORWAY

FIGHTING BACK

Unlike Denmark, Norway — and the British and French forces stationed in the country — resisted occupation fiercely. German soldiers torched homes (below) and advanced north on foot and rail (inset) but often under withering fire. When the capital, Oslo, surrendered in April, King Haakon VII and his government first went into hiding, rallying partisan forces, then fled to London — with Norwegian gold reserves worth millions.

ULLSTEIN BILDERDIENST
INSET: FPG / ARCHIVE PHOTOS

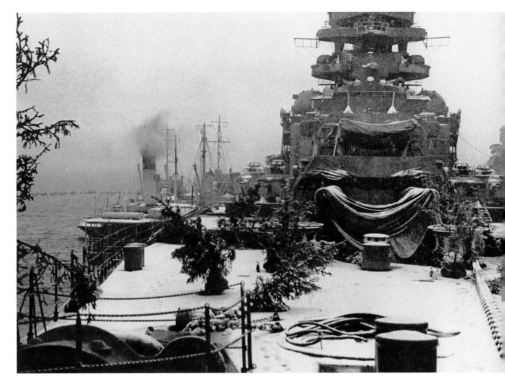

HIDING THE NAVY

Norway's fjords offered natural hiding places for the German fleet, which draped the battleship *Tirpitz* (above) with tarps and branches to blend in with the countryside and foil enemy reconnaissance. Still, the British Navy caught and sank 10 German destroyers in a major battle off Narvik in April.

TOP: IMPERIAL WAR MUSEUM
MH 7267

THE TURNCOAT

A fringe political figure before the war, fascist ideologue Vidkun Quisling, 52 (right, facing), seized a radio station after Oslo capitulated to welcome the Nazis and proclaim himself prime minister. By war's end, his name had become a world synonym for traitor, and he was arrested, tried and executed by firing squad.

RIGHT: NATIONAL ARCHIVES

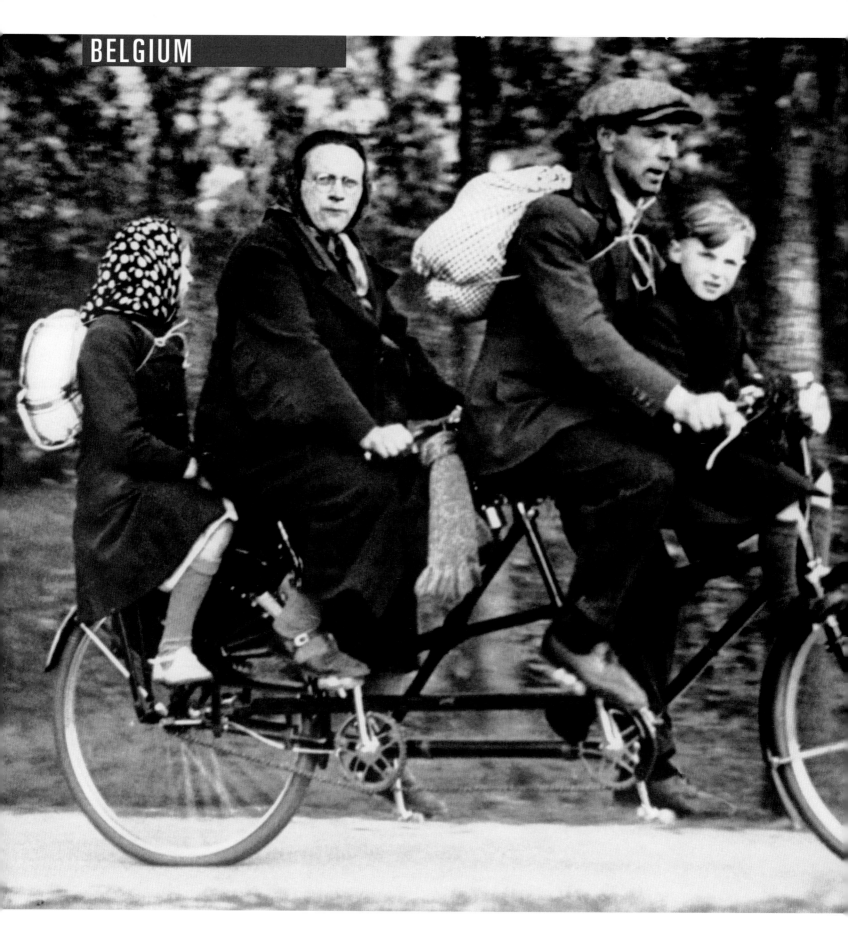

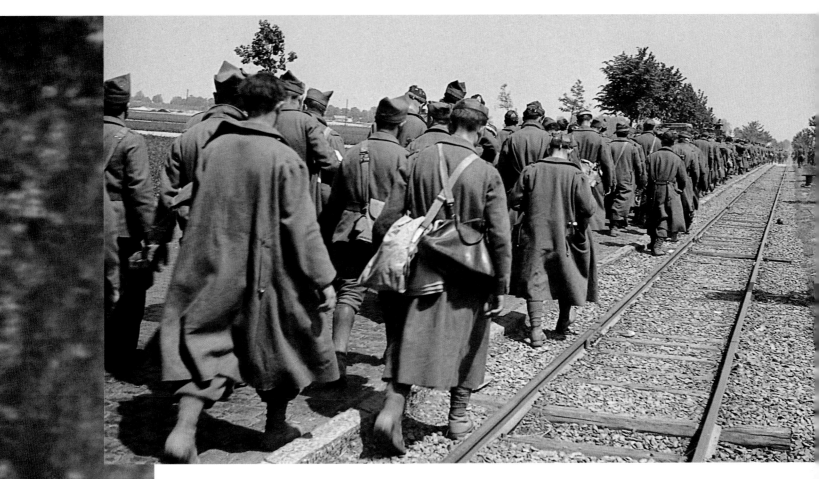

THE ROUT

Though its Army fought bravely, Belgium was no match for the ferocious armored and airborne assault on May 10. Blowing bridges (right) and taking prisoners by the thousands (above), the German attackers terrified the civilian population. Grim families fled toward France by any means available, even a bicycle built for two (left). On May 28, refusing the pleas of his Cabinet to flee to London, King Leopold III surrendered. He was imprisoned by the Germans until the end of the war.

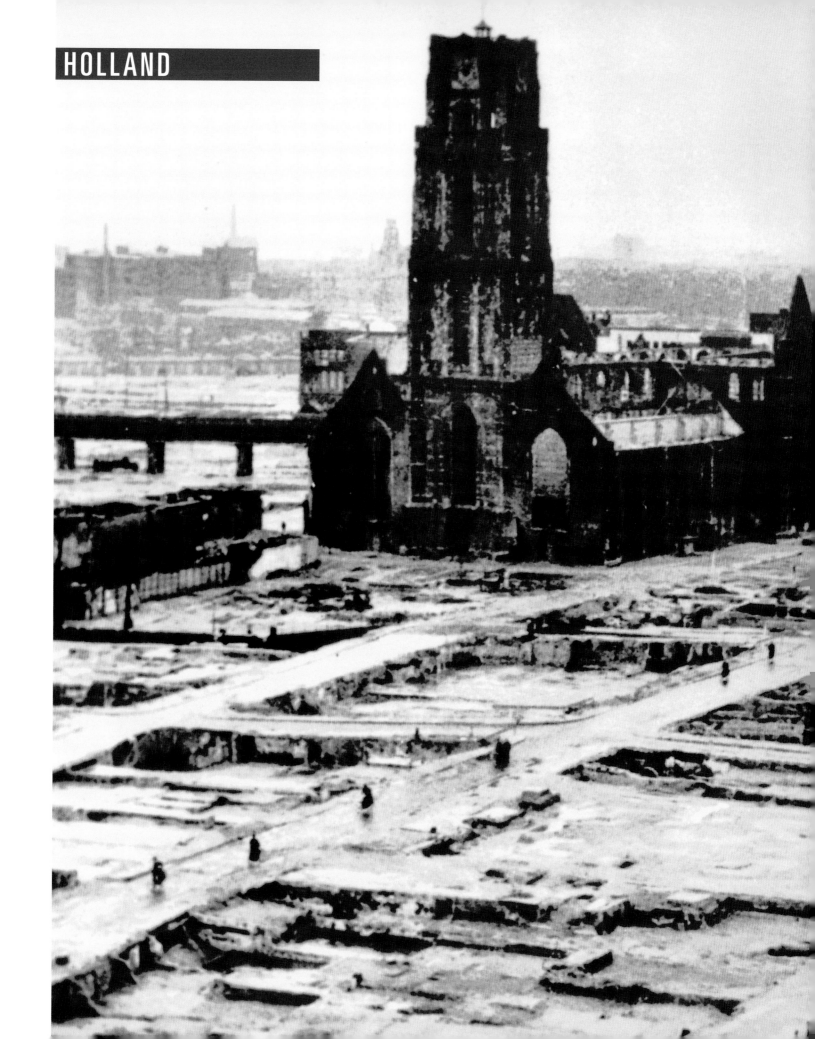

BRUTAL BARGAINING

On the same day they entered Belgium, the Nazis thrust into Holland. Surrender terms were being negotiated when, on May 14, the Luftwaffe needlessly bombed the center of Rotterdam, killing more than 800 people and wounding several thousand. It was a vivid example of Hitler's use of *Schrecklichkeit* (frightfulness) to force his enemies into submission. Queen Wilhelmina escaped to England to set up a government in exile, and Dutch resistance continued throughout the war.

NATIONAL ARCHIVES

HOLLAND

IRON FIST

The German Army quickly seized key Dutch cities and military bases. An hour after the bombing of Rotterdam, soldiers (left) patrolled the ruins. Nazi rule over Holland was harsh. When Dutch Jews were rounded up in February 1941, the nation staged a general strike. By war's end, some 200,000 Dutch resisters had been sent to concentration camps.

HUGO JAEGER / TIMEPIX

A DAUGHTER DIES

A Dutch father wounded in a German bombing raid on Amsterdam contemplates the body of his young daughter as he awaits medical aid. Holland was prepared to open its dikes and flood the countryside in self-defense, but the Nazis moved too fast. They saw the Low Countries as the swiftest route toward capturing the ultimate strategic prize on the European continent: France.

HULTON / ARCHIVE

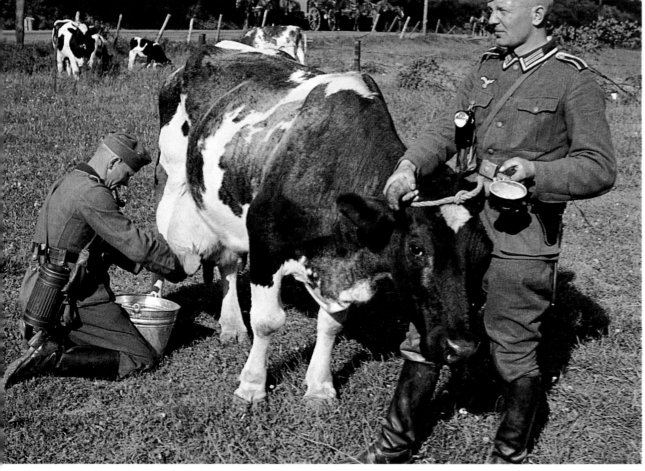

GOT MILK?

German soldiers help themselves on one of Holland's famously productive dairy farms. Such pillage was not always so harmless. In Belgium the Germans confiscated so much food that by autumn 1940, an estimated one fifth of its population had been reduced to starvation. The Nazis' most infamous looting: the art treasures of occupied countries.

HUGO JAEGER / TIMEPIX

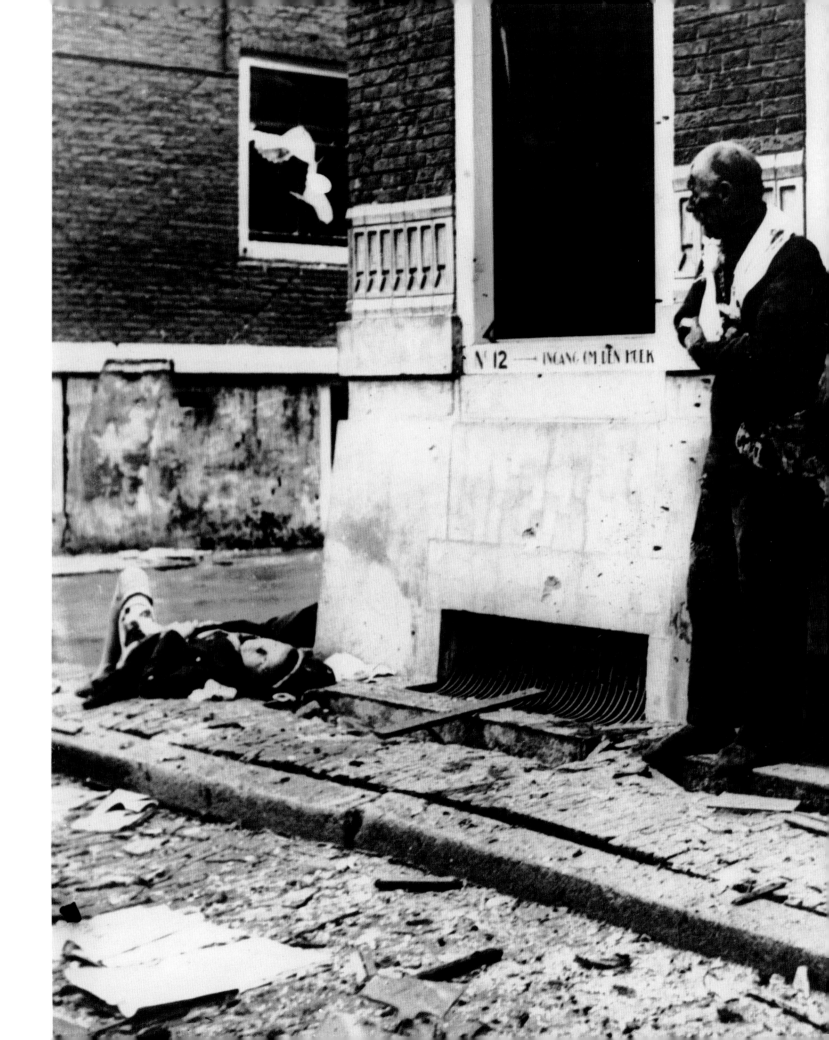

FRANCE

COMME IL FAUT

Before the Blitzkrieg the French Army prepared itself for everything but what happened. At left, an officer concentrates on cooks' hands and finger-nails for cleanliness. Once considered the best in the world, the French Army was dogged by infighting, polit-ical divisions and poor morale and equipment. Even worse was its strategy of immobile defenses — the fabled and useless Maginot Line.

WIDE WORLD

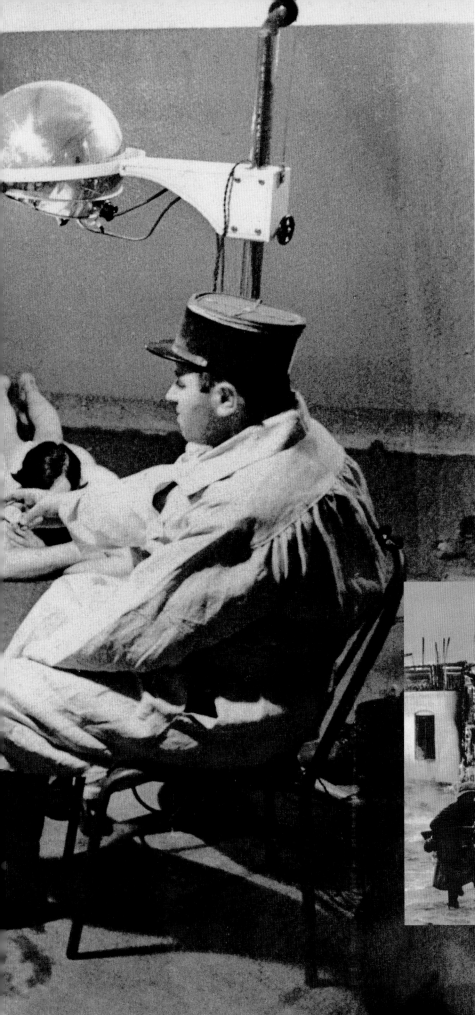

<

TAN LINE

An elaborate border chain of underground forts stretching from Switzerland nearly to Belgium was begun by war minister André Maginot in 1930. Bristling with weaponry, the complex was a miserable billet for troops — cold, damp, smelly and crowded. The boring routine was occasionally broken (left) with supervised sessions under a sunlamp.

PARIS MATCH

REAL WAR

The "phony war" ended in May 1940. The Germans attacked above the Maginot Line, burning villages (below) and driving refugees westward. Some French units fought bravely — General Charles de Gaulle's armored division, for one. But the French Army mostly collapsed, and a vast force of British and French troops became trapped at the channel port of Dunkirk.

HULTON / ARCHIVE

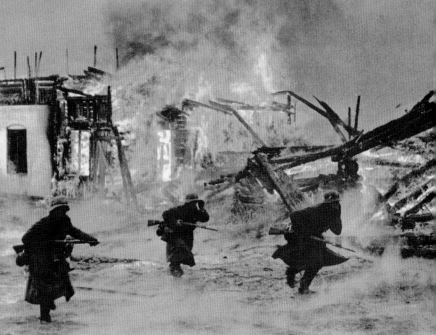

SALVATION

With his Panzers encircling the Allied Army at Dunkirk, Hitler inexplicably hesitated. The Luftwaffe was often grounded by bad weather or peppered with rifle fire from the beach (below). In nine days at the end of May, 953 vessels — from warships (inset) to yachts — crossed the Channel and back again in an historic evacuation. Troops waded out to rescue, and the British Army was saved to fight another day.

HULTON / ARCHIVE
INSET: BROWN BROTHERS

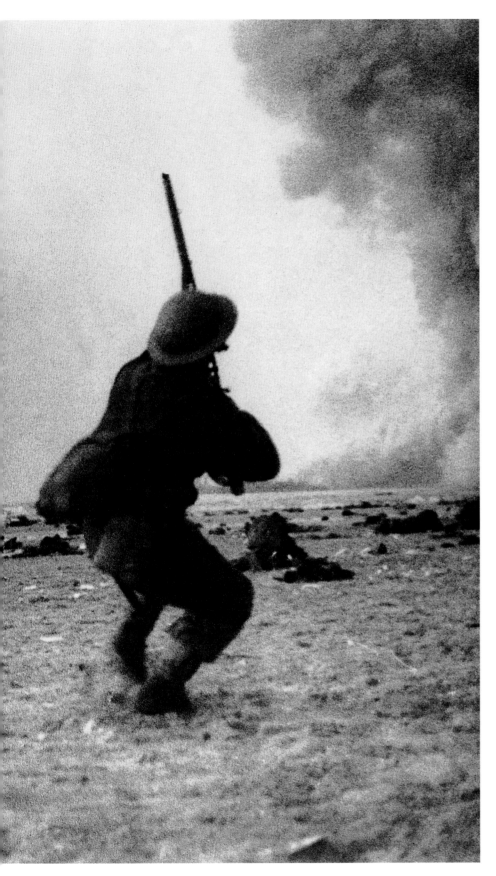

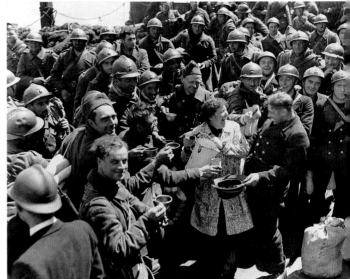

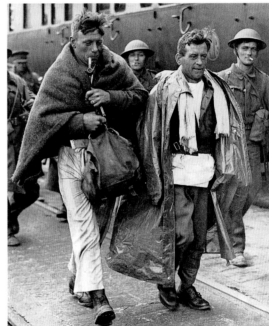

HEROES' WELCOME

In all, 338,000 men were plucked from captivity or death. Some 200,000 were British (above); the rest French, Belgian and Polish (top). Most of the French were sent back to rejoin their Army's final battle. It was brief. France surrendered on June 22 in the same railway car near Compiègne where Germany had signed the armistice in 1918.

TOP: THE TIMES, LONDON
ABOVE: MARCH OF TIME / TIMEPIX

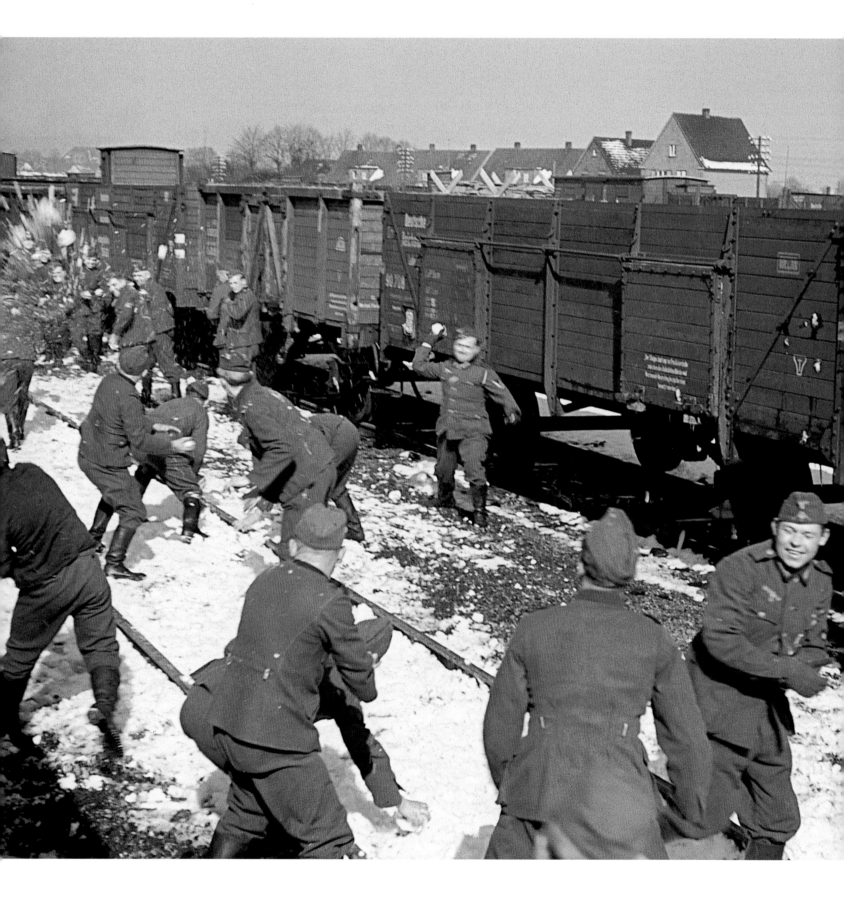

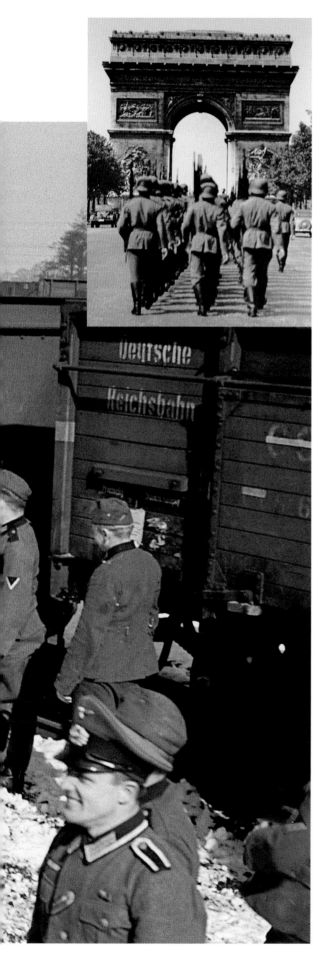

OCCUPATION LIFE

The military collapse of France — symbolized by the Wehrmacht's march under the Arc de Triomphe (inset) — led to the dismemberment of the Third Republic. Alsace-Lorraine along the border was soon absorbed into the Reich; the rest of the French provinces were split between a Nazi–occupied sector in the North and West and Marshal Philippe Pétain's collaborationist regime in the South, headquartered in the city of Vichy. With hostilities on hold and German supremacy virtually unchallenged, daily life settled down. Some refugees returned to their homes (right), piling high the family car with cherished possessions. German soldiers strolled the streets of Paris, pausing to admire a curbside *artiste* in Montmartre (top right), or took playful recess in a train yard for a snowball fight (left). Not all the French laid down their arms, though. In a dramatic BBC radio broadcast from London on June 18, 1940, General Charles de Gaulle summoned his countrymen to resist, giving birth to the Free French movement. De Gaulle was a bristly ally, both the British and the Americans found, but almost singlehandedly he kept the French dream of *liberté, égalité, fraternité,* alive in these grim days.

LEFT: HUGO JAEGER / TIMEPIX
INSET: PIX INC. / TIMEPIX
TOP RIGHT: UNDERWOOD
PHOTO ARCHIVES
RIGHT: HEINRICH HOFFMANN /
TIMEPIX

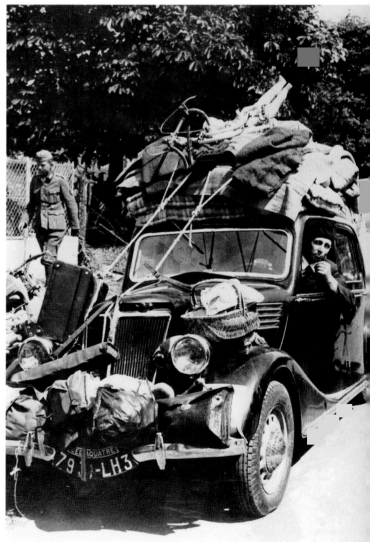

THE SOVIET UNION

Rise and Fall

Probably no other society in history has known the terror and tragedy experienced by the USSR. In the decade before Hitler's invasion, Premier Joseph Stalin caused the death and imprisonment of millions of his citizens through purge and farm collectivization. He then signed a pact with Hitler. Yet this same fierce leader (below in a wartime poster) also rallied his nation in the struggle that eventually defeated the Nazi war machine. Postwar, the Soviets absorbed the countries their troops had occupied and challenged the U.S. as a second nuclear-armed superpower. This Cold War only ended in 1991, when the USSR was toppled by its own people.

THE GRAB BEGINS

The wartime fate of the Baltic Republic of Latvia typified Soviet-Nazi cynicism. Independent since World War 1, the state, along with Lithuania and Estonia, was tossed to Stalin by secret agreement with Hitler in August 1939. Soviet occupation forces entered the capital, Riga, in the spring of 1940, greeted robotically by citizens like these (above). In July the new government asked to become a Soviet Republic. Latvia was briefly taken over later by the Germans but after the war was again a member of the Soviet bloc.

ABOVE: WIDE WORLD
LEFT: DAVID KING COLLECTION

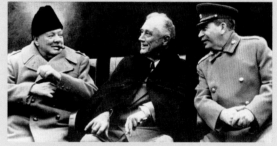

FINAL SUMMIT

Sure of Germany's defeat, Churchill, Roosevelt and Stalin (above) met in February 1945 at the Crimean port of Yalta to discuss the postwar political map of Europe. The Soviet leader vowed to hold free elections in Poland. Instead, he imposed Communist regimes on it and most of Eastern Europe. This was the wartime Big Three's last meeting. In April, the ailing FDR died. In July, Churchill's Conservative party was defeated at the polls, and he resigned as prime minister.

CORBIS / BETTMANN

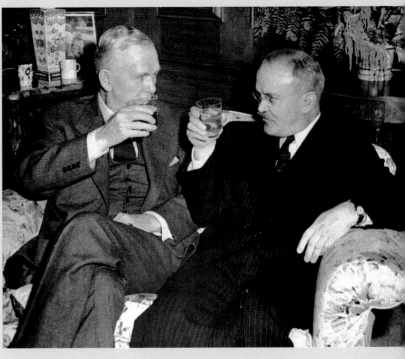

THE FIRST REBEL

Communist leader Josip Broz, a.k.a. Marshall Tito (above, far right), directed Yugoslav partisans in savage fighting against the Nazis, then unified the fractious Balkans into a federated postwar republic. But Tito defied Soviet orthodoxy, and in 1948 his Communist party was expelled from Stalin's alliance, the Cominform. For the first time, Moscow had been challenged.

BRITISH OFFICIAL PHOTO

MOLOTOV COCKTAIL

The pose was cordial, but relations were worsening in 1947 between Soviet foreign minister Vyacheslav Molotov and Secretary of State George Marshall (top right). The United States backed anti–Communist parties in Greece and Turkey and launched the $13 billion Marshall Plan to rebuild Europe.

WIDE WORLD

AERIAL LIFELINE

The Cold War nearly turned hot over Berlin. In 1948, the city's American, French and British zones were blockaded by the Soviets — a stark challenge to the West. The Allied response was an around-the-clock airlift of supplies. A total of 275,000 sorties (as at right) were flown before the Soviets backed down 15 months later.

CORBIS / BETTMANN

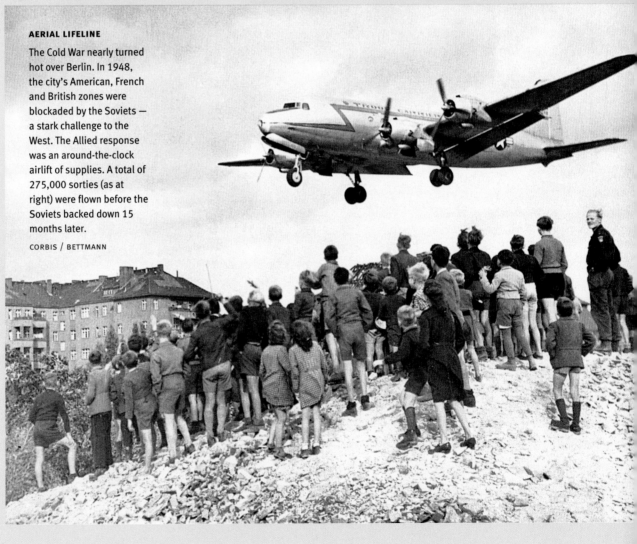

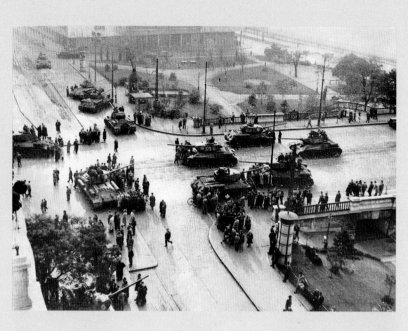

GRIM ESCALATION

When the Soviets detonated their first atomic bomb, in 1949 (and bragged about it in bellicose posters, as above), America lost its monopoly on nuclear weapons, and the Cold War escalated to an infinitely more dangerous level. Russian scientists delivered the weapon to Stalin three to five years sooner than the U.S. had expected, thanks in part to secrets leaked by physicist-spy Klaus Fuchs. The race for a "superbomb" began.

JVZ PICTURE LIBRARY

MOSCOW FLEXES

Soviet muscle was on display in the late 1950s. When Hungarians launched a popular revolt in October 1956, Soviet tanks rumbled into Budapest (right top) and crushed it in 13 bloody days. Eleven months later Moscow stunned the world again, this time with a propaganda coup — the first man-made space satellite, *Sputnik I* (right). Americans were scared. What happened to our technology, they asked? The U.S. orbited its own satellite in January 1958 and began an examination of research and science teaching in the country. Vice President Richard E. Nixon salvaged some national pride when he outblustered Soviet premier Nikita Khrushchev in their famous July 1959 "kitchen debate" (right).

RIGHT, TOP TO BOTTOM:
CORBIS / BETTMANN;
MICHAEL ROUGIER / LIFE /
TIMEPIX; HOWARD SOCHUREK /
LIFE / TIMEPIX

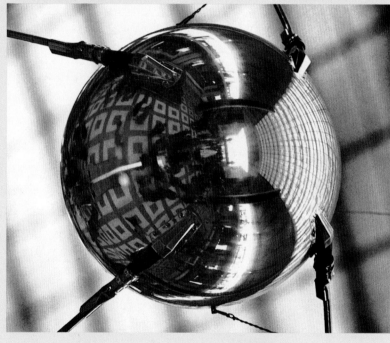

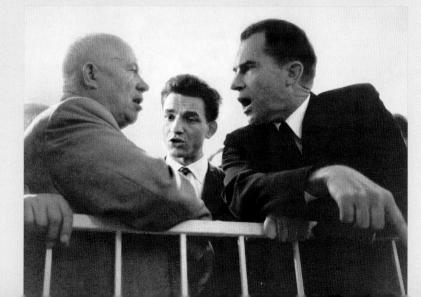

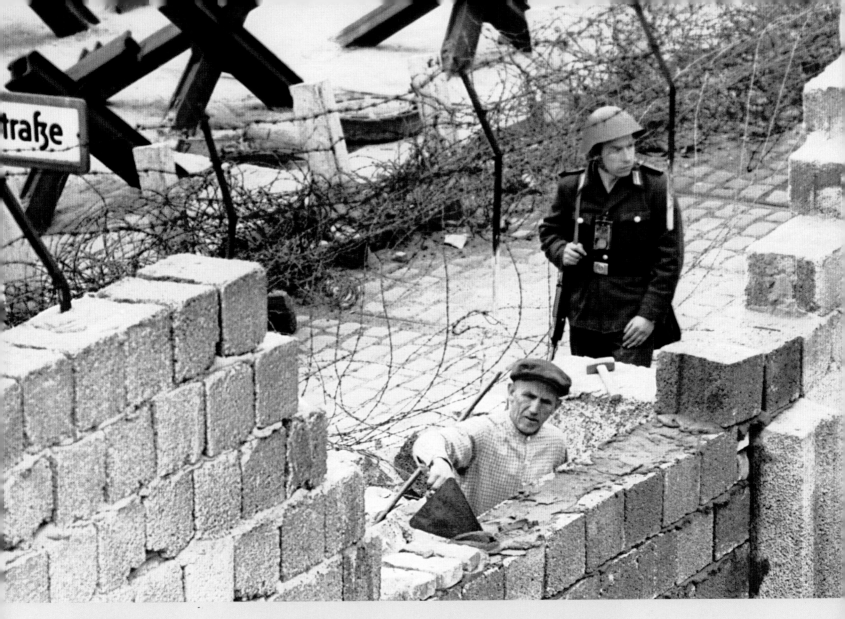

SEALED OFF

Under watchful guard, an East German mason (above) erects the ultimate symbol of Soviet repression: the Berlin Wall. By mid-August 1961 as many as 2,300 people were emigrating daily from East to West Berlin. The Communists' crude response was a 28-mile-long barrier through the heart of the city, stanching the human flow. The wall was finally torn down in 1990.

ABOVE: WIDE WORLD

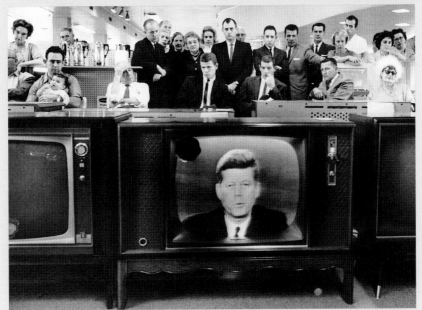

TO THE BRINK

On October 22, 1962, 50 million Americans crowded around television sets like these in a Los Angeles store (left) to hear President John F. Kennedy announce a naval blockade of Cuba after the Soviets installed missiles 125 miles from U.S. shores. For 13 days nuclear war was a hair trigger away. Then Khrushchev backed down and agreed to withdraw the weapons.

RALPH CRANE / LIFE / TIMEPIX

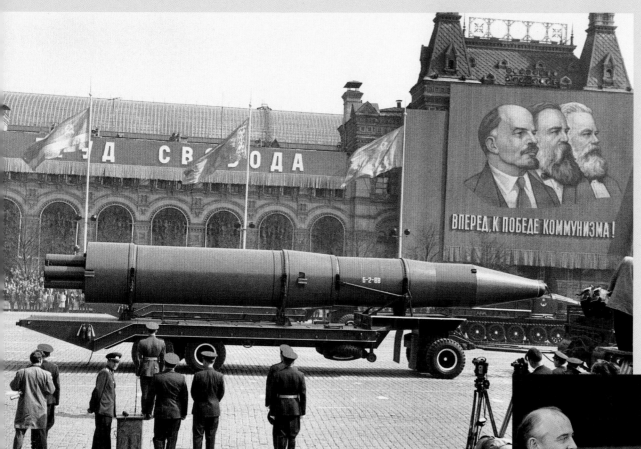

PEOPLE POWER

Boris Yeltsin, 59 (right), presided over the dismantling of the Soviet Union in 1991, after the ex-Moscow party boss became Russia's first democratically elected president. The garrulous Yeltsin (he liked his vodka) bravely faced down a coup, reformed the economy, sweetened relations with the West and signed a major nuclear disarmament treaty with the U.S.

SERGEI GUNEYEV / TIMEPIX

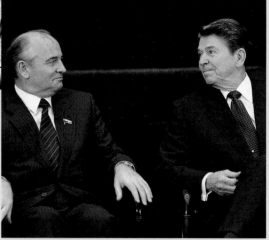

MUTUAL TERROR

The USSR first tested a hydrogen device in 1953 and two years later had bombs. They could be carried in huge ballistic missiles (flaunted at every May Day parade in Moscow, as above) and annihilate any country on Earth. America had the same weapons, of course. Their arms race cooled a little after the frightening Cuban missile crisis. Then in 1963 the United States, Britain and the USSR signed a treaty banning nuclear testing in the atmosphere, underwater or in space. It was a first step.

ABOVE: STAN WAYMAN / LIFE / TIMEPIX

MR. SOLIDARITY

What a concept: a worker's revolt against a so-called worker's paradise. In 1980, Poland's Solidarity movement grew out of a strike in a Gdansk shipyard led by an ebullient electrician, Lech Walesa, 37 (left). Awarded the Nobel Peace Prize in 1983, he was also elected president of Poland in 1990. The shackle between Moscow and the Eastern European satellites was broken.

LEFT: ALAIN NOGUES / CORBIS-SYGMA

EYE CONTACT

Two years after he branded the Soviet Union the "Evil Empire," President Ronald Reagan met with Premier Mikhail Gorbachev in Geneva, in 1985 (above), the first of four summits. Surprisingly, they hit it off. Gorbachev began democratizing the USSR, easing some economic controls. Yet tensions continued, especially after the Soviets invaded Afghanistan in 1979.

ABOVE: BILL FITZPATRICK / WHITE HOUSE

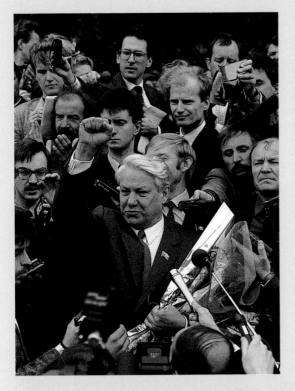

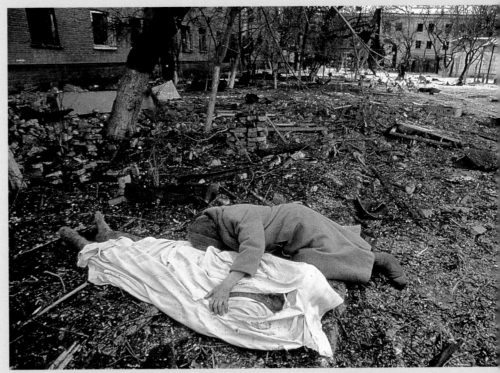

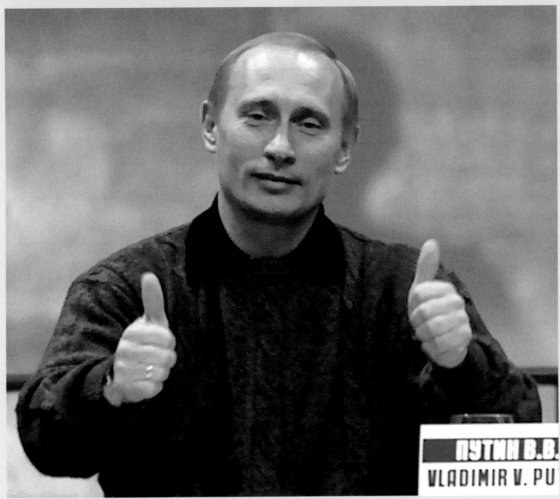

STREET KILLING

Once the USSR was no longer a union, long suppressed ethnic and religious fervor erupted — nowhere more ferociously than inside Russia itself. When Chechnya tried to break away in 1991, the armed response was massive. In the capital of Grozny, as thousands died, thousands mourned (including this mother, above, with her dead rebel son). The city of 500,000 lay in ruins.

PAUL LOWE / MAGNUM

INTO THE FUTURE

After the ailing Yeltsin stepped down at the end of 1999, Vladimir Putin, 47 (left), was elected president, the first time power had been transferred by ballot in Russia's history. Putin, an ex-secret police officer, faced a formidable agenda: a shaky economy, political corruption, continued fighting in Chechnya and an uncertain role in world affairs.

REUTERS NEWMEDIA INC. /
CORBIS

WAR ON HIGH

The fate of Britain and the Free World — the term was used without irony — hung in the balance as these school-children (left) watched a dogfight high above Kent. In mid-August the Germans unleashed the full fury of the Luftwaffe in advance of Hitler's planned invasion of the island. Nazi air minister Hermann Goering boasted that his three-to-one advantage in planes would destroy the Royal Air Force in four weeks. By month's end, the Nazis were hurling an average of 1,000 sorties a day at England.

In response the young pilots of the RAF scrambled day after day (top). Their losses, although about half those of the Germans, were still fearsome. The aerial combat was often caught by gun cameras. A German Messerschmidt 110 (middle left) has been hit and is smoking. A desperate British pilot swings his flaming Spitfire (middle right) away from a Heinkel bomber, seeking room to bail out.

Below, a British soldier guards a crash-landed Luftwaffe fighter. By September 17 Hitler had seen enough: He called off the invasion and stepped up nighttime bombings of London and other cities, hoping to pound England into submission. That failed too. As Churchill declared to the world about the Battle of Britain: "Never in the field of human conflict was so much owed by so many to so few."

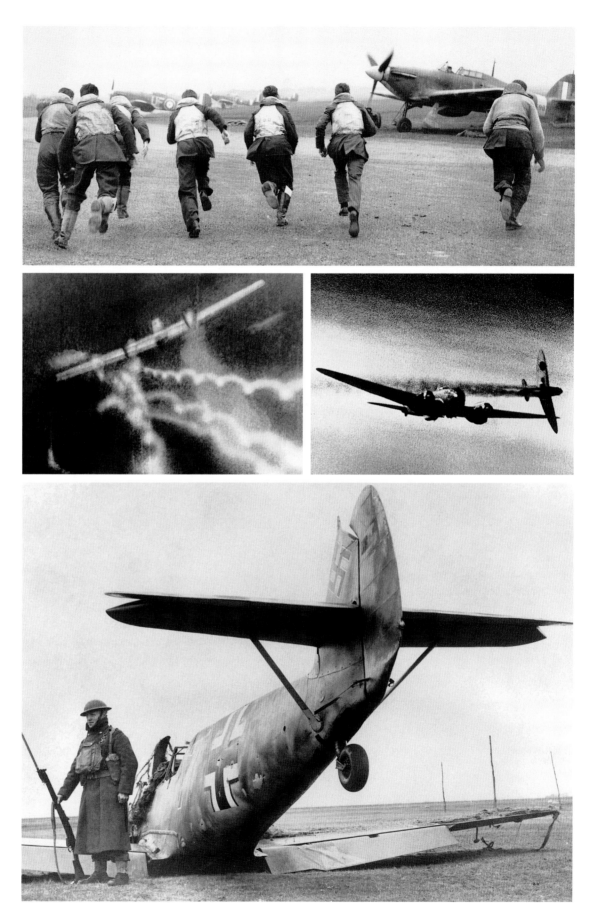

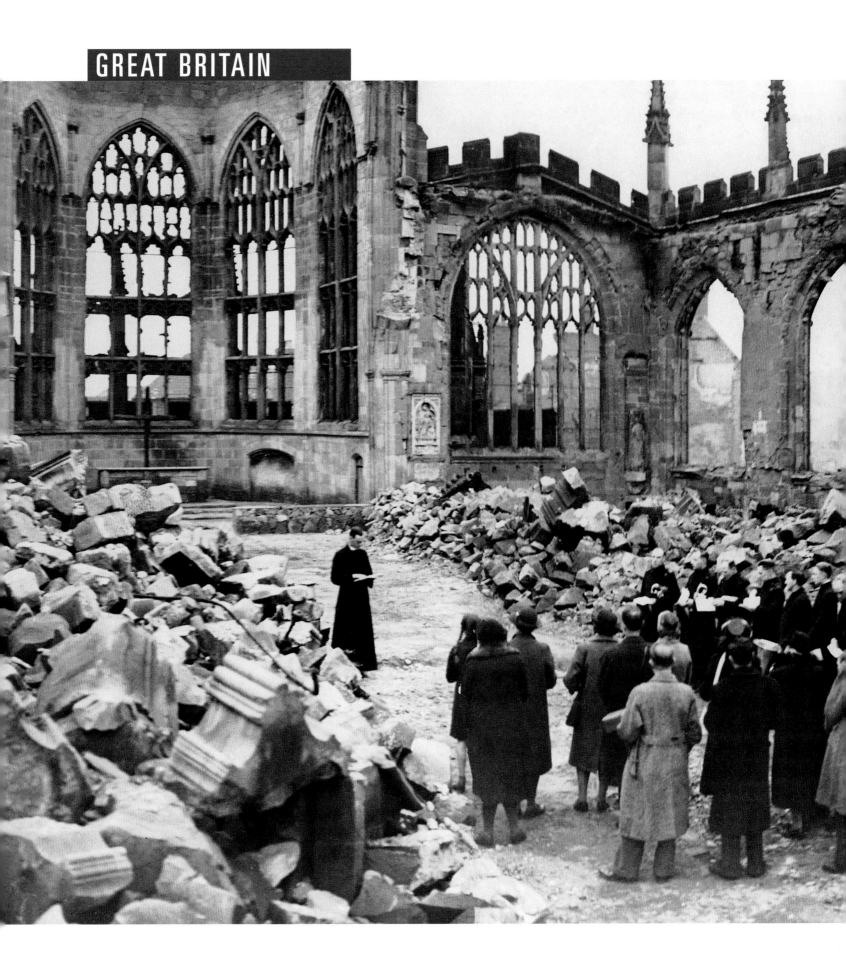

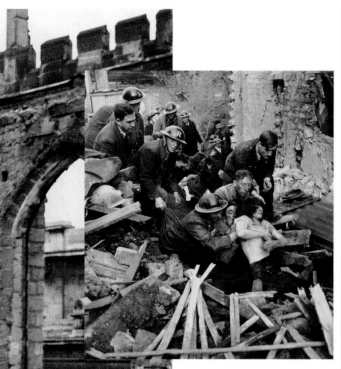

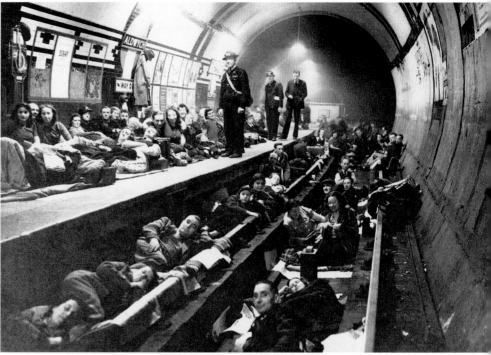

BRAVING THE BLITZ

German bombing killed more than 43,000 British civilians and injured nearly 51,000 from July 1940 to May 1941. Yet the embattled island's will to prevail grew stronger as the attacks continued. In Coventry parishioners gathered for a poignant outdoor service in the ruins of the city's historic cathedral (left). In London, where bombings came daily for almost two months, specially trained rescuers pulled a woman from the rubble (inset, above), a scene replayed every day. The subway stations sheltered as many as 177,000 citizens at night (top right), and 1.5 million women and children were evacuated from London, including this unhappy little Chatham girl (right).

LEFT: THE LONDON MIRROR
INSET: TIMEPIX
TOP RIGHT: WIDE WORLD
RIGHT: IMPERIAL WAR MUSEUM
HU 59253

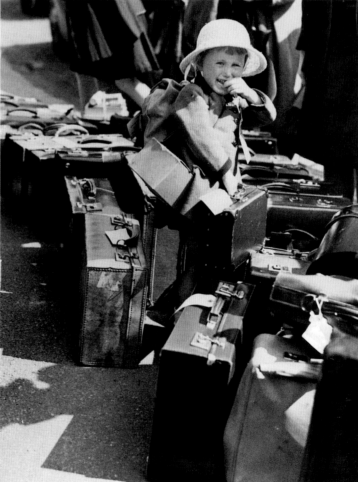

BIOGRAPHY

WINSTON CHURCHILL

British Bulldog

He was the quintessential Briton of the Twentieth century, yet his mother was American. His prewar political career was haunted by calamitous misjudgments. Yet in May 1940, 65-year-old Winston Churchill met his destiny at last when he succeeded Neville Chamberlain as prime minister. "I have nothing to offer you but blood, toil, tears and sweat," he said in his first of many spine-tingling speeches. And thus at the time of human freedom's greatest peril, this cigar-puffing, brandy-swigging Tory summoned his countrymen to fight for victory at all costs. They did what he asked.

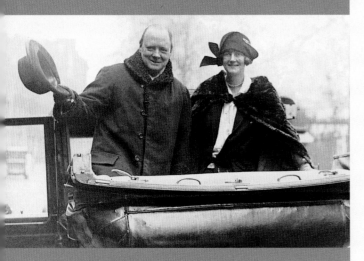

MILITARY MAN

Young Winston developed a lifelong attachment to the glories of the British Empire. He fared poorly as a student at Harrow (right, 1889) but graduated from Sandhurst — the West Point of the UK — and traveled to India, the Sudan and South Africa as soldier and war correspondent (middle right, 1899). Captured during the Boer War, Churchill escaped and became a minor hero back home. He was soon elected to the House of Commons. As First Lord of the Admiralty, he modernized the Royal Navy and, realizing the military potential of aircraft, learned to fly in 1914 (bottom right). In 1915 he pressed for an Allied assault against the Turks in the Dardanelles that ended with the loss of 265,000 Allied soldiers at Gallipoli. Churchill resigned, his political star in eclipse. In 1924 he returned as chancellor of the echequer but took England on the gold standard, with ruinous economic results. In 1929 he was turned out of office again, to a decade of political exile punctuated by his denunciation of the Nazis.

RIGHT, TOP TO BOTTOM: CORBIS / BETTMANN; WIDE WORLD; HULTON / ARCHIVE

<

DARLING CLEMMIE

"My most brilliant achievement was my ability to be able to persuade my wife to marry me," Churchill once said. That he did in 1908, forming a lively union with Clementine Hozier that would last 56 years and produce five children. In political campaigns Clemmie was usually at his side (left, in 1924).

LONDON NEWS AGENCY PHOTO, LTD.

WITH HIS TROOPS

During the worst days of the war, Churchill lifted spirits with his oratory and personal visits. Here, inspecting coastal defenses, he tries out a tommy gun, teeth clenched as usual on a premium Cuban cigar. The Germans later made a poster from this photograph, depicting Churchill as a Chicago-style hoodlum.

RIGHT: TIMEPIX

AT THE EASEL

Churchill was as delighted by the play of light and color as he was by the sonorities of language. Before, during and after the war, he devoted many hours to watercolor painting, as he did while vacationing at Cap d'Antibes, on the French Riviera, in 1935 (inset). Painting also helped him subdue what he called the "black dog" of depression.

CORBIS / BETTMANN

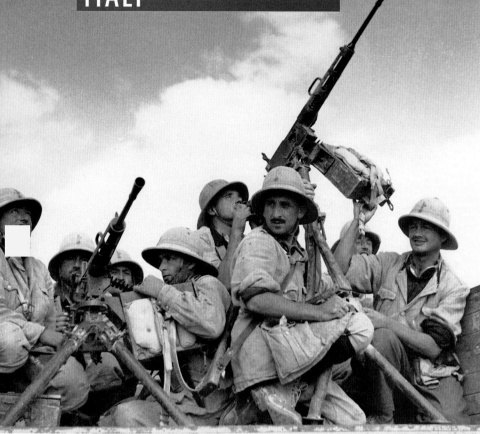

ITALY

>

DREAM DENIED

Mussolini dreamed of restoring the Roman Empire and cast his eyes toward Greece and North Africa. In July he ordered Marshal Rodolfo Graziani, a veteran of the 1936 invasion of Ethiopa (right, reviewing troops in Libya), to prepare an offensive on British-held Egypt. His army (including a motorized brothel) dithered, then drove 60 mostly unopposed miles into Egypt.

ISTITUTO LUCE

<

OUTGUNNED

This Italian anti-aircraft battery (left), like the rest of the Army, was surprised by a British counterattack in Egypt in December. In two months the British won four major battles, advanced 400 miles inside Libya and took 130,000 prisoners. In February 1941 the Italian Tenth Army surrendered, turning over a vast booty of supplies.

ISTITUTO LUCE

<

GREEK FARCE

In October, Italy invaded Greece through Albania, which Mussolini had seized in 1939. For two weeks the campaign went well (left, soldiers repair a bridge), then ran into elite Greek infantry familiar with mountain terrain. The Italian retreat soon turned into a rout — 30 miles back into Albania. Adding to Mussolini's woes: The British sank three of his battleships at Taranto, on Italy's heel.

CORBIS / BETTMANN

UNITED STATES

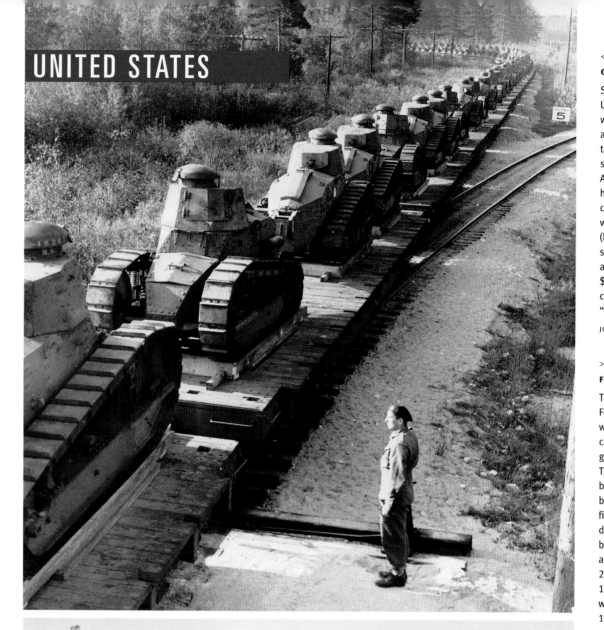

GEARING UP

Still officially neutral, the U.S. began tilting hard toward its beleaguered Allies and beefing up its own military — despite a clear aversion to war in the country. After FDR won a third term, he developed Lend-Lease, a crucial lifeline that began with antiquated weaponry (like these tanks, left, being shipped through Canada) and eventually totaled some $50 billion in arms. Churchill called the program "Hitler's death warrant."

JOHN BOYD

FEELING A DRAFT

These awkward civilians at Fort Dix, New Jersey (right), were among the first to be called when the draft began, in November 1940. They are measured for combat boots while carrying a bucket of sand for proper fit. The U.S. moved to double the size of the Navy, build 36,000 planes a year and boost the Army from 200,000 to a million. By 1947 selective service would bring more than 10 million men into the armed forces.

GEORGE STROCK / LIFE / TIMEPIX

NOT QUITE READY

Shouldering a rifle in formation (left), as part of the Manual of Arms, was only one of the tasks to be learned by Army volunteers at Fort Ord, California, in November. The country was like these rookies: not ready for war. Popular opinion had to be roused; industry had to be marshaled. Both would happen dramatically within a year.

UNDERWOOD PHOTO ARCHIVES

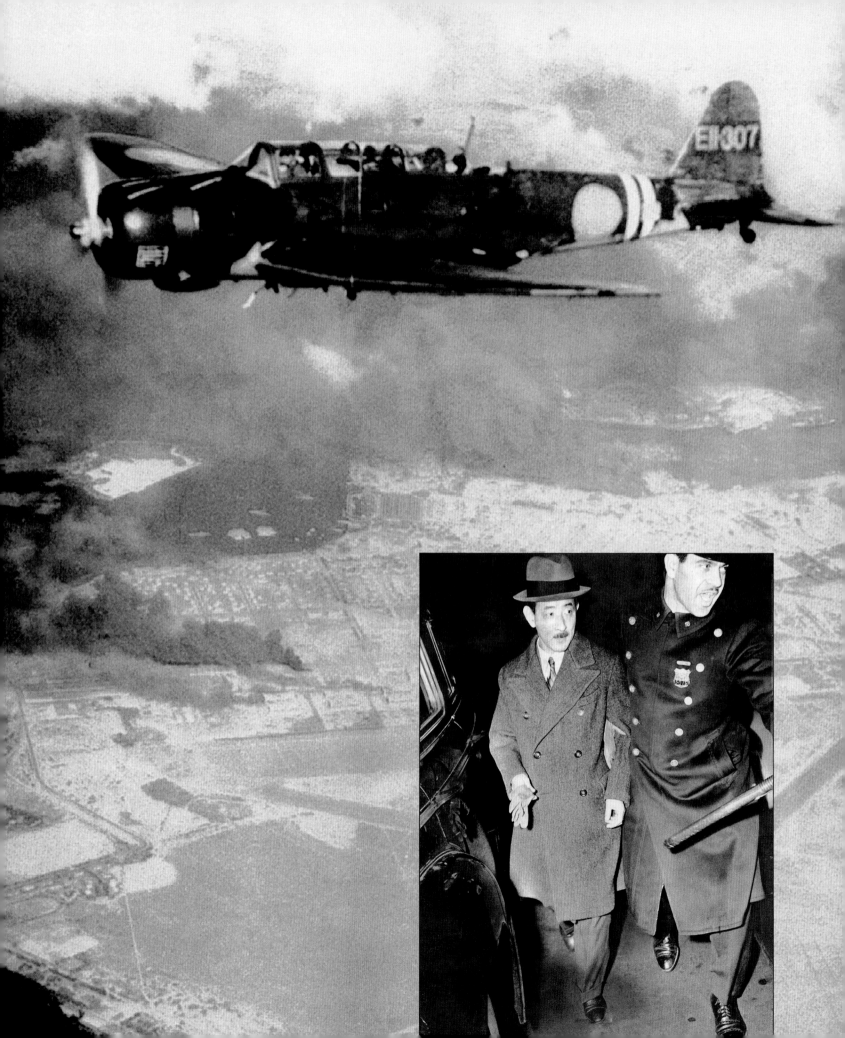

1941

FINALLY, AMERICA IS FORCED INTO WAR

For two years the United States was officially neutral. It bent the rules some by escorting British convoys in the Atlantic and sending shiploads of supplies to England under Lend-Lease. But when a German submarine sank a U.S. destroyer in October, killing 115 sailors, Washington's reaction was cautious. The message: We will not be provoked. Then we were. Japanese bombers appeared over Pearl Harbor (left) on December 7. The sneak attack so infuriated America that a Japanese diplomat had to be escorted to safety by a cop in New York (inset). The United States declared war on Japan next day, on Germany and Italy three days after that.

LEFT: YOMIURI SHIMBUN
INSET: CORBIS / BETTMANN

The Killing Moves Around the Planet

by Gerhard L. Weinberg

WORLD WAR 2 TRULY ASSUMED global dimensions of unprecedented scope and ferocity only in 1941. It is true that the British and French empires were involved from September 1939 on. There was naval action on the world's oceans and fighting on the African continent. But in 1941, because of decisions made in Germany and Japan the year before, more people than ever were drawn into the vortex of war.

Adolf Hitler and the German General Staff had hoped to attack the Soviet Union in the fall of 1940, but practical considerations resulted in their postponing the invasion to 1941. Preparations for it and the resumption of preparations for war against the United States had been ordered in the summer of 1940.

Simultaneously, the government of Japan debated whether to take advantage of the defeat of France and the Netherlands and the likely defeat of Britain to seize their Pacific and Asian colonies and, perhaps, American possessions as well. The Japanese took the first major step in this direction with the occupation of northern French Indochina in September of 1940, but the issue was still to be resolved.

In the first months of 1941 the Germans prepared for the invasion of the Soviet Union. To avert a collapse of Benito Mussolini's rule in Italy, they sent Erwin Rommel to help Italian forces hold the Libyan remnant of Italy's colonial empire. The northeast African portion of that empire had been conquered by the British and was beyond reach.

Because Germany needed Romania's oil and because that country had been occupied by its troops as part of the planned attack on the Soviet Union, Berlin wanted to preclude a Balkan front that could disrupt their operations in the East. They decided to invade Greece. And when they doubted that Yugoslavia would remain submissive to German demands, they included it in the Balkan campaign of April 1941. In short order those countries were crushed — along with the support provided by Britain. Crete was seized by airborne assault.

The heavy losses incurred in the capture of Crete discouraged the Germans from trying such operations again — on Malta, for example; but their effort to close the southeastern entrance to Europe was seen by some as a step into the Middle East. It indeed was a step Germany itself expected to take after the defeat of Russia.

Hoping to replace British influence in Iraq with Axis control, some pro-German nationalists tried to push out the British. This failed in spite of German assistance made possible by the cooperation of the Vichy French authorities in Syria — and led to the invasion of that country by British forces.

On June 22, the day after the Syrian capital of Damascus was taken by Britain, Germany and its European allies attacked the Soviet Union. In

In late August, British and Soviet forces jointly moved into Iran to forestall a German invasion. They wanted to keep Iran's oil refineries out of Nazi hands; these Indian troops did the job.

BRITISH OFFICIAL PHOTO

the preceding two years Joseph Stalin had tried to avert war with Germany by helping it with supplies and a naval base and by hoping to join the Tripartite Pact of Germany, Italy and Japan. He had rejected as provocations all warnings, including summaries of the German plan of attack provided by the United States and his own intelligence apparatus. He misread his enemies as they misread the Soviets.

German preparations for the invasion of the Soviet Union were based on the assumption that the Soviet state would collapse after initial defeats; the campaign would be over before winter. That would provide Germany with two things: vast space to set-

tle farmers and the raw materials, especially oil, for war against the United States. Russia's major cities would be leveled, 30 to 40 million inhabitants would starve to death as the military appropriated food, and quick victory there would be followed by the conquest of the Middle East and Northwest Africa.

The German armies did win great initial victories and captured hundreds of thousands of prisoners, the majority of whom were killed or died in custody. But these victories did not lead to a Soviet collapse. The critical issue was not where the German forces would be halted but whether the Soviet regime could maintain its hold on the unoccupied portions of the country, as Alexander I had when Napoleon's Army reached Moscow. But neither the czarist nor the provisional government had been able

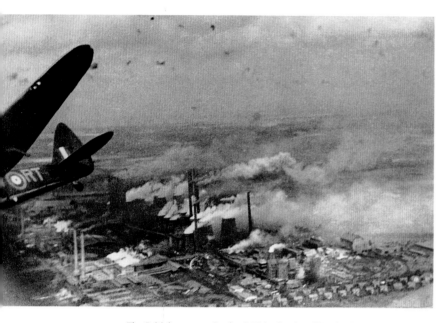

The British were paying back Hitler for the Blitz. This low-level, daylight RAF attack in August was aimed at Cologne power stations. The Blenheim at left has dropped its bombs; two more planes are about to.
BRITISH OFFICIAL PHOTO

to do so in 1917, when the Germans did not even advance as far as in World War 2.

By late August 1941, as Soviet counterattacks on the central portion of the front led to the recapture of the small town of Yelnya, it was clear that early blows had not toppled the regime. On the contrary, its hold on the unoccupied areas was firm and enabled it to draw on the human and material resources needed for a continuing war effort. It was an effort assisted by German atrocities that made Stalin look benign — a considerable accomplishment — and provided the government with its only period of legitimacy in the eyes of the population. That firm control, not specific battles, doomed the invaders. Any who doubt this should contemplate the fate of David had his slingshot missed Goliath.

From June 1941 the overwhelming majority of World War 2 fighting took place on the eastern front, but at the same time another program of mass slaughter began. The Germans started systematically murdering handicapped citizens in the fall of 1939.

Now they began the systematic killing of Jews, first in the newly occupied portions of the Soviet Union; then with help rather than opposition from the military, they extended the policy to all of Europe within their reach.

What came to be called the Holocaust got under way in the summer of 1941; and as Hitler explained to an enthusiastic grand mufti of Jerusalem in November, it was to be extended to all countries of the earth. Although the campaign against the Soviet Union was clearly turning against the Germans, with defeats at both ends of the front and at Moscow in November and December, the murder of Jews would continue.

During the fighting on the eastern front, the British fought on in Africa, in the skies over Europe and on the oceans. Most dramatic were the increasing air raids by the Royal Air Force that both obliged Germany to divert resources from the East and heartened the peoples of occupied Europe. At sea the British hunted German submarines and, after losing the battle cruiser *Hood*, sank the German battleship *Bismarck*. They also sent substantial supplies to the Soviets, a choice over the defense of the British colonies in Southeast Asia that would eventually cost them dearly.

The United States also began to send aid to the Soviets. The American reaction to the German victories of 1940 had been a major push to build up the military, establish the first and only attempt at something of a coalition government and elect a President to a third term for the first time. Franklin Roosevelt hoped that aid to Britain and the Soviets would enable them to defeat Germany without active American participation, and that once Japan saw that Germany was losing, it would refrain from joining the Axis. Delay and what was later called deterrence were the key American policies; they came within two weeks of working. By mid-December the Japanese would have seen the German defeats at Moscow and

in Libya and might have stayed out of the war. But Japan was in a fatal hurry.

From the perspective of Tokyo, the German invasion of the Soviet Union reopened the choice: Head south across the Pacific or attack the Russian rear. The Japanese decided on the first, having signed a neutrality treaty with Moscow in April 1941. In July, Tokyo took the decisive step of occupying southern French Indochina, a move away from their ongoing war against China and toward a war with the Dutch, British and the Americans. Assured that U.S. planes would not be allowed to use bases in the Soviet Far East to attack Japan, promised by Germany and Italy that they would join war against the United States, well informed about the weakness of Allied forces in Asia and the Pacific, the Japanese decided to strike.

The plan for war against the United States had for years assumed that Japan's fleet would await the American Navy as it moved across the Pacific to relieve the Philippines and other areas seized by Japan, then destroy it in a great battle. This would assure safety for the newly conquered greater Japanese Empire and facilitate a negotiated peace.

But a few weeks before Japan's offensive into the Philippines, Malaya and the Dutch East Indies, Admiral Isoroku Yamamoto, the Commander of the Combined Fleet, threatened to resign unless the original plan was replaced by his pet scheme to attack Pearl Harbor. The Japanese Naval Staff gave in, thereby allowing him to wreck Japan's basic concept on the first day of hostilities. After a peacetime attack, the American people would not consider a negotiated settlement — and most of the ships Yamamoto imagined sunk were raised, while most of their crew members survived to participate in the rebuilding of American naval power.

The Japanese attacks into Malaya and the Philippines, followed by assaults toward India and Australia and the declarations of war on the United

Friend and foe alike mobilized their civilian populations to salvage metal for weapons. Collection depots were a familiar sight in the United States and in Japan, too (above), where scrap iron was piled up in the street.

States by Germany and Italy, spread hostilities to virtually every continent and every ocean. It was not until 1942 that Japanese planes bombed Australia and Japanese troops landed in the Aleutians while German submarines sank ships in sight of the American East Coast, but World War 2 had indeed become a global conflict.

Gerhard L. Weinberg, the author of numerous books, including A World at Arms: A Global History of World War II, *has taught at four universities. He directed the American Historical Association project for microfilming captured German documents before their return.*

DOWN AND OUT

After seizing Egyptian territory with ease in 1940, Mussolini became overconfident. Why not? By early 1941 his ground forces in Libya outnumbered the British in Egypt nearly seven to one. But in the air and on the sea the Axis powers would prove vulnerable. This Italian fighter (left) never made it home. Allied soldiers inspect the burned-out hulk in the Libyan Desert.

CAMERA PRESS

AN ELASTIC FRONT

It was a seesaw war in North Africa. Both sides attacked, then retreated. One result was a huge haul of prisoners, especially among the Italians. The British offensive in late winter filled tent villages with POWs, who stripped to their skivvies for this casually guarded work detail (top right). Combat in the desert was about to change: A German general named Erwin Rommel arrived from France.

HULTON / ARCHIVE

LOCAL HERO

The British put together highly effective combat forces from their colonies and possessions around the world. This fierce Sudanese volunteer (right) took up arms in East Africa on the Eritrean front, where the Italians were gradually driven out. It was the same story next door in Ethiopia, where Emperor Haile Selassie returned from exile to his throne in Addis Ababa in May.

UNDERWOOD PHOTO ARCHIVES

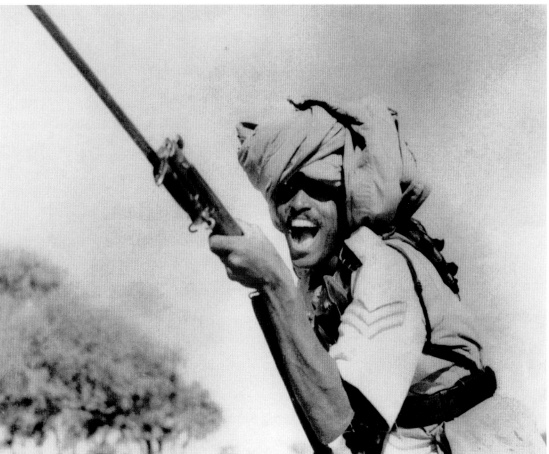

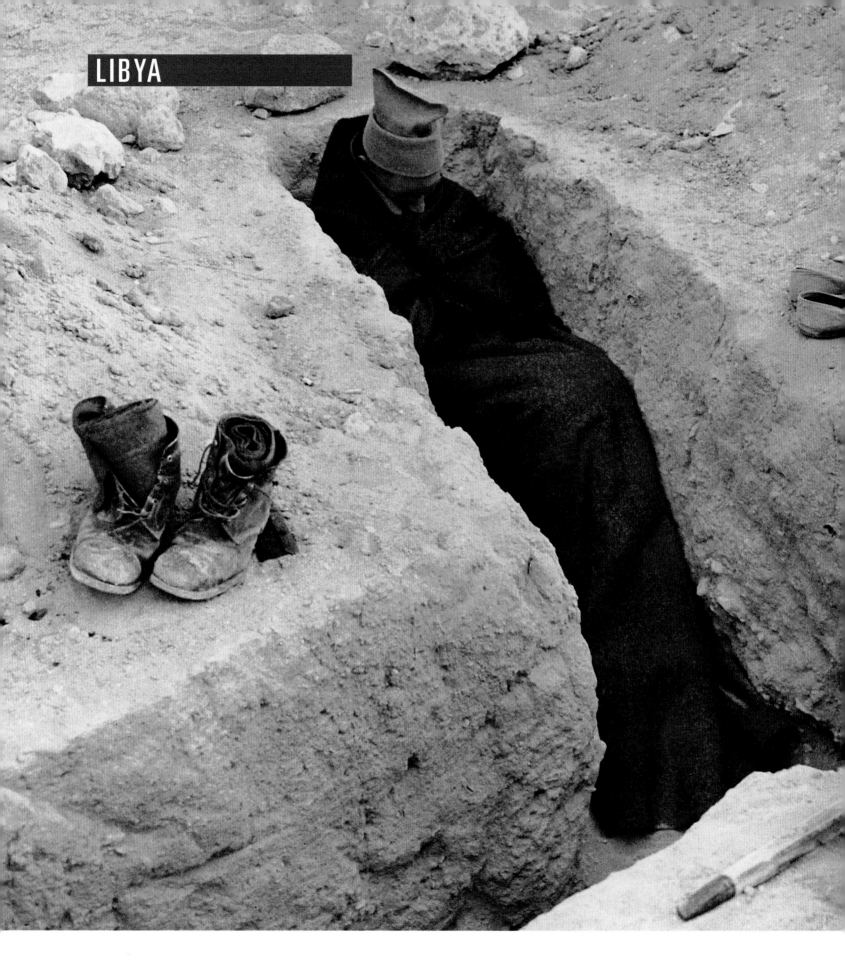

TERRIBLE TOBRUK

By the end of January the British had captured key Libyan port cities, including Tobruk. Because Churchill then made one of his rare tactical blunders, it was a fleeting victory. He redirected troops from Africa to Greece, leaving behind one division, mostly Australian. Rommel's Panzers counterattacked and isolated Tobruk. The encircled Allies dug in (through the hard desert soil, left) and kept the Germans at bay with artillery (top right). Late in 1941 a much battered Tobruk was finally relieved. By mid-1942, however, the Germans returned, took the city and 30,000 Allied POWs.

LEFT AND TOP RIGHT: BRITISH OFFICIAL PHOTO

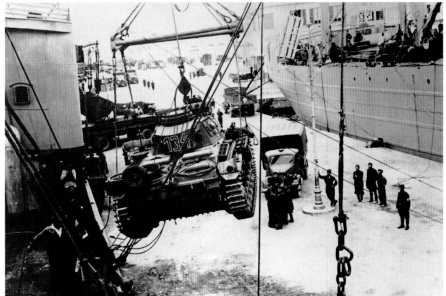

>

ROMMEL RESCUE

Mussolini was reluctant to accept German reinforcements, but Hitler gave him no choice. The Führer sent the elite Africa Corps, under Rommel, to Libya. Though new to desert warfare, they acclimated quickly (including the use of netting to keep desert bugs off, right). Matériel poured into Tripoli (a tank arrives, middle right) as well as men. Within six weeks Rommel launched an offensive. By May the Germans had regained most of the ports lost by the Italians and surrounded Tobruk.

MIDDLE RIGHT: ULLSTEIN BILDERDIENST
RIGHT: KEYSTONE PRESSEDIENST

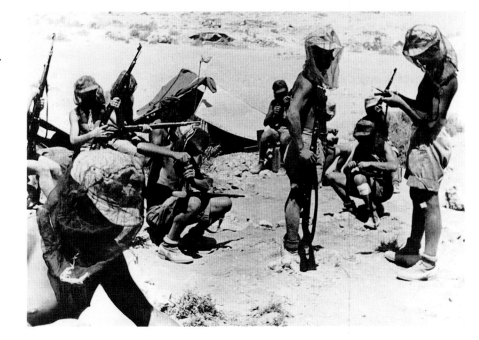

The Sky Falls

In April, five months after its troops had subdued the Italians, the glory that was Greece failed. Axis forces, mostly German, rushed in from Romania and Bulgaria. The Greeks, bolstered by 58,000 British soldiers, fought bravely again. But by late May the Nazi flag was hoisted over the Acropolis (above). As the Brits fled to the coast for evacuation, their anti-aircraft tried to fend off German bombing and strafing (right). Recognizing the Greek enemy's courage, the Nazis, in an uncharacteristic, storybook gesture, allowed the defeated officers to retain their swords. Hitler then went a step further: Once the armistice was signed, he ordered all Greek POWs released.

ABOVE: BUNDESARCHIV, KOBLENZ
RIGHT: MANSELL COLLECTION / TIMEPIX

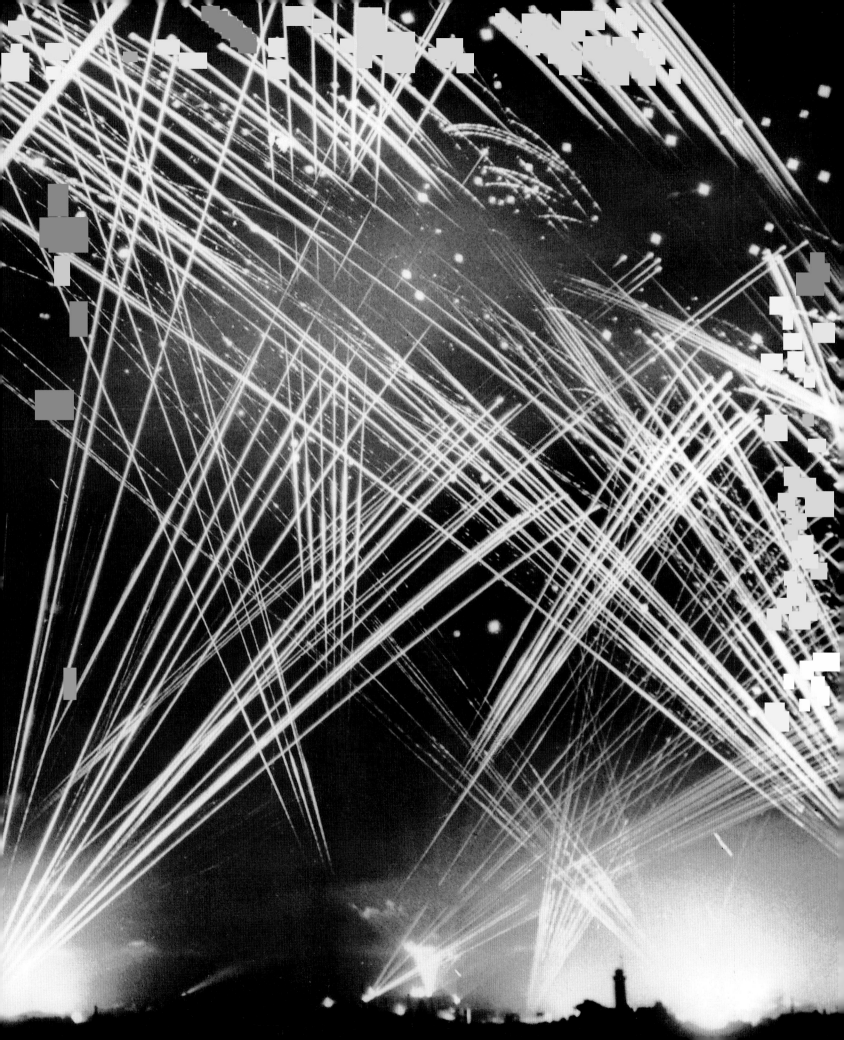

BIOGRAPHY

ERWIN ROMMEL

Martial Artist

The rise and fall of the Third Reich can be traced in the career of Erwin Rommel. Son and grandson of teachers, he broke with family tradition by entering the Army. After serving with distinction in World War 1, he taught at three military academies and wrote a well-regarded training manual. When World War 2 began, he was put in charge of Hitler's escort battalion and then led an armored division to decisive victories in France in 1940. That won Rommel the personal congratulations of his Führer (below) and the command of German forces in North Africa. But the two men's relationship, like the empire they tried to build, would collapse in bitter recriminations.

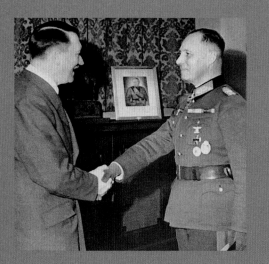

IN WAR AND LOVE
In 1915, after recovering from his first wound, Rommel returned to the trenches (left, front) in France's Argonne forest. During the war he won Germany's highest decoration by capturing a mountain and 9,000 Italians stationed there. In 1916 Rommel married Lucie Mollin, 22 (below), and they had one son. Rommel was unusually devoted to his wife, and no matter where the Army sent him, he wrote to her nearly every day.

LEFT AND BELOW: COURTESY OF MANFRED ROMMEL
BELOW LEFT: WIDE WORLD

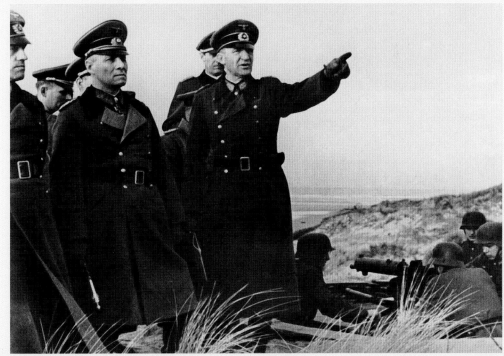

THE FOX FALTERS

In 1941, as Commander of the Africa Corps, Rommel (above) stormed through British defenses in Libya and Egypt, earning him the nickname Desert Fox. But the growing Allied strength overwhelmed him at the Egyptian city of El Alamein. Recalled to Germany, Rommel was given responsibility for defending the Continent against an invasion (above right, center, at the English Channel).

TOP, LEFT TO RIGHT:
HEINRICH HOFFMANN /
BILDARCHIV PREUSSISCHER
KULTUREBESITZ; U.S. ARMY

>

A HERO'S DEATH

Implicated unjustly in the July 1944 attempt on Hitler's life, Rommel was given a choice: Commit suicide and your family will be cared for, or stand trial. He took poison and was buried with full military honors in Berlin on October 19, 1944 (right).

SUEDDEUTSCHER VERLAG,
BILDERDIENST

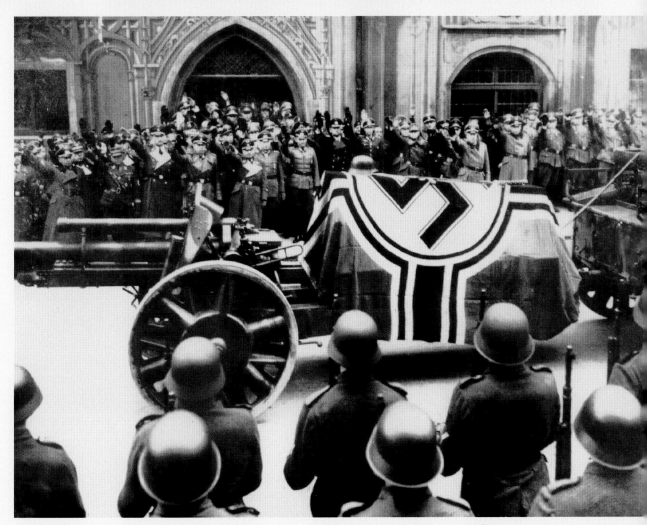

YUGOSLAVIA

PANCEVO JUSTICE

The men with haunted look below are about to be hanged — like their neighbors at right. They were victims of the Nazi policy of 10 civilians for every German occupier killed or wounded in Pancevo, in the Serbian part of Yugoslavia. After their country signed a treaty with Germany in April 1941, rebellious Serb officers overthrew the government. Hitler's response was swift; he sent in troops, losing only 151 soldiers against an antiquated, mule-equipped Army. Resistance continued, however, and the Germans retaliated by dragging victims off the streets — businessmen with suits, ties and spectacles still in place. The noose is just being slipped over the head of the man at far right.

RIGHT AND INSET:
GERHARD GRONEFELD /
DEUTSCHES HISTORISCHES
MUSEUM-BILDARCHIV

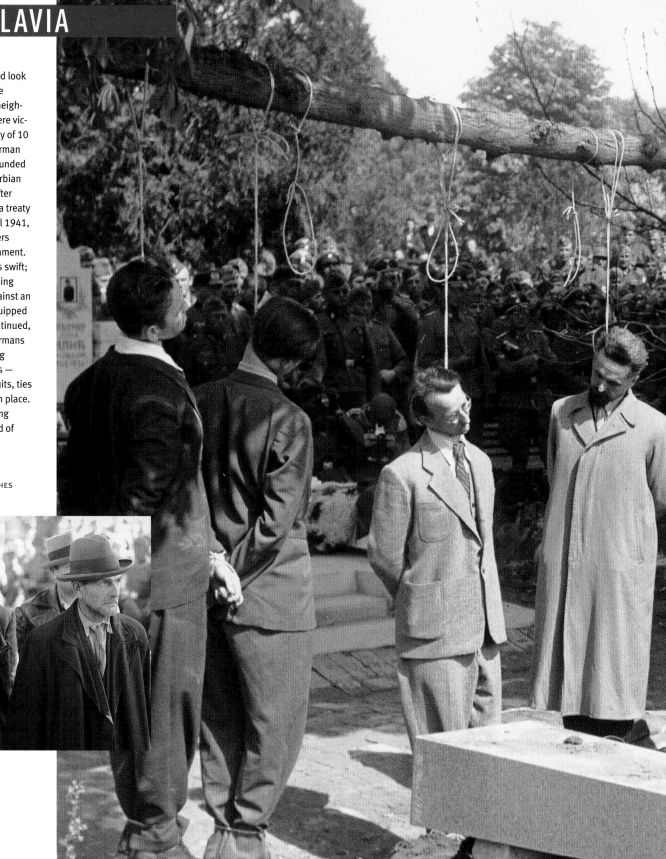

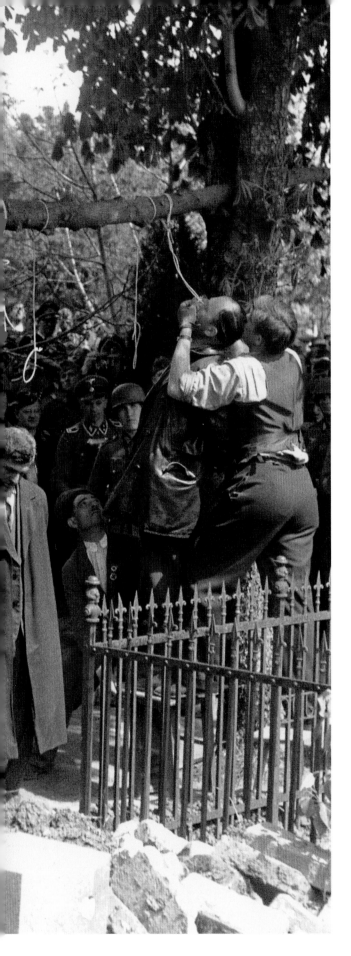

A NAZI WELCOME

Pieced together in the wreckage of World War 1, Yugoslavia was a crazy ethnic quilt dominated by the Russian Orthodox Serbs, whom the Nazis considered natural enemies. But in May the Germans were welcomed as liberators in Zagreb (right), capital of the anti-Serbian, mostly Catholic Croatia. Other Yugoslav territories were traded off to Axis allies.

CORBIS / BETTMANN

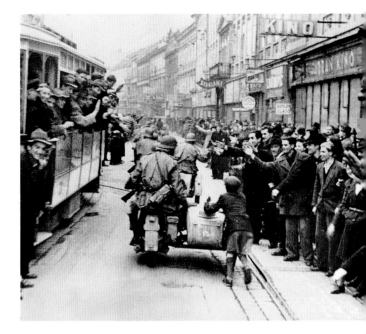

COPYCAT CRIMES

Calling themselves Ustashi, or "rebels," right-wing Croatians declared independence from Yugoslavia and established a Fascist puppet state. Adopting Nazi methods, they harassed and murdered Serbs, Jews and Gypsies, young and old (right).

BILDARCHIV PREUSSISCHER KULTURBESITZ

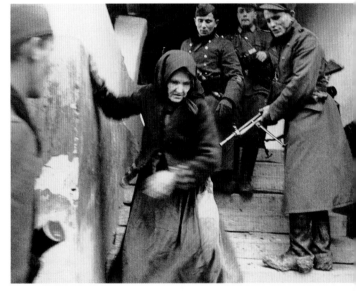

EARLY SOLUTION

As their units watch from a distance, German officers administer the coup de grâce to civilians lined up for execution against a garden wall in Pancevo. To expedite the elimination of resisters and undesirables, and to reduce the stress on their own, sometimes reluctant soldiers, in 1941 the Germans began to experiment in Poland with more "efficient" methods — leading to the Holocaust.

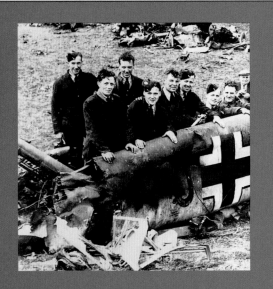

CRIMES AGAINST HUMANITY

Defining Justice

The crime of genocide predated the Third Reich by many years (for instance, the murder of more than a million Armenians in Turkey from 1915 on). But the Nazis took mass slaughter to horrific new levels with specialized killing equipment. After discovering mountains of corpses at liberated concentration camps, the Allies put death's top bureaucrats on trial at Nuremberg for crimes against peace and humanity. Through these and other cases, the international community established a precedent for prosecuting war crimes, a task that never ends.

<

ONE NAZI GONE

The first Nazi war criminal did not have to be captured; he parachuted into Scotland on a bizarre one-man peace mission in 1941 (left, his wrecked plane). Rudolf Hess, a longtime Hitler crony, was held as a POW and tried at Nuremberg. He was sentenced to life and spent 41 years in prison until his death, in 1987. He was the last of the Third Reich leaders.

WIDE WORLD

>

IN THE DOCK

At Nuremberg in 1945, 22 leading Nazis went on trial (top right). Their main defense: We were only following orders. It was rejected, and the Allied tribunal found 19 of them guilty. Ten went to the gallows. Luftwaffe chief Hermann Goering (extreme left) cheated execution by taking poison the night before. In a later trial of 23 concentration-camp doctors, witnesses included a former prisoner who showed scars on her legs (right). They were the result of grotesque medical experiments performed in the camps. Sixteen doctors were convicted.

RIGHT, TOP AND BOTTOM:
HULTON / ARCHIVE

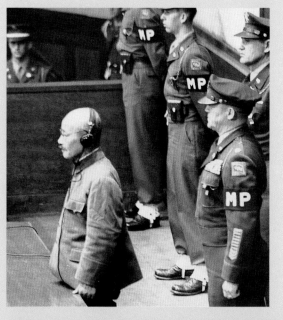

<

TOJO IS DOOMED

Modeled on Nuremberg, an international military tribunal in Tokyo tried 25 Japanese leaders for war crimes. It sentenced 7 to death, including General Hideki Tojo, 61 (left), who as prime minister had authorized the attack on Pearl Harbor. Some 900 of his countrymen were also executed by the Allies for mistreating prisoners and for other atrocities.

WIDE WORLD

>

FINAL MOMENTS

Away from Nuremberg and Tokyo, where hanging was the dominant form of execution, many German officers were sentenced to die as they had lived — by the gun. Convicted by a U.S. Army court, General Anton Dostler (right) is tied to a stake before a firing squad in Aversa, Italy, in 1945, while a chaplain somberly offers prayers.

NATIONAL ARCHIVES

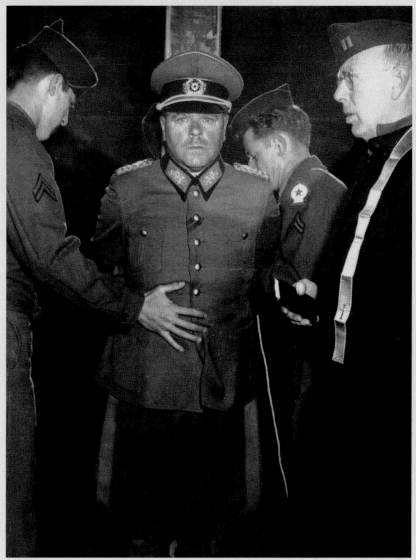

FRUITLESS CHASE

Long after others had given up the chase, Holocaust survivor Simon Wiesenthal (near left) relentlessly pursued escaped Nazis. In 1972 he publicized his search for Martin Bormann, a deputy führer who was sentenced to death in absentia at Nuremberg. Rumor had him hiding in Paraguay. But in 1973 a skeleton uncovered in West Berlin was ruled Bormann's.

NEAR LEFT: FRANZ GOESS

FRANCE REMEMBERS

As Gestapo chief in Lyons, Klaus Barbie (below, facing) was responsible for 4,000 deaths and the deportation of twice that number. After the war, he worked briefly for U.S. intelligence, which resettled him in Bolivia; France extradited him 30 years later. At his trial, Barbie was unregenerate. Sentenced to life, he died in prison in 1991.

LEFT: HULTON / ARCHIVE

<

MASS MURDERER

Adolf Eichmann, 55 (above), testifies on his own behalf from a bullet-proof glass cage in an Israeli courtroom in 1961. The ex-Nazi had been kidnapped in Argentina by Israeli agents and tried for his role in the deportation of Jews to concentration camps. He denied knowing what was going on there. Nobody believed him. A three-judge panel ordered him to be hanged.

ABOVE: MARLIN LEVIN

>

IDENTITY CRISIS

Struggling with Israeli guards in 1988, John Demjanjuk of Cleveland, Ohio, shouts his innocence: "I am not Ivan the Terrible!" Though born in the Ukraine, the naturalized American denied he had been a brutal guard at Treblinka. He was allowed to return home. But recent Soviet evidence indicates Demjanjuk lied about his past, and he could face loss of his citizenship.

RIGHT: JIM HOLLANDER / REUTERS / ARCHIVE

<

CROATIAN CLEANUP

A dashing pro-Nazi officer from Croatia, Dinko Sakic (near left, with his wife, Nada) ran a concentration camp in his home state that exterminated Jews, Serbs and local dissidents. In 1999 Croatia broke with its wartime past, brought Sakic back from Argentina and put him on trial (far left). He was sentenced to 20 years.

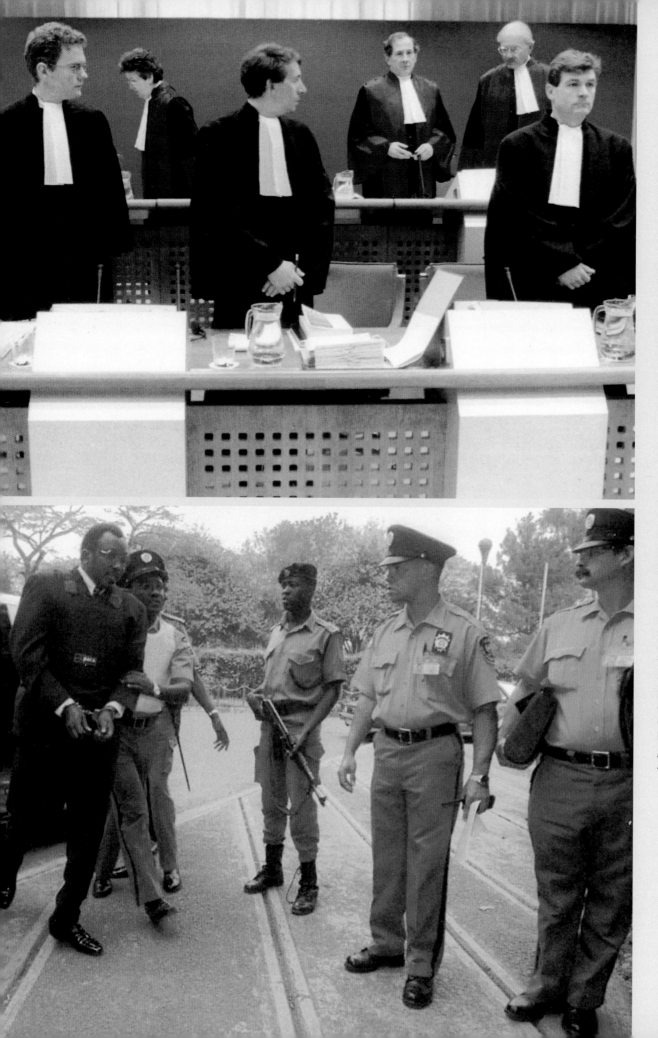

A WORLD COURT

In 1993 the United Nations assembled a war-crimes tribunal (left) in The Hague, Holland, to try to bring justice to the Balkans, also the scene of major atrocities in World War 2. The court has a total of 41 judges (one from the U.S.) and a staff of 1,000-plus. They have the power to imprison the guilty but not to impose the death penalty. There have been 100 indictments from the former Yugoslavia so far, with 20 convictions and 2 acquittals.

JASPER JUINEN / REUTERS / ARCHIVE

DARK CONTINENT

A handcuffed Jean-Paul Akayesu, 45 (left), entered a UN tribunal in 1998 in Tanzania, where the former mayor of Taba, in Rwanda, was found guilty of genocide. A member of the Hutu tribe, he urged local residents to murder 2,000 rival Tutsis during the Rwandan civil war. He was the first person convicted of genocide by an international court and was sentenced to life imprisonment.

ANTONY NJUGUNA / REUTERS / ARCHIVE

MAYHEM BY MACHETE

Foday Sankoh, 63 (above), self-proclaimed liberator of Sierra Leone, is in jail awaiting trial for murder and mutilation (ordering his troops to hack off the limbs of civilians). He also smuggled diamonds to finance his 10-year rebellion against the government. The country's militia captured him in 2000.

WIDE WORLD

VICTIMIZING WOMEN

It was the first international trial to consider sexual atrocities as crimes against humanity. Dragoljub Kunarac, 39 (top right, adjusting his earphones), and two fellow Serbs were convicted of managing detention camps in Bosnia, where Muslim women were imprisoned and raped in the early 1990s. The men's punishment was long prison sentences. The bitter ethnic conflict that fragmented Yugoslavia into warring states was started by the president of Serbia, Slobodan Milosevic, 60 (right). Voted out of office in 2000, he was arrested, and in June 2001 his countrymen turned him over to the UN to be prosecuted for war crimes.

TOP RIGHT: POOL / REUTERS / ARCHIVE

RIGHT: PETAR KUJUNDZIC / REUTERS / ARCHIVE

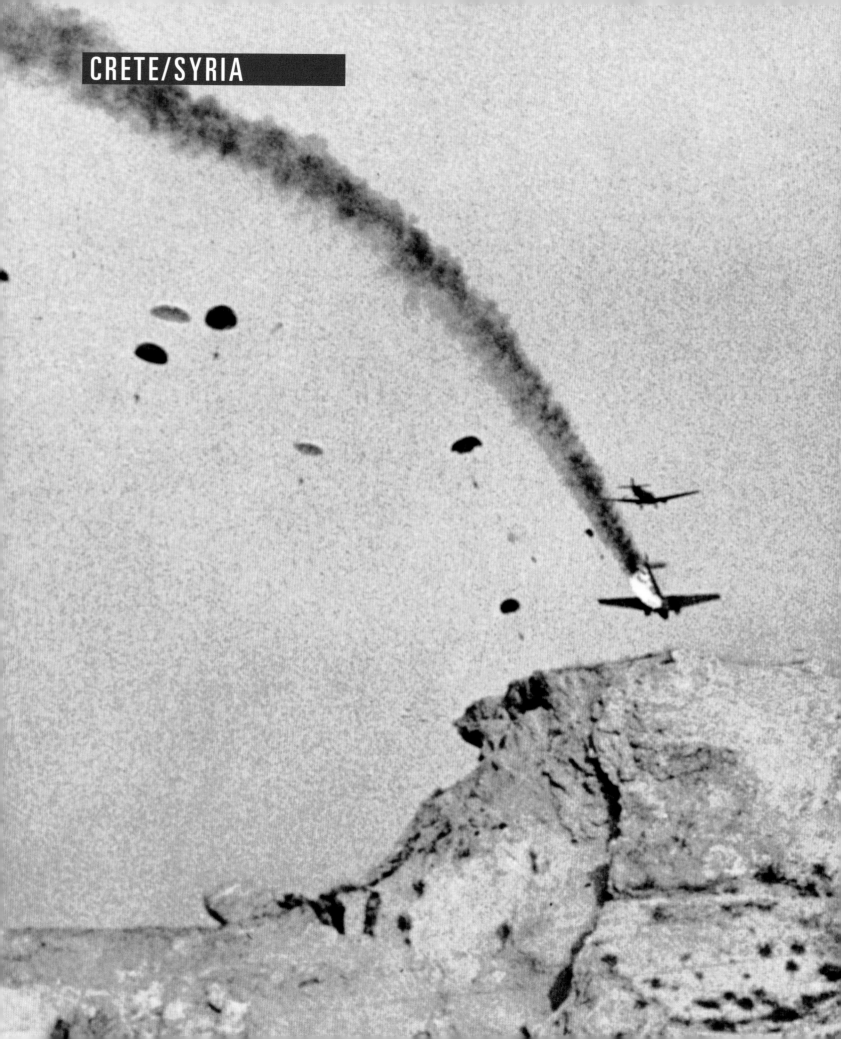

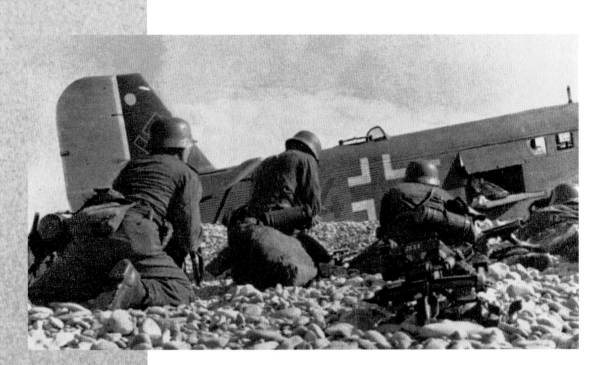

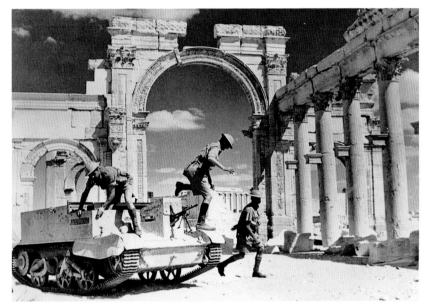

ISLAND HOPPING

To conquer the island of Crete, the Nazis dropped invaders by parachute. The strategy had enormous drawbacks. Low-flying transports (far left) — and their human cargo — were vulnerable to ground fire. Other paratroopers were injured on impact. Still, enough Germans landed safely (inset) to prevail over British forces, which were evacuated in May and June. Tallying his losses, Hitler said, "Crete proves that the days of the paratroopers are over." The Allies came to a different conclusion and sent in their airborne from 1943 on.

FAR LEFT: BRITISH OFFICIAL PHOTO; INSET: FROM "HURRA DIE GAMS," BY JULIUS RINGEL, LEOPOLD STOCKER VERLAG, GRAZ, 1958

AFTER THE ROMANS

Fearful that pro-Nazi Vichy officials in French-controlled Syria would open that country to the Axis, the Allies struck first — and won. After taking Palmyra in July, British soldiers (left) searched its ancient Roman ruins — evidence of an earlier conquest — for snipers. In the capital of Damascus (left) a Free French machine gunner created a strange tableau as he guarded a busy street. The 38,000 Vichy troops taken prisoner in Syria, including members of the French Foreign Legion, were given the chance to join De Gaulle's Free French. Most refused.

LEFT, TOP: BRITISH OFFICIAL PHOTO; LEFT: GEORGE RODGER / LIFE / TIMEPIX

109

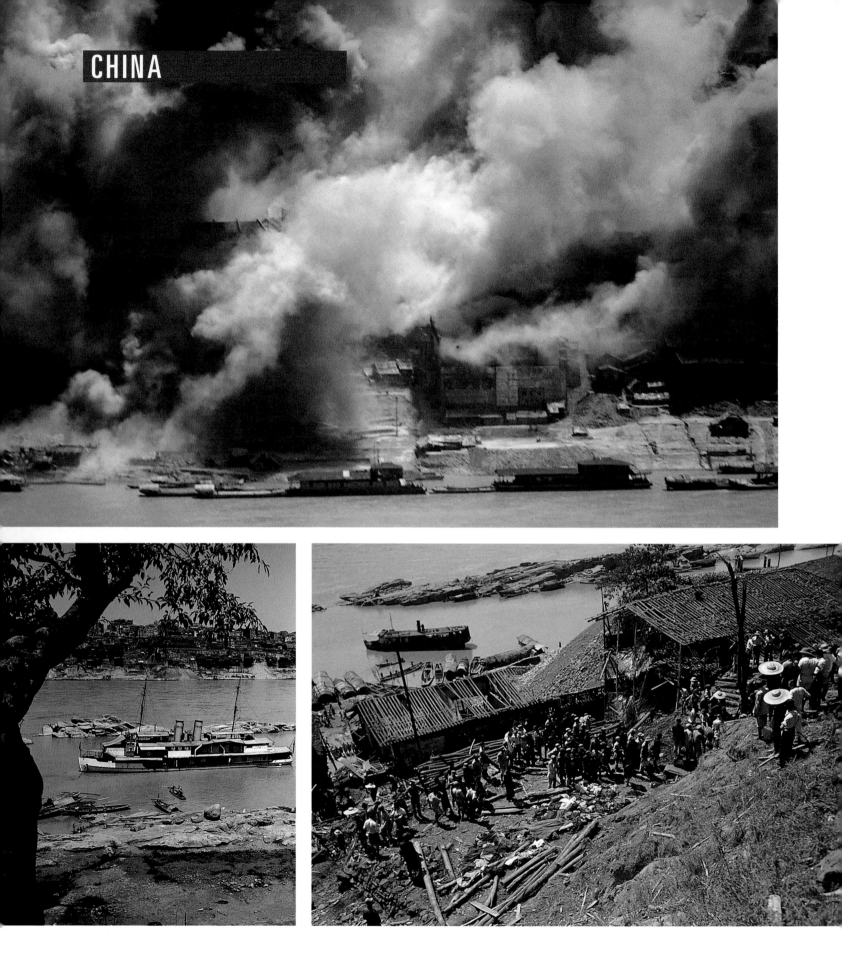

CHINA

TRIAL BY FIRE

Air raids were routine in Chungking as the Japanese attempted to bomb Nationalist headquarters into submission. Flames regularly engulfed the city's bamboo housing (left), burning some inhabitants alive. Finally, additional shelters were built and air-raid sirens installed. Still, some residents ran for cover when they spied forewarned government officials heading out of town.

COLOR CODED

It wasn't patriotism that prompted the German embassy in Chungking to cover its lawn with a giant swastika. The point was to direct Japanese bombers away from Axis property. It worked. The flag was clearly patched together with mismatched fabric, a sign of the deprivations of life in embattled China.

UP THE RIVER

Home to fishermen and ferrymen, as well as the American Embassy, the banks of the Yangtze River were an all-too-easy target. Resting at anchor, the U.S. gunboat *Tutuila* (far left) emerged unscathed from the Japanese air raid. Not so the people working along Chungking's busy riverfront. Rescue workers (near left) pull the dead and the wounded from the wreckage.

ALL: CARL MYDANS / LIFE / TIMEPIX

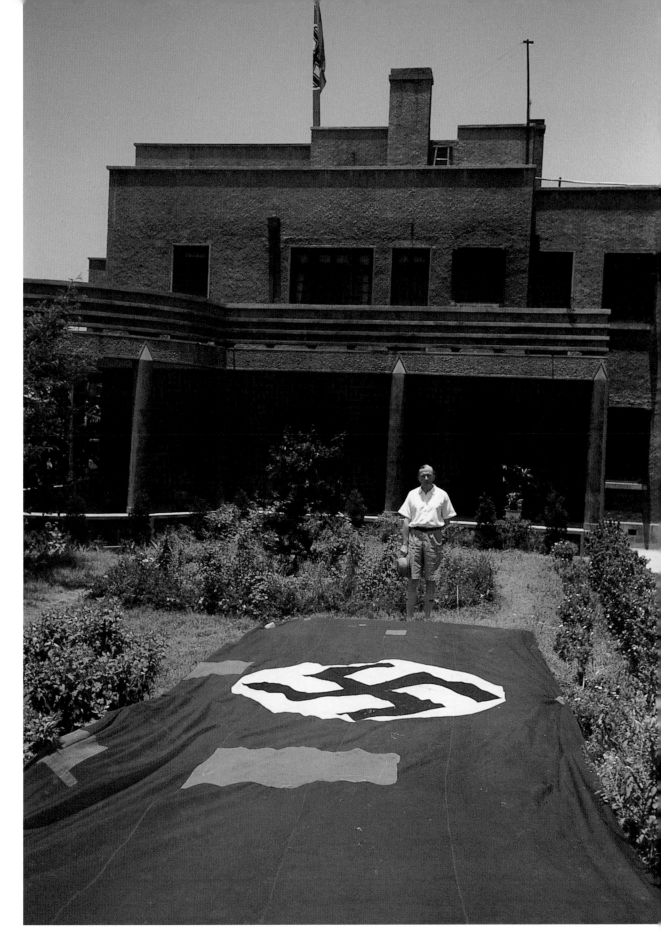

LIBYA

Shifting Sands, Shifting Fortunes

Stuck in a desert stalemate reminiscent of trench warfare, Australian defenders of Tobruk withstood a harrowing Africa Corps siege for eight months. Rommel's troops staved off British relief efforts in May and June but failed to breach the fort. In November the Allies' Operation Crusader drove the overextended Germans into the dunes (left) and out of eastern Libya. Doggedly pursued by Tobruk's newly liberated Aussies (top), as well as South African troops, advancing under the cover of a smoke screen (above), the German Army eluded capture and regrouped in the western part of the country.

LEFT: BILDARCHIV PREUSSISCHER KULTURBESITZ
TOP: AUSTRALIAN WAR MEMORIAL
ABOVE: IMPERIAL WAR MUSEUM E6772

LIBYA

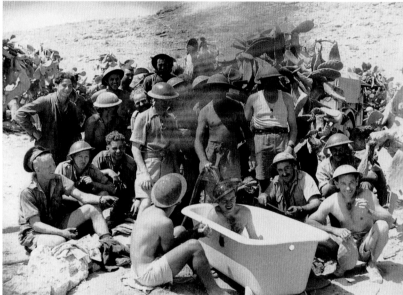

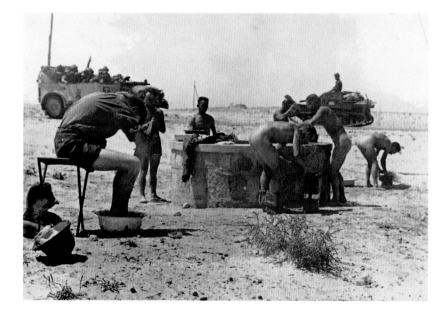

NEXT: GODLINESS

Much of the life of the combat soldier can be described as flying once was: hours of boredom punctuated by moments of sheer terror. During those downtimes, the soldier tries to resurrect the amenities of normal existence, including cleanliness. That's not easy in the arid desert. Here, North Africa combatants are doing their best. At right, a German trooper scours the grime from his uniform with sand. His buddies in the Africa Corps (bottom left) strip to take advantage of a rare well. An Australian in Tobruk (middle left) has an audience as he bathes in a tub abandoned by the Italians; the water came from an engine's cooling system. And the luckiest of all are the Australians at Bardia (top), who plunged into the cooling Mediterranean.

TOP AND MIDDLE LEFT: AUSTRALIAN WAR MEMORIAL; BOTTOM LEFT: ROBERT HUNT LIBRARY; RIGHT: SUEDDEUTSCH-ER VERLAG, BILDERDIENST

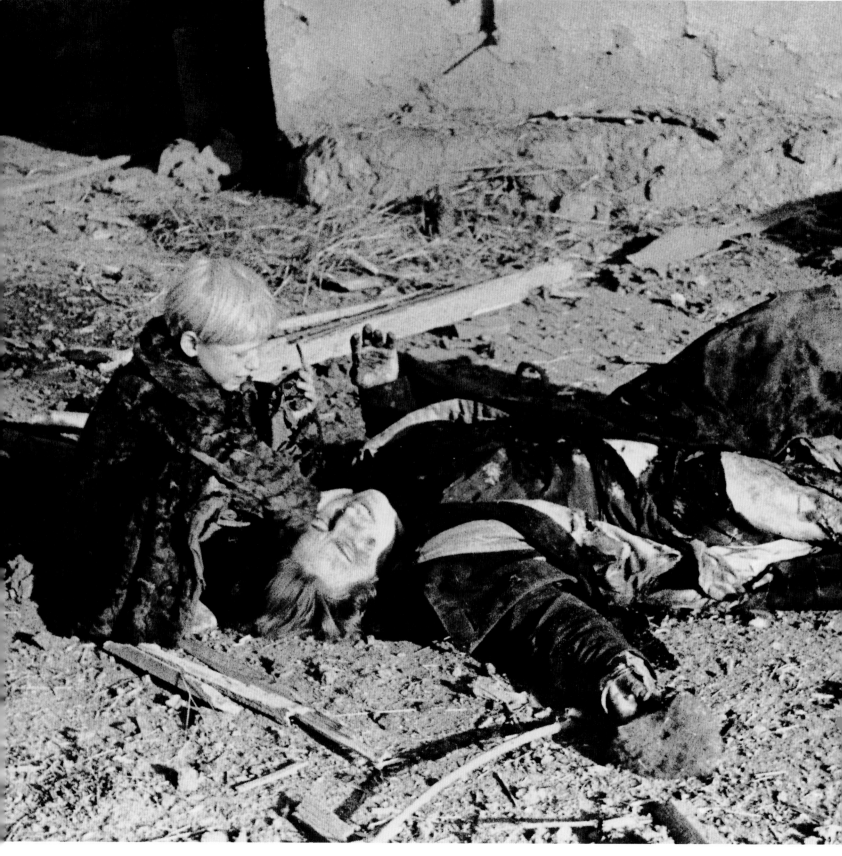

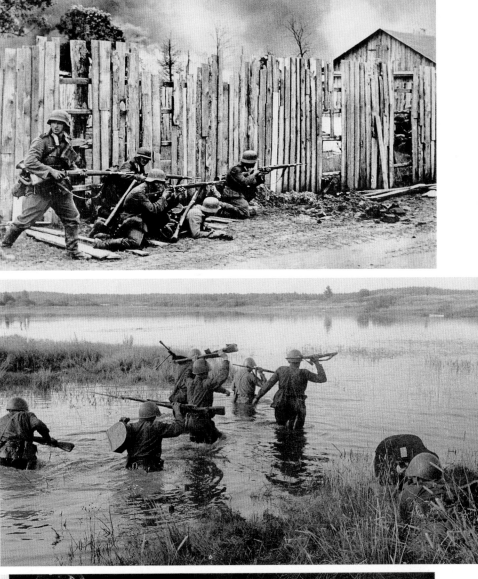

ENTER BARBAROSSA

Germany attacked the Soviet Union on June 22, revoking without warning their nonaggression pact. The long-planned invasion was code-named Barbarossa, for a twelfth-century Teutonic king who, legend had it, would someday arise from sleep to help his nation. The USSR, with its Communist government and large Jewish population, represented everything that Hitler loathed. It was also a ripe target; Stalin had purged his military of its most seasoned officers and ignored warnings of an impending attack. Nazi troops advanced rapidly through small border towns (top right) behind savage, indiscriminate bombing (after such an air raid a little boy, left, strokes his dead mother's face). Soviet forces reeled back, including these soldiers (right) who fled through a swamp to escape the deadly Blitzkrieg.

LEFT: NOVOSTI
TOP RIGHT: CORBIS / BETTMANN
MIDDLE RIGHT: SOVFOTO

THIS JUST IN

Community radio brought Soviet propaganda to its citizens. Sometimes the reports were true. In July workers gathered on a collective farm (right) to hear that England would aid the USSR with weapons and supplies. The cheering news later that year: In August, the Allies occupied Iran; in November, President Roosevelt extended Lend-Lease to Moscow.

MARGARET BOURKE-WHITE /
LIFE / TIMEPIX

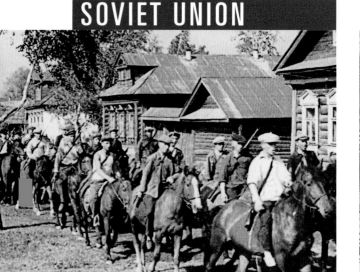

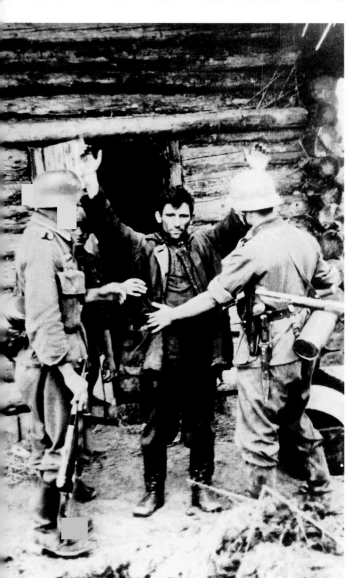

THE PARTISANS

"The perfidious military attack on our fatherland" was how Stalin described it to the nation (using a noun with unusual religious connotations rather than the more common "mother country"). Soviet citizens of every faith and ethnic background responded. Among the bravest were guerrillas who operated behind German lines. Farmers offered up their own horses and mustered in a village on the eastern front (left, top). Peasants poled a boatload of supplies to partisans hiding in the Belorussian woods (above). Gradually these irregulars transformed themselves into well-armed squads who were willing to risk direct assault, like these (right) running past an already dead German. But pity suspected partisans who were captured (left). They were almost always shot immediately. The policy made the survivors fight even harder.

LEFT, TOP: MOVIE TONE NEWS / TIMEPIX; ABOVE: DAVID KING COLLECTION; LEFT: AKG; RIGHT: DAVID KING COLLECTION

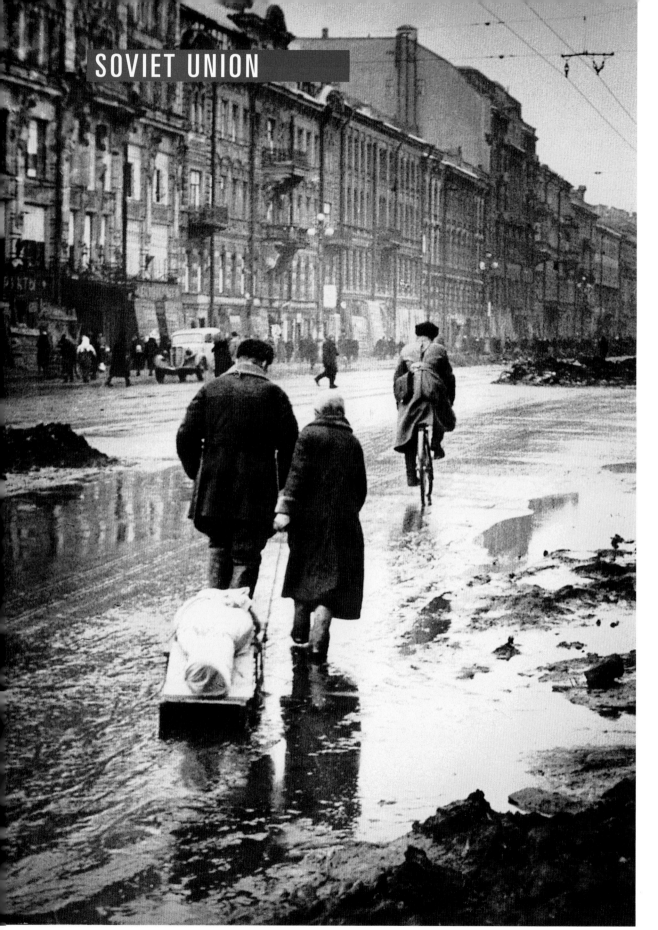

SOVIET UNION

<

LENINGRAD SCENE

The Germans reached Leningrad in September and laid siege for a brutal 900 days. The population began dying from air raids and artillery, hunger and cold. The estimated civilian toll eventually reached an appalling million. At left, a couple tows a sled carrying a child's tiny corpse through the downtown streets. It was a common sight. The bicyclist does not even notice.

PERILOUS RESCUE

By autumn, Leningrad's connection to the Soviet interior was all but severed. Yet Red Army patrols ventured to the city perimeters, deliberately drawing Axis fire. At right, a defender carries his wounded comrade to safety, perilously close to an exploding shell. Finally, in early 1943, the Soviets opened a corridor to the city at a cost of 250,000 casualties. Leningrad took its courageous place in history.

ICY RESPITE

The city was under almost constant attack. At near right, a shell burst sends pedestrians running for cover, while the bodies of citizens killed earlier are left on the street. With hard winter came some relief, as trucks eluded the Germans by crossing frozen Lake Ladoga (far right) at night with food and medicine.

ALL: DAVID KING COLLECTION

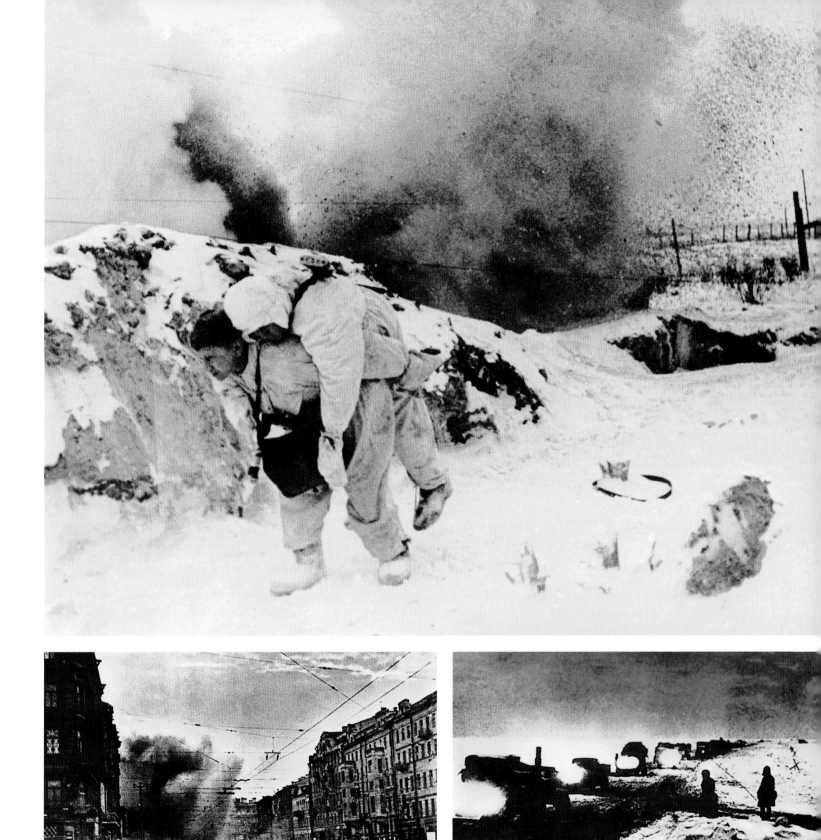

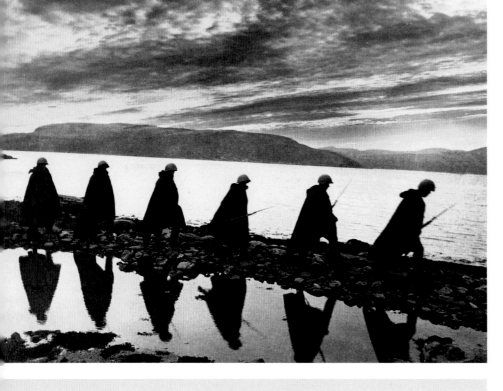

MURMANSKY DUTY

Murmansk is perched on Kola Bay, 125 miles above the Arctic Circle (and 1,220 miles from Moscow). Its name comes, aptly enough, from an indigenous tribe's word for "the edge of the earth." Yet because of Gulf Stream currents, the city boasts an ice-free harbor year-round, which made it the ideal port for Allied military supplies. These same Allies used Murmansk as a base for their anti-Bolshevik campaign after World War 1. Its critical importance 20 years later made stationing Soviet troops there essential despite its remote location. In this land of the midnight sun, a Soviet patrol (left, top) is silhouetted against an almost never dark sky. The British sent advisers as well as equipment, and (left) a technician checks out a Soviet airman. The role of women in the war effort was crucial — Socialist ideology awarded them theoretical equality; but female pilots here (right) were employed in reconnaissance and supply flights rather than the combat missions of their counterparts farther south.

ALL: DAVID KING COLLECTION

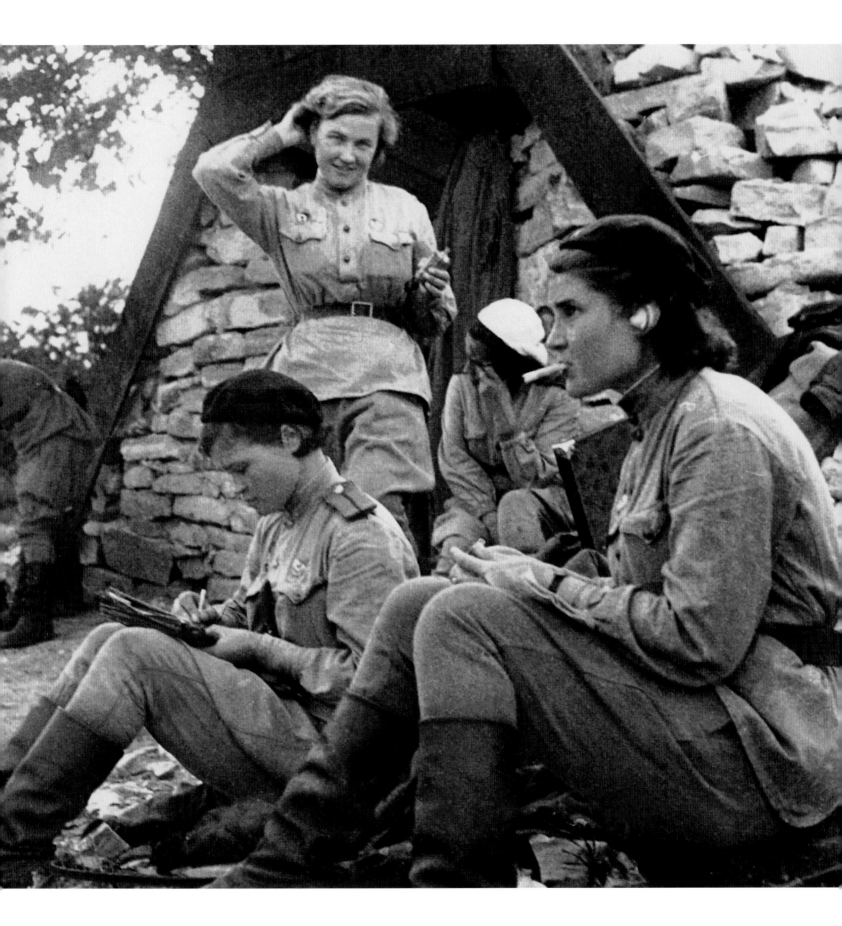

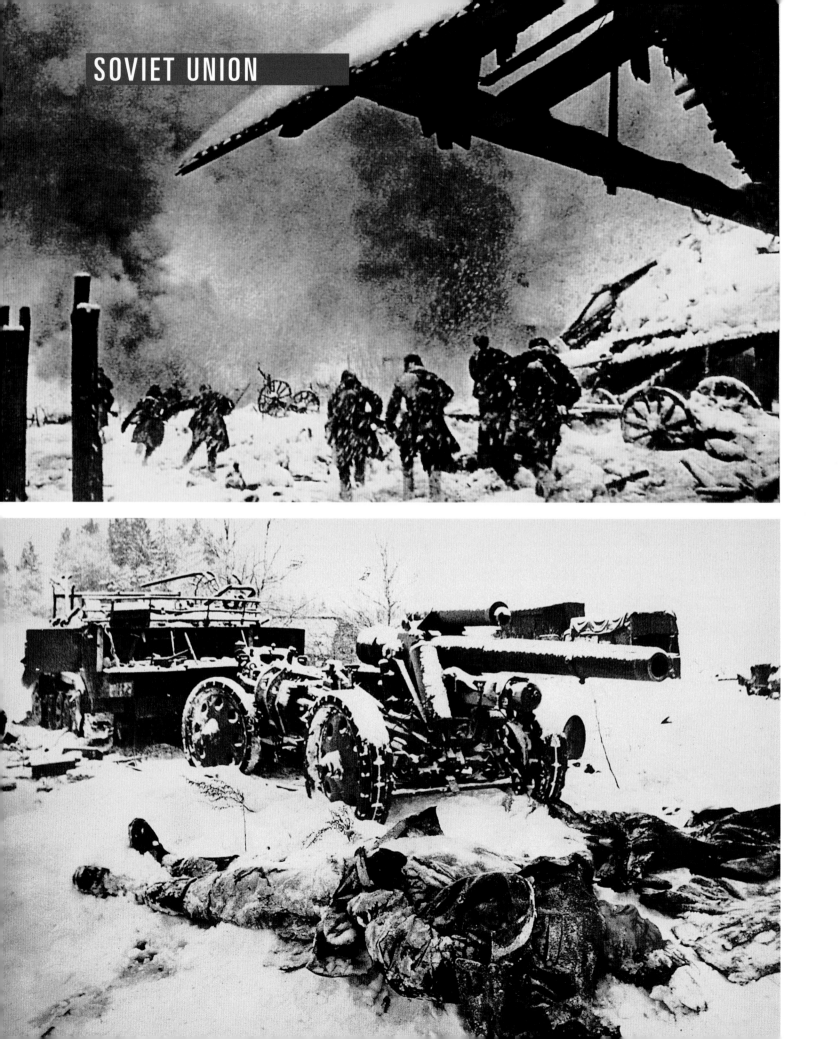

NO TANKS

German forces were closing in on Moscow; by the start of December, they were only 10 miles away. Even earlier, to impede the assault, more than 100,000 civilians were recruited to dig tank traps outside the city limits. The work crews were predominately female (right), since virtually every able-bodied man between the ages of 16 and 50 had been drafted into the military.

THE COLDEST FRONT

Even by Russian standards, the winter of 1941 was both early and fierce, hitting subzero temperatures before the holidays. The overconfident Germans thought they would be in Red Square by then; they were wearing summer uniforms and boots. The Red Army was quick to exploit the weather; encircled soldiers were able to fight their way out in a blizzard (left, top). The Nazis floundered. Their weapons would not work in the cold; they suffered horribly from frostbite. Two thousand soldiers would require amputations. Their supplies dwindled. Roads were often impassable, and the rail lines had been destroyed by the Soviets. The German offensive collapsed on December 5. Next day, the Soviets, with better planes in the sky and British tanks on the ground, counterattacked. German casualties (left) soared past a million.

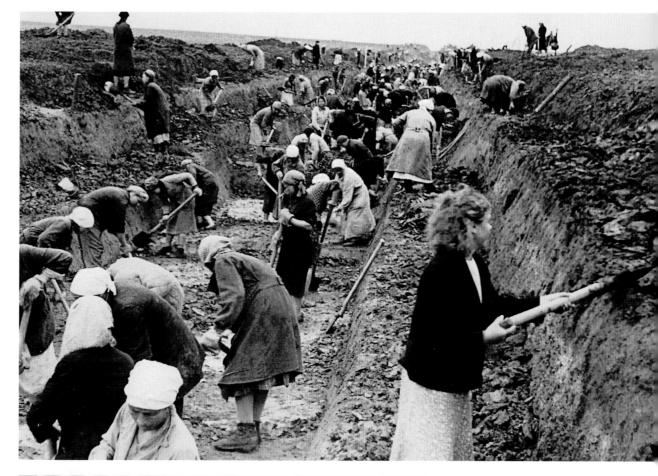

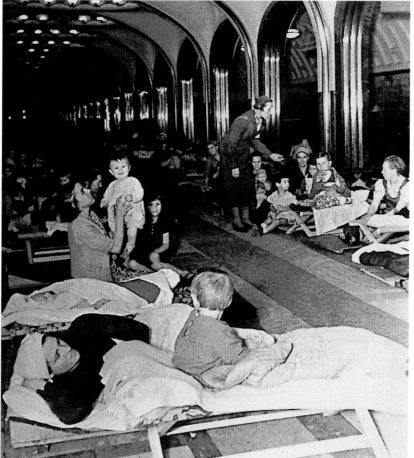

DEEP SLEEP

At the insistence of Stalin, who presciently feared enemy attack one day, the Moscow subway was built 130 feet below the streets (much deeper than New York's shallow system). The extra depth allowed the city's elegant metro stops to double as bombproof shelters (left) where mothers and their children slept regularly.

ALL: DAVID KING COLLECTION

125

POISED FOR ATTACK

The *Akagi* was at battle stations (right), its planes warming up, its superstructure protected against bombs and shells. It was one of six aircraft carriers, plus more than 20 other vessels, steaming secretly toward Hawaii. On another carrier, the *Shokaku*, its skipper (inset) surveyed the flight deck next to a message exhorting his pilots to victory. The Japanese rationale for war was this: It had to import 80 percent of its oil. The U.S. had cut off exports and demanded Japan withdraw from conquered territories that supplied much of the rest. To Washington these were righteous diplomatic acts; to Tokyo they were economic blackmail. A military response seemed the only choice.

RIGHT: MANNOSUKE TODA, TOKYO
INSET: NATIONAL ARCHIVES

LAUNCH AIRCRAFT!

H-hour had come. The strike force was within 260 miles of Honolulu, hidden by a storm front, maintaining strict radio silence — and undetected by the U.S. military. The carriers turned into the wind (left) for launching the first of its 360 bombers and fighters. At 6 a.m. that Sunday, pilots and air crews hurried across the flight deck of the *Shokaku* (left, middle) to their planes. A few minutes later, the order to launch aircraft was given, and as the carrier crew watched (left, bottom), the attack that would change history was under way. It had been carefully planned for months and was executed with precision. Ten hours later, Japanese planes also bombed U.S. airfields in the Philippines.

TOP LEFT: NATIONAL ARCHIVES
MIDDLE AND BOTTOM LEFT: MAINICHI

>

WAKE UP, FOOLS!

One Japanese pilot fortified himself with a grim, bilingual drawing that showed bombs falling, ships exploding, American sailors being blown overboard and attacked by sharks. The Japanese characters say: "Hear! The voice of the moment of death. Wake up, you fools." The cartoon was found in the wreckage of one of the few planes the U.S. shot down. All told, the Japanese lost 29 aircraft and 185 airmen.

PEARL HARBOR

DEAD MEN AND SHIPS

The Japanese knew the layout of Pearl Harbor intimately — from spies' reports and a detailed model built by the Imperial Navy. They timed their raid for Sunday morning, when the warships — and their anti-aircraft guns — would be undermanned. Their planes were spotted on Army radar at 7 a.m., but ignored. Less than two hours later the Pacific fleet was in ruins. Battleships were special targets. The *Arizona* (far right) was on the bottom, while (from left) the *West Virginia* and the *Tennessee* took massive hits. All in all, 18 ships were sunk or damaged that day. Two U.S. aircraft carriers at sea were spared. A few bodies washed ashore (inset), but many more were entombed in sunken vessels.

RIGHT: U.S. NAVY
INSET: ADMIRAL FURLONG
COLLECTION, HAWAII STATE
ARCHIVES

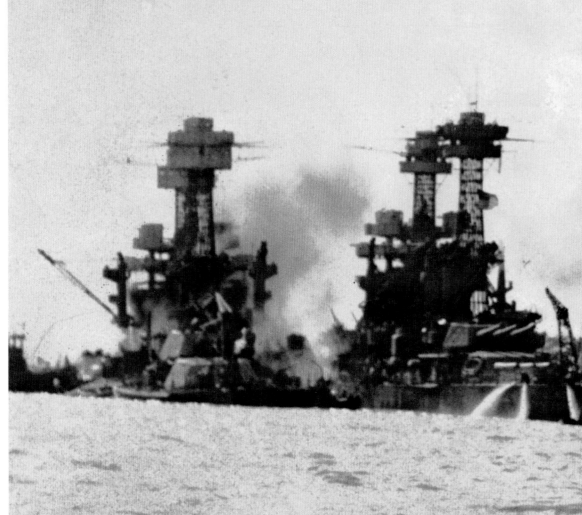

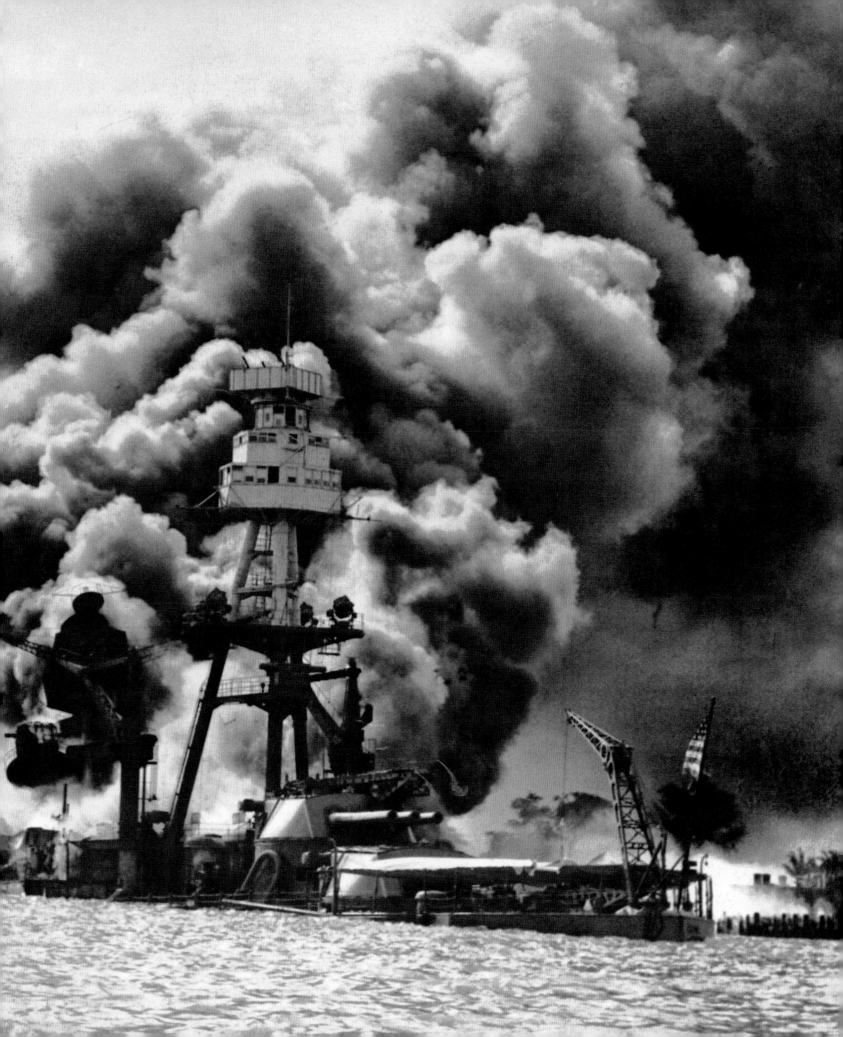

PEARL HARBOR

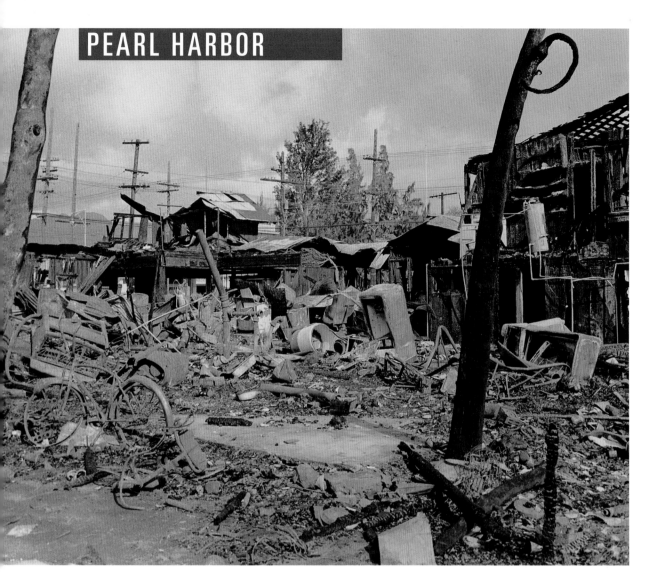

HOMES GOT IT TOO

Japanese bombs did not fall only on military targets. Parts of Waikiki, the chic resort area of Honolulu, were reduced to burned-out refrigerators and mangled bicycles (left). Other residents living in the hills were unaffected by the raid; some of them watched the havoc in astonishment from their front lawns. The tourist hotels were away from the line of fire too.

CORBIS / BETTMANN

FRIENDLY FIRE

Atrocious accidents added to the death toll. The three occupants of this car (right) died when an unexploded U.S. anti-aircraft round fell back to Earth and burst on impact. Other residents died from Japanese bombs and strafing. Civilian casualties in the attack were 103: 68 killed, 35 wounded.

NATIONAL ARCHIVES

A CLOTHES CALL

Talk about too close for comfort. Marveling at his survival, a Honolulu resident sticks his hand through a new opening in a pair of slacks held by his wife. The pants were drying on a clothesline just a few yards from their house when shrapnel ventilated them. He's armed — as were other civilians — against the possibility of ground attack that harrowing day.

PATHE / TIMEPIX

MEDICAL SCHOOL

At a school near the Navy base, local residents, including some uniformed nurses, quickly set up a makeshift hospital on the grounds. While some men climbed to the schoolhouse roof to put out fires (near right), others formed litter teams (far right) and carried the wounded to first-aid treatment under the palm trees.

NEAR AND FAR RIGHT:
PATHE / TIMEPIX

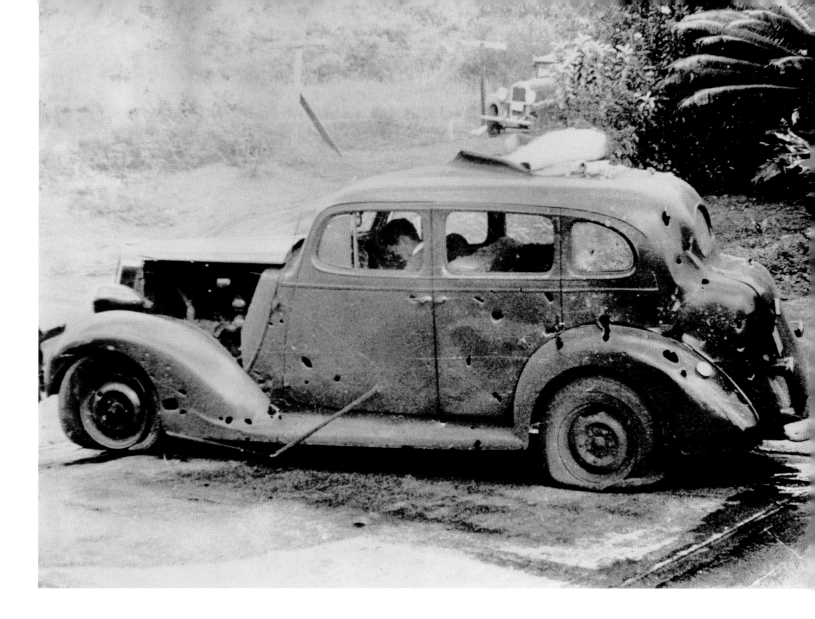

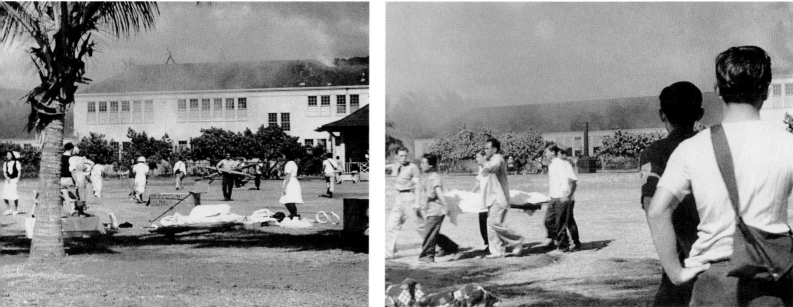

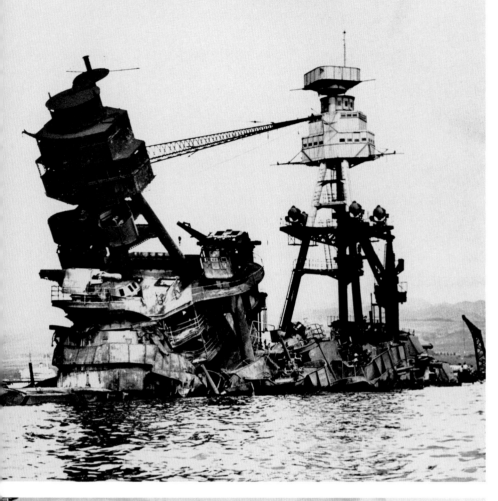

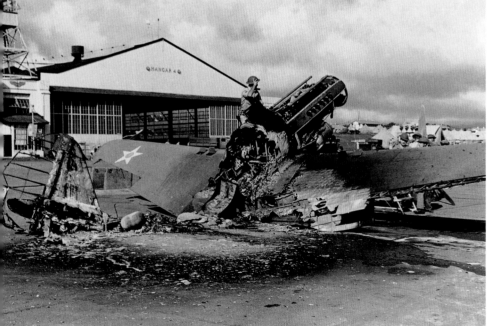

> **QUICK FAREWELL**

There were 4,575 military casualties at Pearl Harbor, including 2,403 killed. Swift burial was imperative. On December 8, 15 victims of the raid were temporarily laid to rest (right) under a single flag while Marine riflemen fired a volley and a bugler played taps. The bodies were later moved to an Oahu military cemetery or sent home. This beach site became a golf course.

NATIONAL ARCHIVES

THE DAY AFTER

On land and sea Pearl Harbor was littered with gruesome souvenirs of its devastation. Other battleships were salvaged and repaired, but the *Arizona* (top left) sat out the war at its last berth — a watery grave for 1,177 sailors and Marines. It was later turned into a national memorial. Some of the crew who survived the attack "returned" after their deaths, decades later, having asked that their ashes be sprinkled into the harbor at the wreck so they could be buried with their shipmates. At nearby Wheeler Field (left), a P-40 fighter was among the 188 U.S. planes destroyed on the ground. Within a year American factories were producing an average of 10 times that many aircraft every month.

TOP LEFT: ROBERT LANDRY /
LIFE / TIMEPIX
LEFT: NATIONAL ARCHIVES

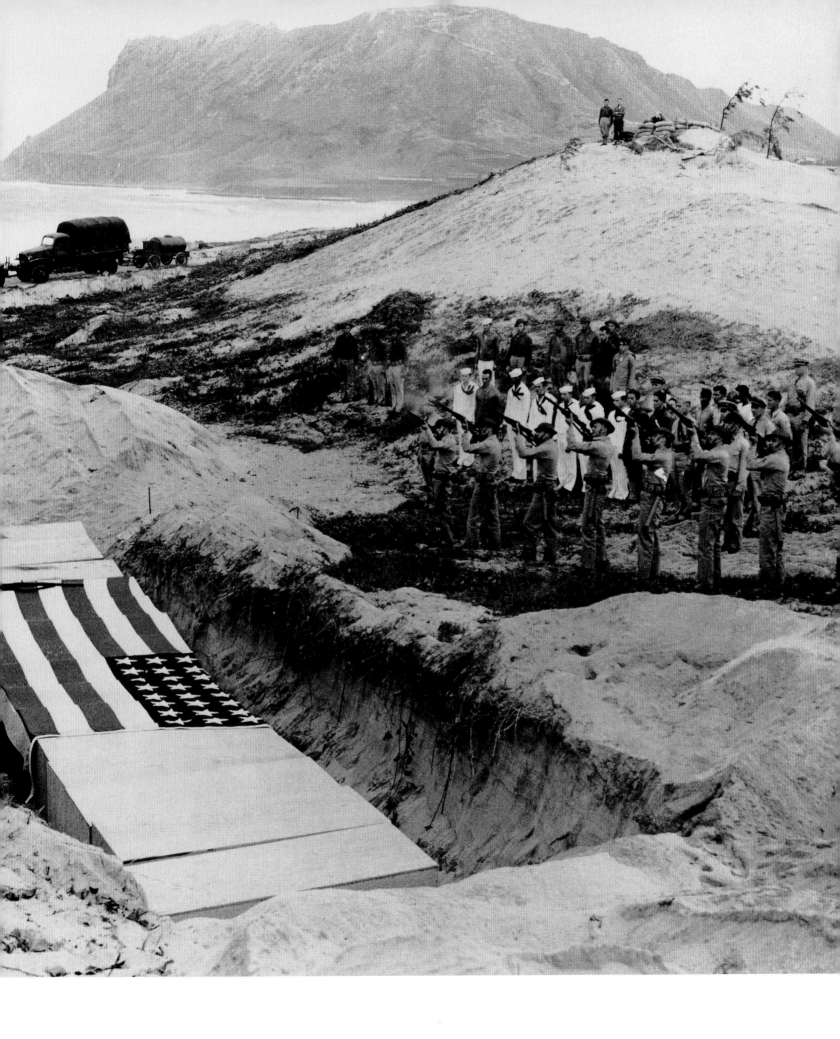

FRANKLIN DELANO ROOSEVELT

Mister President

The only child of American blue bloods, Franklin Delano Roosevelt (below at 3) was born to public service. He was particularly inspired by his fifth cousin, Teddy. An indifferent student, armed with little but his diplomas from Harvard and Columbia Law School, young Franklin won a seat in the New York State Senate in 1910. His rise thereafter was rapid. Within three years he went to Washington as Assistant Secretary of the Navy and in 1920 ran for Vice President on the Democratic ticket. Beaten in the general election, he faced a more serious setback the following summer — polio. Here, too, his defeat was only temporary.

TWO WHO COUNTED

Two early relationships had long-term impact on FDR's career. Smitten in his student days by his idealistic distant cousin, Eleanor, Roosevelt married her in 1905. The couple, seen at their summer home (above), grew apart once she discovered his infidelity, but in place of romance a lasting political alliance developed. With his polio-crippled legs locked in braces, Roosevelt linked himself to progressive New York governor Al Smith (right), nominating him for President at the 1928 Democratic convention. Smith lost the general election; FDR fared better, replacing his mentor in Albany.

LEFT: WIDE WORLD
TOP: FDR LIBRARY
RIGHT: CORBIS / BETTMANN

FALA AND FRIEND

Roosevelt was elected to the White House an unprecedented four times. Everything about him was news: his wife, their family, even his pet Scottie, Fala (above, in the presidential limousine). One part of his life was off-limits: His severe disability was rarely written about, and he was almost never photographed using crutches or a wheelchair.

ABOVE: CORBIS / BETTMANN

<

INTO BATTLE

By 1940 FDR had won American approval for helping the Allies in the European war, short of sending troops. In 1941 he was warned that a Japanese attack was possible. But Pearl Harbor stunned him and the nation. On December 8 he signed the declaration of war (left) and helped lead America and the world to victory.

THOMAS D. MCAVOY / LIFE / TIMEPIX

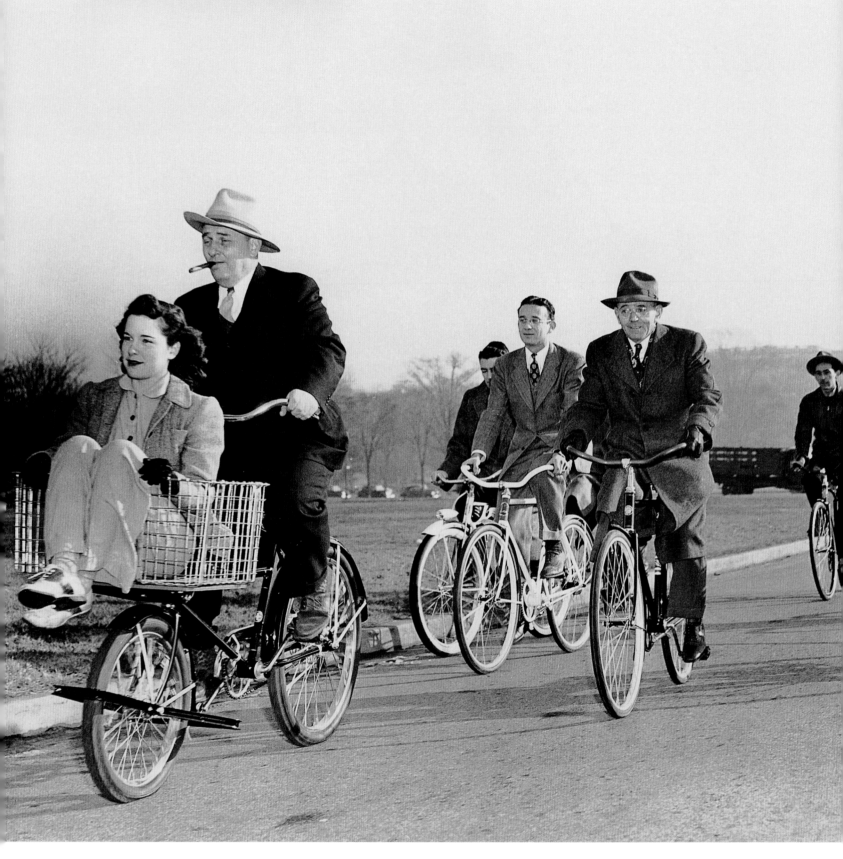

BUCKLING DOWN

Pearl Harbor swept isolationism out of America, and the country prepared for a war whose dimensions were unknown. Would our cities be bombed or sabotaged? As long as the answers were uncertain, national landmarks like the Washington Monument (right) were guarded by anti-aircraft batteries. On the West Coast, fear of Japanese submarines prompted the U.S. Coast Guard to send a cutter out to escort crab fishermen back to port (middle right). For all branches of the military, enlistments soared. Not only was it the patriotic thing to do, it was a chance to pick your service. More than a thousand young men were taken to the Army base on Governors Island, in New York Harbor, with the Statue of Liberty on the horizon (bottom right), first for a photo op, then for examination by the doctors to see if they were fit enough to give up those civvies.

RIGHT, TOP TO BOTTOM:
THOMAS D. MCAVOY / LIFE /
TIMEPIX; LIBRARY OF
CONGRESS; WIDE WORLD

<

FUELISH GESTURE

Setting a gas-saving (and public relations) example, price-control administrator Leon Henderson, 46 (left), pedaled to work near the Capitol with stenographer Betty Barrett as his passenger. They had plenty of company. Nearly a year after war began, gasoline was rationed, and nonessential driving sharply curtailed across the country.

CORBIS / BETTMANN

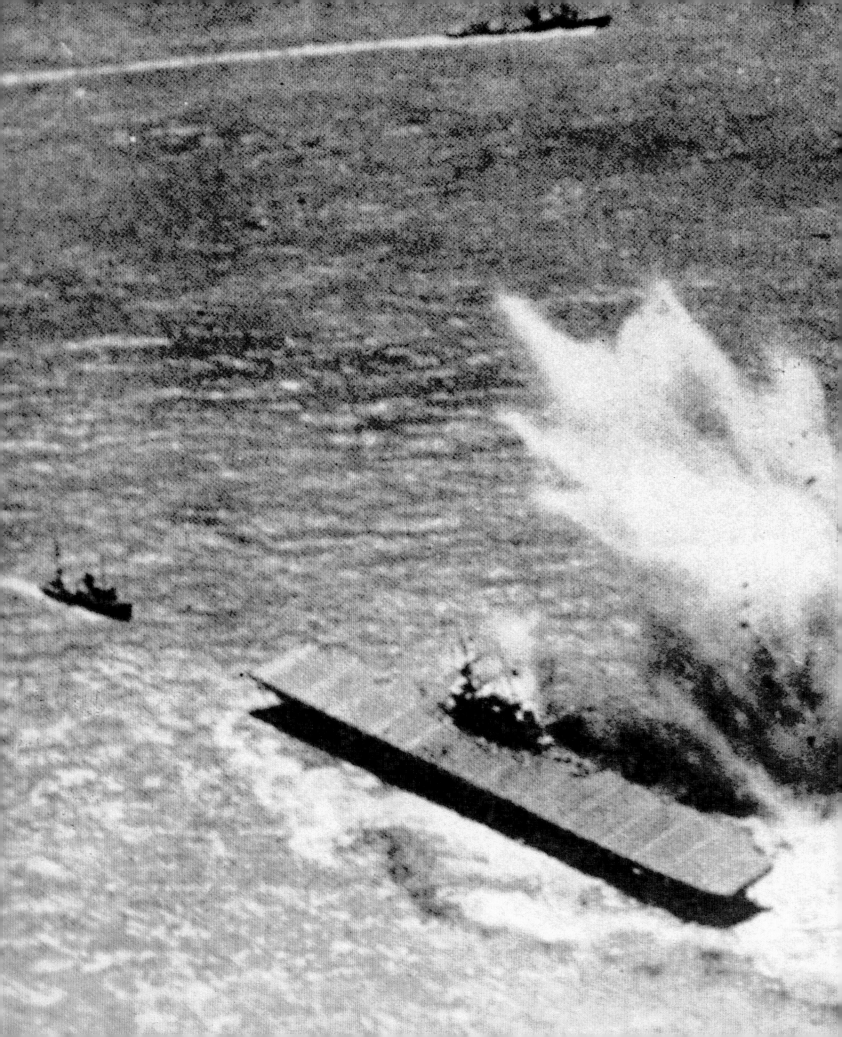

19 42

TWO VICTORIES REVERSE THE MOMENTUM

A massive bomb-burst rocks the USS *Yorktown* (left) at the Battle of Midway; Soviet engineers quietly cut German barbed wire at Stalingrad (inset). These two events on opposite sides of the world represented Allied victories that changed the character of the war. The *Yorktown* was eventually sunk, but Midway took a harsher toll on the Japanese. They lost four carriers, 332 aircraft and 3,500 men — and, more critical, momentum in the Pacific. Later in the year the Red Army won an equally electrifying victory at Stalingrad, where Nazi troops were first halted, then overwhelmed.

The Beginning Comes to an End

by Harry A. Gailey

THE YEAR 1942 opened with a continuation of the military disasters in the Pacific that had started with the destruction of the main U.S. fleet at Pearl Harbor. The Japanese controlled the air and sea lanes that enabled their armies to advance with surprisingly little opposition in Malaya, Burma and the Philippines.

By mid-February Singapore, the so-called Gibraltar of the East, surrendered to a numerically inferior Japanese Army, ending the Malayan campaign. By May the British and the Chinese had been driven out of Burma. The Japanese juggernaut was slowed briefly in the Philippines, but U.S. forces there surrendered on April 9, and the island fortress of Corregidor fell on May 6.

The Japanese assault on the Dutch East Indies was equally effective as their Navy crushed the small combined Dutch, U.S. and British force in a series of battles in February. By the end of April the Japanese controlled Southeast Asia, occupied the islands of New Britain and New Georgia and had landed on the north side of New Guinea, threatening the Australian outpost of Port Moresby. The Australian high command, with the bulk of its regular Army in the Middle East, decided to defend the mainland along a line from Brisbane to Melbourne, if Japan invaded.

In Europe the situation was hardly better. Britain remained unconquered and kept up night air attacks on the Continent; its situation, however, was increasingly desperate as German U-boats threatened to cut off supplies necessary to continue the war. Despite the convoy system, the losses in the Atlantic would amount to more than one million tons of shipping during the year. British ground forces confronted the Axis only in North Africa, where the 8th Army briefly had success in Cyrenaica, in the eastern part of Libya. That favorable situation was reversed by June as Field Marshal Erwin Rommel's Italo-German armies broke the British defenses and pursued them eastward before being halted at El Alamein, just 60 miles from Alexandria, Egypt.

In Russia the German Army, although stopped short of its major objectives after suffering 800,000 casualties, still dictated the offensive. In the previous year most of the forward elements of the Russian Army had been destroyed. In the Kiev pocket alone 650,000 Russian troops were captured. In the early months of 1942 the Germans eliminated the salients the Russians had driven into their lines.

Reinforced by 57 satellite divisions, the Wehrmacht resumed the offensive in late June directed at the Crimea, the Caucasus and Stalingrad, the major Russian city on the Volga River. As before, the Germans obliterated most of the opposition. Sevastapol was captured at the beginning of July, and the huge 6th Army reached Stalingrad by August 23. Germany's Army Group A was deep in the Caucasus within reach of its valuable oil fields. Despite the

A genial, fast-rising Dwight David Eisenhower, 51 , met the press after he was made U.S. Commander in Europe in June 1942. His strategic talent was soon validated by invasions of North Africa, Sicily and Italy.
WIDE WORLD

grim circumstances on all fronts, there were some positive indicators for the Allies. Chief among these was the harnessing of U.S. industry for the war effort. By the end of the year, war matériel of all types was flowing to every theater. Continued productivity would be the most important factor in defeating the Axis powers.

At the same time, volunteers and draftees had increased the U.S. military to a size that would enable the country to fight a two-front war. Although lacking a single military command, the Allies agreed on future activity. The strategic goals of the war were provided by President Roosevelt and Prime Minister Churchill, aided by the Combined Chiefs of Staff. Cooperation at the highest level in the United States was attained by the amicable relations between the Army Chief of Staff, George C. Marshall, and the newly appointed Chief of Naval Operations, Ernest J. King.

After considerable negotiations, command responsibility in the Pacific was divided between Admiral Chester Nimitz, the new naval chief at Pearl Harbor, and General Douglas MacArthur, who arrived in Australia in March. The compromise worked well in most cases. MacArthur's top responsibility was the defense of Australia. Nimitz controlled the bulk of the Navy and was in charge of actions in the Central and South Pacific. A commanding General for Europe had not yet been selected, although it was agreed that Europe took precedence over the Pacific. The choice of General Dwight Eisenhower to spearhead the American invasion of North Africa indicated that he was the likely candidate. Thus before the end of the year, the pieces were in place for the move from defense to offense in all theaters.

Although the Axis powers were dominant, their position was flawed. Japan had no unified command. Its Navy and Army were openly jealous of each other. Further, the country had no coherent strategy to defeat the United States. Instead, its planners were

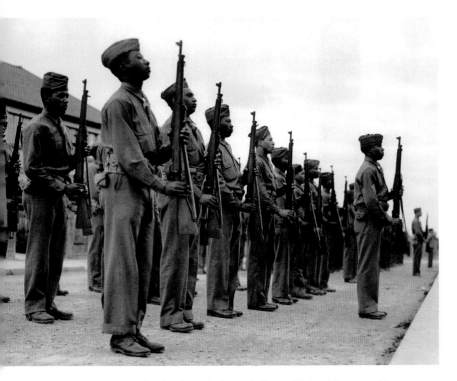

Reflecting the nation's racial climate, black soldiers served in segregated units, mostly as truck drivers, cooks, mechanics and so on. They were finally sent into combat after manpower grew short.

HULTON / ARCHIVE

infected by what a Japanese Admiral later called "the victory disease." Their conquests had come so quickly that the idea of reducing the area of conflict to deal with the United States was not seriously considered.

Thus Japanese forces were spread throughout Southeast Asia and the Pacific and could be supported only by continued domination of the sea lanes. Instead of taking advantage of its naval superiority to capture Midway and inflict further damage on Hawaii in the weeks after Pearl Harbor, Tokyo shifted Admiral Chuichi Nagumo's carriers to the Indian Ocean. Not until months later — stung by the Doolittle raid on Tokyo — did Admiral Isoroku Yamamoto, Commander of the Combined Fleet, begin to plan for the invasion of Midway and the destruction of what remained of the U.S. fleet.

Despite naval and air superiority, Japanese leaders delayed the occupation of the central and eastern Solomons when there was no Allied force that could

prevent it. Only in July did they send troops to those islands. Another Japanese mistake was the failure to interdict the Allies' long supply line to Australia. The Japanese also never understood how to use submarines effectively. Their rigid idea that the role of submarines was to attack the enemy fleet, not its shipping, was unchanged by the success of the Germans in the Atlantic. This was true despite the fact that Japanese submarines were excellent and their "long lance" torpedo was the finest in the world.

The Germans had similar command problems. Far from being a united state, Germany was a federation whose leaders feuded with one another, vying for status and prestige. By 1942 the vaunted General Staff and the equally excellent officer corps had been reduced to secondary positions in strategic and tactical planning. Hitler had taken control of the armed forces. Senior generals who disagreed or did not perform to his satisfaction were removed from command. His vacillation the year before had spared Moscow from capture, and he chose to make Stalingrad the primary goal of the summer offensive. He also ordered no retreat when the military situation worsened in North Africa. A similar command would doom the 6th Army at Stalingrad.

In the Pacific the first indication that Japanese fortunes might change was the Coral Sea naval battle on May 7 and 8. They had devised a complex invasion force whose objective was Port Moresby. It was intercepted by the U.S. Navy, and the resulting air battles were a tactical standoff. However, the transports containing the assault force turned back. Japan never again posed such a threat to Australia.

Soon afterward, Admiral Yamamoto decided to attack Midway. The subsequent air battle begun on June 4 was a disaster for Tokyo. Forewarned by cryptographers who had broken the enemy code, the U.S. Navy deployed its three carriers northeast of Midway and ambushed the invaders. A combination of factors, not the least of which was luck in catch-

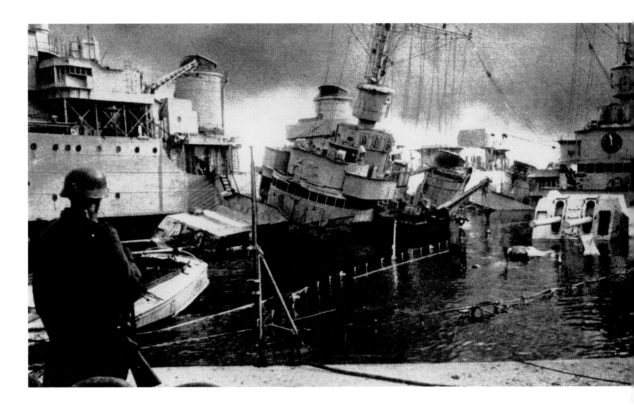

After the Allied landing in North Africa, in November, a worried Hitler ordered that Vichy France be occupied and the French fleet in Toulon seized. French sailors scuttled their ships shortly before German troops arrived.

HULTON / ARCHIVE

ing the Japanese in the midst of rearming their planes, led to the sinking of their four carriers. Midway was not in itself the turning point of the Pacific war. But the damaged Imperial Fleet never again had the superiority it once enjoyed.

The next major defeat for the Japanese was at Guadalcanal, where a battle between an invading United States Marine division and superior Japanese forces began in August. The enemy poured in troops, backed by a large part of their Navy and Air Force. In a series of engagements, the U.S. fleet gained a tactical draw while reducing their air superiority. By December the Marines, now reinforced by the Army, had a firm hold on Guadalcanal.

Even before that, the Australians had halted the Japanese in New Guinea. In September, MacArthur began his campaign to secure bases on its North Coast. The first steps toward the eventual conquest of the large strategic island had been made. Guadalcanal and New Guinea reversed the Japanese advance on land. Henceforth they would be on the defensive.

Meanwhile in North Africa, the Germans were decisively defeated in early November at the second battle of El Alamein and began the long retreat across the desert to Tunisia. In its first commitment of combat troops, the United States landed in three places in French North Africa that month. After a brief flurry of resistance, the French capitulated and Allied forces moved eastward, where the final battles for control of North Africa would take place.

More destructive for Germany was the failure of its Russian summer offensives. By December the single-minded campaign to capture Stalingrad had bogged down, and the Caucasus was evacuated. The second Russian winter and the tenacity of its people had ended any chance of a German victory.

The war would continue for two and a half years, claiming the lives of millions more, but the defeats suffered by the Axis in 1942 were critical. Allied military potential, backed by awesome productivity, allowed a shift to the offensive around the globe. To paraphrase Churchill, 1942 was not the beginning of the end but the end of the beginning.

Harry A. Gailey is Professor Emeritus (military history) at San Jose State University in California. He is the author of six books on World War 2: The War in the Pacific; MacArthur Strikes Back; "Howlin' Mad" vs. the Army; The Liberation of Guam; Bougainville, 1944-45; *and* Peleliu, 1944.

SOUTH PACIFIC

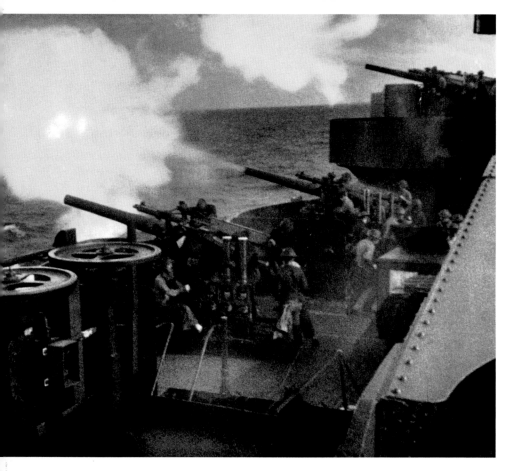

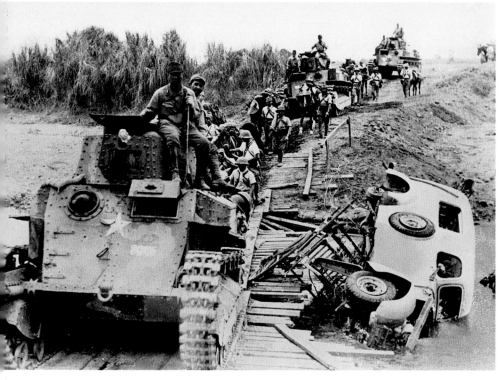

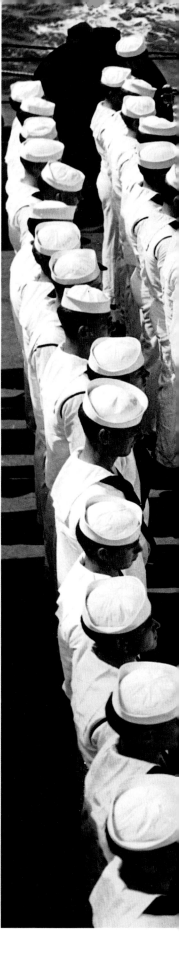

< >

STRIKING BACK

The Japanese moved with chilling speed. By early 1942 they controlled a defensive perimeter extending from Burma to the Aleutians. Their expectation was simple: The U.S. would fight a limited war and cede much of the captured territory in a negotiated peace. Pearl Harbor backfired on them, inciting America to total war. By February small U.S.-carrier task forces began to retaliate, shelling the Gilbert and Marshall islands (left), the scene of bloody ground fighting two years later. But Navy casualties were already mounting. For the traditional burial at sea, the dead sailor's shipmates (right) put on their dress whites to honor his sacrifice.

LEFT: PATHE / TIMEPIX
RIGHT: ROBERT LANDRY / LIFE / TIMEPIX

<

ADDING BURMA

Burma fell quickly to Japanese infantry and tanks (left). It cost the Allies their supply route to China on the Burma Road and potential air bases within bombing range of Japan. The British retreat into India imperiled that country — the Japanese would actually invade briefly — and damaged London's prestige in the East.

CORBIS / BETTMANN

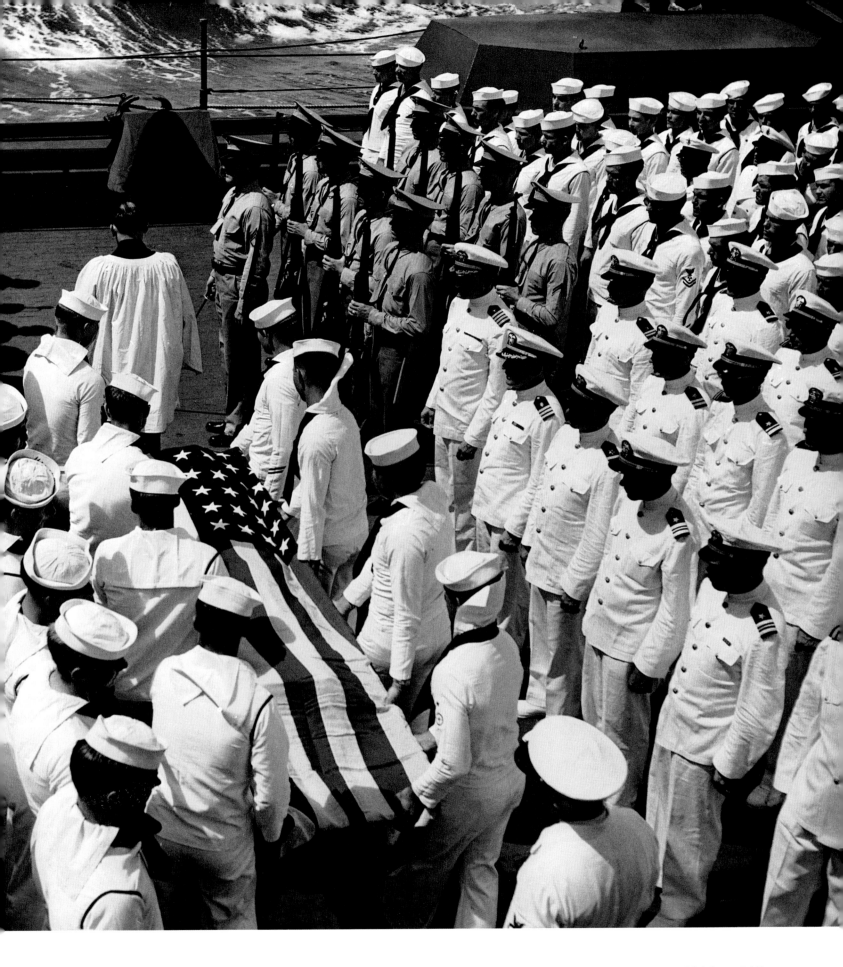

BATAAN

MIGHTY MAC

Four weeks before the worst defeat in U.S. military history, General Douglas MacArthur, 61, was ordered to leave the embattled Philippines for Australia (where throngs greeted him, above). He vowed theatrically (and, as it turned out, accurately), "I shall return." In April, 76,000 of his American and Filipino troops on the Bataan Peninsula surrendered (top right).

ABOVE: CORBIS / BETTMANN
TOP RIGHT: TSUGUICHI KOYANAGI

DEATH MARCH

A desecrated flag (left) attested to the demoralizing American defeat. But the 65-mile forced march to a prison camp was an even more inglorious stain against the Japanese. Filipinos and GIs, carrying sick and wounded comrades in litters (right), were beaten during this six- (for some, 12-) day "Death March" in searing heat. Some 10,000 died on the way, 15,000 soon after in the camp, from disease, wounds and exhaustion.

LEFT: FPG / ARCHIVE PHOTOS
RIGHT: NATIONAL ARCHIVES

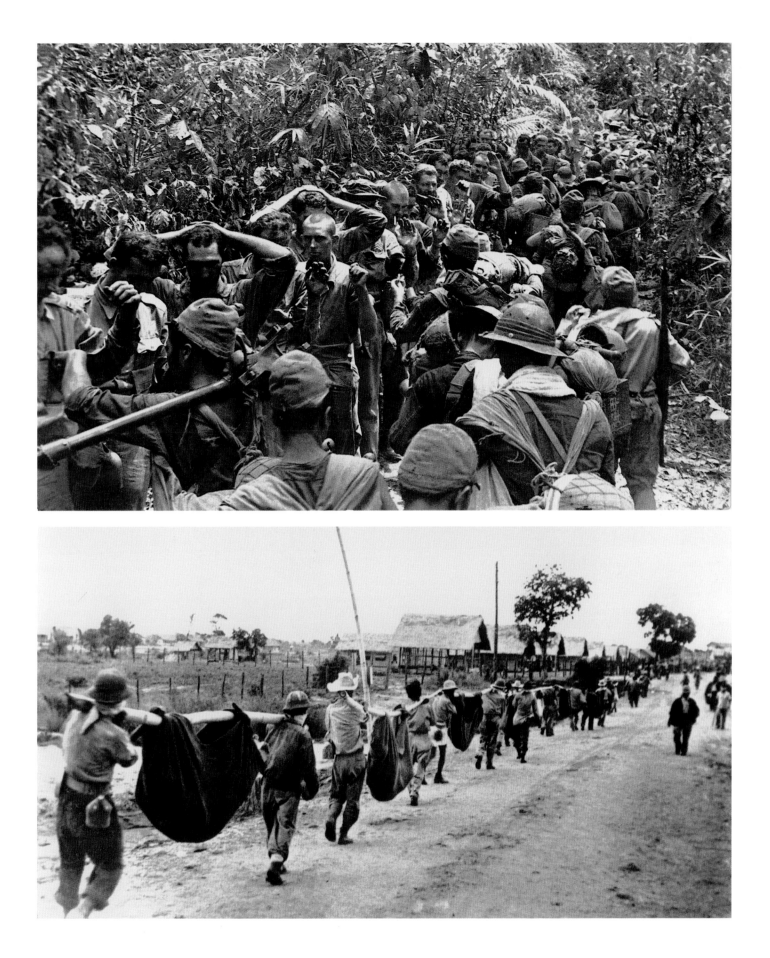

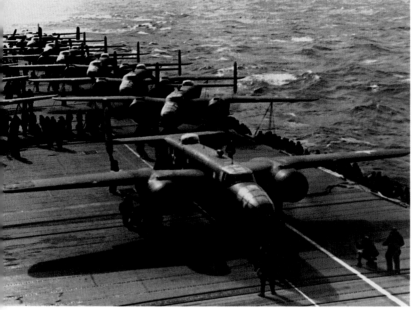

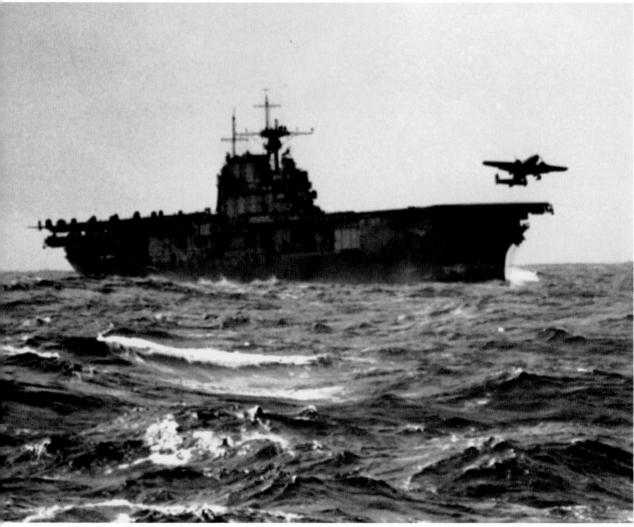

TARGETING TOKYO

Bomb Tokyo. Only four months after Pearl Harbor? FDR liked the audacious idea; it would boost American morale and scare the Japanese. On April 18 Lieutenant Colonel James Doolittle, 45, led 16 B-25s (top left) off the flight deck of the USS *Hornet* (left). They bombed several cities (and photographed Tokyo, above). Some of the U.S. fliers landed or bailed out in China; others were captured; 16 died. Though the damage was minimal, the surprise and consternation were great. The raid made Doolittle a hero (at right, after getting the Medal of Honor). It also pushed an angry Japan into the disastrous Battle of Midway.

TOP LEFT AND ABOVE: U.S. NAVY
LEFT: WIDE WORLD
RIGHT: HARRIS & EWING
PHOTOS

LOSING LIMBS

Germany's attitude toward its war wounded was respectful and caring — at least until its medical facilities were overwhelmed by massive casualties. This rehab center specialized in amputees. After recovery in bed (above), the patients were turned over to physical therapists who had them tossing medicine balls and testing their new prostheses (right). Family members and girl-friends were encouraged to visit (left). Images like these were used by Josef Goebbels's Nazi propaganda machine "to teach every citizen heroic attitude." The German people had to learn to accept any hardship, he declared, for fatherland and Führer.

ALL: HUGO JAEGER / TIMEPIX

< >

CARRIER COMBAT

It was the first naval battle in history in which ships did not exchange fire. Coral Sea, in May, was decided by aircraft. The major U.S. loss was the carrier *Lexington* (left), which blew up when Japanese torpedoes ignited its store of bombs. All but 216 of its crew were rescued (survivors scramble to safety, right). Technically it was a Japanese victory but a costly one. They had to abandon plans to capture Port Moresby, on New Guinea, and the invasion threat to northern Australia disappeared. Two damaged Japanese carriers returned home for repairs and were critically absent from the Battle of Midway a month later.

LEFT AND RIGHT: U.S. NAVY

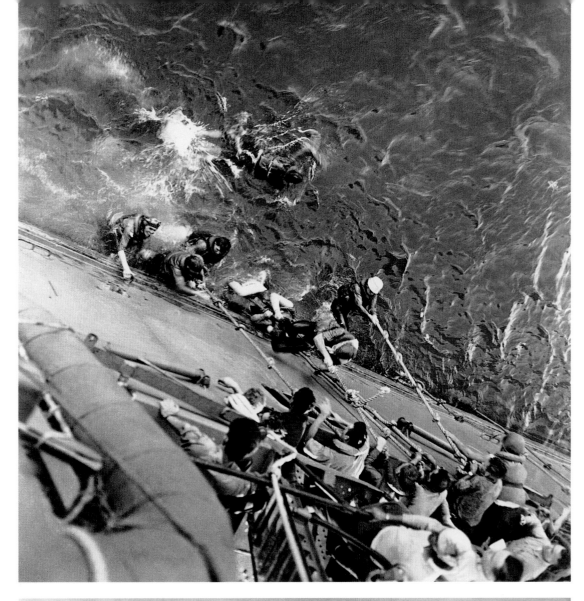

A FLOATER

The two opposing fleets were 175 miles apart. Not only did they never shoot at each other, they never even saw each other. One Japanese light carrier was sunk, and more than 70 planes shot down, a significant loss to their Pacific forces. One of them floats eerily in the placid tropical ocean (right). A major lesson of Coral Sea for the U.S.: It needed to beef up its own plane production.

HULTON / ARCHIVE

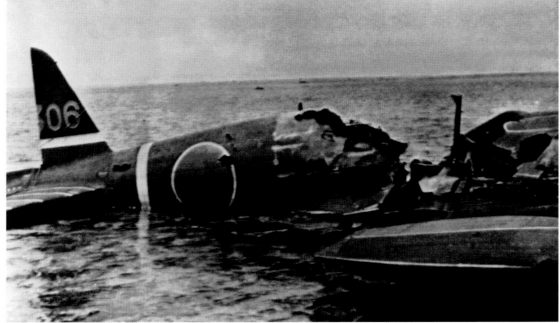

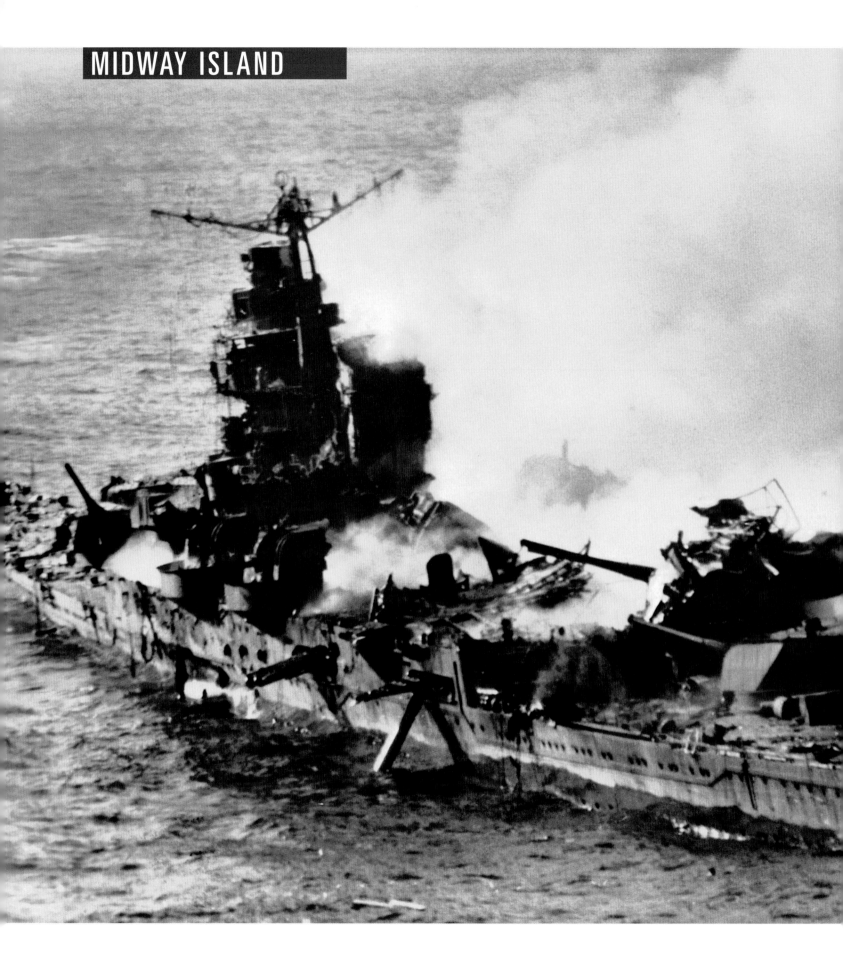

WINGED VICTORY

< >

If Coral Sea was ambiguous, the Battle of Midway, in June, was not. It meant Japanese domination of the Pacific was over. They lost four carriers, 100 experienced pilots and the heavy cruiser *Mikuma* (left). The main U.S. casualty was the carrier *Yorktown* (right, being hit by a torpedo). The ship had been damaged at Coral Sea but was quickly patched up and returned to duty, for its last tour, as it turned out.

LEFT AND TOP RIGHT: U.S. NAVY

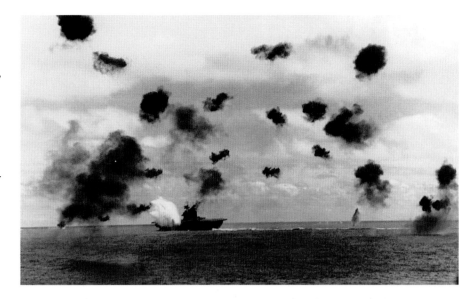

THE TARGET

The Japanese fleet's mission was to take tiny Midway Island as a base for possible raids on Hawaii, even the U.S. West Coast. Carrier planes hit the atoll at dawn (right), setting oil storage tanks ablaze; but when the pilots returned for fuel and more bombs, they were caught on the flight decks by U.S. aircraft.

U.S. NAVY

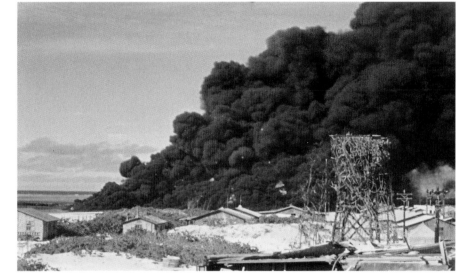

SAVED AT SEA

Wounded and burned sailors were often transferred at sea by breeches buoy (right) to bigger ships with better medical facilities. Only 307 U.S. lives were lost at Midway. The toll could have been much greater except for U.S. code breakers who knew that Japan was planning a trap at Midway for the American Pacific fleet. It backfired.

WIDE WORLD

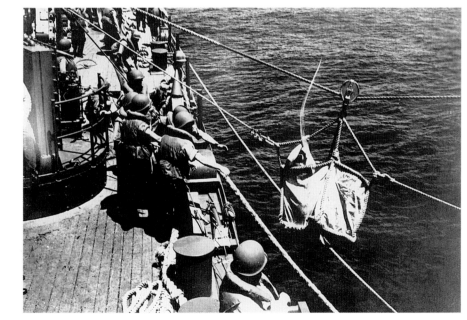

UNITED STATES

THE ROUNDUP

Early in 1942 the United States, fearful of sabotage, ordered the removal from the West Coast of anyone of Japanese ancestry. Aliens in Los Angeles were rounded up like common criminals (right), and their property was seized. It was the beginning of one of the most flagrant violations of civil liberties in American history.

CORBIS / BETTMANN

IRONIC HONOR

Two Japanese-American soldiers visiting their families at Heart Mountain ironically stand honor guard beside the casket of a World War 1 veteran who died in the Wyoming camp. While 120,000 Japanese-Americans were interned for up to three years, 33,000 others served in the U.S. armed forces, including the much decorated 100th Battalion and 442nd Regimental Combat Team, which fought in Europe.

RIGHT: HANSEL MIETH / LIFE / TIMEPIX

BITTER LANDSCAPE

A student artist (right) captures the bleakness of the Heart Mountain internment camp. Inside the barracks nine members of the Akiya family (above) gather in one room of their cramped space. Camps for the "evacuees," as they were called, were surrounded by barbed wire and guarded by watchtowers.

RIGHT AND ABOVE:
HANSEL MIETH / LIFE / TIMEPIX

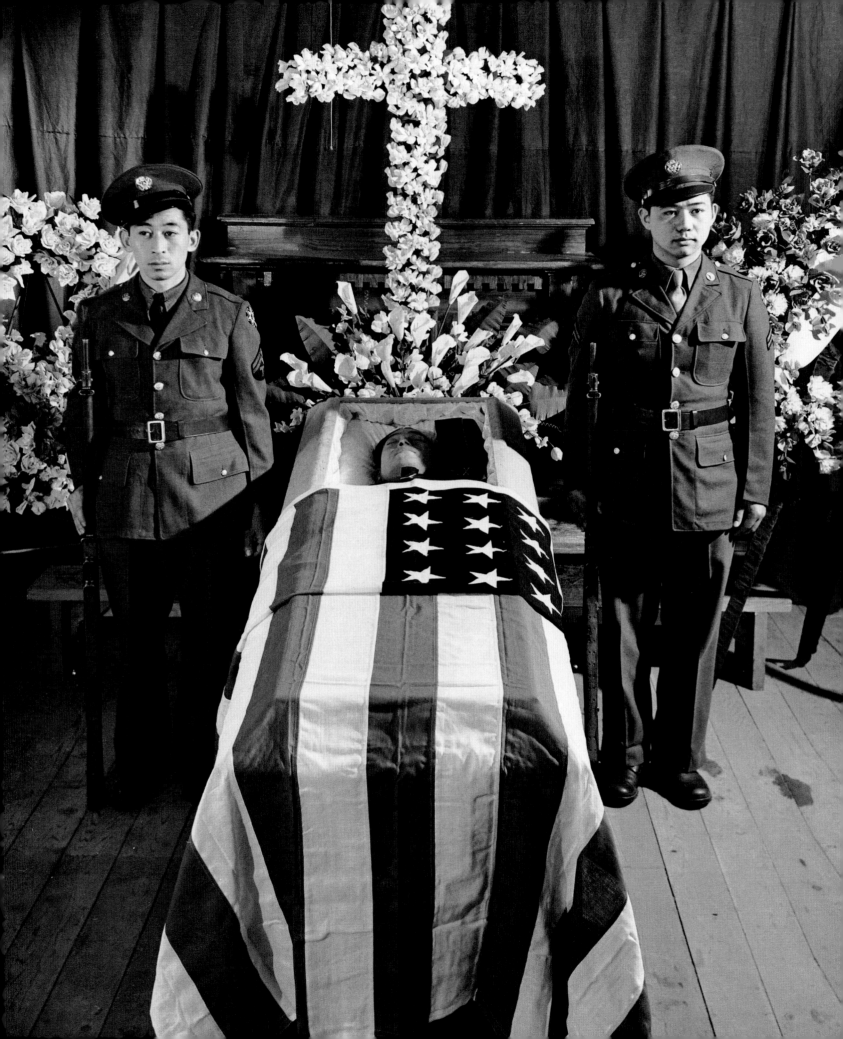

SOVIET UNION

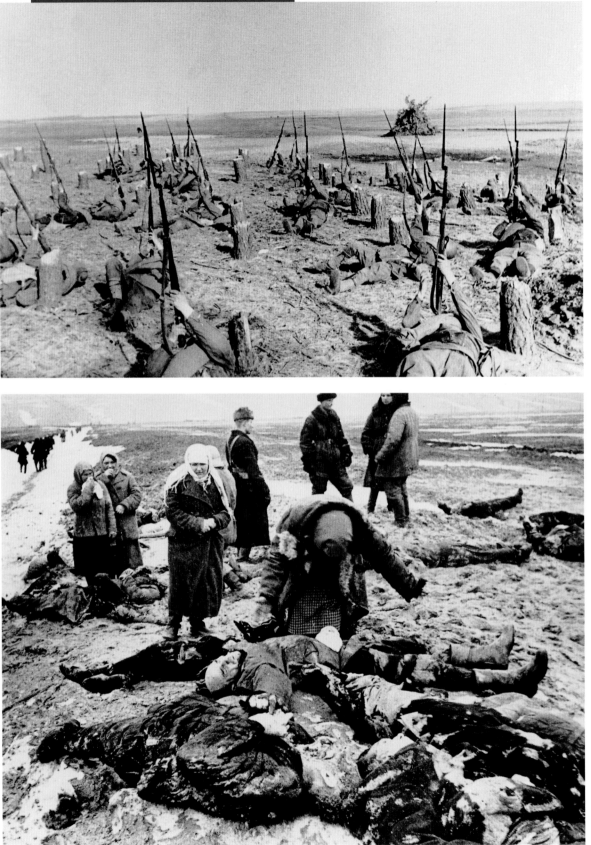

<
SHOOTING UP

In the absence of anti-air-craft weapons, a Red Army rifle group (left) fires at Luftwaffe planes overhead near German-held Kharkov. It was a futile gesture, as was Stalin's attempt at this time to split the eastern front. German Panzers repulsed the attack in mid-May, ultimately encircling three Soviet armies. In 22 months Kharkov would change hands four times.

SOVFOTO

>
MEDIC NEEDED

A German soldier in Russia (right) has just had his left arm blown off in this shock-ing picture by a German photographer. The severed limb is in the foreground. It serves as a grisly symbol of the titanic carnage on the eastern front. German casualties this year went past one million; for the Soviet Union it was close to four million.

HUGO JAEGER / TIMEPIX

<
BITTER HARVEST

Russian peasants at Kerch (left) look for loved ones among civilians shot by German troops. After suffering through a frigid winter of intense fighting, the Germans were desper-ate for food, fresh clothes and optimism that they could hold out against a Soviet vow to retake the Crimea. The cruelest among them did not bother to dis-tinguish between citizens and soldiers.

DAVID KING COLLECTION

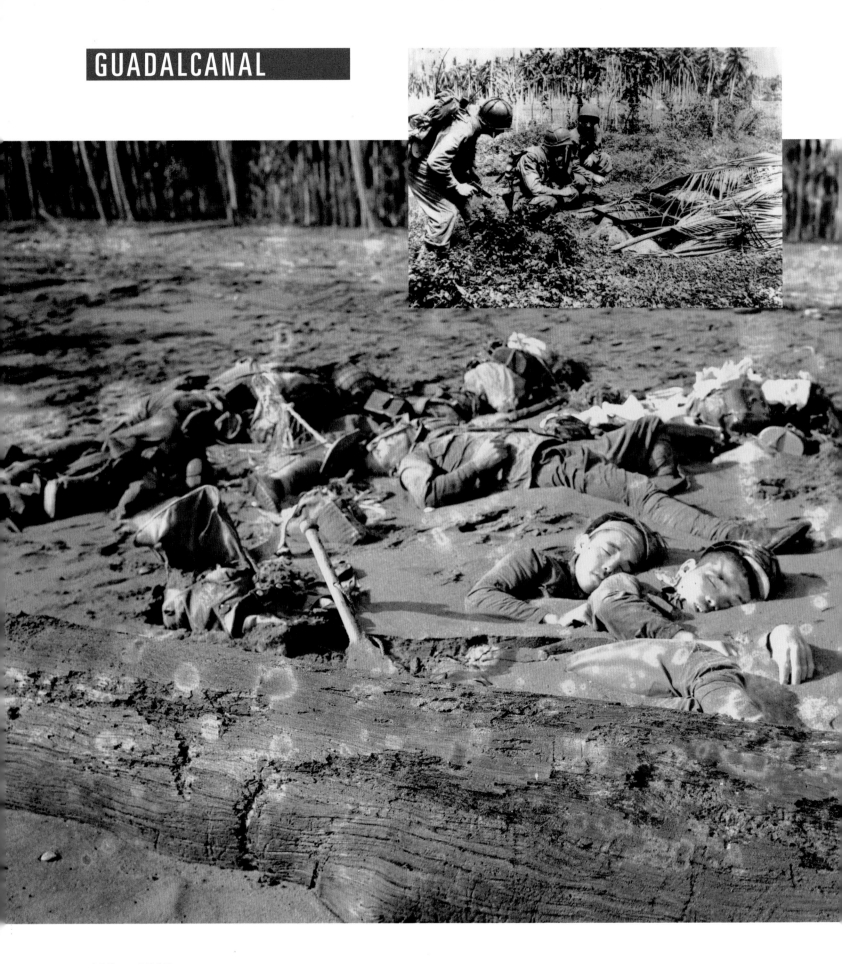

<

A HIGH PRICE

When the U.S. discovered the Japanese building an airfield on Guadalcanal, in the Solomons, a force of 11,000 Marines invaded, taking the airstrip easily. Then the Japanese poured in reinforcements. In the bitter fighting that followed, their casualties were especially high (left, soldiers half-buried in an Ilu River sandbar); Marines cautiously inspect a bunker (inset). What was supposed to be a short battle dragged on for six bloody months.

LEFT: U.S. MARINE CORPS
INSET: HULTON / GETTY

>

ISLAND ALLIES

Armed natives of nearby Florida Island (top right), whose gardens were pillaged by Japanese occupying forces, aided the Americans during tree-to-tree, hand-to-hand combat in the malarial jungle. When found, Japanese survivors often attacked suicidally rather than surrender.

HULTON / ARCHIVE

>

LOST AT SEA

The island was the center of furious naval battles, too, in which the Japanese lost more than 20 ships (at right, one of the victims). Guadalcanal was the Allies' first major victory over the Japanese and set the pattern for the island-hopping strategy that won the Pacific.

HULTON / ARCHIVE

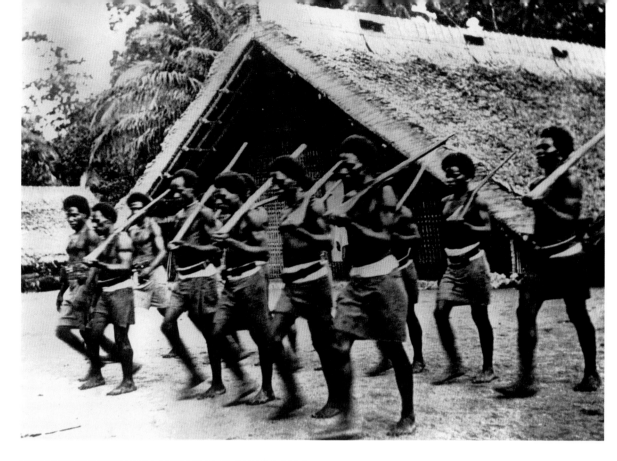

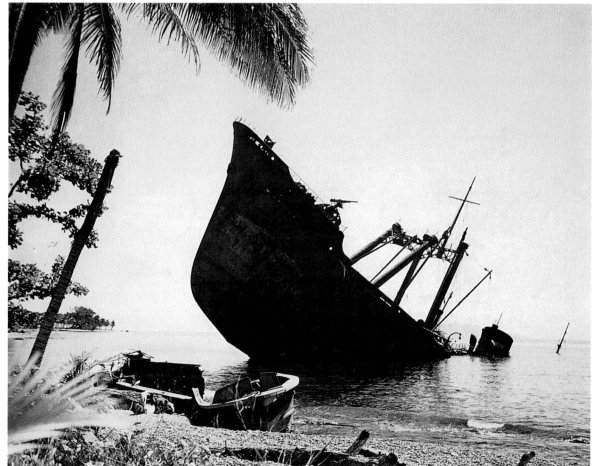

BIOGRAPHY

Brave Men

American legend had it that a Massachusetts mother lost five sons in the Civil War. It wasn't true (even though President Lincoln thought it was and wrote her a famous letter of condolence). But the unthinkable did happen in World War 2. After a boyhood friend was killed at Pearl Harbor, the five sons of Thomas and Alletta Sullivan, of Waterloo, Iowa, enlisted in the Navy together. They asked not to be separated, and all were assigned to the cruiser *Juneau*. The ship sailed to the Pacific and on November 13, 1942, was sunk by a Japanese submarine off Guadalcanal. Of the 700 sailors aboard, 690 died, among them all five Sullivan brothers.

At First, a Publicity Bonanza

The Navy played the Sullivans' patriotism for all the publicity it could get, both as they were signing up (top) and after they went aboard the *Juneau* (at left, from left, Joseph, Francis, Albert, Madison and George). Since their deaths, however, the Navy has never assigned family members to the same ship. The grieving family (above) gathered at home in front of a mantle bearing their sons' portraits. With mother and father are daughter Genevieve and grandsons Tommy, 14 months, and Jimmy, 7.

TOP: CORBIS / BETTMANN; LEFT AND ABOVE: WIDE WORLD

The Family Name Lives On

The anguished mother (left) was photographed clutching the telegram announcing that her sons were missing and presumed dead. At the government's request, family members made appearances at war-bond rallies. And in April 1943, at a San Francisco shipyard, Alletta Sullivan (above), with her daughter beside her, christened *The Sullivans,* a new destroyer named for her boys. Shortly after, daughter Genevieve honored her dead brothers by enlisting in the Waves.

ABOVE: WIDE WORLD
LEFT: CORBIS / BETTMANN

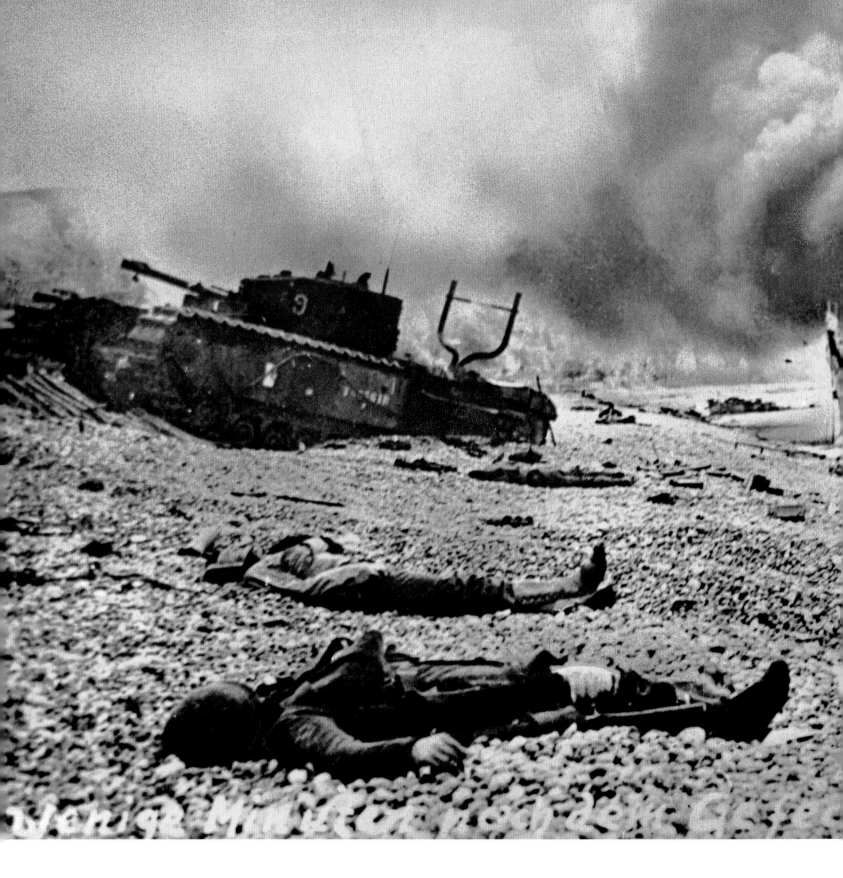

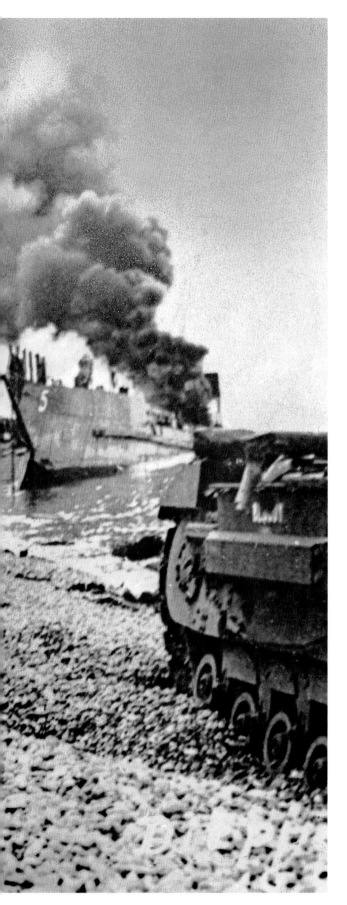

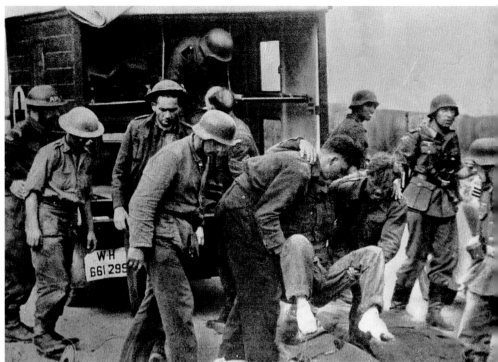

Canadian Catastrophe

The idea was simple and ill-conceived: 6,000 troops, mostly Canadian, would stage an attack in August on the port of Dieppe to test German coastal defenses (in preparation for D day). Instead, a skirmish in the Channel with a German convoy delayed the landing until daylight. It was met by hellish Nazi fire. At left, a burning landing barge, abandoned tanks and 2 of the 907 Canadians killed testify to its ferocity. Under guard, a few of the 1,946 POWs (top) carry away the wounded. For the fortunate ones (above) who got back to England, it was a plucky thumbs-up.

LEFT: CANADIAN ARMY PHOTO
TOP: CORBIS / BETTMANN
ABOVE: DAILY MIRROR

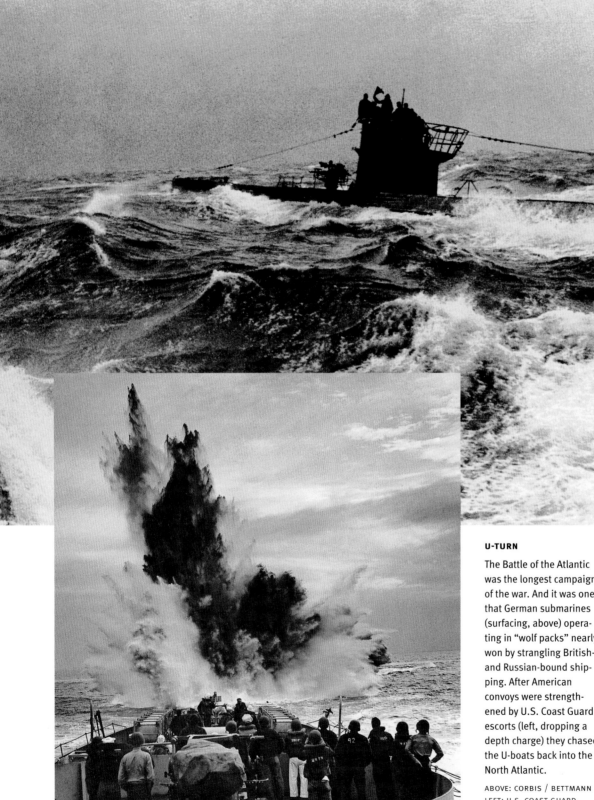

U-TURN

The Battle of the Atlantic was the longest campaign of the war. And it was one that German submarines (surfacing, above) operating in "wolf packs" nearly won by strangling British- and Russian-bound shipping. After American convoys were strengthened by U.S. Coast Guard escorts (left, dropping a depth charge) they chased the U-boats back into the North Atlantic.

ABOVE: CORBIS / BETTMANN
LEFT: U.S. COAST GUARD

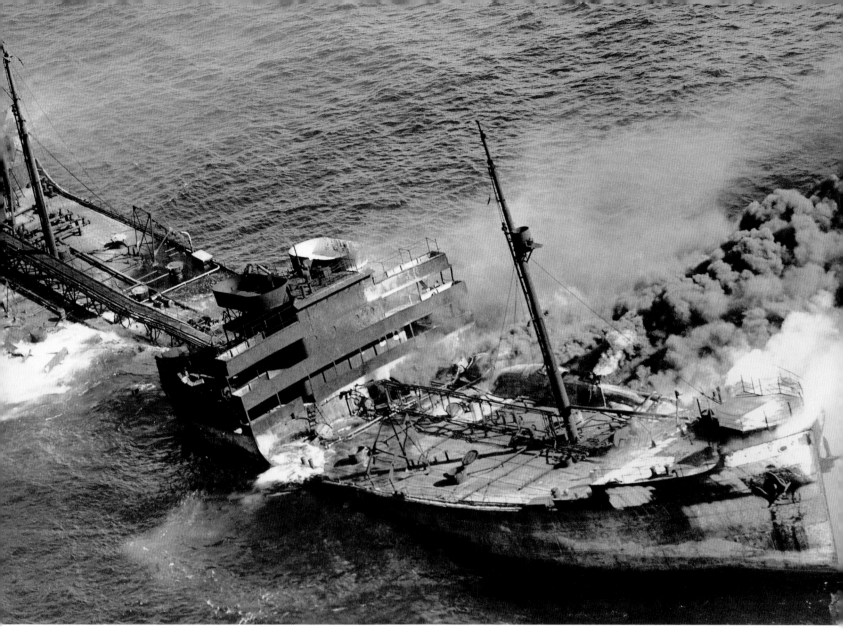

OFF OUR SHORES

The American tanker *R.P. Resor* sinks (above) after it was torpedoed, on February 26, five miles off Sea Girt, Delaware. Of the crew of 50, only two survived. It showed how menacingly close U-boats came to the country's East Coast in early 1942. But the unprecedented speed of U.S. shipbuilding soon surpassed Allied losses and forced the Germans, with 696 of 830 subs sunk, to concede the seas.

ABOVE: NEW YORK DAILY NEWS

ICE BOAT

Russian sailors chip tons of ice off the superstructure of the Soviet warship *Parizhkaya Kommune* (left) after it ran into a winter storm while guarding a convoy en route to Murmansk. Such storms often forced vital supply runs to steam dangerously close to the Norwegian coast, and German U-boat bases, where Allied freighters were frequent victims.

IMPERIAL WAR MUSEUM
RUS. 2240

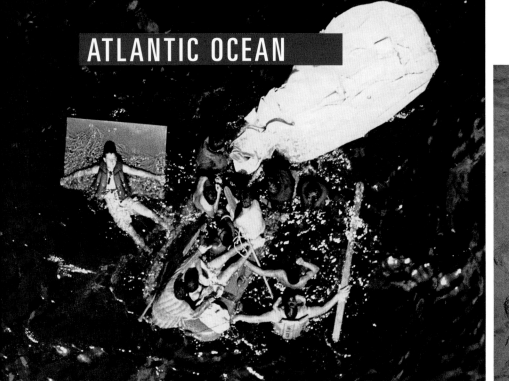

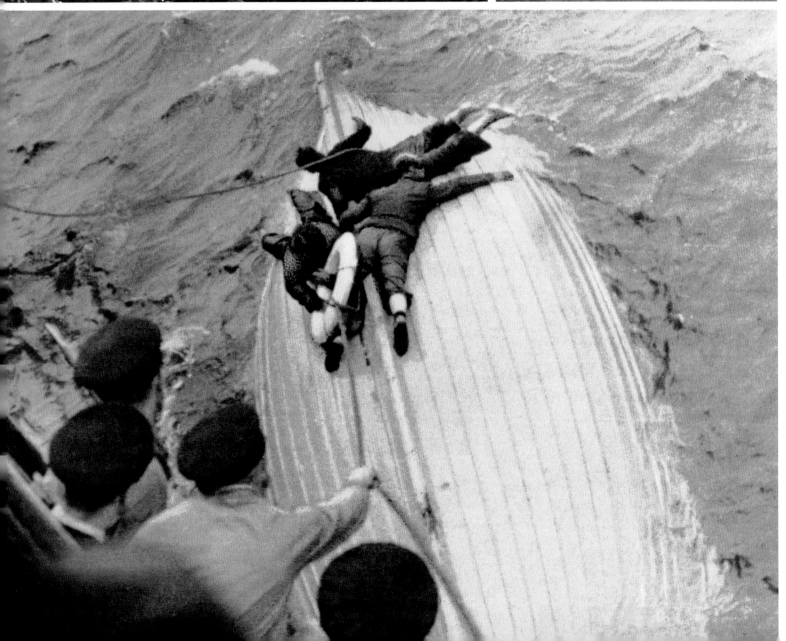

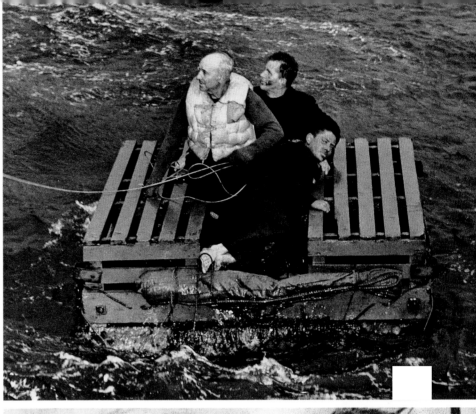

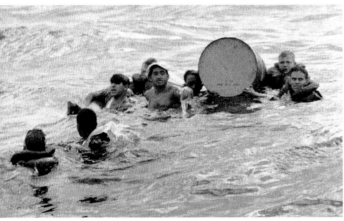

Surviving at Sea

Absent the surpassing bravery of Allied merchant seamen, the Axis powers might have prevailed. More than 50,000 merchant crewmen lost their lives, but countless others survived more than 2,500 sinkings in the often frigid seas on sheer guts. Here are a few examples. After abandoning ship, seamen swim to safety through blinding oil slicks (right). They cling to oil drums (above), life rings (top) and overturned lifeboats (left). They show gaunt relief to U.S. Coast Guard rescuers who throw them a line (top, right) or drop a raft from a blimp (top, far left). Some of them were providentially found just in time, like the unconscious Chinese sailor (top, near left). As the ancient maritime hymn goes, "Oh hear us when we cry to thee, for those in peril on the sea."

RIGHT: U.S. NAVY
ABOVE: CORBIS / BETTMANN
TOP AND LEFT: MANSELL COLLECTION / TIMEPIX
TOP, RIGHT: U.S. COAST GUARD
TOP, FAR AND NEAR LEFT: WIDE WORLD

SOVIET UNION

MOMENT OF DEATH

Combat soldiers see death all the time; civilians rarely do. Here are those irreversible moments when the war — and life — ended for three men on the Russian front. Trying to cross an open field, a German rifleman flings his arms skyward when the bullet strikes (far right). One Soviet soldier topples backward (right) as his unscathed companions attack, and another falls victim (above) to shrapnel from a land mine. War is a matter of numbers — guns, bullets, men. The Nazis found themselves overextended; the Red Army could easily replace the dead.

FAR RIGHT: AKG PHOTO
ABOVE: ANATOLI GARANIN

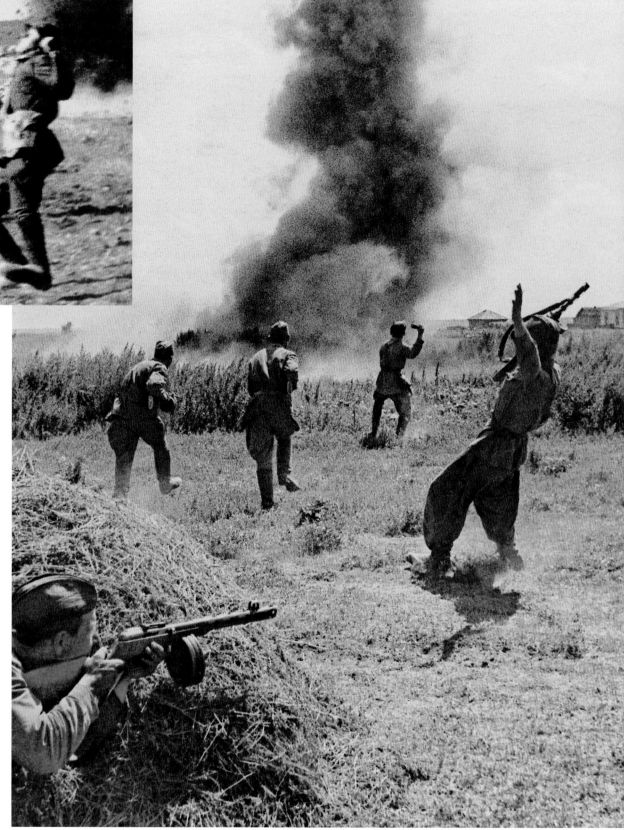

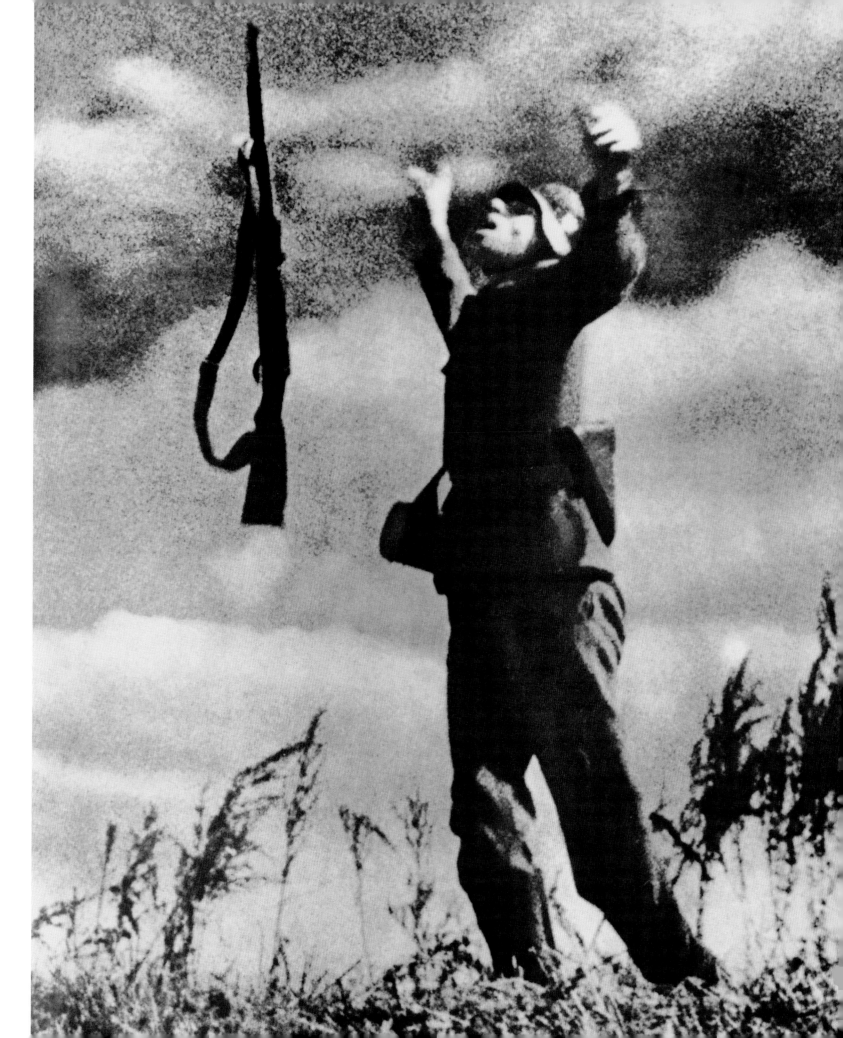

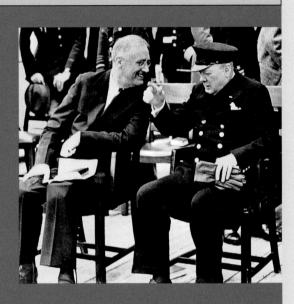

THE UNITED NATIONS

Keeping the Peace

Roosevelt and Churchill had their first wartime meeting in August 1941 aboard a ship off Newfoundland. The rapport was immediate. They produced the joint declaration of the purposes of the war against Fascism known as the Atlantic Charter. Its principles, agreed to on January 1, 1942, by 26 nations, became the foundation for the United Nations. The charter foreshadowed a fairer and freer postwar world. The common hope was of a forum that would settle disagreements and, most important, have military power to intervene in disputes that turned violent — authority that the doomed League of Nations never had.

CORNERSTONES

As the war came to an end, delegates from 50 countries gathered in San Francisco to draw up the charter and in June to hear the new American President, Harry S. Truman (right, at podium). The name United Nations was Roosevelt's idea. "If civilization is to survive," FDR wrote the day before his death, on April 12, "we must cultivate the science of human relationships." In October 1949 Norway's Trygve Lie, the first secretary-general (below, extreme left), helped set the cornerstone of the UN's permanent headquarters, in New York City.

LEFT: BROWN BROTHERS
RIGHT: THOMAS D. MCAVOY / LIFE / TIMEPIX
BELOW: WIDE WORLD

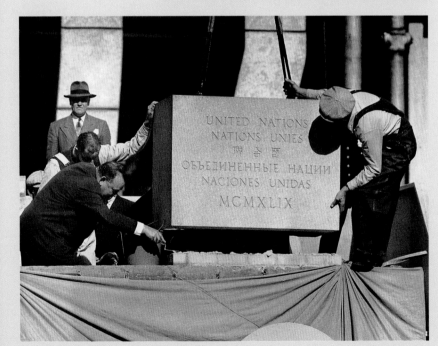

THE NEGOTIATOR

After his predecessor was assassinated, in September 1948 acting UN mediator Ralph J. Bunche (above, center, in Haifa), a Howard University professor and civil-rights activist, began 11 months of ceaseless efforts to negotiate peace between a newborn Israel and surrounding hostile Arab states. War had broken out shortly after both sides rejected a UN plan to partition Palestine. When the Arabs attacked Israel in May 1948, Trygve Lie called it "the first armed aggression since World War 2." A series of armistices were signed the next year, for which Bunche received the Nobel Peace Prize, in 1950. The second African-American so honored was Dr. Martin Luther King, in 1964.

ABOVE: UNITED NATIONS

KOREAN STANDOFF

When Communist North Korea invaded South Korea, in 1950, the U.S. responded first (above, fighting in Seoul). Then troops from 15 other countries rallied under the UN flag. The conflict dragged on until 1953, when an armistice was signed, and U.S. and South Korea soldiers began patrolling a demilitarized zone between the two countries. They are still there.

ABOVE: NATIONAL ARCHIVES

GREAT HEIGHTS

Monitoring the UN-mediated 1949 dispute over Kashmir, a state between India and Pakistan, was not work for anyone with vertigo. UN observers (left) traveled to 13,000 feet amid some of the world's highest peaks to check on the cease-fire line. After a negotiated truce, one third of Kashmir went to Pakistan, and the rest became the Indian state of Jammu and Kashmir.

LEFT: UNITED NATIONS

SUEZ CRISIS

A sole UN peacekeeper at the Suez Canal (right) seems a frail bulwark against World War 3. After a Soviet-backed Egypt abruptly nationalized the canal and Israeli troops, backed by Britain and France, attacked in 1956, another global conflict loomed. Canadian diplomat Lester Pearson won the Nobel Peace Prize in 1957 for offering troops to the UN to stabilize the situation.

HOWARD SOCHUREK / LIFE / TIMEPIX

SHAMEFUL PAST

Secretary-General Kurt Waldheim of Austria was less effective in resolving disputes, such as his unsuccessful talks with Greek Orthodox archbishop Makarios over Cyprus (right), than his predecessors. Some critics believe he shied from tougher negotiating because he was hiding his past as a Nazi Lieutenant in Greece and Yugoslavia during World War 2.

LOOMIS DEAN / LIFE / TIMEPIX

CONGO DEATH

The UN sent a force of 20,000 to the Congo in 1960 to halt the civil strife that followed independence for the former Belgian colony. It also distributed food to hungry war refugees (right) who flooded into the cities. Tragically, Secretary-General Dag Hammarskjold was en route to the rebellious Congolese province of Katanga to stop further bloodshed when his plane crashed. Katanga president Moise Tshombe (above) lays a wreath on the bier.

TERENCE SPENCER /LIFE / TIMEPIX

>

DESERT VIEW

Australian UN troops take up positions between Syrian and Israeli forces on Mt. Hermon, in the Syrian Golan Heights (right). Their presence ended a costly war that broke out in October 1973, when Arab states launched a surprise attack on Yom Kippur. The UN-supervised truce was enforced by 1,200 troops, including Canadians and Peruvians.

Y. NAGATA / UNITED NATIONS

>

NOBEL LAUREATES

In a salute to 40 years of dangerous missions, United Nations forces (right) were awarded the Nobel Peace Prize in 1988. About 500,000 UN personnel and troops from 58 nations, wearing the symbolic blue berets or helmets, had then participated in security efforts in seven war zones; 733 of them were killed in the line of duty.

WIDE WORLD

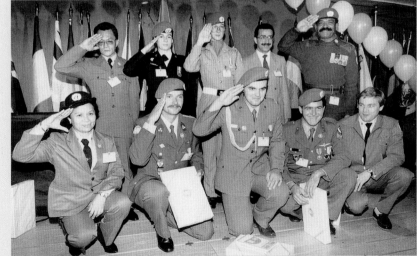

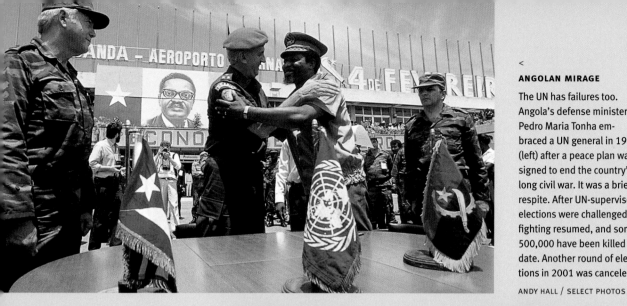

ANGOLAN MIRAGE

The UN has failures too. Angola's defense minister Pedro Maria Tonha embraced a UN general in 1989 (left) after a peace plan was signed to end the country's long civil war. It was a brief respite. After UN-supervised elections were challenged, fighting resumed, and some 500,000 have been killed to date. Another round of elections in 2001 was canceled.

ANDY HALL / SELECT PHOTOS

LATIN HARMONY

Bringing a lasting end to El Salvador's 12-year civil war, Secretary-General Javier Perez de Cuellar (right, center) presides over the signing in 1991 of a UN-mediated peace agreement in New York. Through his persistence and imaginative political strategies (and aided by the end of the Cold War), the former Peruvian diplomat restored the UN's prestige after Waldheim.

RAY STUBBLEBINE / REUTERS / ARCHIVE

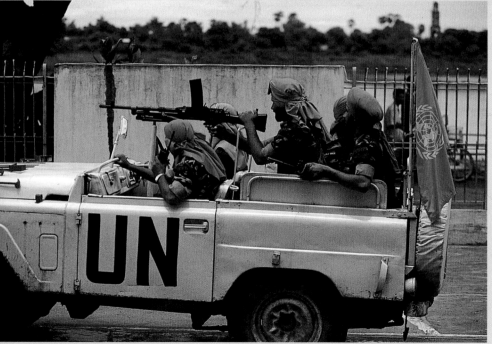

CAMBODIAN PATROL

Indian UN troops (left, in blue burnooses) made sure the Communist Khmer Rouge would not disrupt Cambodia's first free election, in May 1993. This was one of the most expensive peacekeeping efforts ($1.6 billion). But it was rewarded when 90 percent of eligible voters risked death threats to approve a constitutional monarchy with Prince Norodom Sihanouk as king.

GREG DAVIS / TIMEPIX

EASY DOES IT

Ever so gingerly, in 1993 a UN soldier (right) removes one of the 10 to 20 million land mines buried in Iraq over the previous two decades. Meanwhile, the UN General Assembly declared its own war, calling for a ban on the production, stockpiling and export of land mines, which had maimed or killed more than a million people since 1975.

MASAO ENDOH / CORBIS / SABA

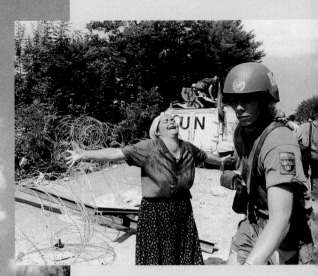

CRY HAVOC

This Bosnian woman (above) berates a Dutch peacekeeper for betraying a UN promise to protect her town, Srebrenica, from "ethnic cleansing." On July 11, 1995, the Serbian Army pushed aside a small Dutch UN force, loaded 8,000 men and boys onto buses and after murdering them hid their bodies in mass graves.

ABOVE: HAVIV / CORBIS / SABA

TENSE LEBANON

Irish UN soldiers stand guard in Israeli-occupied southern Lebanon (inset) in March 2000. The tense duty had been shared by 5,600 blue helmets since 1978. After Israeli troops ended their 18-year occupation, in May 2000, UN peacekeepers fanned out across the Israel-Lebanon border with surprisingly few incidents.

INSET: ALEXANDRA BOULAT / SIPA

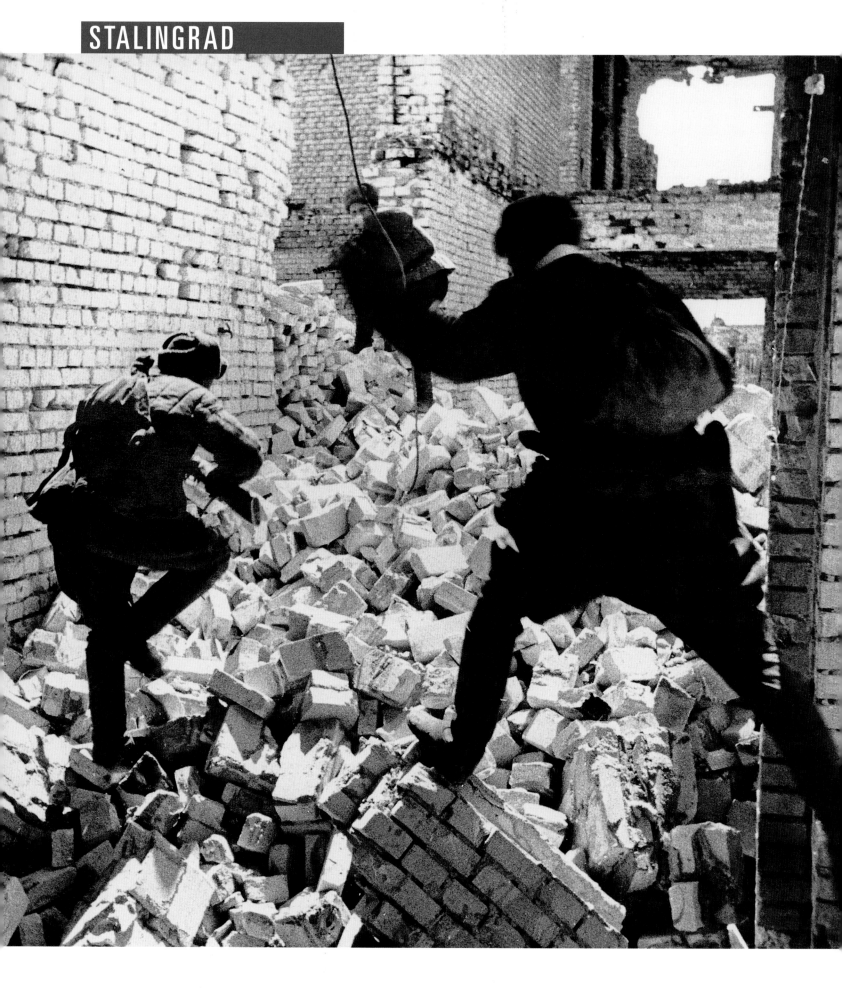

<

IN PURSUIT

Hitler's orders were to take Stalingrad and leave "not one stone atop another." The Germans quickly occupied all but a narrow swath of the city along the Volga River. Then the Red Army pushed back, through rubble-strewn alleys (left). The fighting was point-blank, house by house, floor by floor. The Soviets regained by night what they lost by day.

DAVID KING COLLECTION

>

FEEDING FIRES

German artillerymen (right) pour more shells into an already burning city. The fires forced the Red Army underground, where it lived in tunnels and bunkers. Still, it fought as if retreat across the Volga was impossible, stalling the Axis advance until November 19. Then a surprise Russian counterattack caught some 225,000 Germans in a fatal noose.

HULTON / ARCHIVE

>

AMID THE RUINS

In this pathetic scene, a family (right) cooks a meal in the devastation of Stalingrad. They were among the 50,000 surviving civilians trapped in the city's cellars, sewers and shell holes after the Luftwaffe dropped incendiary bombs that killed 40,000. Most of the 500,000 residents of the Soviet Union's third largest city were evacuated.

AKG PHOTO

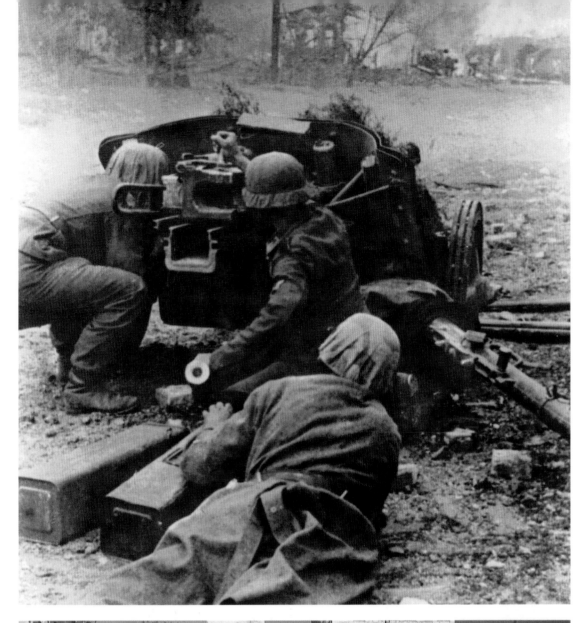

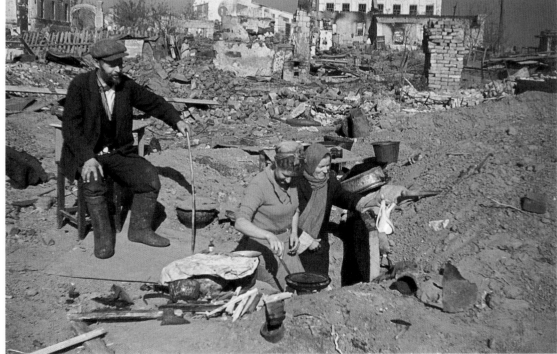

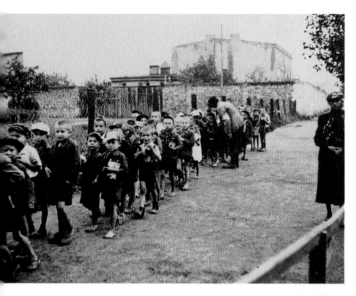

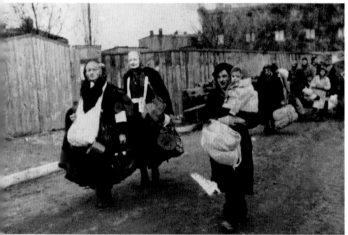

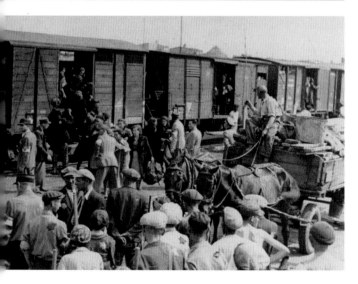

EXTERMINATION BEGINS

A year after the Nazis forced the 204,000 Jews of Lodz, Poland (one third of the city), into a small ghetto, they transported 55,000 of them and 5,000 gypsies to a newly operational death center, in Chelmno. Thus began the first mass exterminations of Hitler's Final Solution. In early September the Germans forced all boys and girls under 10 out of their homes and lined them up on a Lodz street (top left), then rounded up elderly women, carrying both their belongings and small children (left). All were marched to the railway depot, herded into freight cars (bottom left) and taken to Chelmno. There they were bathed, made to enter sealed trucks and gassed to death with exhaust fumes. When Lodz was liberated, in 1945, only 1,000 Jews were left.

>

AWAITING DEATH

On the eve of the liquidation of the Mizocz ghetto, in the Ukraine, in October, some of its 1,700 residents fought back but were quickly defeated. Those who survived, including these naked Jewish women (right, some holding infants, at least one pregnant), were taken to a ravine south of Rovno and shot. Among the corpses a Nazi police officer (inset) fires at those few still alive.

ALL:
UNITED STATES HOLOCAUST
MEMORIAL MUSEUM

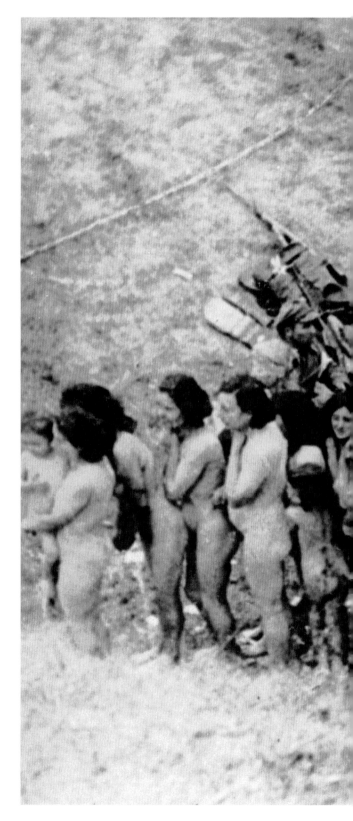

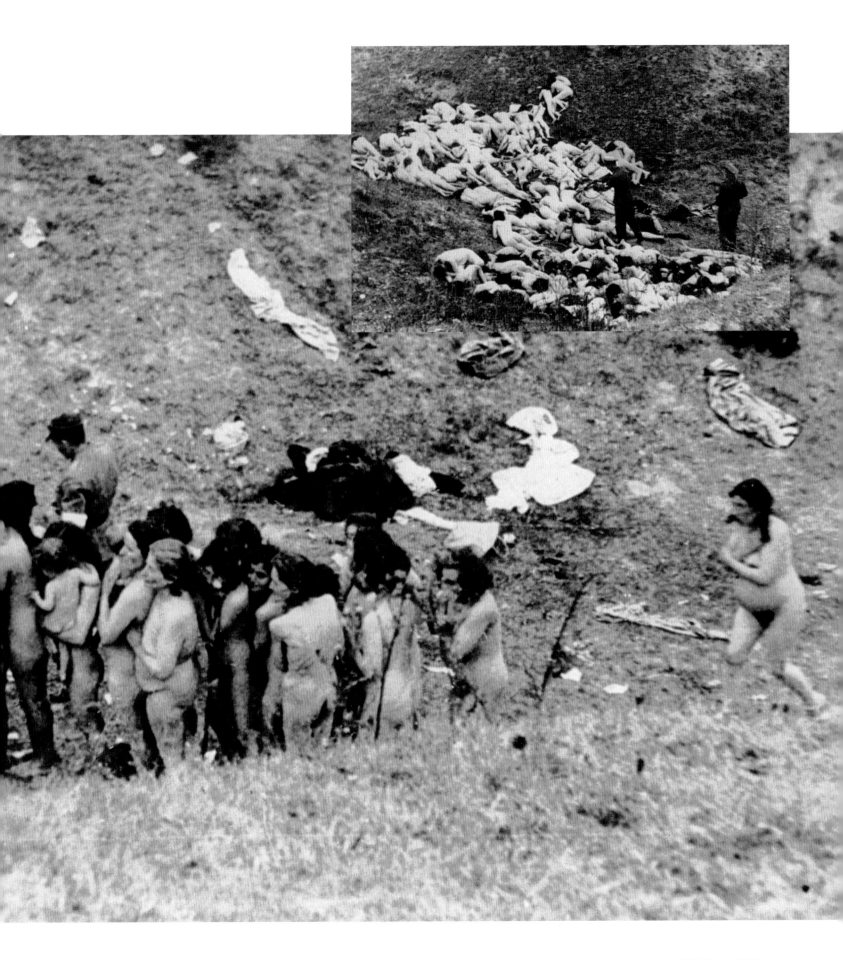

JOSEPH STALIN

The Man of Steel

By the time Josepf Vissarionovich Dzhugashvili, the son of a Georgian shoemaker, rose to power in 1924, he had long called himself Stalin, "man of steel." And with metallic coldness, the former Orthodox seminarian rid himself of all party rivals and launched a ruthless campaign to force 25 million farmers onto state collective farms. Fifteen million peasants died by execution or starvation. Beginning in 1933 his purges doomed 600,000 party members and the nation's military leaders. Stalin's dictatorship was secure, but his nation vulnerable. In 1939, fearing Hitler, he tragically tried to appease him.

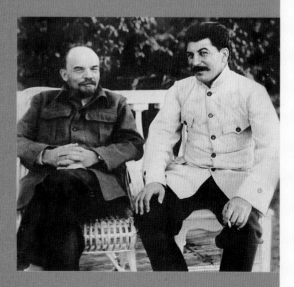

COMRADE CONVICT

Though his party condemned robbery to finance revolution, Stalin (in a 1908 czarist-police mugshot, right) was undeterred. After joining the Bolshevik underground in 1899 and taking the alias Koba (after a Georgian outlaw), he was arrested and escaped from prison five times between 1902 and 1913. In prison he incited others to organize and riot.

RIGHT: DAVID KING COLLECTION

FATHER DEAREST

Stalin once said his "last warm feelings" died with his first wife, in 1907. Their son, Yakov (who died while a German POW), was raised by relatives. Stalin was an unforgiving father to the children of his second marriage (right): Vasily (who died an alcoholic at 41) and Svetlana (who defected to the U.S. in 1967). A convincing actor, though, Stalin could be convivial when the occasion demanded (bottom right, 1935).

RIGHT: DAVID KING COLLECTION
BOTTOM RIGHT: SOVFOTO

<

ERSTWHILE FRIENDS

Communist party leader Lenin (left, with Stalin in 1922) once valued his disciple's decisiveness, if not his theoretical insights. But the year before Lenin's death, in 1924, he wrote a testament to the party charging that Stalin was too insensitive to the Soviet Union's minority nations and too crude to head the party. Lenin's judgment was ignored.

LEFT: SOVFOTO

Славе великому Сталину

En Route to an Empire

By 1940, Stalin's cult of personality achieved breathtaking proportions, as seen in this aquatic salute (top). In a 1926 prelude to power, Stalin (at left) and Leon Trotsky (with goatee) put aside their rivalry to carry the coffin of the chief of the Soviet secret police. Stalin later blocked Trotsky from power, had him expelled from party and country and then murdered in Mexico City. In 1945, meeting with Churchill and President Truman (above) at the last Big Three summit of the war, Stalin won concessions that enabled him to build a Communist empire.

TOP AND LEFT: DAVID KING COLLECTION
ABOVE: CORBIS / BETTMANN

WRAP IT UP

The effects of war hit the home front with price controls to prevent inflation and ration stamps for sugar, coffee, meat, shoes, nylons, tires and gas. A few civilians, such as doctors, were entitled to unlimited gas. Other motorists (left, in New Jersey) wrapped and stored their cars. Slogans like "When you drive alone, you drive with Hitler" encouraged carpooling.

R.E. STACKARD

RUMP SESSION

Movie stars like Rita Hayworth became Uncle Sam's most effective salespeople for mobilizing the country — and sewing a GI's trousers at Camp Callan, in San Diego, was a publicity stunt for a noble cause (right). Big Hollywood names also sold war bonds, promoted scrap drives, denounced the black market and served doughnuts at USO clubs.

WIDE WORLD

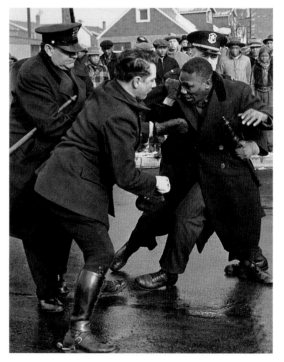

AMERICAN DILEMMA

The war sharpened the country's racial ambivalence. Blacks were enlisting in big numbers, including heavyweight champ Joe Louis (near left, Camp Upton, New York). Meanwhile a race riot broke out in Detroit (far left) after whites tried to prevent blacks, in town for war-plant jobs, from moving into the Sojourner Truth housing project, in a formerly white area.

FAR LEFT: CORBIS / BETTMANN
LEFT: RALPH AMDURSKY

EL ALAMEIN, EGYPT

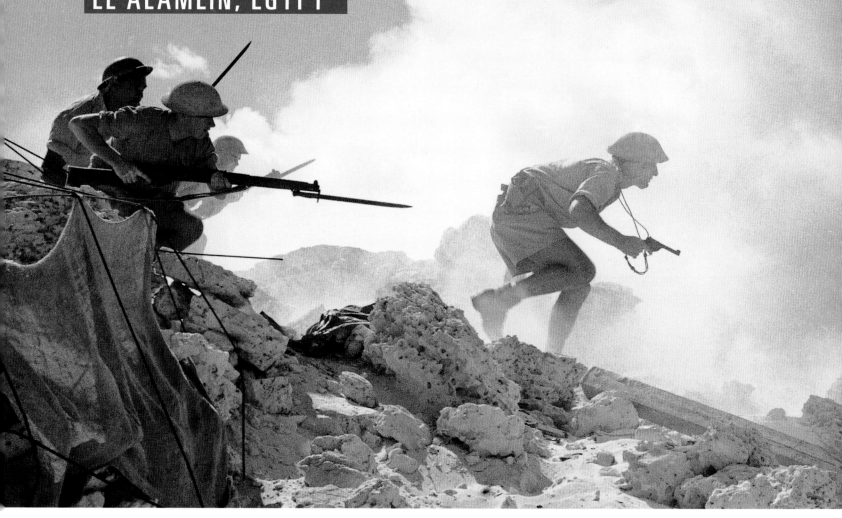

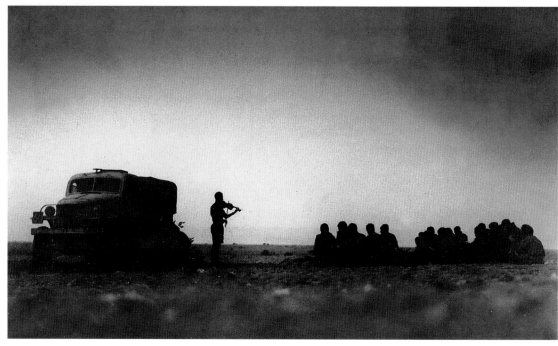

TRUE GRIT

It was the decisive battle of El Alamein that doomed Rommel. His Africa Corps was a threatening 70 miles from Alexandria when Australian troops, with bayonets drawn, attacked in early November (above). The close combat started the Germans' 2,000-mile retreat west across the desert. On the eve of battle, a British chaplain plays a soothing violin (left) for his outfit.

ABOVE: IMPERIAL WAR MUSEUM
E 18908
LEFT: ROBERT LANDRY / LIFE /
TIMEPIX

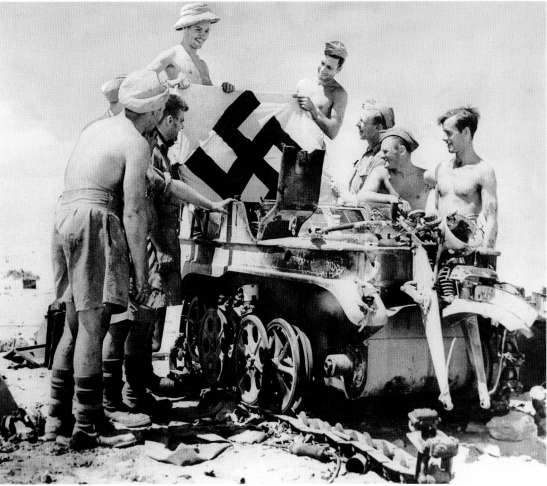

MONTY'S MOMENT

Handpicked by Churchill to deliver the desert, bantam British Field Marshal Bernard Law Montgomery, 54 (watching the battle, top right), carefully prepared his campaign. He refused to attack until he outnumbered Axis forces two to one — and the moon was full. British troops proudly display evidence of their victory (right).

TOP RIGHT: CAMERA PRESS
RIGHT: MANSELL COLLECTION / TIMEPIX

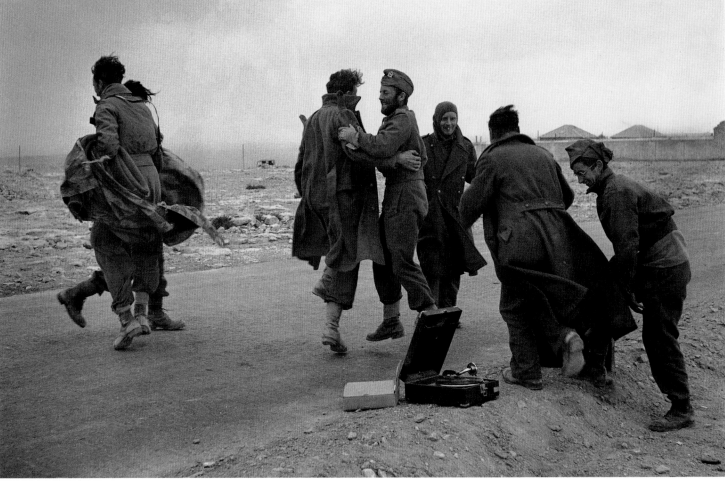

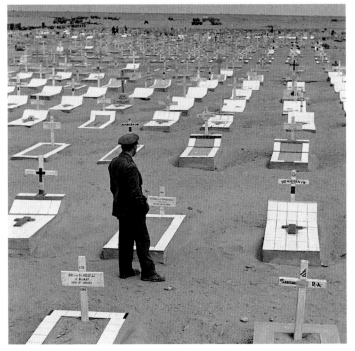

SHALL WE DANCE?

The desert war went from joy to despair and back again for both sides. British soldiers (top left) had reason to dance — to a captured Italian phonograph — after Allied forces retook Bardia, Libya, in January. The ill-prepared Italians suffered greatly all year (a soldier carries his wounded buddy, bottom far left). By June it was Britain's turn to be humiliated; 33,000 surrendered to Rommel at Tobruk (where a British cemetery was laid out, bottom near left).

COUNTERCLOCKWISE FROM TOP LEFT: IMPERIAL WAR MUSEUM E7517; IMPERIAL WAR MUSEUM E7540; GEORGE RODGER / LIFE / TIMEPIX

>

COURAGEOUS MALTA

Malta was the base for British subs and aircraft that harassed German supply lines. That explains why it became one of the most ferociously bombed places on the globe (top right, the Opera House, in Valetta). Britain's George VI was so touched he gave the Maltese a medal for bravery.

>

TORCH CARRIERS

Halfway around the world from the embattled Pacific, American ground troops got their baptism of fire when they invaded Algeria, on November 8. It was called Operation Torch. Three days later, the Vichy French agreed to a cease-fire and turned their guns on the Axis powers. The Yanks headed for Tunis in hopes of finishing off the Germans fast. It took six months.

IMPERIAL WAR MUSEUM

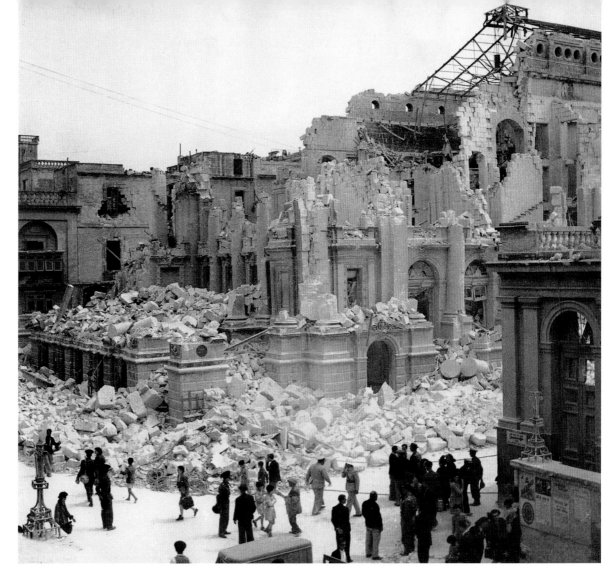

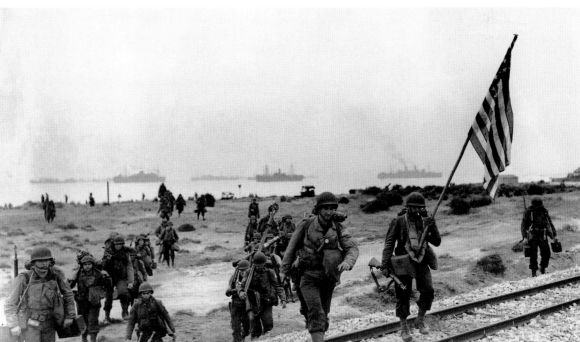

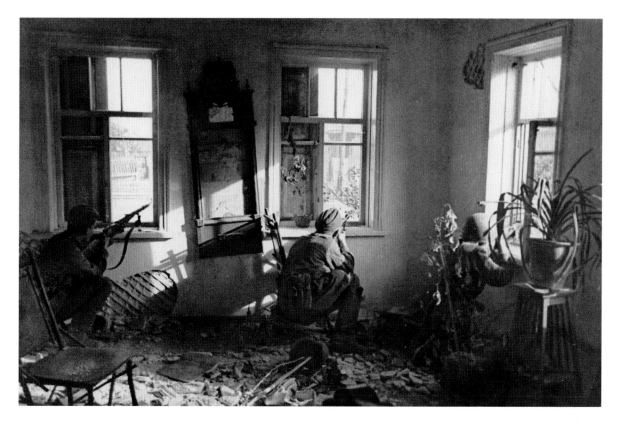

<

ENDGAME

Exhausted German soldiers climb out of a bunker to a shattered landscape, dead comrades and grim captors (left). The Red Army had completed its surprise encirclement of 300,000 Nazi troops in late November. Hitler, believing that supplies could be airlifted in, refused to allow his Stalingrad commanders to organize a breakout and retreat.

DAVID KING COLLECTION

HOUSE FIRE

The fighting was factory to factory, living room to living room (right). The Germans began to realize their enemies would never give up. A disheartened German soldier wrote home: "I ask myself, Has mankind gone crazy?"

SOVFOTO

ETERNAL FLAME

A disabled tank is the final resting place for a German soldier whose riddled uniform is still aflame (right). His fate reflects his Army's. On November 19 Red Army artillery on three fronts battered enemy positions around the city. Then Soviet tanks broke through, trapping three Romanian divisions. Other Axis troops withdrew in panic.

GLOBE PHOTOS

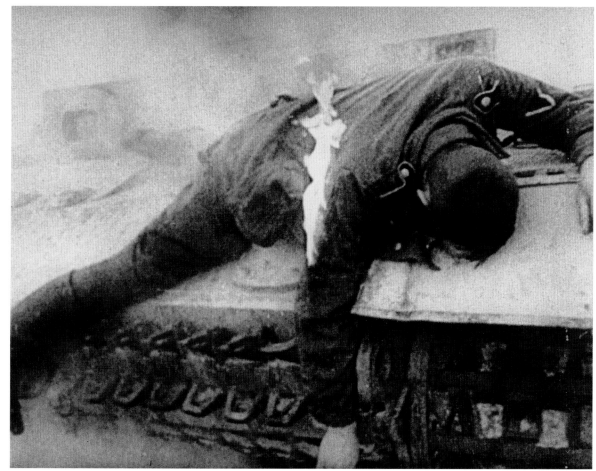

STALINGRAD

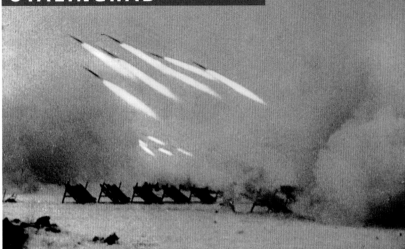

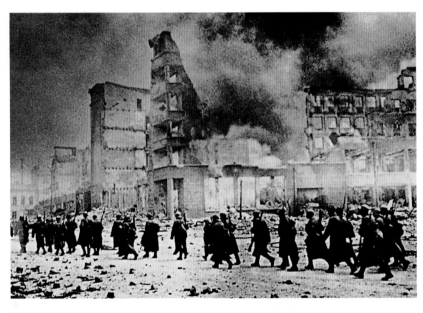

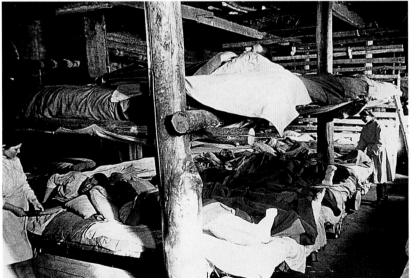

<

FIERY FINALE

With Germany's Sixth Army in its bear grip, the Red Army pounded Nazi positions with rocket fire (left). Only a trickle of fresh supplies and no reinforcements reached the Nazi troops, while fresh Russian reserves (middle left) streamed into the battered city to replace the weary, wounded and dead. Treatment of the wounded was crude on both sides (bottom left, a Soviet field hospital built of logs). But as winter arrived, more than 20,000 German casualties tried to stay alive in unheated aid stations. The death toll from exposure and starvation was horrendous.

TOP LEFT: RUSSIAN NEWSREEL
MIDDLE AND BOTTOM LEFT:
DAVID KING COLLECTION

INDUSTRIAL WASTE

The Red October factory was the scene of fighting through much of the siege. The original German advance had nearly overrun it and reached the Volga. The Soviets held. Then as snow settled on the tangled wreckage, they won it back (right). The 62nd Army were the heroes, led brilliantly by General Vasili Chuikov. His opposite number was the ill-fated General Friedrich von Paulus, who later surrendered despite Hitler's orders not to.

RIGHT: DAVID KING COLLECTION

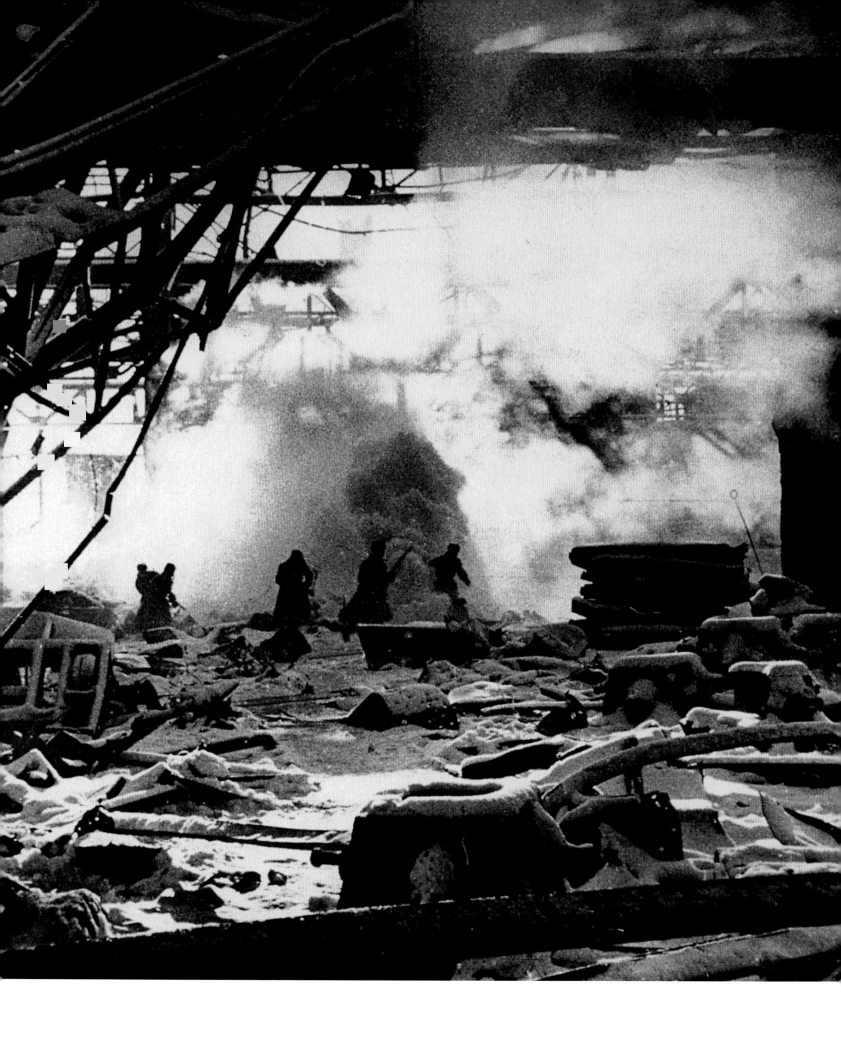

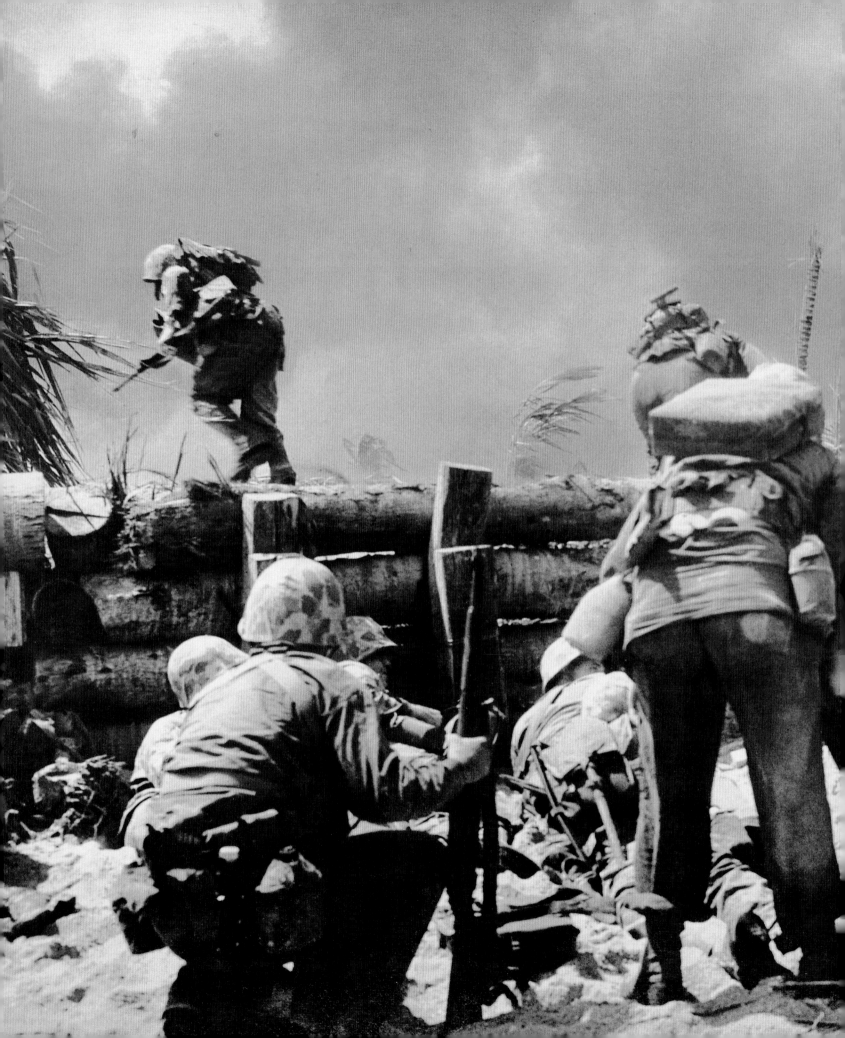

19 43

FROM ATOLL TO AIR, THE WAR GRINDS ON

Europe was the first priority, the Allies had agreed. But encouraging developments there and in North Africa prompted an increase in attention to Asia. The first targets were Japan's island territories in the Pacific. The 76-hour battle for tiny but heavily fortified Betio, in the Tarawa atoll (left), was one of the most savage of the war. Meanwhile in Europe, as the world awaited the Allied invasion of France, U.S. bombers (inset, B-17s with fighter contrails above) demonstrated the value, and peril, of daylight raids to smash German cities.

A Deadly Game of Leapfrog

by Ronald H. Spector

SHORTLY BEFORE MIDNIGHT on February 8, 1943, Japanese destroyers completed the evacuation of the last of some 11,000 troops from the vicinity of Cape Esperance, at the northwest tip of the island of Guadalcanal, in the Solomons. The soldiers being evacuated, according to one account, "wore only the remnants of clothes. All had dengue or malaria. They were so undernourished that their nails and hair had all stopped growing. Their buttocks were so emaciated that their anuses were completely exposed, and on the destroyers that picked them up they suffered from constant and uncontrolled diarrhea." These men were the lucky survivors of Guadalcanal, a six-month battle that had caused the deaths of at least 30,000 Japanese and 7,000 Allied soldiers. Nine months later, in November, about 1,000 U.S. Marines and sailors died in four days on the Tarawa atoll, in the Central Pacific, an area about the size of the Pentagon and its parking lots. The Japanese garrison of about 4,700 died almost to the last man.

The year thus began and ended with some of the most wrenching and hardest fought battles of the Pacific war. Those two names, Guadalcanal and Tarawa, once meant much in the minds of Americans who could remember the war and in the patriotic iconography of the country. Yet neither has managed to survive in this country's popular imagination into the twenty-first century. Instead, the mass media have efficiently pared down the American public's understanding of the war in East Asia and the Pacific to four events: Pearl Harbor, the Battle of Midway, the struggle for Iwo Jima (which provided all-purpose symbolism) and the use of the atomic bomb against Japan.

The battle for Okinawa also gets some media attention because, though it lacked a famous flag raising, it was the last battle and involved the kamikazes, or suicide bombers, as well. They continue to exert a horrified fascination that the routine slaughter, disease, dismemberment, drownings, starvation and atrocities of the war seem unable to match. So as we move further away from the conflict in time, the gap between significance as seen by historians and significance as expressed in popular memory grows ever wider.

Concerning 1943, the gap is very wide indeed. Outwardly little changed during the year. There were more American victories, but the Japanese Empire — certainly all the important parts of it — remained intact. The Japanese Navy had not been defeated, and there were millions of Japanese soldiers under arms who had not even been committed to battle. In hindsight, however, it is clear that by the end of the year Japan was doomed.

One reason the battles and campaigns receive little attention may be that they occurred in very strange, out-of-the way places. The largest opera-

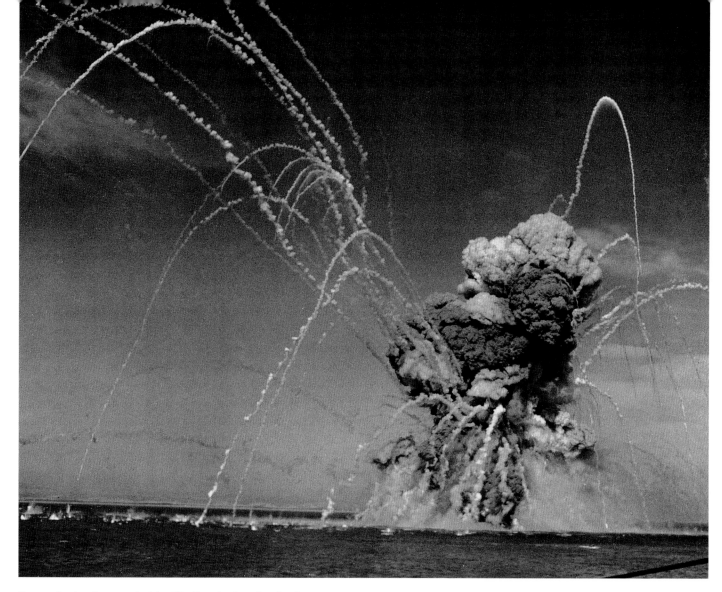

German dive-bombers attacked the Allied invasion force heading for Sicily in July. This American cargo ship took a bomb amidships; the fire spread to its munitions, and these deadly fireworks resulted.

tions during the first half of the year were in the remote Aleutian Islands, in the North Pacific, west and a little south of Alaska. The Japanese had seized two of these islands, Attu and Kiska, as a diversion at the time of the Battle of Midway, in June 1942. (It gives some idea of the weather in that area of the world that it took over a week before U.S. reconnaissance planes determined that the Japanese were there.)

Attu was recaptured in May after some hard fighting, but Kiska was not assaulted until August 2, when an armada of almost 100 ships carrying 34,000 troops converged on the island. Shortly be-

fore, Japanese destroyers had secretly evacuated the entire garrison of more than 5,000 men in 55 minutes. In Washington, Navy Secretary Frank Knox and Chief of Naval Operations Admiral Ernest J. King anxiously awaited word of the Kiska landings. The first radio message reported that the invading troops had found only a few dogs and some hot coffee. "What does this mean?" exclaimed Knox. "The Japanese are very clever," King replied. "Their dogs can brew coffee."

Most of the other fighting in 1943 occurred in an even more remote region, the northern coast of New Guinea and the Solomon Islands chain, in the Southwest Pacific. This was the theater of operations assigned to General Douglas MacArthur and Admi-

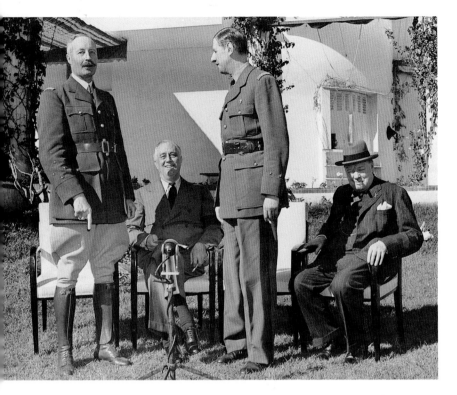

At a Roosevelt-Churchill summit in Casablanca in January, the two feuding Free French leaders met reluctantly. General Henri Giraud (left) later faded from the scene; General de Gaulle didn't.

CORBIS / BETTMANN

ral William F. Halsey, probably the two most famous American figures of the Pacific war. Many of their countrymen, even those with little knowledge of history, have heard of them, but few could tell you anything about where they fought most of their battles — another quirk of popular memory. It is as if most citizens had heard of Eisenhower and Bradley but didn't know where Normandy was.

The objective of MacArthur and Halsey was to advance along the top of New Guinea and up the ladder of the Solomons until they were in position to cut off and attack Rabaul, the major Japanese base in the South Pacific, on New Britain Island. Halsey was subordinate to MacArthur for these operations, but the ships in his fleet were still under the control of Admiral Chester Nimitz, Commander of the Central Pacific Theater and the Pacific Fleet. This odd arrangement worked fine because MacArthur and Halsey got on well together, and MacArthur seldom interfered with the conduct of Halsey's operations.

Code-named Cartwheel, the campaign against Rabaul did not really get under way until the summer of the year, with landings by Halsey's forces on New Georgia, in the Solomons, and in September by Australian and American troops at Lae, on the New Guinea coast. After New Georgia developed into a long slugging match, similar to Guadalcanal, Halsey decided to bypass the next island to the north, Kolombangara, and land on Vella Lavella, a lightly defended island closer to Rabaul.

This leapfrogging tactic was possible because American dominance of the sea and air in the South Pacific was great enough, and American engineers could build airfields fast enough, to make the risk worth taking. Later, Nimitz and MacArthur would adopt leapfrogging on a much larger scale, pushing the Japanese back and drawing them into a war of attrition that cost them heavily in ships and planes.

But the Cartwheel operations were very slow. They were too slow for Admiral King, who wanted to open a new front with an advance across the Central Pacific through the Marshall, Caroline and Marianna islands, as had been provided for in the Navy's pre-1941 plan for war with Japan, code-named Orange. None of the other Allied generals and admirals liked this idea much. The British First Sea Lord warned that it would lead to "a fleet action in which the whole area was surrounded by Japanese shore-based air."

That was exactly what King wished for. Like all Navy strategists, he wanted to force the Japanese into a decisive fleet battle. He was confident the Navy's new weapon, the fast-carrier task forces then organizing and training at Pearl Harbor, could both win the battle and cripple any island-based air attack.

By May, King had gotten the backing of Army Chief General George C. Marshall, who needed King's support for a cross-Channel invasion in Eu-

rope, and that of Air Force Chief Henry H. Arnold, who wanted to base his new B-29 super bombers in the Mariannas. An invasion of the Gilbert Islands, west of Hawaii, was set for November.

As Nimitz was receiving his orders for the Gilberts operation, a chain of events that would go far toward deciding the outcome of the Pacific war had already begun in the western Pacific. To wage war, Japan was dependent on the import of raw materials and fuel from its Asian Empire to the home islands. By mid-1943 sinkings by U.S. submarines had begun to interfere seriously with these vital imports and to devastate Japanese merchant shipping.

The Japanese had begun the war with too few ships to supply their empire and armed forces and no real concept of how to protect shipping. In the first year of the war this had not mattered very much; U.S. submarines were plagued by faulty torpedoes and ineffective skippers. But by mid-1943 these problems were well under control. There were more submarines than ever, with improved radar and sonar, and American code-breakers were able to read the enemy's shipping code.

For reasons that are still not clear, the Japanese never attempted to counter the American submarine offensive either by waging one of their own or by aggressive anti-submarine measures, as the Allies had done in the Atlantic against German U-boats. The result: The submarine campaign wrecked Japan's economy. By the end of 1944 about half of its merchant fleet, including replacements, and about two thirds of its tankers had been sunk.

Through all the hard fighting of 1943 there were few hints that the war would soon get easier for the Allies, but it did. In support of the Gilberts operation, the fast carriers demonstrated their ability to take on Japanese air bases and neutralize them. The combination of these carriers and amphibious assault, tested at such high cost at Tarawa, soon proved unstoppable in the Central Pacific.

Supplies reached the Allied effort in North Africa by ship and plane across the Mediterranean. This U.S. transport's crew enjoyed a spectacular view of the pyramids on their flight into Cairo.
AKG PHOTO

Japanese warships, planes and experienced airmen lost trying to stop Halsey and MacArthur could never be replaced. Meanwhile in America, factories and shipyards had built a fleet and an air force more than twice as strong as at the beginning of the year. By the end of 1943, the dual advance through the Southwest and Central Pacific, the submarine campaign and the fast-carrier striking force had all become mutually supporting. The pattern of Japan's defeat was clear.

Ronald H. Spector's most recent book is At War at Sea: Sailors and Naval Combat in the Twentieth Century. *He is Professor of History and International Relations at George Washington University and has served as Distinguished Guest Professor at Keio University in Tokyo.*

NEW GUINEA

NO MAN'S ISLAND

Its climate was inhospitable, its jungles and mountains nearly impassable. But New Guinea, located only 100 miles from Australia, held immense strategic appeal for both sides. Allied forces, dominated by tough Aussies who had served in North Africa, needed six months to uproot the Japanese from outposts established along the island's North Coast in the summer of 1942.

The defenders were heedless of their lives. The Japanese soldier walking to shore (left) carries a grenade that he refuses to drop until the rifleman on the beach kills him. Tanks (near right) were critical to protect advancing infantry. When men were wounded, they were treated in the jungle, almost where they fell (far right, top).

When they weren't fighting the enemy, the Allies fought the terrain. The troopers at left pieced wood and wire together to cross the Kumusi River. Their destination was Buna, site of a gruesome campaign to drive the Japanese from pillboxes made of coconut logs and sand-filled oil drums. Meanwhile, U.S. B-25s (right) sprinkled an airstrip near Dagua with deadly parachute-borne fragmentation bombs.

TOP LEFT: GEORGE SILK / LIFE / TIMEPIX
LEFT, AND NEAR AND FAR RIGHT, TOP: AUSTRALIAN WAR MEMORIAL
RIGHT: CORBIS / BETTMANN

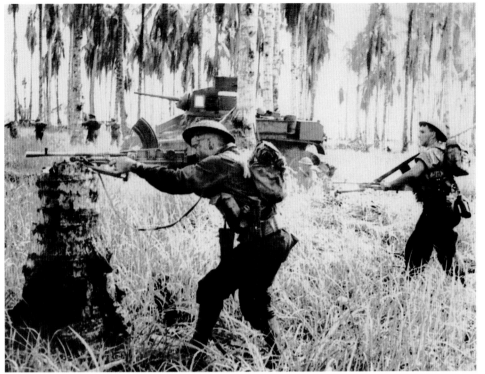

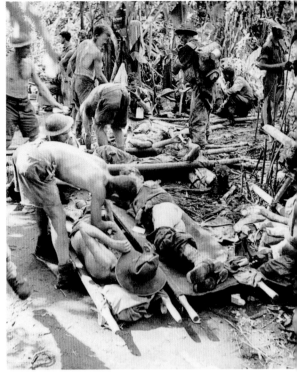

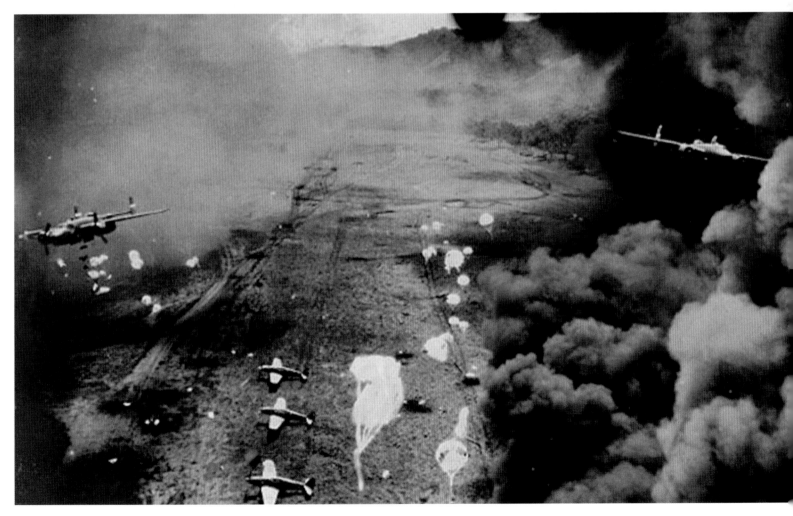

STALINGRAD

COSTLY SALVATION

After four months of siege, the Red Army sent massive reinforcements to Stalingrad, and by January the Germans were themselves surrounded. Dependent on erratic airlifts for food and supplies, the Wehrmacht had to choose between death — quickly, in combat, or slowly, of starvation — and surrender.

Hitler forbade surrender. He dramatized his order by promoting his top General on-site, Friedrich von Paulus, to Field Marshal — a reminder that no German of that rank had ever given up. Nonetheless, Paulus did so, and his troops promptly followed suit. One soldier (top left) waved a white flag and, for emphasis, dressed himself to match.

Though Russians took heart from their first real victory, the citizens of Stalingrad had little to celebrate. Their city (left) was a shell, and residents like this musician (bottom left) returned to gutted buildings without heat, water or power. Of the more than 100,000 who died, some were interred in a mass grave, at right, marked off by salvaged bedsteads and a small plaque.

TOP LEFT: HULTON / ARCHIVE
MIDDLE AND BOTTOM LEFT:
RUSSIAN NEWSREEL
RIGHT: DAVID KING COLLECTION

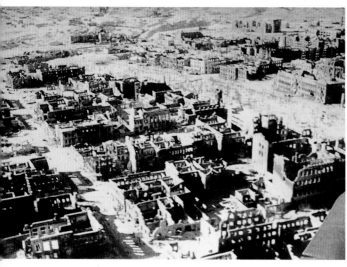

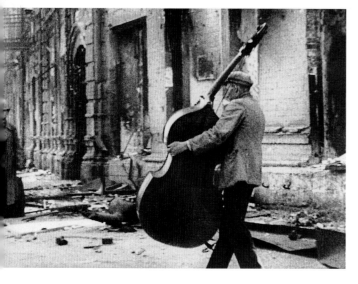

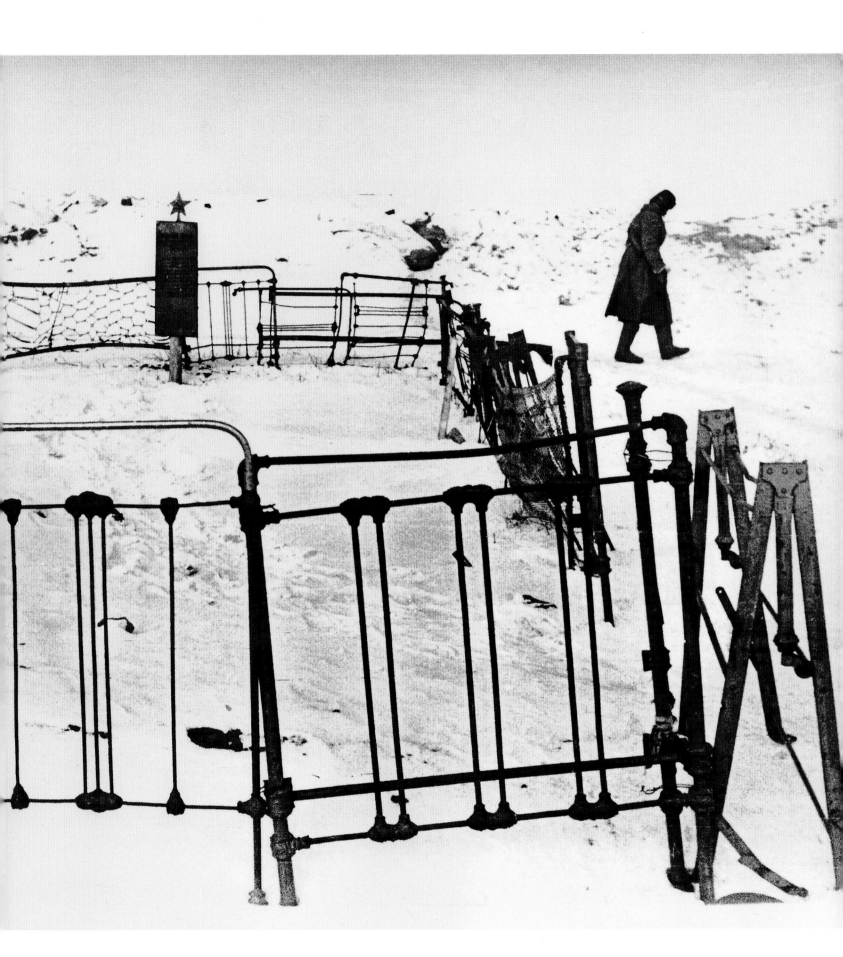

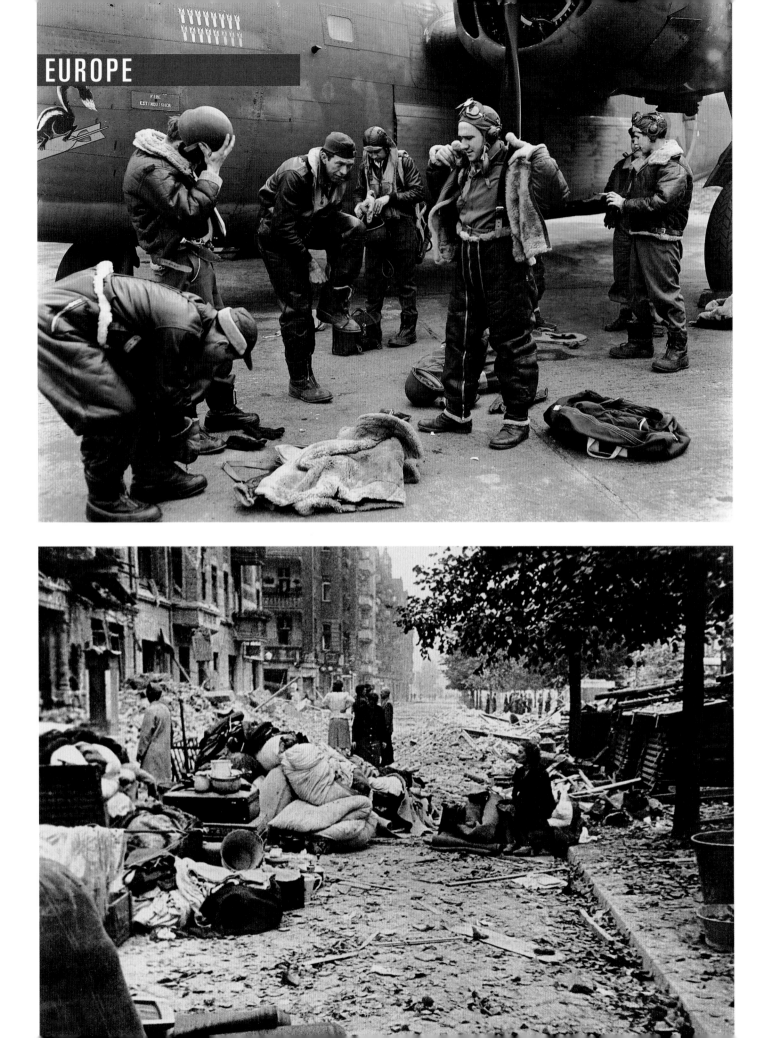

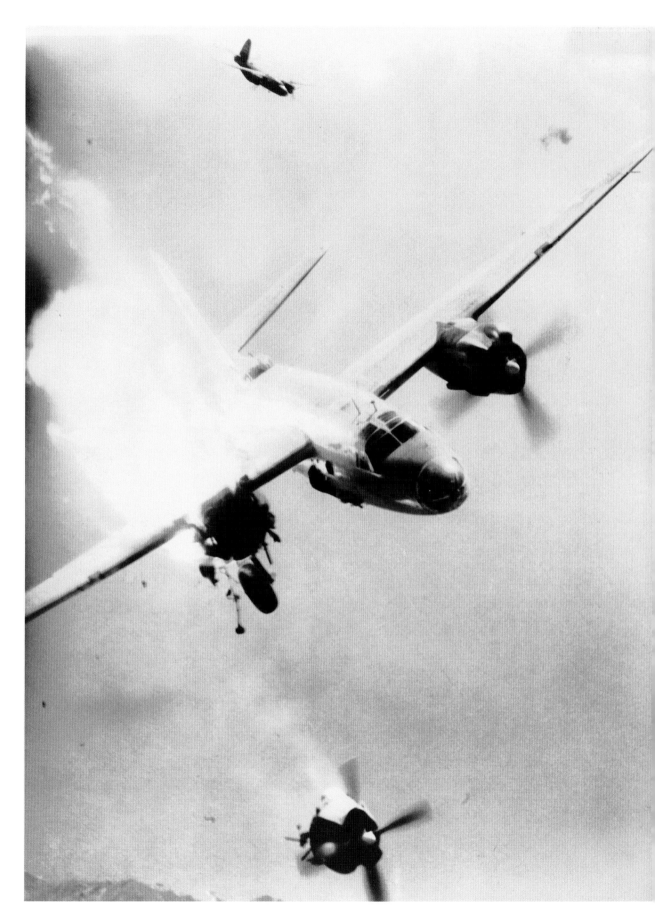

SUITING UP

In England, an American B-24 crew — veteran of 16 missions, from the stencils on the fuselage — pull on helmets and warm high-altitude flight gear (left). Although the United States had integrated its bombing campaign with that of the RAF, their strategies were different. The Yanks flew daytime raids against designated factories; the British attacked whole industrial areas by night.

U.S. AIR FORCE

DEAD AIM

Early on, American bombers were sent over occupied Europe on their own, with often disastrous results. Fighter escorts could defend them against enemies in the air but not on the ground. This B-26 (right) was hit by flak over southern France. Its right engine rips off, propeller still spinning. Minutes later plane and crew crashed into the city of Toulon.

U.S. AIR FORCE

SMASHING BERLIN

As winter approached, Britain began exploiting the longer nights by targeting distant Berlin (left). The German capital would endure four months of intensive raids, perhaps the most prolonged bombing of any city during the war. Superior air-raid shelters and early warning kept civilian deaths to a minimum. But 1.5 million residents were left without homes.

AKG PHOTOS

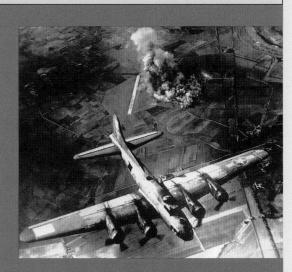

THE RISE OF AIRPOWER

Flight and Fight

Reconnaissance, strafing, an occasional dogfight — those were the limited uses of aviation envisioned during World War 1. Yet, much of the next global conflict would be fought in the skies (above, an American raid on Germany). By the 1930s every major nation was building planes and training pilots — and planning a style of warfare that killed civilians. Successive innovations allowed aircraft to outwit defense systems and release "smart bombs" that found their own targets. The Cold War produced the ultimate air weapon, a pilotless bomb that flew through outer space: the intercontinental missile.

BOMBS AWAY

To demonstrate the offensive potential of flight, in 1921 General Billy Mitchell, Assistant Chief of the Army's Air Service, had a Martin MB-2 unload a phosphorous bomb on a scrapped warship anchored off the Atlantic Coast (right). Making his point did not help Mitchell. His relentless advocacy for an air force independent of the Army got him court-martialed in 1925. He hung up his uniform and died in 1936, seven years before American bombers began dropping phosphorous incendiaries on German cities. By the end of the war, the need for a separate air force, with its own service academy, was no longer in doubt. The new USAF was spun off the Army in 1947, and World War 1 veteran (and future senator) Stuart Symington was sworn in as first Secretary of the Air (left, below).

RIGHT AND BELOW:
U.S. AIR FORCE
ABOVE LEFT:
NATIONAL ARCHIVES

SOUND STRATEGY

When Army pilot Chuck Yeager, 24, broke the sound barrier (700 mph) in October 1947, the boom resonated around the world. He did it in an experimental, rocket-powered X-1 (right), named for his wife, that was launched from the bomb bay of a B-29. Nobody was sure the plane would not self-destruct. Supersonic flight was accepted by the military, and in 1976 by commercial aviation too.

GLAMOROUS GLENNIS

OVER THE WALL

Against a backdrop of Douglas C-47s and C-54s, freshly trained pilots (below) await deployment in Operation Vittles, the Berlin airlift. The United States and England began ferrying food and coal to the western sectors of the city in 1948, after ground traffic was halted by the Soviet Union. Planes delivered 2.3 million tons of supplies during the 15-month mission.

BELOW: J.R. EYERMAN / LIFE / TIMEPIX

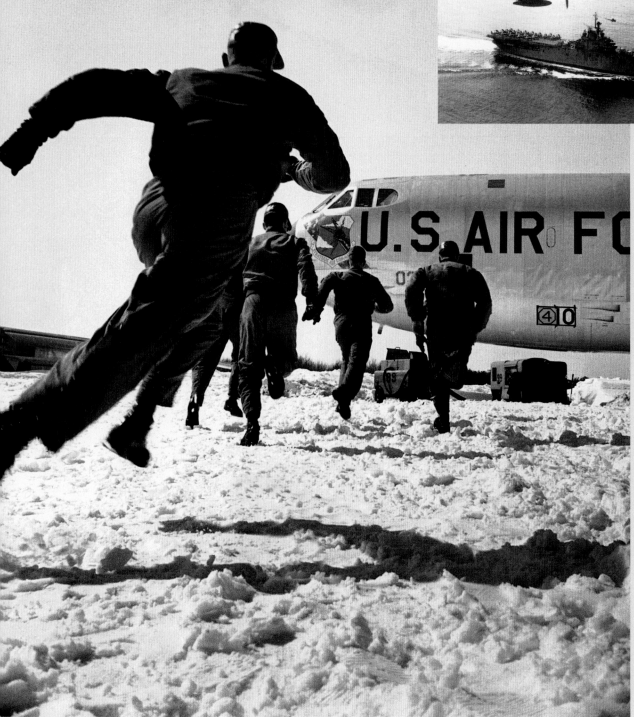

ACTION IN KOREA

The Navy played a key role in the Korean War. Its carriers stood off the coast and sent waves of bombers to hit the invading North Koreans and later the Chinese when they joined the conflict. In 1951 the USS *Boxer* steamed below a flight of F4Us (above). Commissioned in April 1945, too late for World War 2, the *Boxer* carried more than 100 planes and earned eight battle stars for "gallant service" in Korea.

ABOVE: NATIONAL ARCHIVES

<

MISSION TO MOSCOW

The Cold War was chilly indeed for this flight crew (left) at the Air Force base in Westover, Massachusetts, in 1959. Some 65 Strategic Air Command sites across the nation were on 7-day, 24-hour alert, and drills to keep the men on fighting edge were frequent. Here they sprint to their B-52 — already loaded with thermonuclear weapons and prepared to take off within 15 minutes.

LEFT: BOB ISEAR

MINUTEMAN'S MEN

In 1964 these two Air Force captains (left) were in charge of a nuclear-armed intercontinental ballistic missile, called the Minuteman, aimed at the Soviet Union. Their tour of duty: 24 hours spent in a concrete control room 60 feet below the South Dakota prairie. Development of the ICBM program began in 1954; at the height of tension with Moscow, more than 1,200 missiles were at the ready.

BILL RAY / LIFE / TIMEPIX

AIR VIETNAM

Helicopters were the vehicle of choice in Vietnam. In 1968 Chinooks (below top) were ideal for putting men into hot combat situations fast and bringing the wounded out. To support GIs on the ground, the slow but accurate prop-driven Skyraider could shower suspected Vietcong hideouts with phosphorous bombs (below bottom) or napalm.

BELOW TOP: LARRY BURROWS,
© LARRY BURROWS COLLECTION
BELOW BOTTOM: LARRY BURROWS / LIFE / TIMEPIX

DESERT STORMED

The U.S. Air Force, aided by pilots from nine other countries, opened the Persian Gulf War in January 1991 with massive air strikes against Iraq, which had invaded Kuwait the year before— 18,000 tons of explosives in 14 hours. Because radar systems in Baghdad had been crippled, anti-aircraft batteries lit up the night sky (top right) but seldom reached their targets. In the war, ground fire would claim only 38 planes. Allied airmen, by contrast, had far more accurate weapons. The so-called smart bomb, steered by infrared- and TV-guidance systems, blasted this hole in a Baghdad building (right). The attack fleet included state-of-the-art fighter-bombers as well as the F-14 Tomcat (below), a redoubtable two-seater jet that has not been produced since 1992.

TOP RIGHT: CORBIS / SYGMA
RIGHT: NOEL QUIDU / LIAISON AGENCY
BELOW: TODD BUCHANAN

PLANE SIGHT

Refueling in midair on a peacekeeping mission over Yugoslavia in 1999, this B-2 bomber (above) maintained a deliberately high profile. Otherwise, it can be hard to find. Its curved surface is designed to elude radar, and its black paint disappears into the night. That explains why this $1.3 billion piece of machinery is better known as the Stealth.

ABOVE: U.S. AIR FORCE

SPACE SHIELD

Tested again in mid-2001 in the Pacific after some poor showings in previous years, America's defense against enemy missiles performed better (right). President Bush is a firm advocate of such a national missile defense system, although it would violate a landmark treaty signed by the U.S. and the Soviet Union in 1972. Moscow is wary about its deployment.

RIGHT: BRYAN CHAN /
LOS ANGELES TIMES

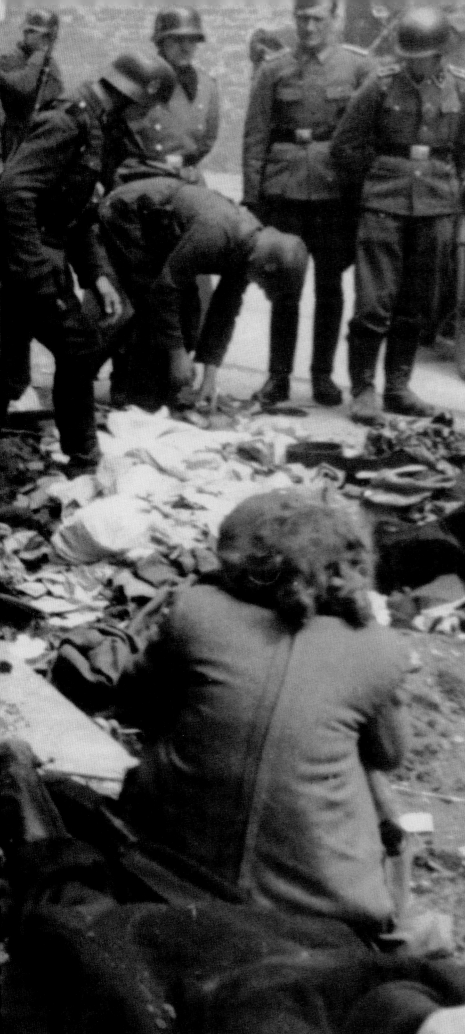

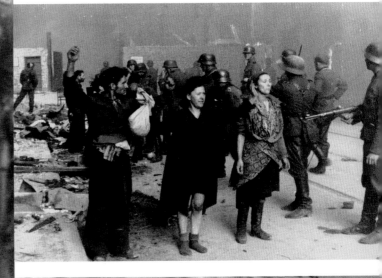

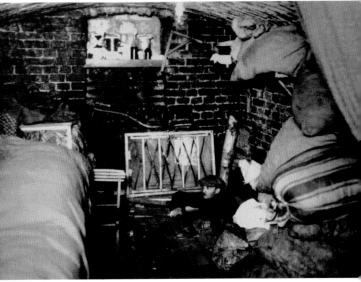

Revolt in the Warsaw Ghetto

Decimated by disease and deportation, the Jews of the Warsaw ghetto had nothing to lose by striking back. On April 19, when German soldiers came to wipe out the sealed, 840-acre district, some 1,500 residents, armed with improvised bombs and a meager cache of weapons, fought them off. The doomed uprising lasted nearly a month. One by one, the guerrillas were captured (left and top) or forced out of their subterranean hiding places (above).

WEAPONS SEARCH

The Germans patrolled the Warsaw ghetto in small squads, searching Jews for weapons. The comparatively privileged executives of the Brauer armaments factory, dressed formally in suits and armbands, submit to an inspection outside the plant (right), while their less fortunate neighbors are lined up against a wall (below). Given the odds against their survival, rebellion leaders had not planned a retreat. By May 16, when the last survivors ran out of ammunition and the ghetto was burned, nearly 60,000 residents had been killed or shipped to concentration camps, where many were murdered on arrival. Some fighters took their own lives before they could be seized; a handful escaped through the sewer system to the countryside.

ALL: NATIONAL ARCHIVES, COURTESY USHMM

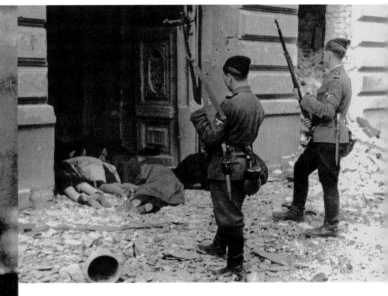

AT DEATH'S DOOR

The Nazis made chilling use of anti-Semitism and ethnic hatreds in occupied lands. The uniformed men surveying these corpses (above) were Ukrainian recruits, known as *askaris*, or parasites, imported to Poland by the SS to help suppress the Warsaw ghetto. Other Ukrainians worked as concentration-camp guards. These foreigners often exceeded the Nazis in viciousness.

CAUTIOUS MESS CALL

In a bit of grotesque timing, members of the SS temporarily halt the killing for a wary lunch break. They had every reason to be watchful. Although the ghetto's defenders were vastly overmatched, they are thought to have killed many more than the official German death toll of 16 soldiers.

THE ALEUTIANS

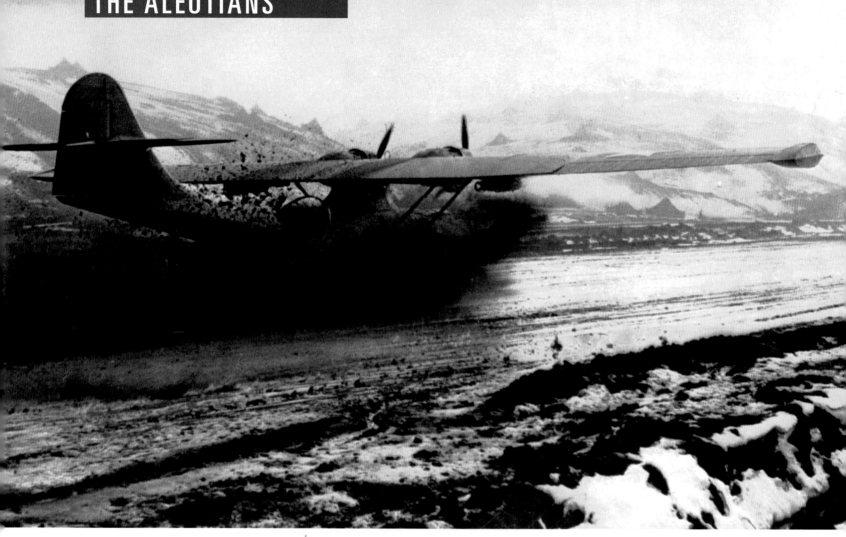

DIRTY BUSINESS

The Japanese invaded two islands, Attu and Kiska, in the Alaskan archipelago in 1942 — mostly to annoy and divert the U.S. A year later Attu was taken back in a sharp 18-day battle; Kiska was abandoned. Operations in the Aleutians were hampered by incessantly foul weather. Fortunately, a Catalina flying boat (above) was uniquely equipped to land on this mud-covered runway.

ABOVE: HULTON / ARCHIVE

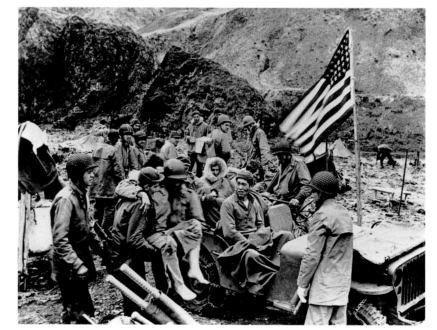

LOST FOOTING

The cold was as dangerous as the enemy on Attu, and the Army's ordinary leather boots were not meant for frigid, water-filled foxholes. Hundreds of members of the 7th Infantry Division were immobilized by frostbite, trench foot and gangrene. Too hurt to put on shoes, let alone walk, this GI (left) was carried to a jeep by a pair of medics.

LEFT: IMPERIAL WAR MUSEUM EM 5984

NO PRISONERS

The Japanese had nowhere to retreat on Attu, so they fought and died or committed suicide with grenades. Several U.S. intelligence officers who tried to talk them into surrendering were killed in the effort. Of the Japanese garrison of 2,500, only 29 survived. One who did not was this soldier (below), found in a dugout after a cautious U.S. search (right). He had been wounded, had bandaged his chest with scraps of cloth and fought to the death.

BELOW: U.S. ARMY
RIGHT: CORBIS / BETTMANN

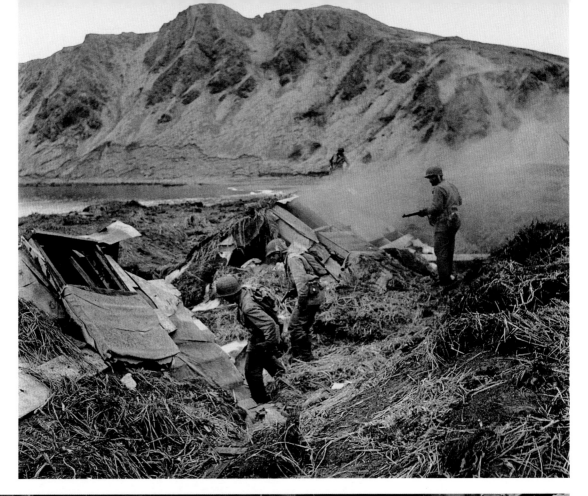

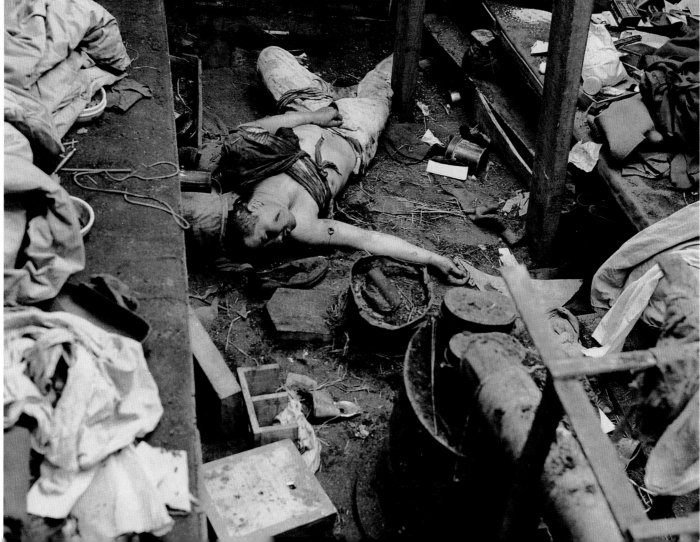

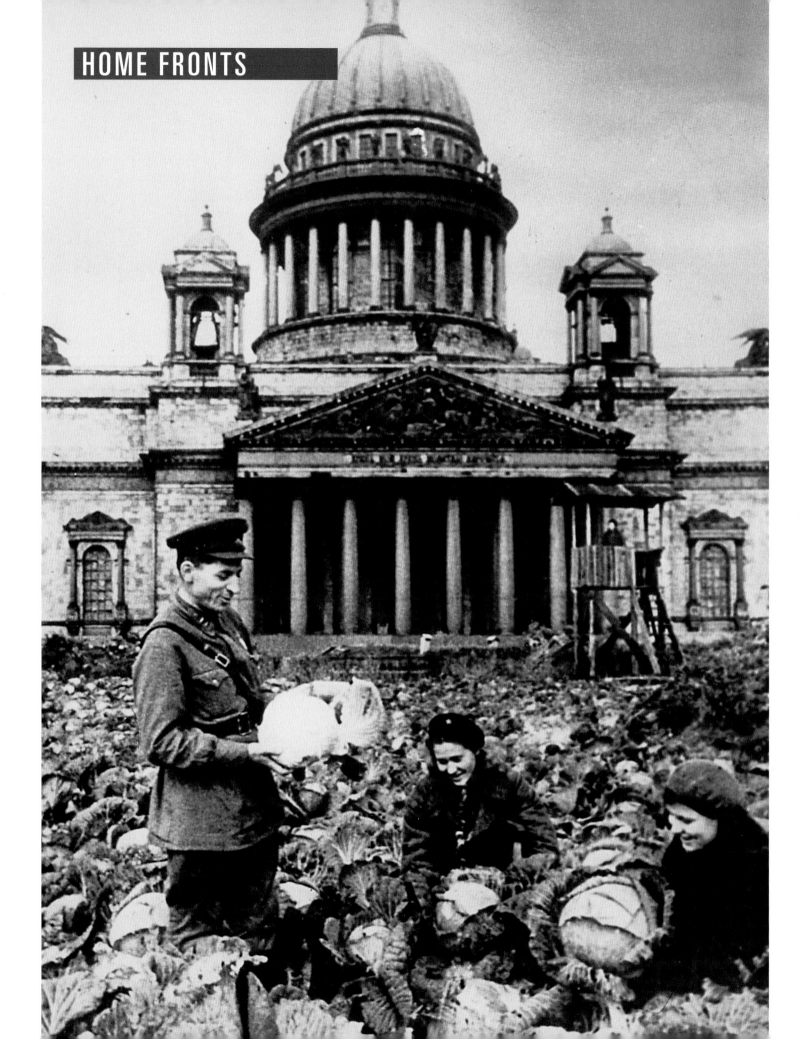

URBAN GROWTH

Wartime shortages prompted city dwellers across the globe to grow their own produce. America called these urban plots victory gardens, and home-ec students at a Portland, Oregon, high school (right) tilled their lawn en masse (and earned academic credit). In Leningrad the square in front of St. Isaac's Cathedral (left) sprouted a bumper crop of cabbage, a Russian staple prized for its vitamin C. Tokyo residents prepared a rice paddy beside the building that housed the Japanese legislature (below left). In London an apartment dweller rolled up his sleeves to tend his rooftop vegetables (below right).

LEFT: DAVID KING COLLECTION
RIGHT: RALPH VINCENT /
PORTLAND JOURNAL
BELOW LEFT AND RIGHT:
MAINICHI

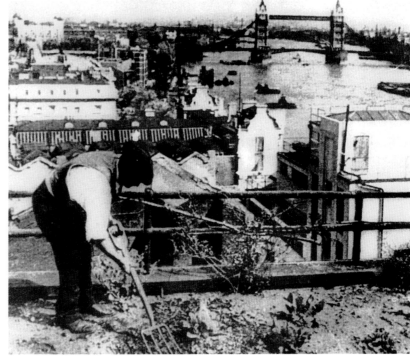

EXIT FIGHTING

Rommel and his army retreated to the mountains of Tunisia to regroup with other German divisions. He gained ground in February, then lost his nerve and withdrew to the south, where he took a drubbing from the British. Devastated, he flew to Berlin to ask Hitler to pull out of North Africa, and was promptly put on sick leave. Without their leader, German forces still inflicted plenty of damage, especially among inexperienced U.S. troops. The American patrol vehicles at left were caught on a road by a Luftwaffe bomber. But improved Sherman tanks with 75-mm guns (inset) helped neutralize the Panzers. So did the arrival of a tough American General named George Patton.

LEFT: BROWN BROTHERS
INSET: ELIOT ELISOFON / LIFE / TIMEPIX

FACES OF DEFEAT

Trapped between Allied armies, Axis forces in Tunisia ran out of fuel, ammunition and food. To comply with Hitler's orders to fight to the last bullet, General Jurgen von Arnim, Rommel's successor, pointed his seven remaining tanks at an out-of-range target and told the gunners to fire until empty. Then he ordered all equipment to be burned, and surrendered 275,000 men in mid-May. Some, like these Italian captives (top right), were only too happy to realize they would survive the war. Others reacted with bitter formality, like the German POW being interrogated (right) by an American intelligence officer.

TOP AND BOTTOM RIGHT:
UNDERWOOD PHOTO ARCHIVES

UNITED STATES

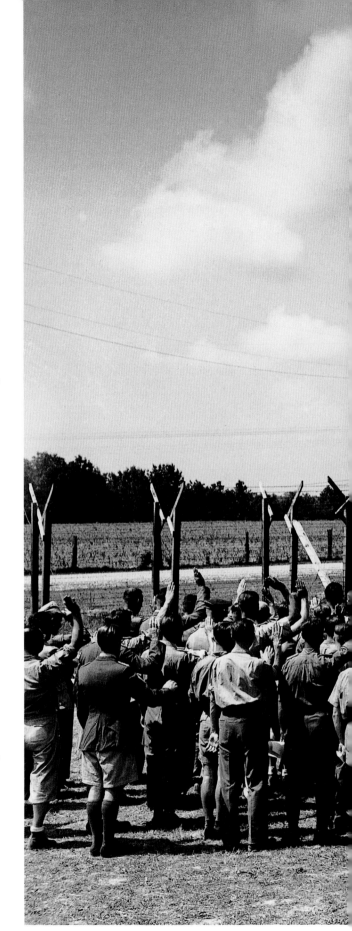

<

HOME SWEET HOME

Axis prisoners of war poured into the United States — 163,000 by September. They were housed in military-style camps all over the country. The barracks were spare but comfortable, and pin-ups (some of girlfriends, some of Hollywood stars) were allowed (left). Their kitchens were filled with American canned goods; their cooks could also prepare home-style breads and dishes as long as costs were comparable to American menus (middle left). Prisoners worked on nearby farms and ranches for 80 cents a day. Some volunteered for other assignments, like filling sandbags when the Mississippi River was flooding (bottom left). Identified by the "PW" on their jackets, they worked under the supervision of the Army Corps of Engineers. Life was good enough for most prisoners that very few tried to escape.

TOP AND MIDDLE LEFT: U.S. ARMY; BOTTOM LEFT: WIDE WORLD

>

HEIL? YES!

This astonishing view of German POWs giving the Nazi salute to a swastika flag (right) could happen only in America. Camp regulations allowed inmates more freedom of speech and assembly than many had enjoyed at home. They could send and receive mail. And if a soldier died in detention, he could be buried in accordance with Nazi protocol.

RIGHT: ED CLARK / LIFE / TIMEPIX

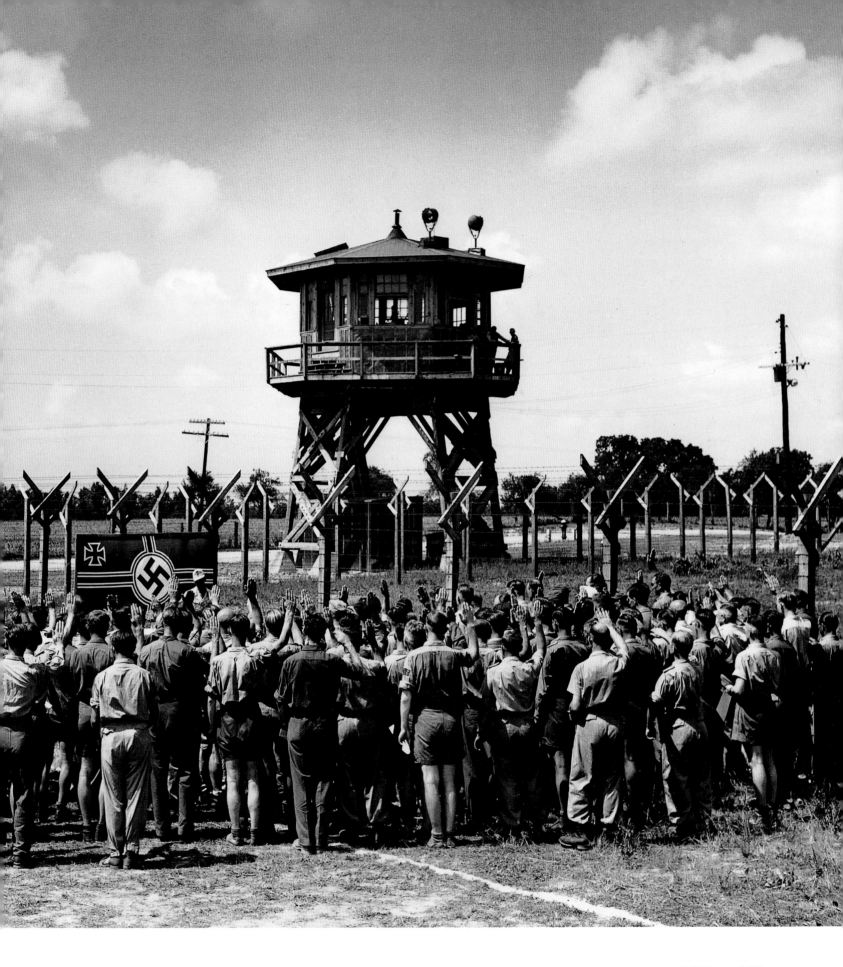

Sighted Sub, Sank Same

Operating in highly effective packs, Nazi submarines destroyed North American shipping almost at will. Then British cryptographers cracked Enigma, the code used by the German military. The Allies began rerouting convoys and finding and attacking subs with long-range planes. Pilots sank the sub above and peppered another with gunfire, near right. Opposite, clockwise from top left: A bomb sends up a deadly spray; sailors abandon their boat; a lone seaman stands helplessly on a battered deck. Of Germany's 39,000 submariners, an estimated 33,000 were killed or taken prisoner. By mid-1943 the Nazis had lost the Battle of the Atlantic.

ABOVE AND NEAR RIGHT: MANSELL COLLECTION / TIMEPIX
OPPOSITE, CLOCKWISE FROM TOP LEFT: U.S. NAVY;
PUBLIC RECORDS OFFICE, LONDON; U.S. COAST GUARD

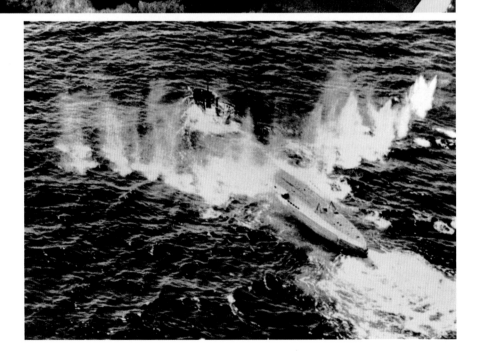

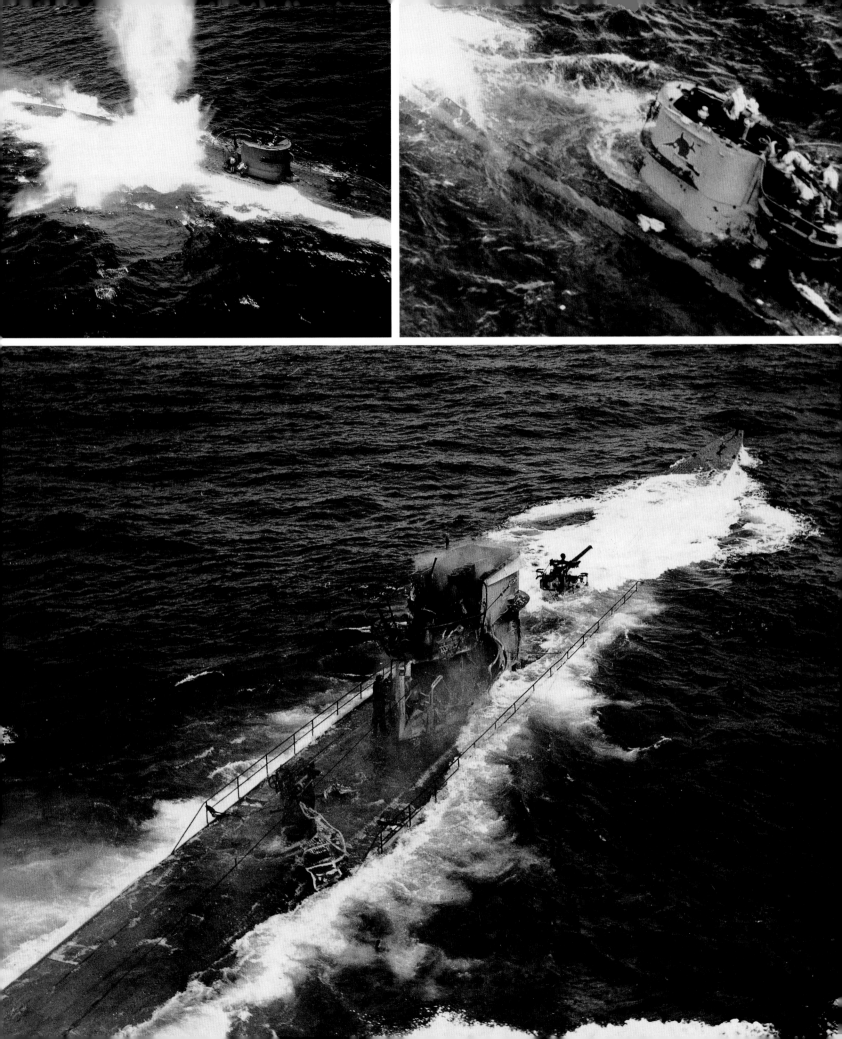

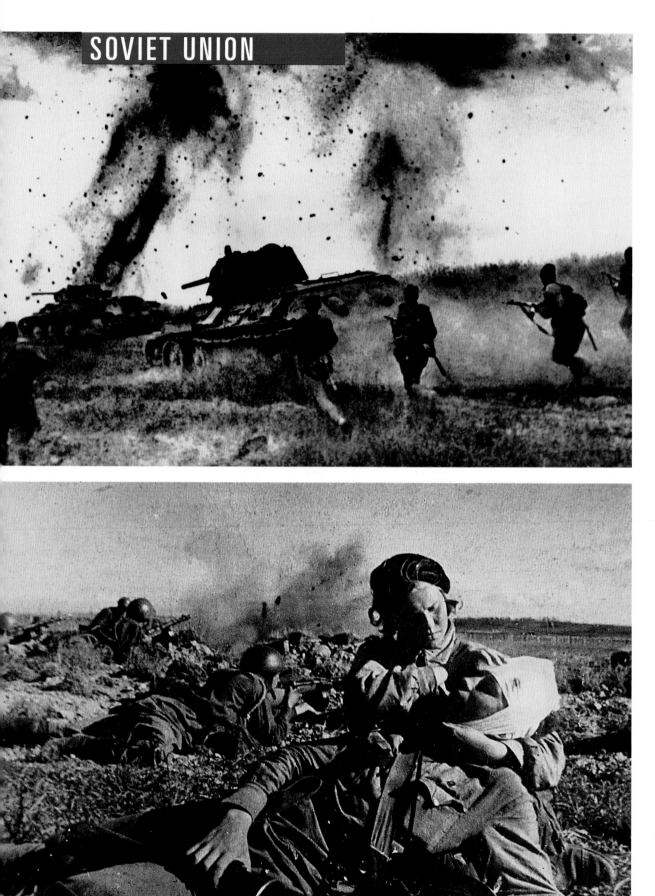

SOVIET UNION

FALLEN CITADEL

A Soviet holdout that faced German occupation on three sides, the small city of Kursk seemed the ideal place for the Nazis to launch Citadel, their renewed Eastern campaign. Hitler's generals assured him their armored divisions would make quick work of the isolated city. But the Führer squandered too much time waiting for his factories to produce improved tanks and weapons.

In the interim the Red Army, alerted by its spies to the impending attack, prepared elaborate defenses — anti-tank trenches and a dense network of mines. The Russians had upgraded equipment of their own, including superior tanks (left) as well as the most powerful massed artillery wielded by any nation. After attacking in early July, the Germans made only halting progress, stymied by Soviet forces in the colossal armored clash at Kursk.

The Red Army absorbed high casualties (at left, a nurse comforts a wounded soldier at the front) but kept fighting. Worse yet for the Nazis, their new Panther tank, deployed prematurely, suffered mechanical failures, and a self-propelled 88-mm gun proved ineffective in close combat. Discouraged by early results, Hitler refused to provide reserve troops, sending them instead to Italy. The dejected artillery officer (right), his gun destroyed and comrade killed, symbolized the German debacle.

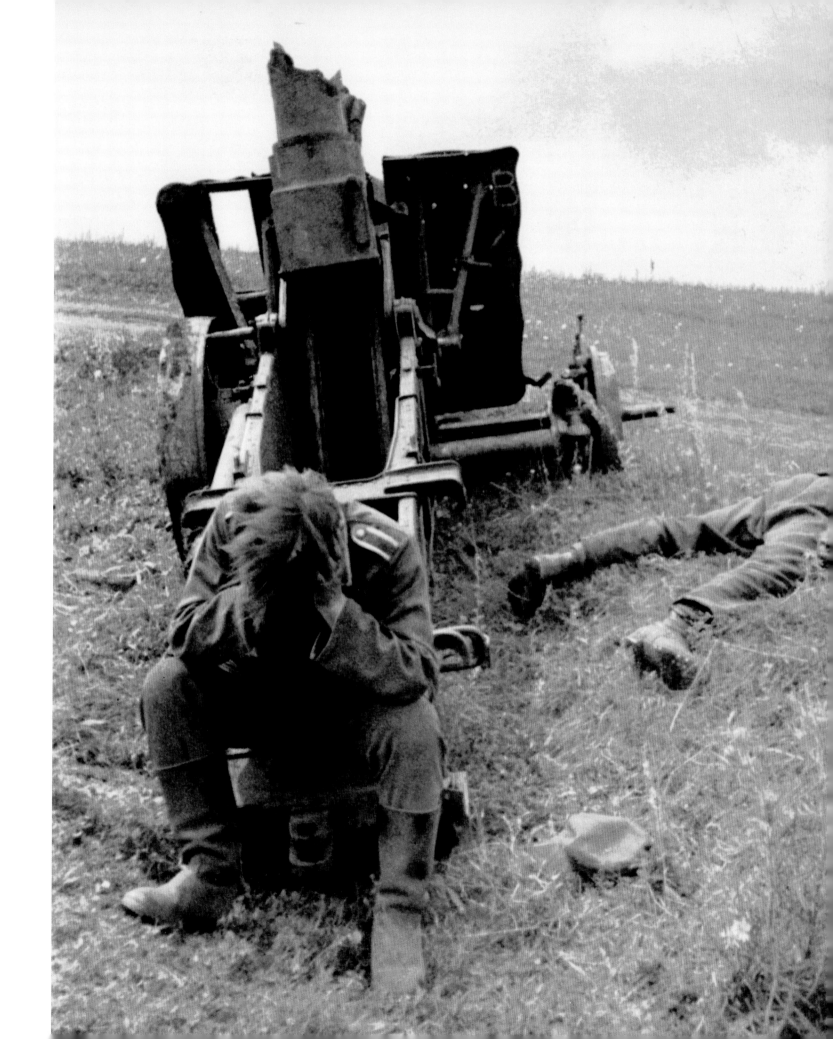

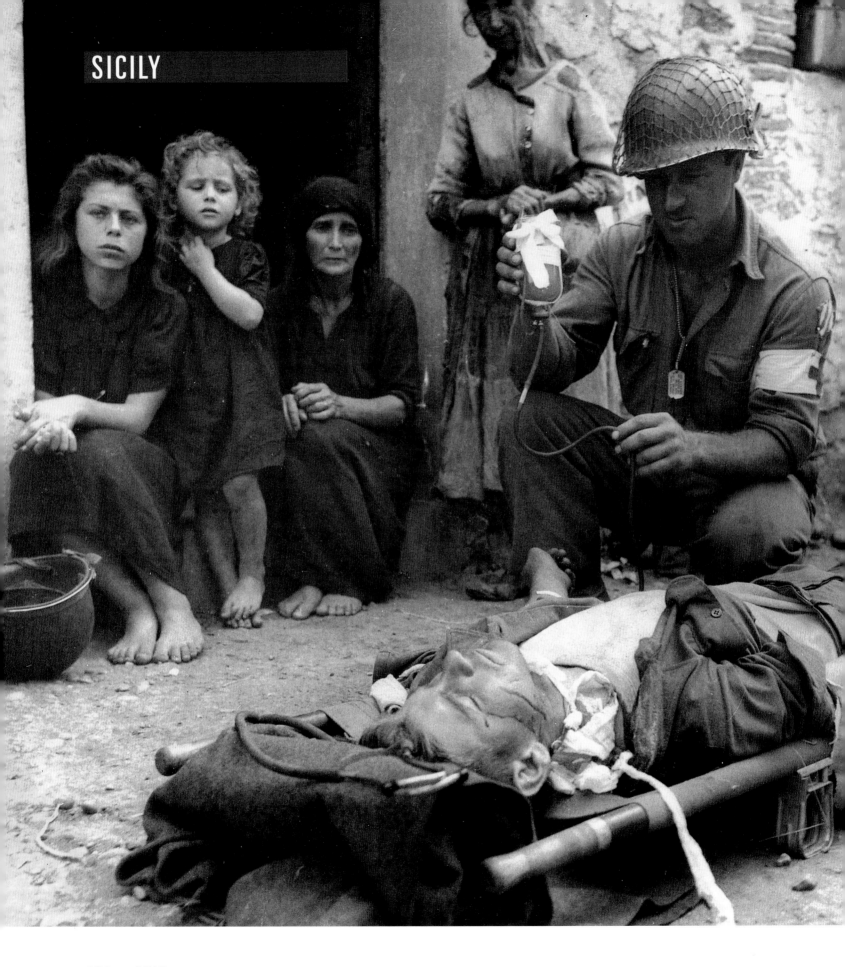

HOUSE CALL

The Allies were not yet ready to invade France, so the U.S. agreed to open a second front of sorts by taking Sicily. It was the largest amphibious assault in history. Fighting was fierce but sporadic. At left, three generations of a Sicilian family, in mourning black, watch sympathetically as a medic drips plasma into a wounded American — a life-saving technique developed only a few years earlier.

LEFT: NATIONAL ARCHIVES

FIRING LINE

Sicily was meant to be a platform for further action in the Mediterranean. Under camouflage netting (right) Yank artillerymen aim their 155-mm howitzer across the Straits of Messina at targets on the Italian mainland. British troops joined General Patton's Seventh Army in conquering the big island in 38 days.

TOP RIGHT: CORBIS / BETTMANN

SURF AND TURF

Sicily's rugged landscape required pack mules (near right), the original all-terrain vehicles. They were essential in the campaign to overcome the stubborn German rear-guard action in the mountains. Citizens of the island, hard-pressed by the war, viewed Allied troops as liberators. In gratitude, residents of Catania draped a British soldier and his rifle with flowers (far right).

NEAR RIGHT: U.S. SIGNAL CORPS; FAR RIGHT: CORBIS / BETTMANN

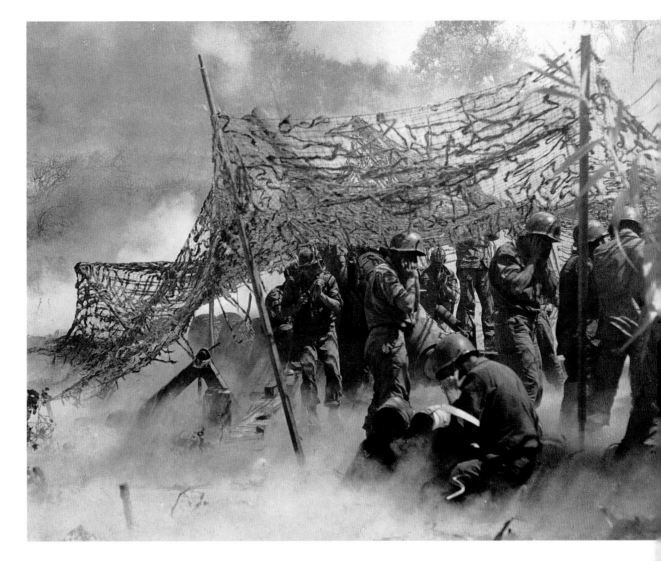

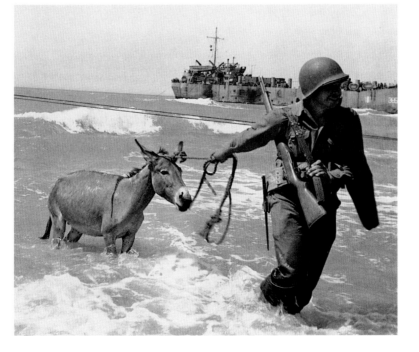

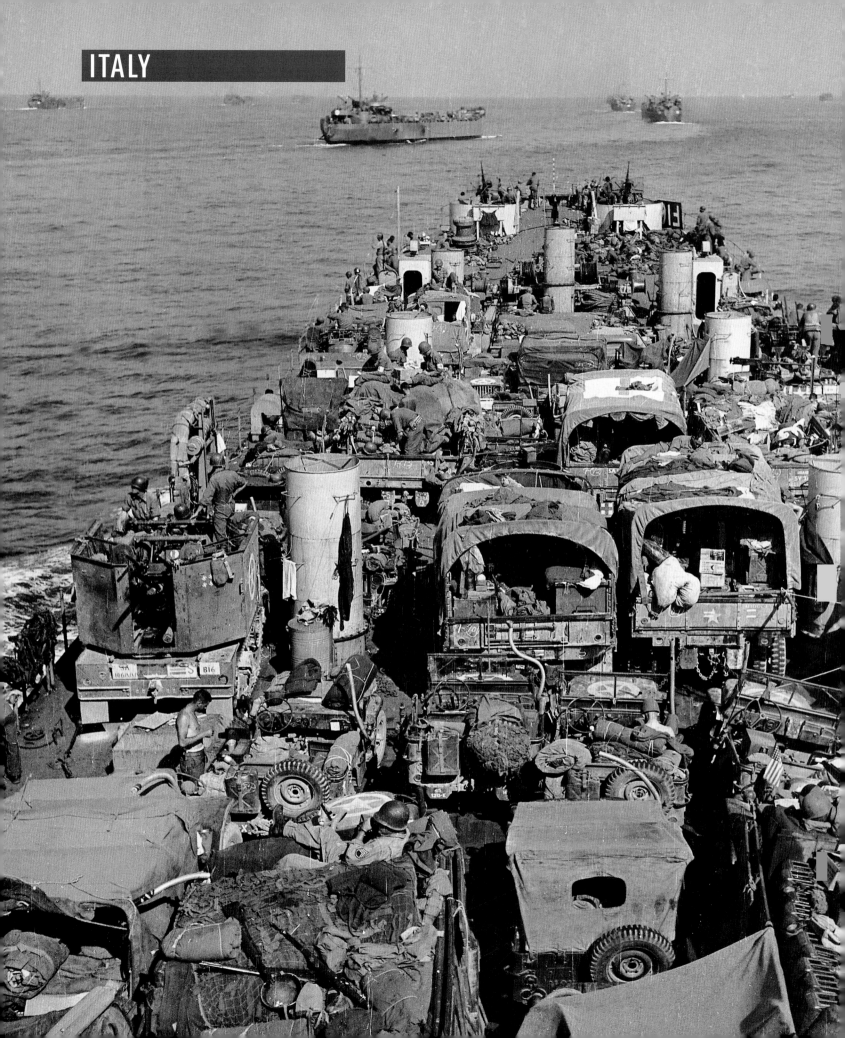

INTO THE BOOT

An American landing ship with every inch of deck space filled (plus a sleeping GI or two, left) heads from Sicily to the historic peninsula. Invading Italy in September was complicated by the country's arrest of Mussolini and its withdrawal from the Axis. The Nazis, who occupied much of Italy, resolved to fight.

Around Naples, Germans and Americans were locked in furious combat, but other Allied forces were advancing in the South. Italians were generally happy to see the Allies (who endeared themselves by deputizing pint-size MPs, above). In contrast, the retreating Germans leveled the countryside. Historic Castel di Sangro (top right) was pulverized and impoverished after the Wehrmacht carried away all the food and valuables it could find.

Angry Italians needed little encouragement to attack the fleeing Nazis. On Corsica (right), local riflemen joined the Allied effort to liberate their island home.

LEFT: GEORGE RODGER / LIFE / TIMEPIX; ABOVE: NATIONAL ARCHIVES; TOP RIGHT: IMPERIAL WAR MUSEUM NA 9665; RIGHT: HULTON / ARCHIVE

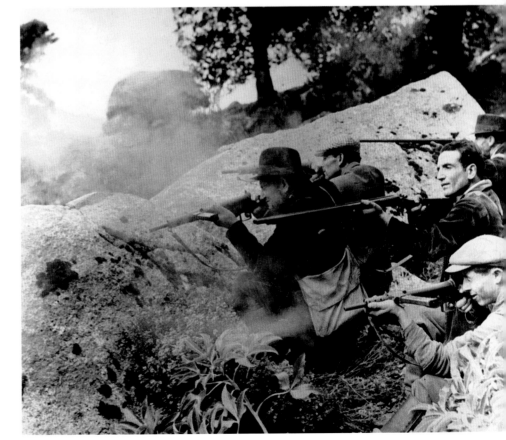

BENITO MUSSOLINI

Fascist Father

An early brute, Mussolini was expelled from two schools for stabbing classmates with a penknife. At 19 he fled to Switzerland to avoid military service. By 1904, when he was deported home, he had discovered his calling: extreme politics. Nominally a Socialist, like his father, he broke with the party's position on staying out of World War 1 and spent 17 months at the front. Sidelined by wounds, he reinvented himself as a Rightist and founded the ultranationalist Fascist party. In 1922 he installed himself as premier. His career inspired Hitler, 49, who toured Florence in 1938 as Il Duce's protégé (below).

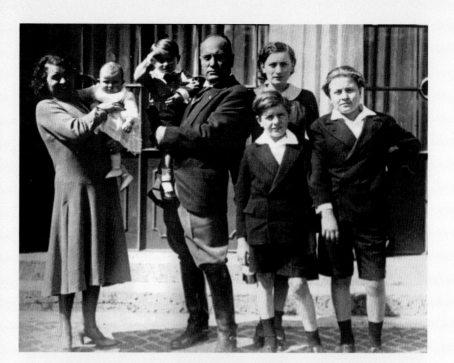

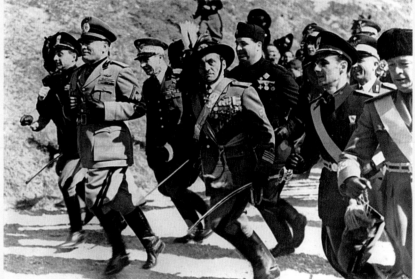

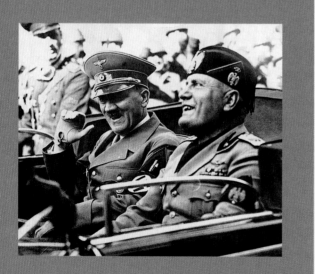

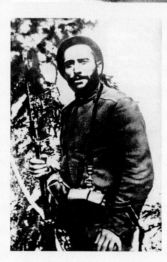

Sire of the New Italy

Mussolini played father to his country — and to his own brood (top) in 1930. They are, from left, his wife, Rachele, 38, and children Anna Maria, Romano, Vittorio, Edda and Bruno. Edda's husband became foreign minister and was later executed at the dictator's order. Proud of his medal-strewn uniforms and his physique, the dictator displayed both at every opportunity, as in this 1940 jog with his officers (above). His own military career ended in 1917 as a sharpshooter in the trenches (left).

TOP AND FAR LEFT: WIDE WORLD
ABOVE: HULTON / ARCHIVE
NEAR LEFT: PIX INC. / TIMEPIX

Dishonor and Death

Il Duce chose a placid mount (right) for this triumphant portrait in 1940. No rearing stallions for him. He claimed that his 1936 defeat of Ethiopia and occupation of territories conquered by the Axis had rebuilt the Roman Empire. But military humiliations would follow. After the fall of Sicily, in 1943, he was arrested, and his country broke with Germany. Still, Hitler sent commandos to rescue the civvies-clad Mussolini from a ski lodge (below), and he became the puppet leader of Italian provinces still occupied by the Germans. The once powerful dictator was captured by partisans two years later and, along with his mistress, brutally murdered.

RIGHT: PIX INC. / TIMEPIX
BELOW: WIDE WORLD

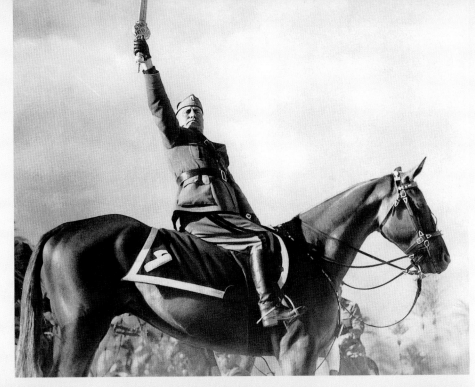

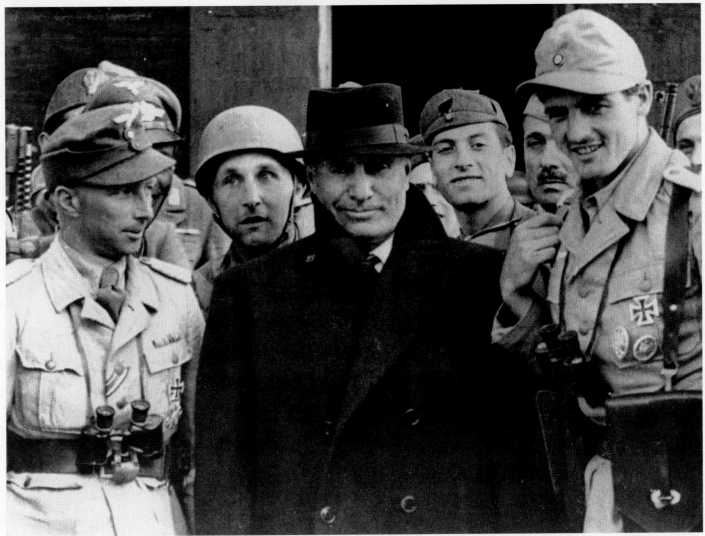

TARAWA

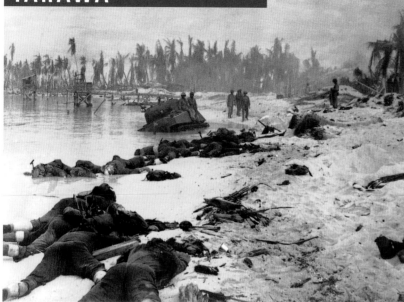

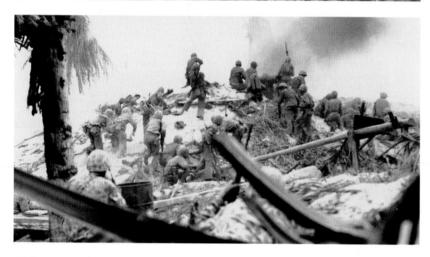

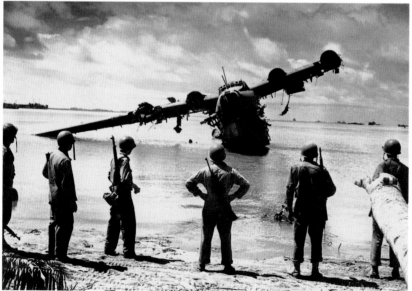

SEMPER FIDELIS

Nature set the Gilbert Islands in protective beds of spiky coral. Then the Japanese, who seized the Central Pacific chain in 1941, introduced some military improvements. They reinforced Tarawa, the largest atoll, with mines, barbed wire, massive artillery and concrete and steel pillboxes.

The Marines invaded in late November 1943, and the first wave died by the score (left) when their landing craft ran aground. Those who made it past the beach had to regroup in the open, because the flat, sandy terrain offered no place to hide. Next, they had to storm Japanese bunkers that had proved impenetrable to naval and aerial bombardment (middle left), though some enemy aircraft were destroyed (bottom left). Working as a team (right) one Marine throws a grenade as his buddy prepares to attack.

The casualties on both sides were grim. Of the 4,800 defenders only 17 were taken alive. America suffered about 1,000 dead and 2,000 wounded, numbers that aroused controversy at home. But the battle put the Allies on the edge of the western Pacific and proved conclusively that a well-planned, heavily armed amphibious assault could succeed, no matter how savage the opposition.

TOP LEFT: U.S. NAVY
MIDDLE LEFT AND RIGHT:
BROWN BROTHERS
BOTTOM LEFT: NATIONAL
ARCHIVES

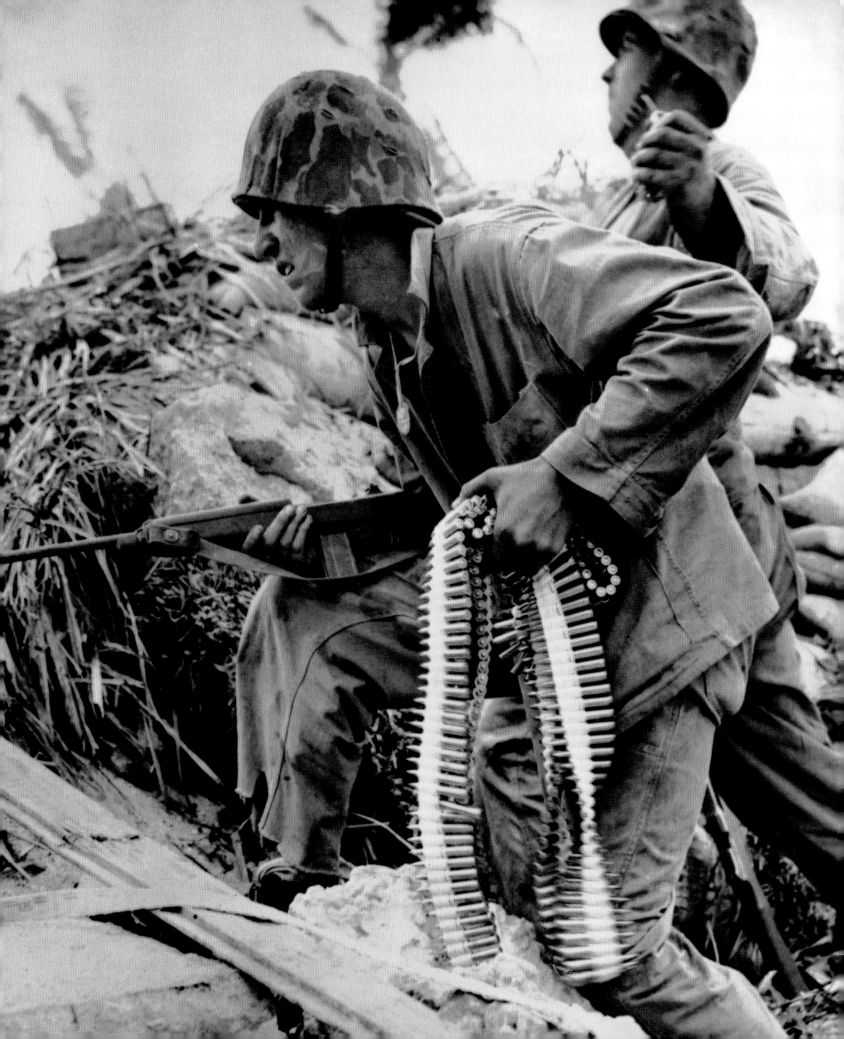

SOUTH PACIFIC

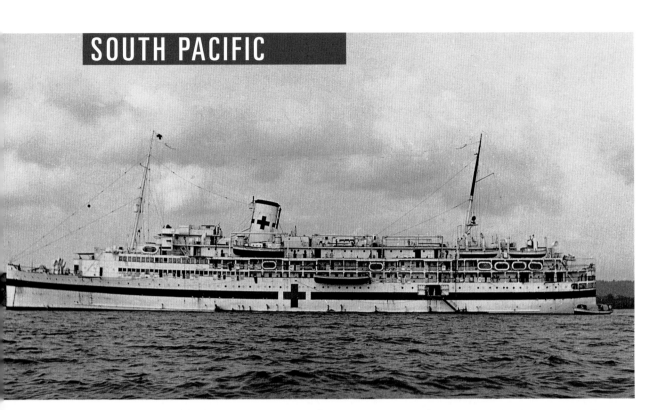

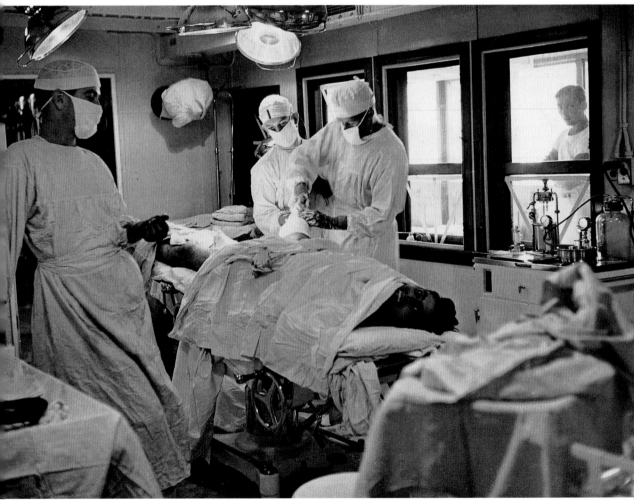

MISSION OF MERCY

Unarmed, unescorted, painted a conspicuous white with a green stripe and a red cross, the hospital ship *Solace* (left) cruised the Pacific. It was one of 15 deployed by the Navy to minister to wounded U.S. sailors and Marines. The converted ocean liner boasted an X-ray room, a whirlpool bath, a clinical lab stocked with rabbits and guinea pigs and a pair of operating rooms ready for 24-hour service.

In one OR (bottom left), a doctor sets a compound fracture. Helping to apply the cast is a pharmacist's mate, a Navy petty officer trained in basic medical skills. Treatment aboard the floating hospital, as its name indicates, was as comforting as conditions permitted. A Marine with serious eye injuries manages to enjoy the ice cream served every day (right), while another casualty, his face and arms seared in battle (bottom near right), simply tries to rest.

A total of 400 patients could be accommodated in the double layer of bunks hung in 72 wards, each watched over by a nurse (bottom far right). When wards were full, the ship's crew gave their bunks to the wounded and slept on cots on the deck.

ALL: RALPH MORSE / LIFE / TIMEPIX

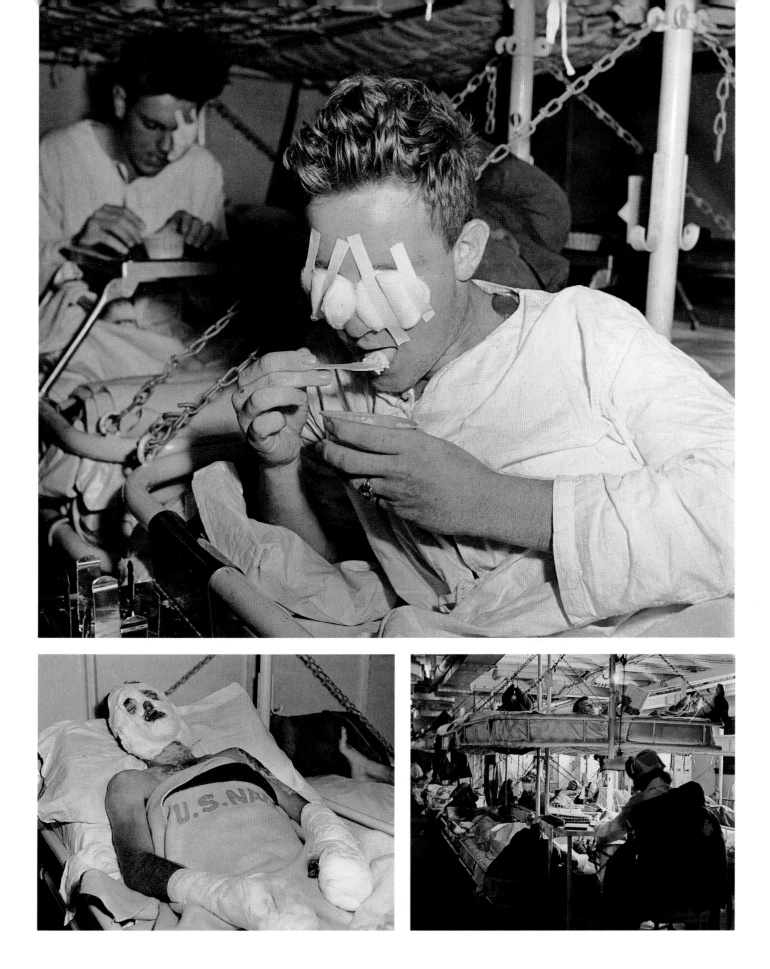

BIOGRAPHY

RICHARD IRA BONG

American Eagle

Sky-struck since his childhood on a Wisconsin farm, Richard Ira Bong, the top U.S. fighter pilot in the war, earned his pilot's license before enlisting in the Army Air Corps. In flight training in California he annoyed — and impressed — his superiors with stunts like buzzing San Francisco office buildings and blowing laundry off an Oakland clothesline. His mischief paid off in the Pacific in 1943: In merely two weeks of combat Bong downed five Japanese planes, earning himself "ace" status. By early November he was up to 21 victories, a feat that earned him a trip back home, where he tried out the governor's desk (above) in Madison before returning to the Pacific.

HOME IS THE HUNTER

An avid hunter, Bong scored a pair of six-point deer (above) while on leave. In the air, the pilot's aim seemed a bit less confident. To ensure nailing his target, he would zoom in perilously close, fire and peel away, defended by his wingmen. In the South Pacific, Bong adorned his P-38 fighter (left) with the image of his girlfriend, Marjorie Vattendall, 19. They married in February 1945 and settled in Ohio, where Bong was assigned to test new aircraft. A week before the war ended, the man who survived 200 combat missions and scored a record 40 kills, died at age 24, when his experimental jet crashed on takeoff.

ABOVE: COURTESY THE BONG FAMILY; LEFT: U.S. ARMY

SOVIET UNION

Reclaiming the Motherland

Pressed by the Red Army, the Nazis retreated from the Soviet Union, back toward Germany. As they left, they inflicted their usual valedictory damages and atrocities. Soon, dispossessed families began returning to the embers of their villages. Below, a milk cow serves as a beast of burden for the single suitcase of a barefoot mother and her children in Belorussia. At right, peasants gather in the ruined foundation of a house in the Orlovsk region to share a hasty meal. At bottom near right, a woman caresses the body of her young son, killed by Germans in Poltava, and bottom far right, a father and son look for their home in the wreckage of Ulyanovo.

BELOW, RIGHT AND BOTTOM FAR RIGHT: DAVID KING COLLECTION
BOTTOM NEAR RIGHT: AKG PHOTOS

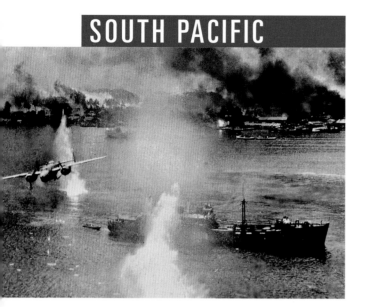

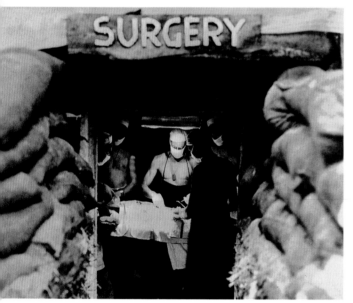

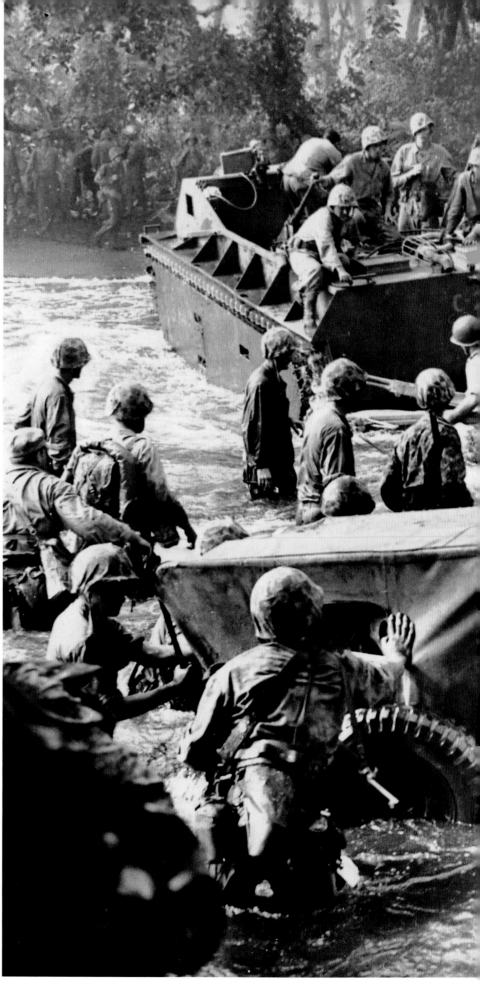

The Battle of New Britain

Building on victories in the Marshall Islands, the U.S set its sights on other enemy outposts in the Pacific. In early November, Army pilots bombed Rabaul (top), the massive Japanese harbor on the eastern tip of New Britain. Meanwhile, Marine and Army troops had gained a beachhead on nearby Bougainville — the largest island in the Solomon chain — and established an underground operating room (above). Then Marines swarmed ashore at Cape Gloucester (right), on the western end of New Britain, eventually isolating Rabaul. The march toward the Philippines continued.

TOP: IMPERIAL WAR MUSEUM NYF 9646
ABOVE: IMPERIAL WAR MUSEUM NYF 18408
RIGHT: IMPERIAL WAR MUSEUM NYF 13041

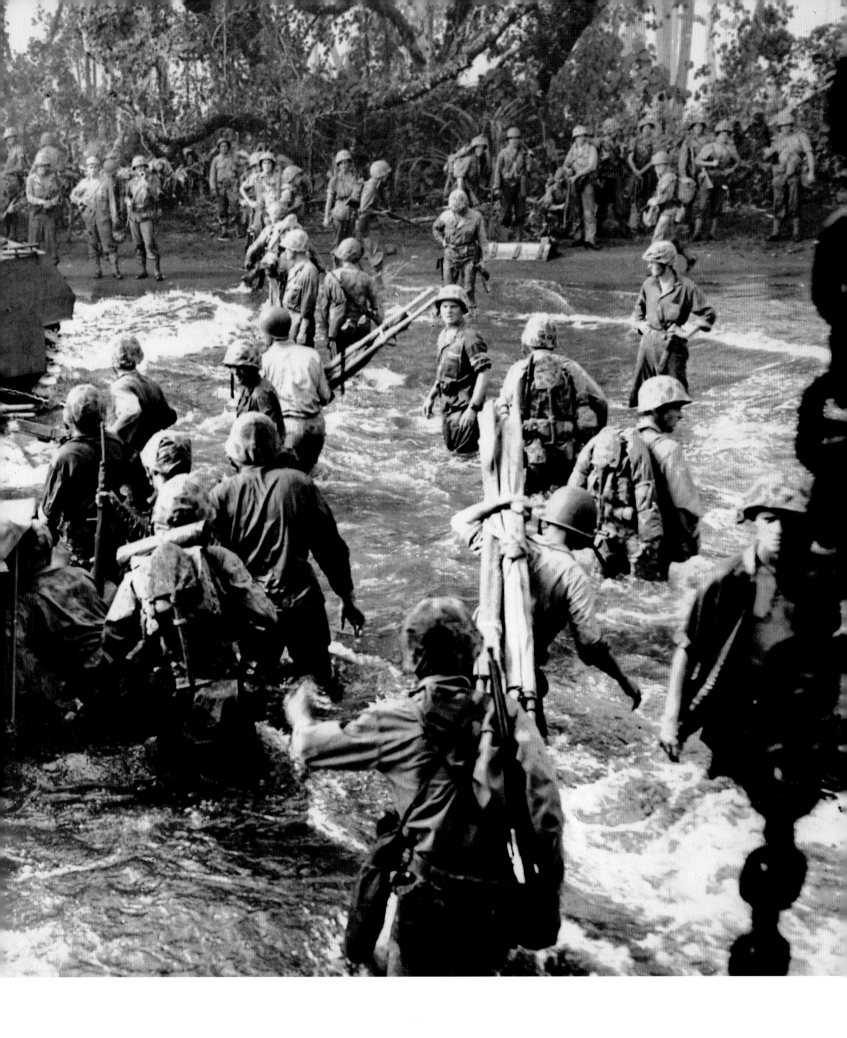

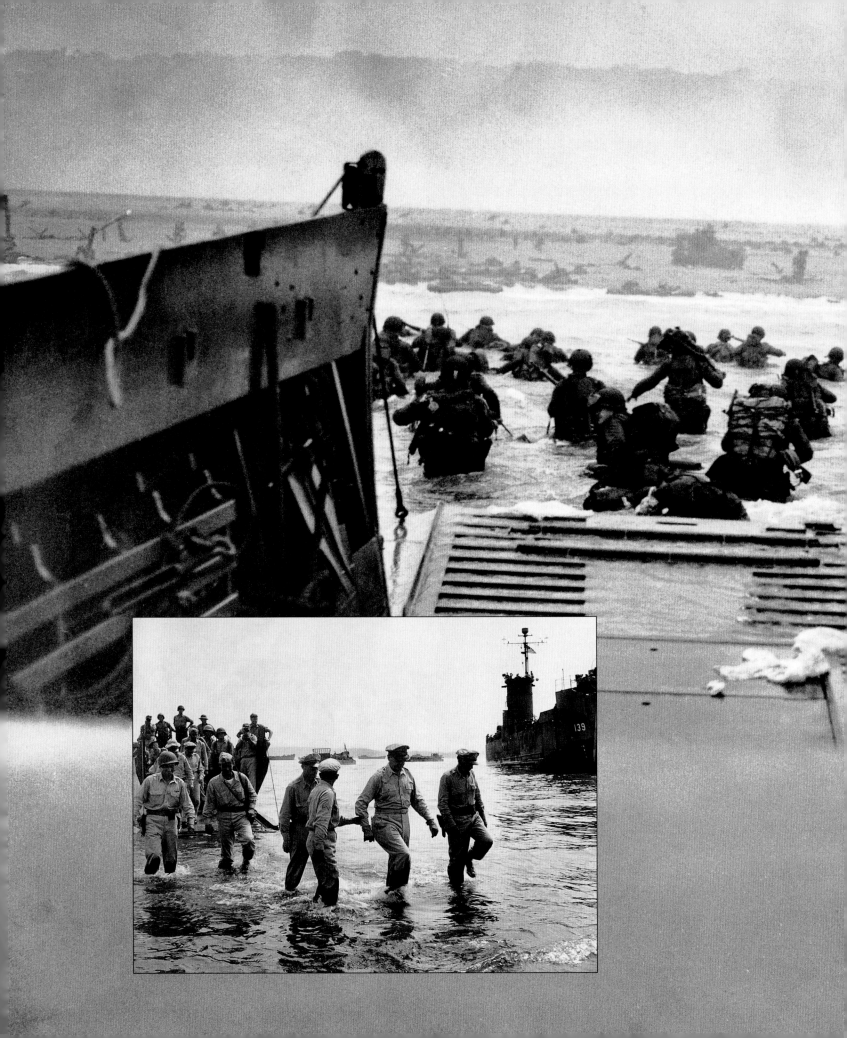

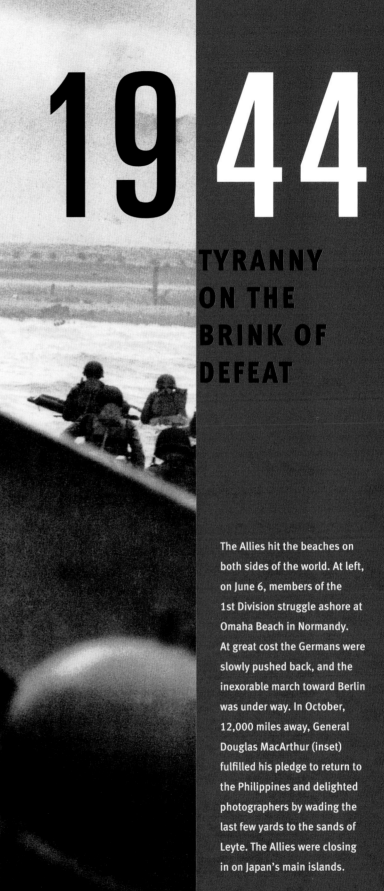

19 44

TYRANNY ON THE BRINK OF DEFEAT

The Allies hit the beaches on both sides of the world. At left, on June 6, members of the 1st Division struggle ashore at Omaha Beach in Normandy. At great cost the Germans were slowly pushed back, and the inexorable march toward Berlin was under way. In October, 12,000 miles away, General Douglas MacArthur (inset) fulfilled his pledge to return to the Philippines and delighted photographers by wading the last few yards to the sands of Leyte. The Allies were closing in on Japan's main islands.

LEFT: NATIONAL ARCHIVES
INSET: CORBIS / BETTMANN

A Desperate Last-Ditch Resistance

by John Keegan

WHAT HAD BEGUN in September 1939 as a local north European conflict between Germany and Poland had swelled by January 1944 into a war that embraced four of the world's seven continents, all of its oceans and most of its states.

Millions had already died, and millions more were soon to die, the majority in the great land, air and sea offensives that the United States, the Soviet Union and the British Empire were poised to deliver against the conquered and occupied territories dominated by Germany and Japan.

The opponents of Germany and Japan had recovered from the shock of their enemies' opening successes, had built vast war industries, armies, navies and air forces and had already reoccupied parts of the territory lost in the early years. Most, however, remained in enemy hands.

In Asia the perimeter of the Japanese area of conquest still enclosed a majority of the islands of the western Pacific, the Dutch East Indies, Burma, Malaya and coastland China. In Europe the German front line still ran deep inside Russia, while all continental European states, except Switzerland, Sweden, Spain and Portugal, were either under German occupation or under governments allied to Germany. Only in Italy, which had changed sides in 1943, did the Western Allies, Britain and America have a foothold inside Hitler's Fortress Europe.

Yet the point of balance had been reached and was soon to tip sharply in the Allies' favor. Except in China, where the Japanese would win huge areas of rich agricultural land during 1944 in the so-called rice offensives mounted to feed the home population, the dictatorships had lost the power to stage large-scale attacks.

In March, the Japanese would attempt an invasion of India from Burma, but it was defeated by the heroic defense of the cities of Kohima and Imphal by the Fourteenth Army, composed of British and Indian troops. In the Pacific islands and the East Indies archipelago, the Japanese were everywhere on the defensive, against widespread attacks by the U.S. Army, Navy and Marine Corps and the forces of Australia and New Zealand.

Germany also had lost its capacity to threaten the survival of its opponents. At sea the U-boats had been defeated. On land the Red Army was on the offensive, while in Italy the Americans and British were pushing relentlessly up the peninsula.

In the air battle Hitler placed much hope in the pilotless weapons he was about to deploy against Britain's home islands. The Luftwaffe, however, had been reduced to a home defense force, as the strength of the American and British strategic bomber forces grew to a point at which they could fly devastating thousand-bomber raids against cities across the length and breadth of Germany by day and night.

A critical ingredient in the secret war against the Nazis was the parachuting of U.S. Office of Strategic Services agents, including this woman (above), into occupied France to aid the Resistance.

NATIONAL ARCHIVES

Britain and America had agreed at the Trident Conference, in May 1943, to launch a cross-Channel invasion in 1944. On June 6 an armada of 4,000 ships, overflown by 13,000 aircraft, landed 180,000 troops on beaches in Normandy. The Germans, taken by surprise, counterattacked, but by June 12 the bridgeheads had been consolidated and the invaders began to wear down the enemy's resistance.

On July 25 the Americans broke out, and on August 20 they and the British encircled the German Army at the town of Falaise. The survivors fled across the Seine with the Allies in close pursuit. Paris was liberated on August 25, Brussels on September 3. On August 15 a Franco-American force landed in the south of France. By October the Germans were defending their own western frontier.

In the east the Red Army had opened a major offensive, promised to the Western Allies, on June 22, the third anniversary of Hitler's attack on Russia. It resulted in the destruction of Army Group Center and led to an advance to Warsaw, where on August 1 the Polish Home Army rose in revolt against German occupation. Stalin cynically allowed the Germans to defeat the Warsaw uprising before liberating the rest of Poland, in which he installed a puppet Communist regime.

The disasters of June in the West and East triggered a military revolt in Germany. On July 20 a bomb placed by the leader of the conspiracy exploded under Hitler's conference table. He survived and took terrible reprisals. The failure of the bomb plot actually reinforced his power over his country, which remained absolute, even as his European empire crumbled. In September both Finland and Bulgaria made peace with Russia, Romania fell to

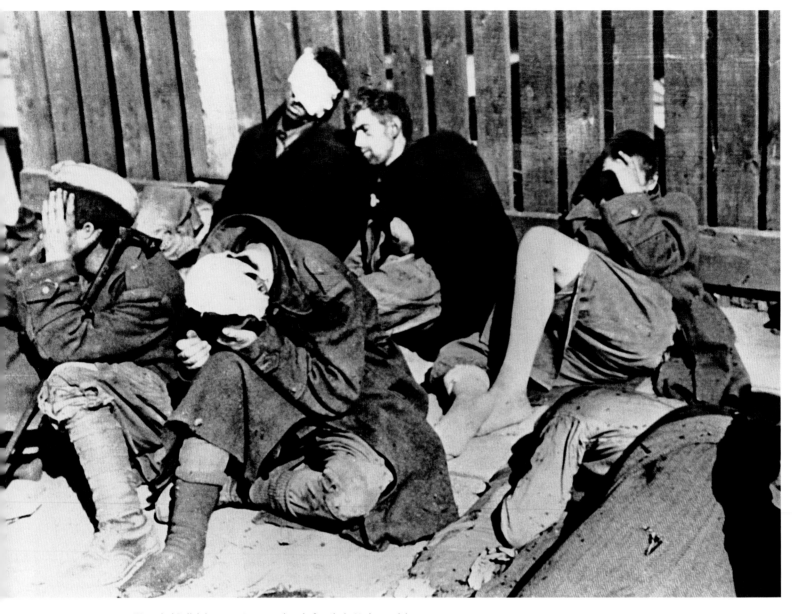

Wounded Polish insurgents surrendered after their 63-day uprising against the Nazis in Warsaw. The advancing Soviet Army had waited outside the city until the troublesome partisans were wiped out.

CORBIS / BETTMANN

the Red Army, and German troops evacuated Greece and Yugoslavia. By December most of Germany's conquests from 1939 to 1942 had been liberated, and the Allies were poised to invade Germany itself.

In the Pacific the Japanese home islands were not yet under threat. United States forces possessed no base from which they could be struck. On the two major oceanic fronts, however — General Mac-Arthur's in the Southwest Pacific, Admiral Nimitz's

in the Central Pacific — huge naval, ground and air forces were preparing to advance. MacArthur's initial aim was to expel the enemy from the island of New Guinea and neutralize the great Japanese base at Rabaul, in the Solomon Islands. Both aims were achieved, at remarkably little cost, by June.

Meanwhile in the Central Pacific, Nimitz's vast fleet of aircraft carriers began a drive through the islands, designed to land amphibious forces and seize bases from which Japan could be attacked by strategic bombers. In January the offensive began with the capture of the Marshall Islands. Step-by-step ad-

vances led to the seizure of important footholds in the Marianas, including Saipan, from which the new B-29 bomber could hit Japan.

The offensive provoked Japan into a counteroffensive that resulted in the decisive battle of the Philippine Sea, June 19 to 20. Admiral Ozawa, with most of Japan's surviving carriers and naval aircraft, was devastated by Admiral Spruance's Fifth Fleet. Ozawa lost three carriers and, in the "Great Marianas Turkey Shoot," almost 400 irreplaceable aircraft and their crews. After the capture of the Marianas and the victory of the Philippine Sea, the defeat of Japan was inevitable.

Success in the Central Pacific prompted President Roosevelt to approve General MacArthur's plan for the recapture of the Philippines. The landings began on the island of Leyte on October 20. In response the Japanese decided to concentrate their fleets and challenge the Americans to a climactic sea battle. Four major surface engagements, largely fought in the narrow waters of the Philippine archipelago, resulted in the loss of 4 Japanese carriers, 3 battleships, 10 cruisers and 500 aircraft. American losses were light. After these Leyte battles Japan had no further offensive power. Its home islands now came under attack from B-29 bombers based in the Marianas, the first of which was flown on November 24.

By December 1, it seemed that both Germany and Japan trembled on the brink of defeat. Desperation, however, was to draw from each the power to inflict unexpected loss on their opponents. On December 16 Hitler launched a surprise offensive against the Americans in the Ardennes, the Battle of the Bulge, which was defeated by the Allies with difficulty. In the Pacific the Japanese prepared to fight a last-ditch defense of the Philippines and on the islands of Iwo Jima and Okinawa.

The sufferings of noncombatants increased. Holland, isolated by the Anglo-American advance to the German frontier, suffered a terrible "hunger win-

Anticipating D-Day, a German soldier inspects a huge gun barrel on the French coast. Hitler ordered a chain of obstacles, concrete bunkers and machine gun-nests to be built, and called them "impregnable."
UNDERWOOD PHOTO ARCHIVES

ter." London continued to flinch under bombardments by V-2 rockets. Normal life in Greece, the Balkans and Eastern Europe was interrupted by civil war and the depredations of occupying armies. The cities of Germany quivered under the relentless assault of the Anglo-American air forces. In the concentration camps the business of systematic cruelty and extermination ground on. The year of 1944 was a terrible 12 months, which the approach of victory in 1945 did little to alleviate. Peace would be no consolation to those who suffered and died in the final agonies of the conflict.

Sir John Keegan was knighted in 2000 for his achievements in military history. He has written some 20 books on war, of which The Face of War *is perhaps the best known. For a quarter of a century he has been a senior lecturer at the Royal Military Academy, Sandhurst.*

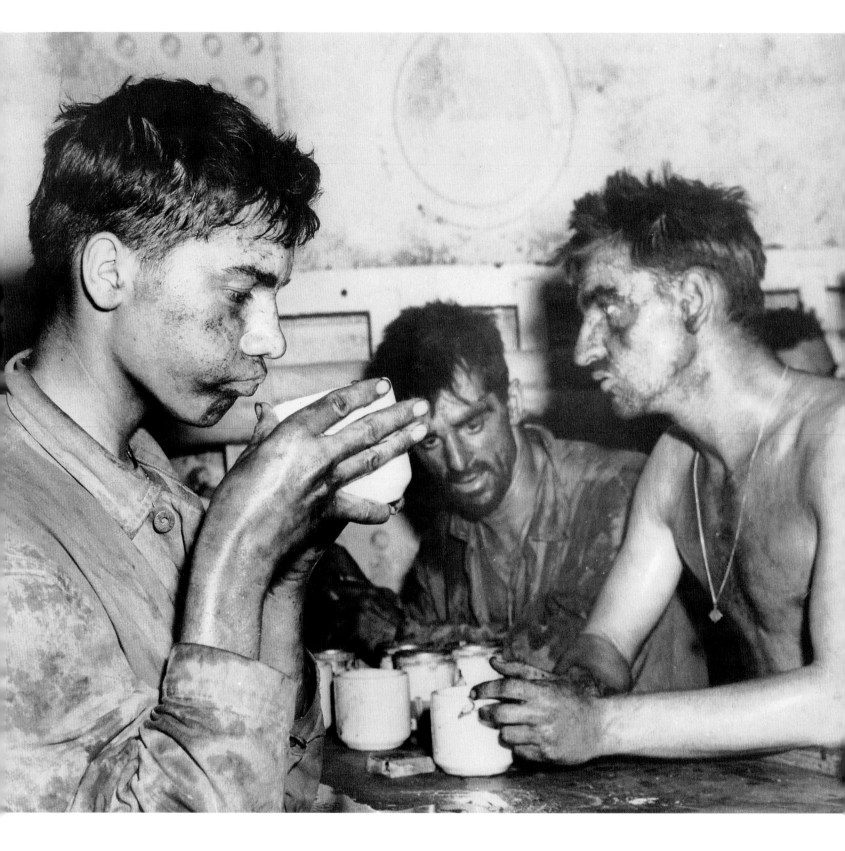

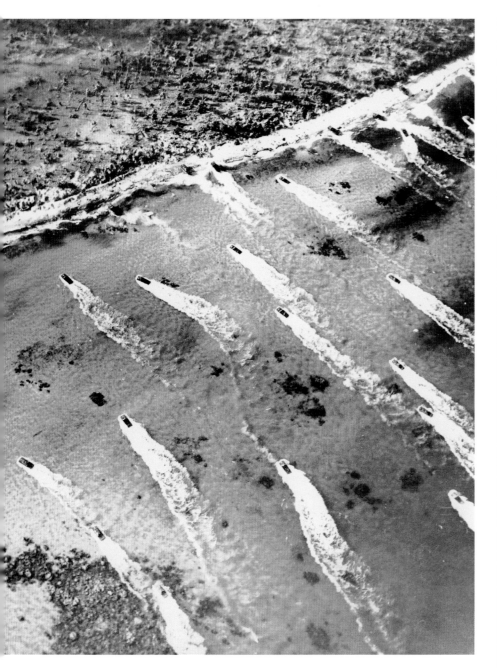

Fighting With Fire

Despite fierce close-range bombardment, the islands had to be taken slowly with bazookas, grenades and satchel charges. One of the most terrifying weapons, the flame-thrower, was often the only way to force the enemy back (below, a fiery attack on a bunker on tiny Namur atoll). After the fighting a Japanese artilleryman (bottom) lies dead on Kwajalein, where the 8,675-man garrison was annihilated. American dead in the Marshalls numbered about 600.

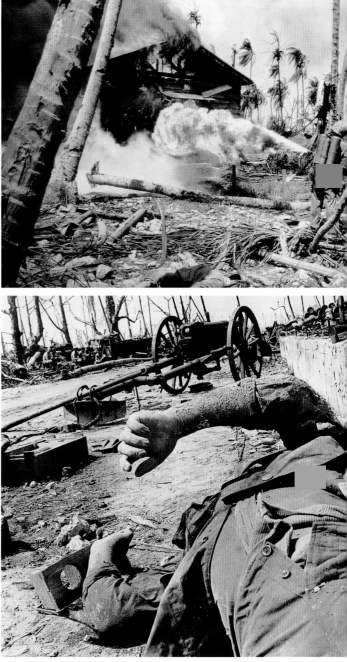

The Filth of War

After the nightmare of Tarawa, in February Admiral Chester Nimitz's fleet moved into Japanese territory for the first time, the Marshall Islands. Ships and aircraft pummelled enemy positions before troops went ashore. On Kwajalein, three combat-weary Marines (left), old beyond their years, take a break after two days of combat. Army units meanwhile cleared out smaller islands nearby. Two weeks later landing craft brought new troops (above) onto the picturesque Eniwetok atoll, some 400 miles to the west.

ANZIO/CASSINO

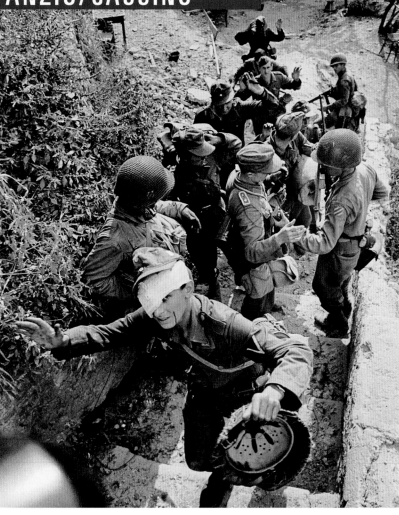

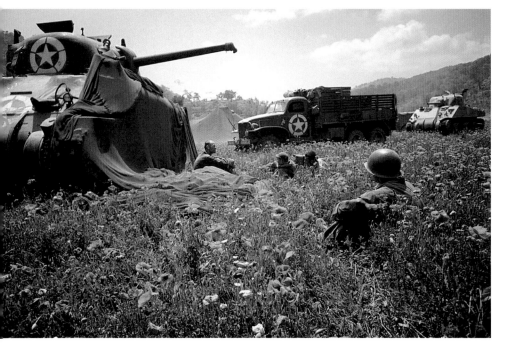

<
ANZIO STANDOFF

When the Allied advance at Monte Cassino was halted, the U.S. and Britain invaded farther north at Anzio. It was a surprise, but the Germans quickly counter-attacked, and a savage stalemate followed. The Americans scored a hard-won victory at Cisterna and took some prisoners (left). But not until the conquest at Cassino did the Allies break through and head north to Rome.

>
HOLY LIGHT

Like twinkling stars, the sun shines through an Allied medical tent (right) riddled by shell fragments the night before. Its strange beauty masks the cost. Five men were killed and eight wounded by German long-range guns on high ground. They constantly rained down explosives on the 10-mile-deep beachhead at Anzio.

<
THE POPPIES GROW . . .

Manning a U.S. tank, Free French soldiers pause in a poppy field (left). It was a rare tranquil moment during the frustrating Allied battle to dislodge the Germans high atop Monte Cassino, from which they could attack anything passing below. In the campaign, these French had the modest advantage of familiarity with mountainous terrain.

ALL: GEORGE SILK / LIFE / TIMEPIX

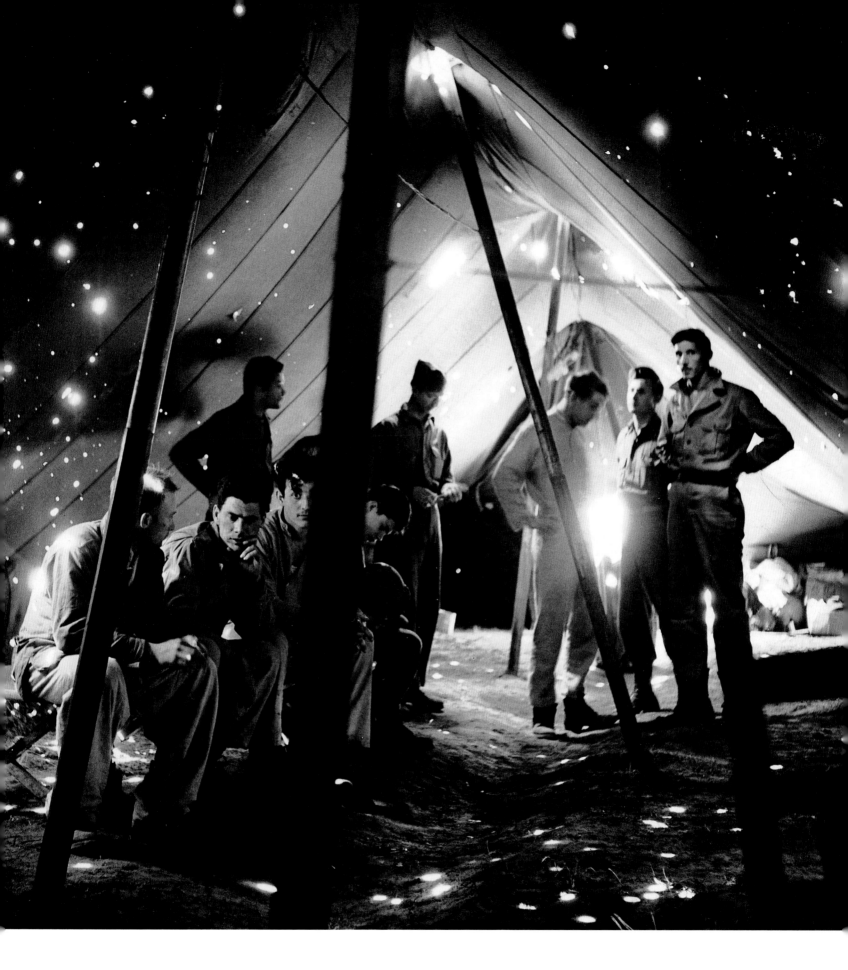

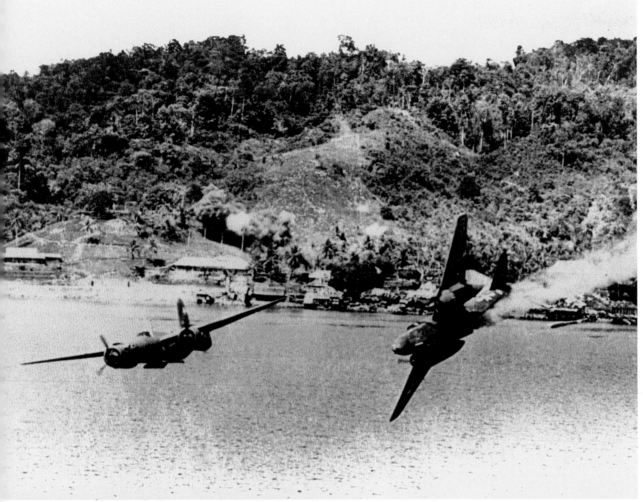

TWO AMERICANS DIE

These pictures (this page and opposite) chronicle the deaths of brave airmen from both sides. At left an American Havoc bomber with a crew of two is hit by anti-aircraft fire after a low-level attack on a Japanese air base in New Guinea. Narrowly missing another bomber, it crashes into the sea (bottom). The air war in the South Pacific was a treacherous business because of mountainous jungle terrain, bad weather, a scarcity of parts for repairs — and, not least, the fanatical determination of the Japanese to resist losing more ground. None-theless, with the crucial support of Army and Navy aviators, the U.S. advanced 550 miles along the coast of New Guinea in just three months.

ALL ON THIS PAGE: MAINICHI

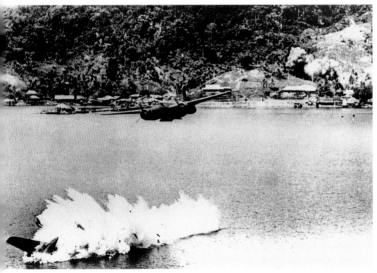

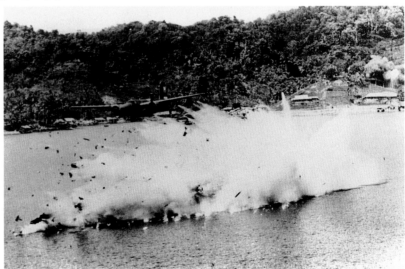

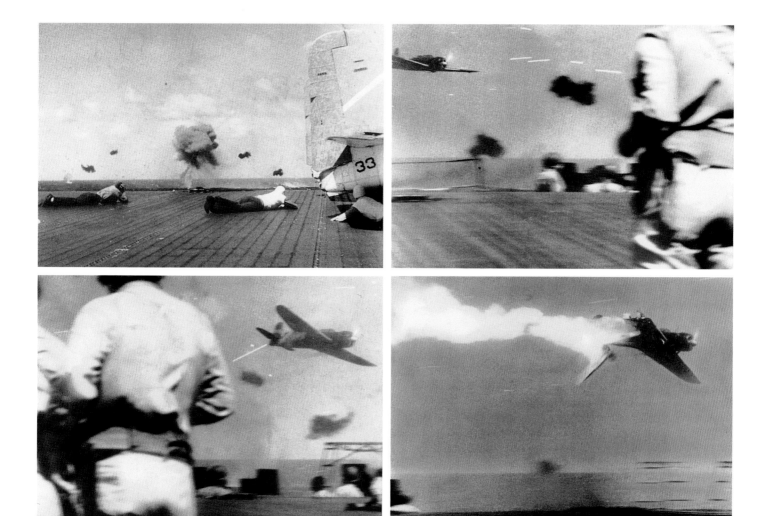

A JAPANESE DIES

After launching a torpedo that missed a U.S. carrier off the Marshall Islands, a Japanese pilot desperately tries to escape. As American sailors flatten themselves on the flight deck (top left), the plane banks to the left until flak tears off one of its wings (middle right). The doomed pilot then hopes to smash into the ship and comes within a few yards before exploding on impact with the ocean (right). In June Japan launched four major air raids on the Fifth Fleet in the Philippine Sea and lost almost 400 planes (versus 30 U.S.). The Japanese air threat ended for good.

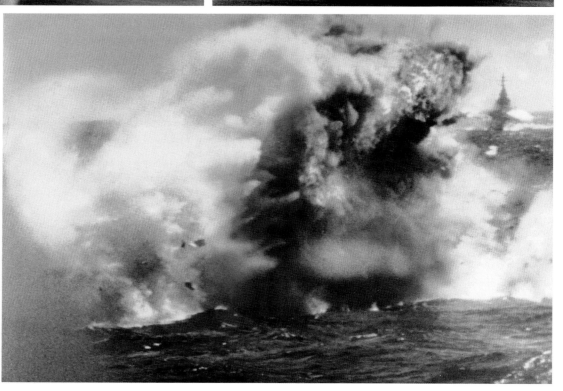

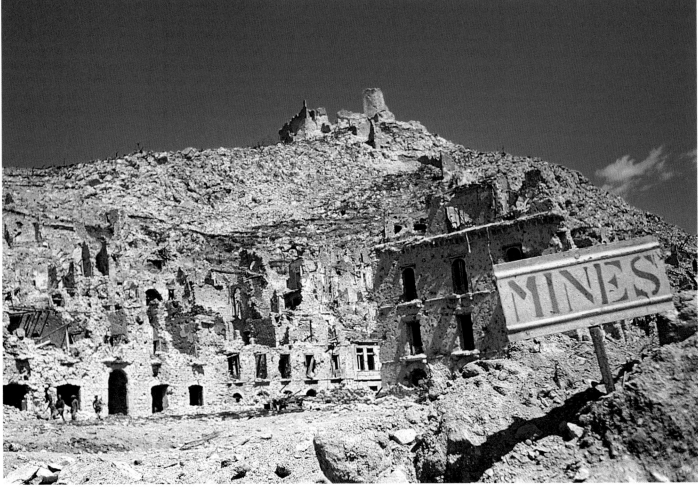

Mount Misery

In an epic battle American soldiers — then British, Indian, New Zealanders, Polish and French — clawed their way up the flinty slopes of 1,700-foot Monte Cassino (above). In February, wrongly convinced that the Nazis were using it to call down artillery fire, Allied bombers leveled the historic Benedictine monastery on its summit. Ironically, the ruins hid the Germans, making attack (two New Zealanders aim high, right) even more dangerous. In mid-May the heights finally fell to courageous Polish troops.

ABOVE: CARL MYDANS / LIFE / TIMEPIX
RIGHT: BRITISH OFFICIAL PHOTO

Hail and Farewell

In early June, Americans (left, filing past the ancient Colosseum) entered Rome as cheering crowds stuck flowers into the muzzles of their guns. FDR declared triumphantly, "The first of the Axis capitals is now in our hands. One up and two to go." Retribution quickly followed liberation. The city's hated Fascist police chief, Pietro Caruso (above, bound in chair), died at the same embankment where he had overseen countless executions. "*Mirate bene,*" he called to the firing squad. "Aim well."

LEFT: HULTON / ARCHIVE
ABOVE: CARL MYDANS / LIFE / TIMEPIX

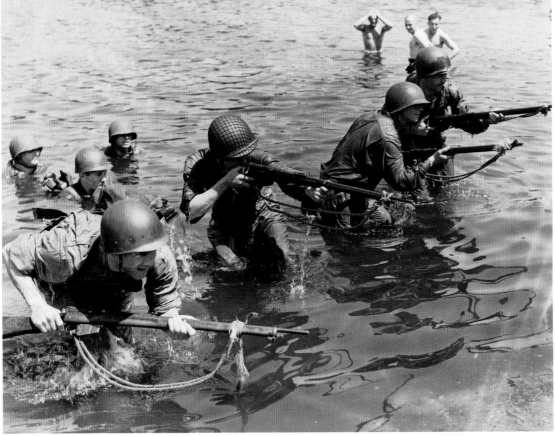

<

PREPPING FOR D-DAY

In the lead-up to D-Day (called Operation Overlord), 1.5 million American men and women squeezed into southern England by early May. They had been training for months, including an armed wade through the Serpentine in Hyde Park (left), to the amusement of a few Londoners. American nurses (bottom left) practice with protective cellophane covers in case the Germans used poison gas.

LEFT: CORBIS / BETTMANN
BOTTOM LEFT: IMPERIAL WAR
MUSEUM NYT 21632

>

HIDE-AND-SEEK

After four years of war Britain took D-Day preparations in stride. A housewife calmly hangs her laundry in a garden (top near right) next to a coastal street choked with invasion vehicles, tanks and equipment. Meanwhile, weapons were stashed all over the island, like these 4,000-pound bombs (top far right), next to grazing sheep. Elaborate efforts were also taken to keep the Germans guessing where in France the Allies would land and where in England they would come from. Rubber decoy tanks (right) were strewn in great numbers along the coast, aimed at confusing the enemy about the site of the genuine buildup of forces.

TOP NEAR RIGHT: IMPERIAL WAR
MUSEUM NYT 27347
TOP FAR RIGHT: IMPERIAL WAR
MUSEUM KY 15356
RIGHT: COURTESY DUNLOP

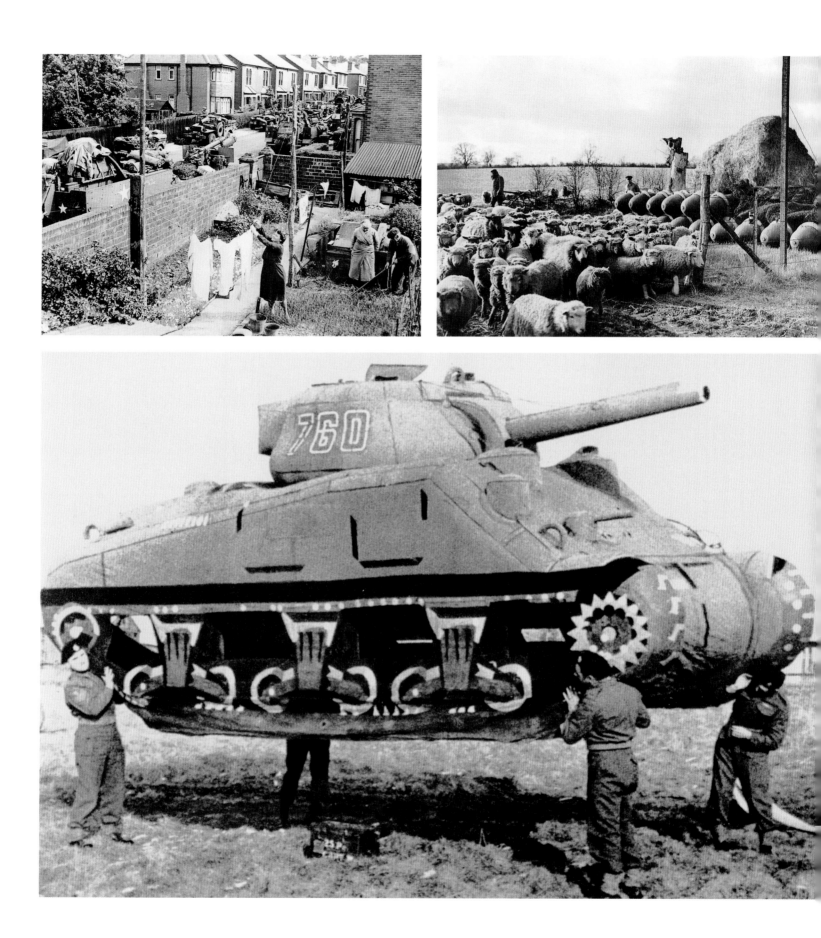

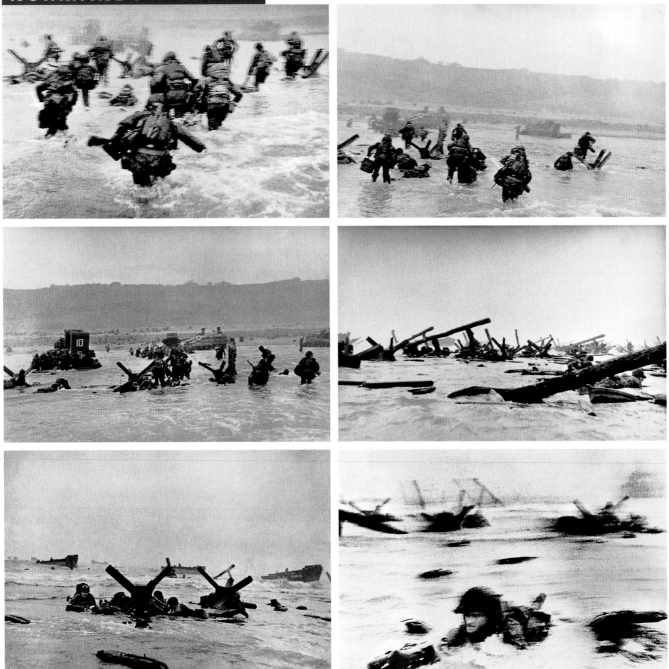

Ordeal on Omaha Beach

Armed with two cameras, *Life* photographer Robert Capa volunteered to hit the French coast, code-named Omaha Beach, with the first wave of 1st Division soldiers. Above, his pictures show GIs wading past — and hiding behind — steel and timber obstacles meant to stop Allied boats and vehicles. Capa later wrote that bullets "tore holes in the water around" him, and he saw an idyllic shoreline become "the ugliest beach in the world."

After four rolls of film, he said his hands were shaking too violently to reload his cameras. He picked his way around floating bodies and hitched a ride on a landing craft back to his ship. A few days later, after the Germans had been driven inland, Omaha Beach (right) teemed with people, tents, trucks, offshore ships and barrage balloons. In less than a week, it was receiving 7,000 tons of supplies daily.

ALL: ROBERT CAPA / MAGNUM

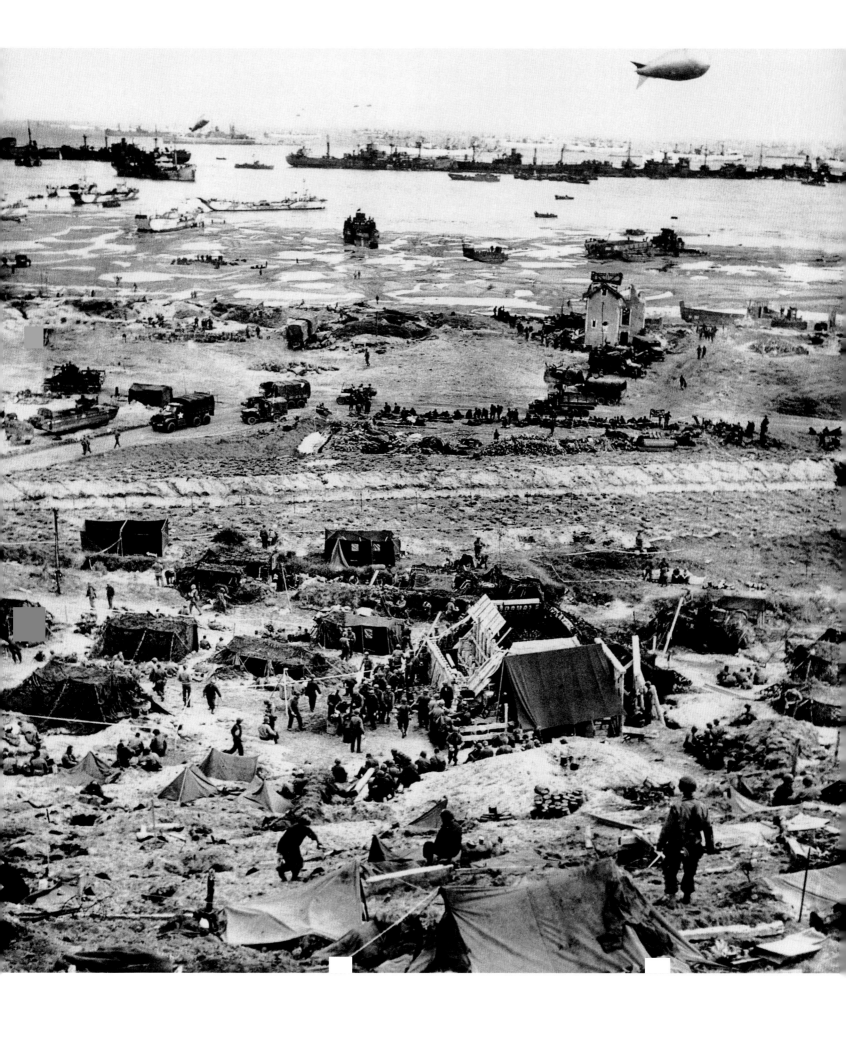

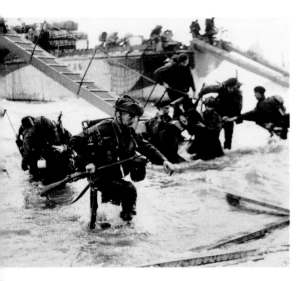

THE OTHER ALLIES

The British role in D-Day was to send 25,000 men to Gold Beach (left) and another 29,000 to Sword Beach, both east of Omaha. (The Canadians went to Juno.) These landings were not so bitter as Omaha, but inland the Commonwealth soldiers met fierce resistance. Their target, the important city of Caen, was not taken until early July.

IMPERIAL WAR MUSEUM

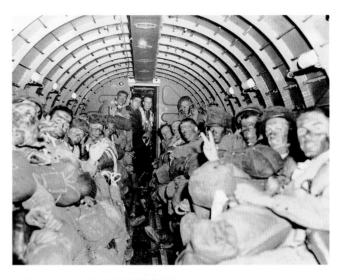

THE DAZED, THE DEAD

The June 6 invasion also included paratroopers and gliders landing behind German lines, some before dawn. These airborne of the 439th Troop Carrier Group (above) give a show of confidence as they await takeoff from England after midnight. Although Overlord caught the Germans by surprise, they rallied quickly and fought hard. Some 8,000 Allied soldiers were wounded, among them these shocked young men (left) awaiting evacuation.

By dusk on D-Day the first American dead were covered with shrouds and buried temporarily in shallow graves on the beach (right). The job was done by mostly black medical orderlies who worked through persistent German artillery fire. A total of 2,500 Allied servicemen died in the assault — a blessed quarter of the number predicted.

ABOVE: U.S. AIR FORCE
LEFT: NATIONAL ARCHIVES
RIGHT: WILMOTT RAGSDALE

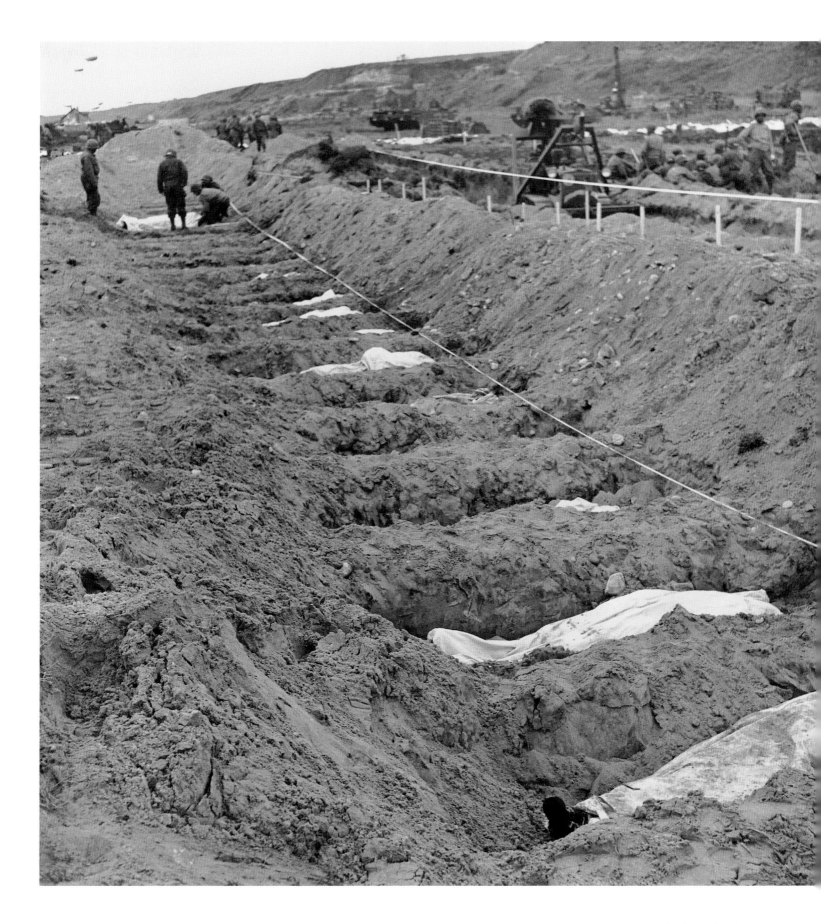

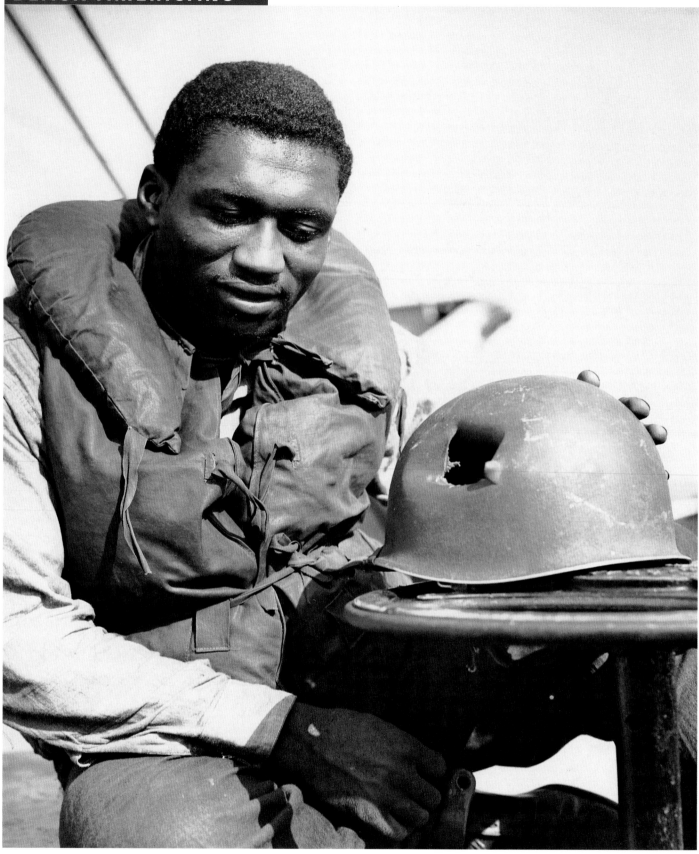

COLOR WAR

As conscripts dwindled, the U.S. military had to move African-Americans — about a million of whom served in the war — from support jobs to combat (though their units remained mostly segregated). They performed well. Some were not only good but lucky — like Coast Guardsman Charles Tyner (left), whose helmet was ripped by shrapnel during the invasion of southern France. The famed Tuskegee Airmen (being briefed as cadets in the States, right) flew 1,578 combat missions and destroyed 261 enemy aircraft. Black infantrymen, pushing jeeps out of the mud (below), fought in the South Pacific. And 150 blacks served as crew of the USS *Mason* (below right), a destroyer that escorted six convoys across the Atlantic.

LEFT: U.S. COAST GUARD
RIGHT AND BELOW:
CORBIS / BETTMANN
BELOW RIGHT:
NATIONAL ARCHIVES

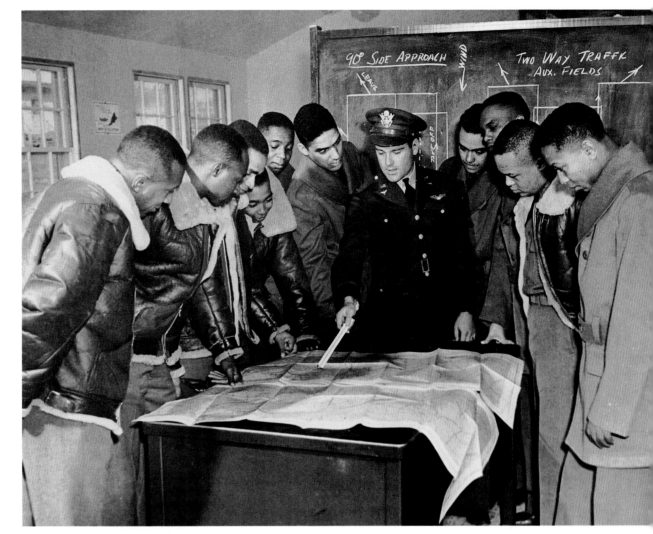

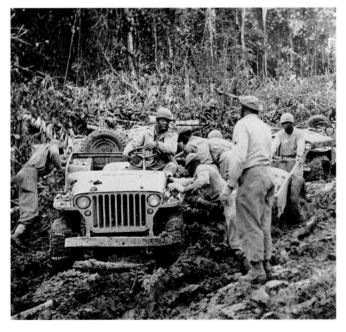

UNITED STATES

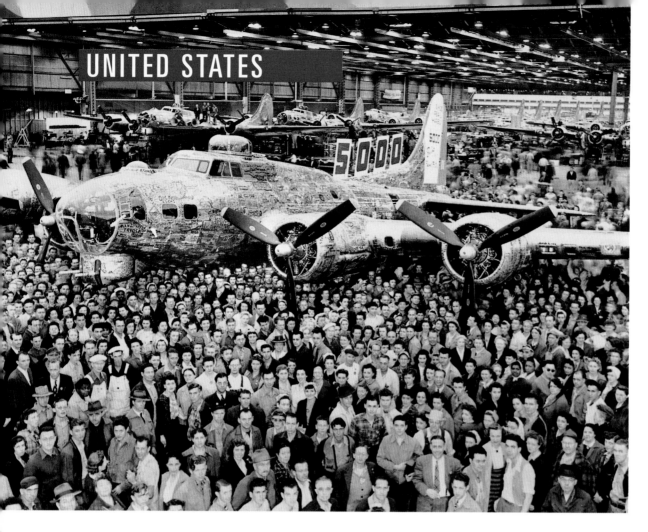

SIGNING OFF

After the 5,000th B-17 came off the assembly line in May, Boeing workers in Seattle (left) celebrated by inscribing it with their John Hancocks. They had reason to cheer. The workhorse B-17 dropped more bombs in the war than any other plane and proved as durable as its name, Flying Fortress. A total of 12,731 B-17s were produced during the war.

LEFT: BOEING AIRCRAFT

SKULL SESSION

Natalie Nickerson, 20, of Phoenix (far left), writes a thank-you to her boyfriend, a Navy Lieutenant, who sent her this grisly memento from New Guinea — the skull of a Japanese soldier, found on a beach and signed by him and 13 buddies. (For the record, the U.S. military frowned on taking such trophies.) In the spirit of the times, Natalie nicknamed the skull Tojo, after Japan's war minister.

FAR LEFT: RALPH CRANE / LIFE / TIMEPIX

HAPPY LANDING

Talk about a P.R. dream! One of college football's greatest stars (Michigan) and recently returned hero pilot, Tom Harmon, marries Hollywood starlet, Elyse Knox. At left, she models her wedding dress made from the parachute that saved her betrothed's life in China. (Actor Mark Harmon is their son.)

NEAR LEFT: HAROLD TRUDEAU

STANDING TALL

These three soldiers (right) lost their left legs in combat in 1943 on the island of New Georgia. Sent to an Army hospital in Texas, they were moved into a physical-therapy program. Here they are tethered to a system of weights and pulleys designed to strengthen their thighs for artificial limbs.

RIGHT: JAMES LAUGHEAD / TIMEPIX

A TOWN'S PAPERWORK

Civilians were asked to collect scrap metal, paper, even grease, to help the war effort. In Livingston, New Jersey (right), this is one day's accumulation of wastepaper — needed for packaging food and supplies for overseas ship- ment; and these are the proud volunteers, old and young, who picked it up. In 1944 communities across the U.S. collected eight million tons of the stuff.

RIGHT: SAM SHERE / TIMEPIX

FRANCE

PORT IN A STORM

Cherbourg was the major port the Allies needed for the drive across France. Above, two GIs on its outskirts blast a German pillbox. Against bitter resistance, the Americans inched forward. The city finally fell on June 27, but the retreating Germans had demolished the docks so thoroughly that they could not be used until August.

U.S. ARMY

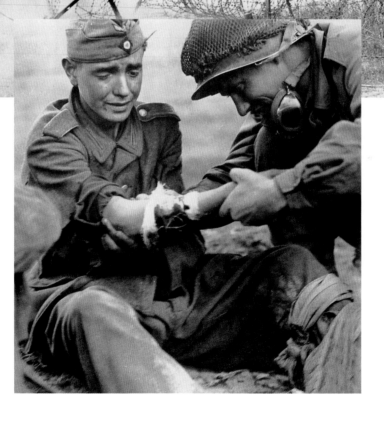

SAMARITAN SOLDIER

A captured teenage Nazi is in tears as he holds out his wounded arm for a sympathetic American to examine as they wait for a medic. The French were sometimes puzzled (and angered) by Americans' kind treatment of prisoners, including giving them oranges, which the natives had not seen in years.

NATIONAL ARCHIVES

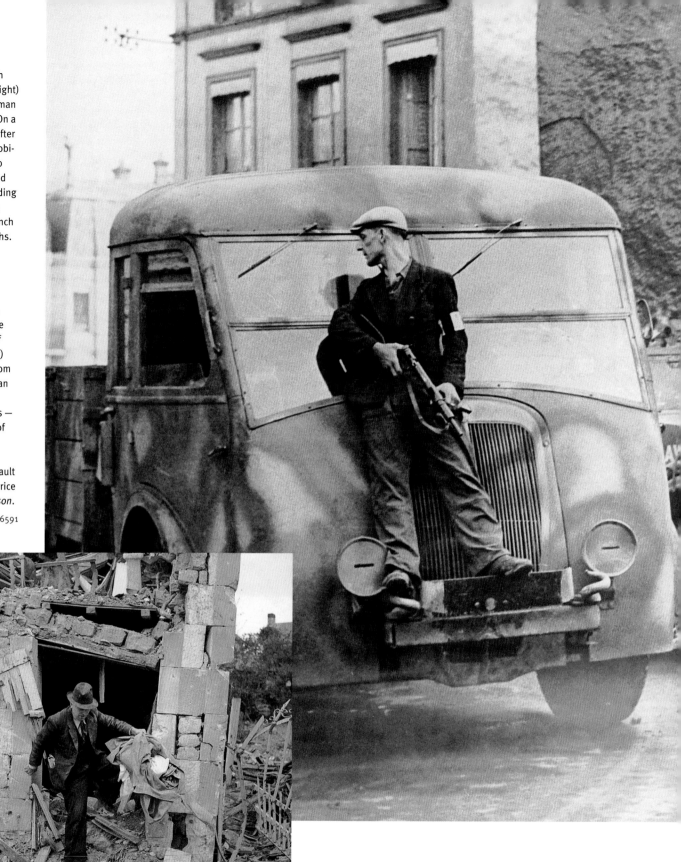

THE FORCE WITHIN

A member of the French Forces of the Interior (right) takes cover from a German sniper outside Dreux. On a BBC signal broadcast after the invasion, the FFI mobilized 200,000 troops to harass the Germans and assist the Allies. According to General Eisenhower, they shortened the French campaign by two months.

NATIONAL ARCHIVES

LITTLE REMAINS

As the war moved east, villagers returned to the wreckage. A resident of Tilly-sur-Seulles (below) salvages belongings from his ruined house after an infantry battle among Normandy's hedgerows — impenetrable barriers of trees and bushes that separated rural fields. A crushing artillery assault won the battle, at the price of this poor man's *maison*.

IMPERIAL WAR MUSEUM B 6591

Lucky Devil

Remarkably unscathed, Hitler visits a Wehrmacht adjutant (right) badly injured in a nearly successful, Army-inspired assassination attempt on the Führer. At a July 20 military briefing in a conference room (top far left) at Hitler's headquarters in East Prussia, a two-pound bomb in a briefcase exploded. It destroyed the room (left), injured seven officers (above, one of the shredded uniforms) and killed four. Because he was seated behind the heavy leg of the conference table, Hitler suffered only minor cuts and bruises. Eight of the main conspirators were hanged immediately. As many as 7,000 other real and suspected conspirators were imprisoned.

ALL: HEINRICH HOFFMANN / TIMEPIX

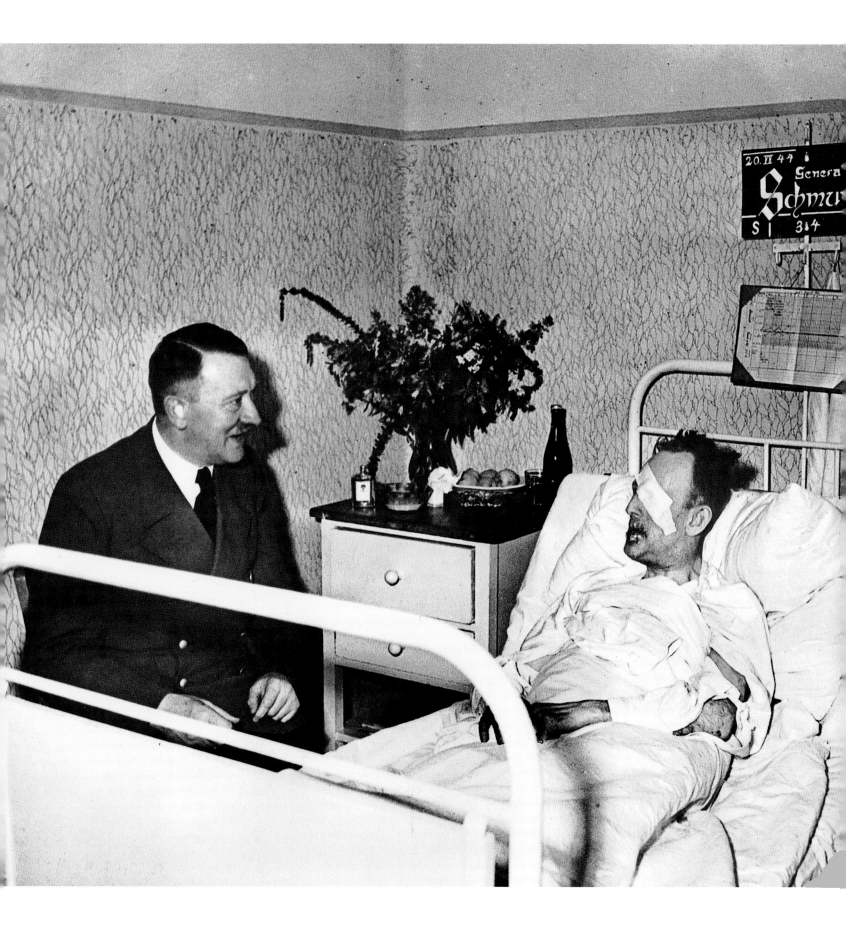

PARIS

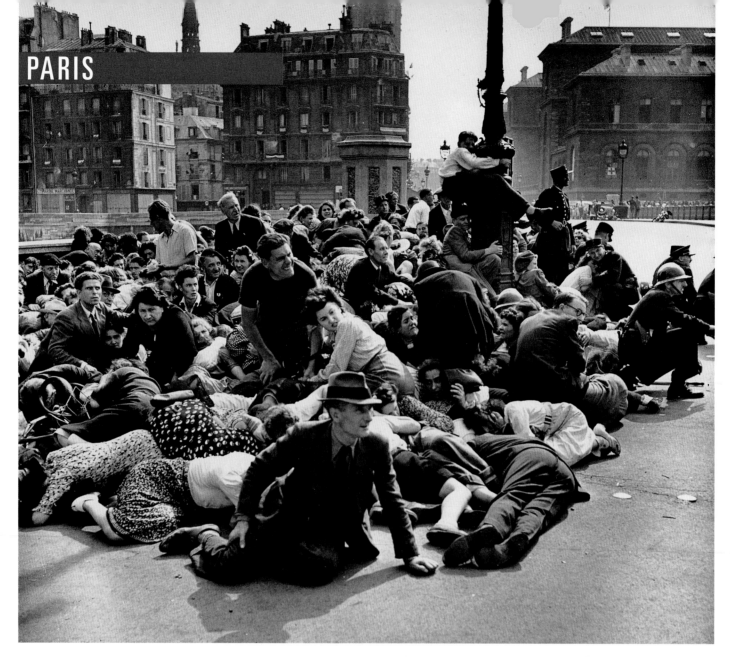

JOY ON HOLD

Jubilant Parisians sprawl on the pavement (above) after German sniper fire interrupts their premature celebration. They had gathered near City Hall to hear Free French leader General Charles de Gaulle proclaim the liberation of Paris. A few hours earlier, on August 24, the first French tanks rolled into the city.

ABOVE: FRANK SCHERSCHEL / LIFE / TIMEPIX

LAST THROES

A Free French soldier (right) dashes to aid a Resistance sharpshooter trying to find a German sniper in a Paris building. Earlier, General Dietrich von Choltitz had quietly and unexpectedly surrendered rather than sack and burn the French capital, as Hitler had ordered — and thus turn it into a second Stalingrad.

RIGHT: RALPH MORSE / LIFE / TIMEPIX

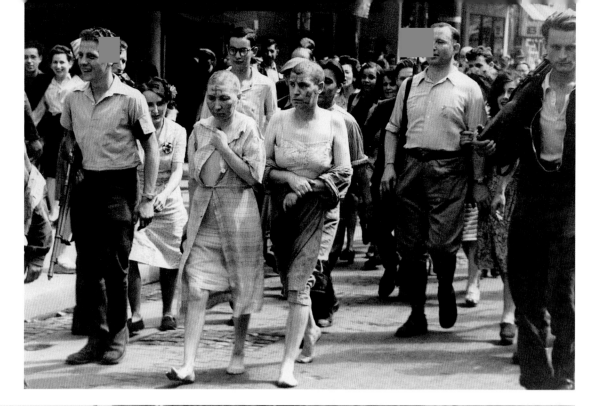

RETRIBUTION

Members of the Resistance parade two women down a Paris street after tearing off some of their clothes, shaving their heads and painting their faces with swastikas (right) to punish them for fraternizing with Nazi occupiers. Below, French ruffians kick and jeer German prisoners rounded up by French forces.

RIGHT: HULTON / ARCHIVE
BELOW: WIDE WORLD

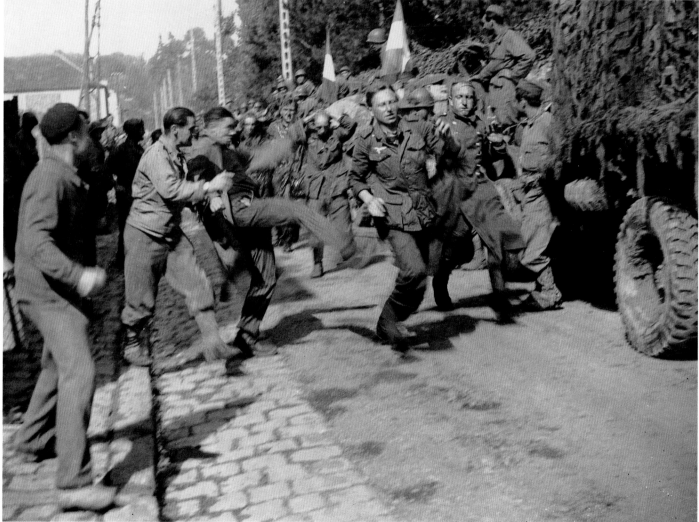

CHARLES DE GAULLE

A Nation's Savior

From boyhood Charles de Gaulle was inspired by crusaders. The son of a philosophy teacher, he excelled at the French military academy, where his thin, 6'4" frame won him the nickname "the big asparagus." On graduation he served in World War 1 (above, at right) under Colonel Henri Philippe Pétain and was captured by the Germans. In 1927 he became Pétain's aide-de-camp. But reverence for the old marshal turned to revulsion when Pétain became French premier and capitulated to the Nazis in 1940. De Gaulle escaped to England and radioed back his famous battle cry, "France has lost a battle, but France has not lost the war."

ARMOR ADVOCATE

A slightly known Colonel de Gaulle (with helmet above) gives President Albert Lebrun (at left) a tour of French tanks along the Maginot Line in October 1939. De Gaulle had long preached (and published) that France would be annihilated in the next war if it did not embrace the concept of quick-moving armored divisions rather than rely on static defenses. "I am well acquainted with your ideas," the President said. "I am afraid they seem much too late to apply." The month before, German Panzers had rolled into Poland.

De Gaulle, joined in London by his wife, Yvonne (top right), and two daughters, in 1940, was soon acknowledged as head of the Free French. Back home, he was tried and sentenced to death in absentia. His look-alike son, Philippe, 23 (right), went on active duty as an ensign while France was still being liberated.

ABOVE: WIDE WORLD
TOP RIGHT: HULTON / ARCHIVE
RIGHT: OSWALD WILD

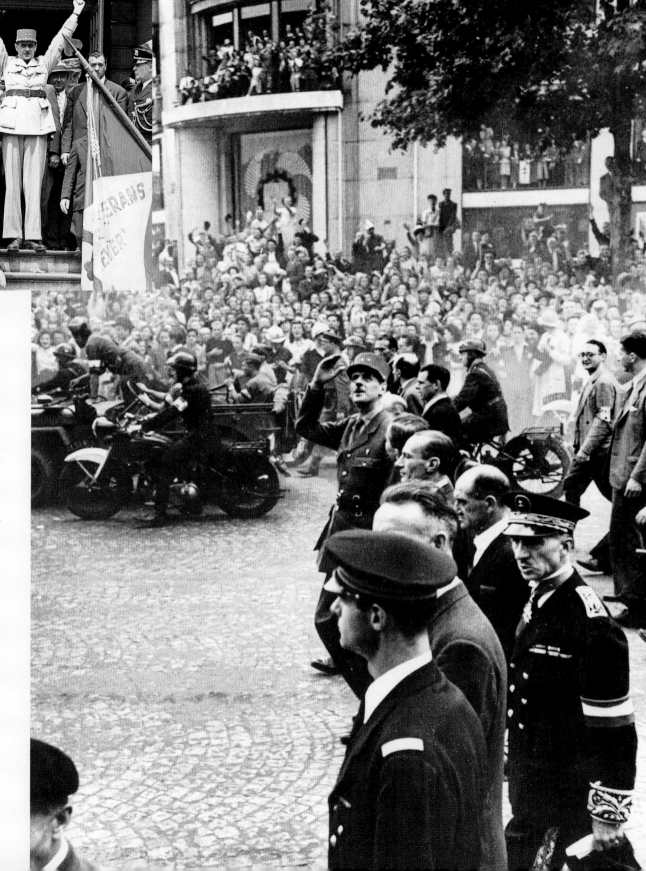

VINDICATION

De Gaulle loved adoring crowds. He got one in July 1944 in New York, where he appeared on the steps of City Hall (above, with Mayor Fiorello La Guardia by his side). In a political masterstroke, the General changed public opinion of him as a difficult politician by eloquently thanking the city for caring about "the soul of France." Two months later the presumptive premier of the Fourth Republic was on the Champs Elysées (right) saluting the wild cheers of "*le grand Charlie*." He caught the fervor of the moment, urging his countrymen and -women not to hide their emotions: "Paris! Paris outraged! Paris broken! Paris martyred! Liberated!"

Mourning in Munich

Nazi flags cover scores of caskets of bombing victims, some identified, some not, at an elaborate state funeral outside a draped monastery in Munich (left). As local Nazi party chairman Paul Giesler (above) speaks to townspeople, survivors pick their way through the ruins (top). The city was one of Hitler's favorites — his political career began there; but its important government offices are what made it a frequent target. More than 6,500 civilians were killed and half a million left homeless in 71 air raids during the war.

ALL: HUGO JAEGER / TIMEPIX

WOMEN IN THE WORKPLACE

Rosie Remembered

The mythic Rosie the Riveter urged women in World War 2 to make "history, working for victory." They did, in record numbers — from packing machine-gun cartridges (below) to putting up oil rigs. After the war, as millions of veterans returned to look for jobs, many women went back home. But not for very long. Though marriage and motherhood beckoned in the 1950s, so eventually did employment, paychecks and personal fulfillment. The number of working women rose again, to 30 percent of the work-force in 1955, and they moved into professions once all but denied them. Equal opportunity became more than just a slogan.

LOCOMOTION

Women today still do many of the jobs they took over during the war. Railroad mechanic is not one of them. But this game-and-greasy squad (left) defied tradition to keep the Long Island Rail Road rolling. In government posters, bicep-popping women were shown in hopes of breaking stereotypes and expanding the workforce in vital defense industries.

LEFT: CORBIS / BETTMANN

ALL FIRED UP

Volunteer female fire-fighters race to their truck in Port Washington, New York. In response to mobilization posters that proclaimed "O.K., Soldier! We'll do our part!," women volunteered in great numbers to take over vital services. One example was the Red Cross. More than three million women ran USO canteens, rolled bandages, helped collect blood and drove ambulances.

RIGHT: HERBERT GEHR / LIFE / TIMEPIX

DISTAFF SARGENT

By 1945, when these WACs (Women's Army Corps, left) shipped out from Britain to France, more than 280,000 women were serving in all branches of the military — the Navy's WAVES, the Coast Guard's SPARS and Women Marines (no acronym). Their rank and title were the same as the men's; so was the pay. Before the war, only the Army and Navy Nurse Corps admitted women.

NEAR LEFT: NATIONAL ARCHIVES
FAR LEFT: DAVID ROBBINS

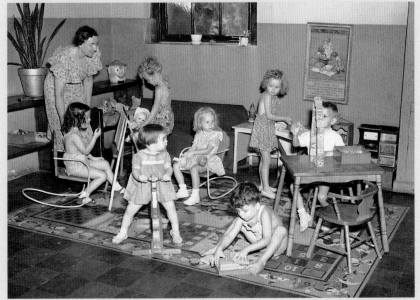

WHILE MOM WORKS

To encourage mothers to take jobs during the war, child-care centers were quickly set up all over the U.S. by companies and the government. Some were open 24 hours a day for round-the-clock shifts. These tykes (left) enjoy a federal center in Atlanta. Most of these centers closed when the war ended, causing a child-care shortage after women began returning to work in large numbers.

LEFT: WIDE WORLD

GOING PUBLIC

Gender was no barrier for two formidable women. Eleanor Roosevelt, an unflinching advocate for across-the-board equality, was named in 1961 by President John F. Kennedy (above) as chair of the President's Commission on the Status of Women. Anna Rosenberg (above right), a former personnel consultant, who was the first female Assistant Secretary of Defense, visits U.S. troops in Korea in 1951.

ABOVE: CORBIS / BETTMANN
ABOVE RIGHT: U.S. ARMY

>

SPACE PIONEER

Jerrie Cobb, 29, the first woman in astronaut training, has a stress test (right) in Albuquerque in 1960. A record-setting aviator, Cobb never made it into space. But her pioneering effort paved the way for Sally Ride, a crew member on a 1983 *Challenger*. Since then, more than 30 American women have gone into space.

RALPH CRANE / LIFE / TIMEPIX

THE MATING GAME

Think of the raised arms of Walter Mondale, 56, and Geraldine Ferraro, 48 (right), as goalposts and envision history soaring through them. Mondale, the Democratic presidential candidate in 1984, picked the feisty Queens, New York, congresswoman as the first female VP nominee of a major party. Ronald Reagan, not gender, defeated them.

NEAR RIGHT: DIANA WALKER / TIMEPIX

OFFICER MATERIAL

Cadet Kristin Baker (above) has a Huckleberry Finn look to her, but don't be fooled. She shattered tradition at an unlikely place, the military academy at West Point, New York, which first admitted women in 1976. Thirteen years later, she was selected Brigade Commander and First Captain of the Corps of Cadets, titles she shared with Robert E. Lee and Douglas MacArthur.

ABOVE: NINA BERMAN / SIPA

<

HAVE A SEAT

Stock trader Muriel Siebert (left, with pet chihuahua Monster Girl) visits a men's room to poke some fun at the boys. She's entitled. In 1982, 15 years after becoming, at 35, the first woman to buy her own seat on the New York Stock Exchange, she had to give an ultimatum: Build her a toilet, or "I was sending them a Port-o-san." A ladies' room was soon installed.

LEFT: ABE FRAJNDLICH / CORBIS / SYGMA

A FRUITLESS WAIT

Suffragist Alice Paul, 92, deserved to wear the ERA button (right). She first proposed an Equal Rights Amendment to the U.S. Constitution that would bar sex discrimination in 1923. Paul died in 1977, the year that Indiana became the thirty-fifth and last state to ratify the doomed proposal. It needed 38.

RIGHT: FRANK WHITE

PINK-COLLAR BLUES

Five-year-old *Ms.* magazine put Palmolive's Madge-the-manicurist (actor Jan Miner, below) on the cover in 1977 to make a point. Eighty per-cent of all working women were still stuck in "pink collar jobs" and earning about 63 cents to a man's dollar. The gap closed to 76.5 by 1999, though it was 66 cents for black women and 56 for Hispanic.

BELOW: COURTESY MS. MAGAZINE

JUSTICE DELAYED

Sandra Day O'Connor is shown the view by Chief Justice Warren Burger (right) from the steps of her new office, the Supreme Court, in September 1981. O'Connor, 51, who was nominated by President Reagan, became the Court's 102nd Justice since 1789 and its first female. Often the deciding vote between conservatives and liberals, she has gained great influence.

NEAR RIGHT: DAVID HUME KENNERLY

DADS COUNT TOO

The 1993 Family and Medical Leave Act was generally aimed at new mothers who worked. But when his wife developed complications during her pregnancy, Maryland state trooper Kevin Knussman (right) asked for paid leave both before and after their daughter was born. The state said no, and he sued. In 1999 a federal jury awarded him $375,000 for sex discrimination.

RIGHT: DANUTA OTFINOWSKI

FEMINIST SCALPEL

Women like breast-cancer surgeon Monica Morrow of Chicago (near left) repre-sent a huge change in American medicine. They made up 25 percent of all U.S. doctors and nearly 44 percent of students in medical school in 2000. Dr. Morrow is an advocate of less invasive lumpec-tomies instead of radical breast removal for appro-priate cancer patients.

BLACK / TOBY

WOMEN ON TOP

While women hold only about a tenth of the top jobs at Fortune 500 companies, in 1999 this fab five (near left) had crashed through the glass ceiling: (left to right) Citigroup CFO Heidi Miller, Hewlett-Packard CEO Carly Fiorina, eBay CEO Meg Whitman, Ogilvy & Mather CEO Shelly Lazarus and Morgan Stanley/Dean Witter internet analyst Mary Meeker.

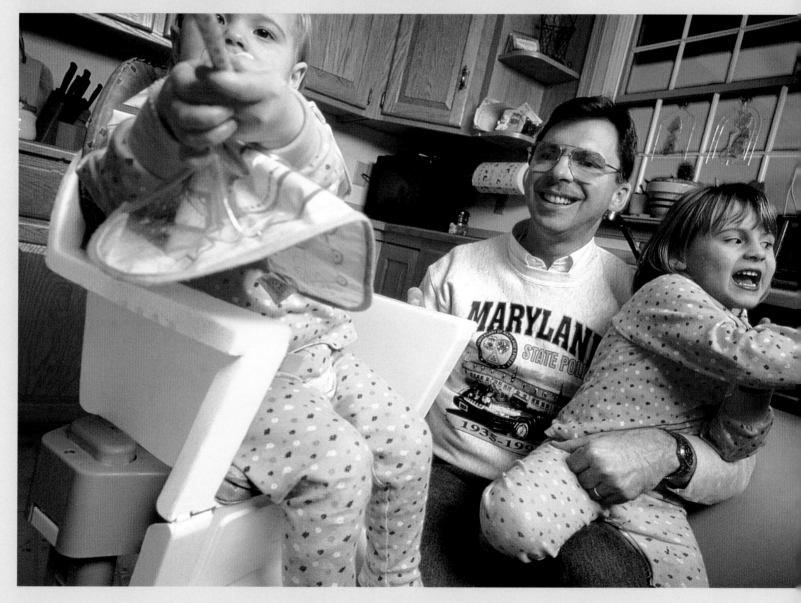

"V" for Vengeance

Germany aimed its first pilotless weapon, a jet-propelled V-1, or buzz bomb, at London in June. A V-1 (top left) drops behind the towers of the Law Courts Building and (left) explodes. Some 2,000 V-1s killed 6,000 people, wounded 40,000 others and damaged 200,000 homes in the city. Among the survivors was this woman (right) being lifted out of the rubble of her building.

But it was after Hitler saw a film of a test of the V-2 missile (above, at Peenemünde, the Baltic Island rocket base) that he thought he had the means to bring Britain to its knees. The V, after all, stood for *Vergeltungswaffen*, or vengeance weapons. At a speed of 3,600 miles per hour, V-2s could deliver a one-ton warhead without warning. Hitler wanted them used immediately against Britain, but deployment had to be postponed after Peenemünde was bombed.

The Nazis began firing V-2s in September, killing 2,500 Londoners before Allied troops overran their launch sites. Wernher von Braun and other German rocket scientists surrendered to Americans to avoid capture by the Soviets and later helped the U.S. develop its space program.

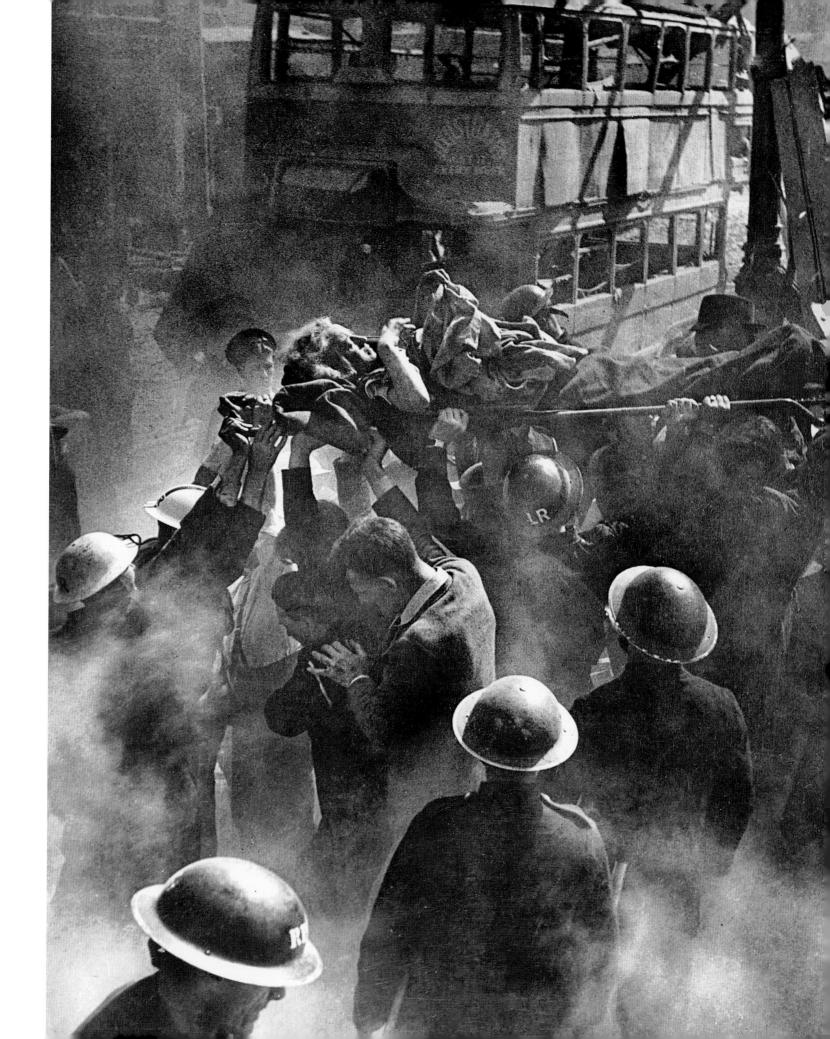

Innocents Abroad

These children offer wordless witness to the barbarism of war around the world: In Naples a little boy helps a companion who has lost a leg (top left). A Yugoslavian refugee girl in Egypt (top middle) shows an angelic face and a hand mutilated by the Germans. A Greek boy (above) who survived Nazi massacres in his area stares in reverence at his British liberator (who pins a Union Jack on his sleeve). And in St. Sauveur-le-Vicomte, an embattled town in Normandy, a resilient French boy named Jean-Louis (left) bravely watches an American medic treat wounds inflicted by a German hand grenade.

On the opposite page (top near right) Marines try to soothe a crying toddler with a rations tin at a refugee camp on Saipan. A mournful Chinese boy surveys the desolate landscape that was his village near Changteh (top far right). He was separated from his parents during evacuation and has returned to his ruined home in hopes they are looking for him. Children at a German concentration camp inside Russia (right) wait solemnly for liberation.

TOP LEFT AND TOP NEAR RIGHT: NATIONAL ARCHIVES
TOP MIDDLE: JOHN PHILLIPS / LIFE / TIMEPIX
ABOVE: HULTON / ARCHIVE
LEFT AND TOP FAR RIGHT: UNDERWOOD PHOTO ARCHIVES
RIGHT: DAVID KING COLLECTION

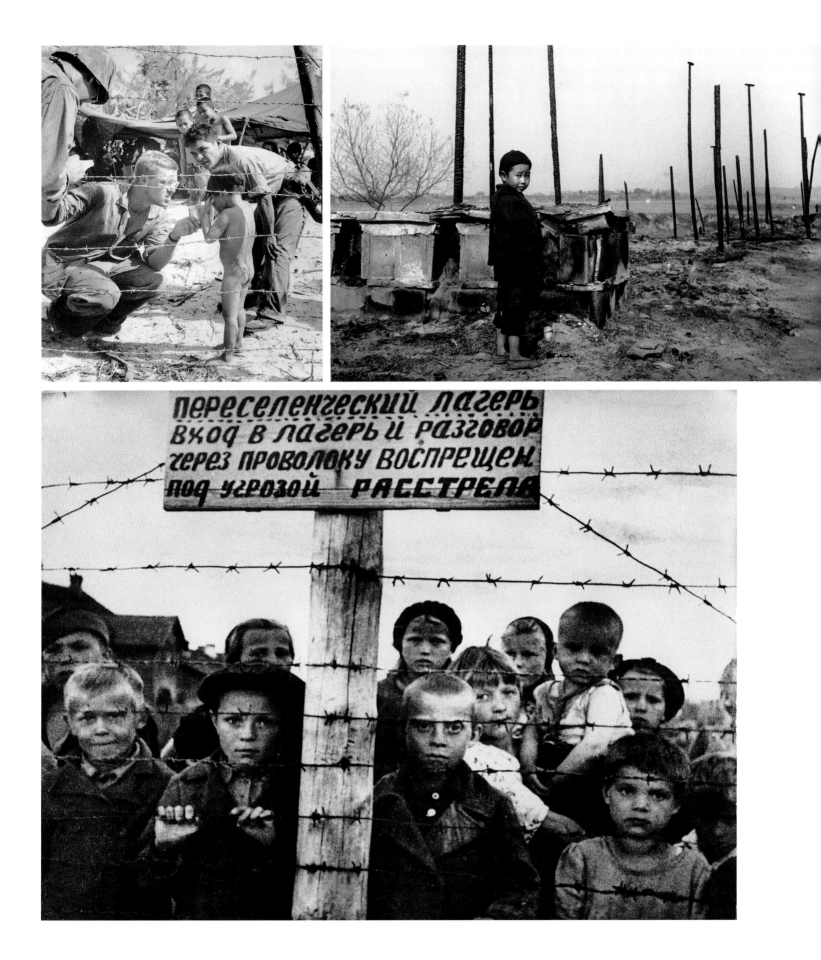

BURMESE DAYS

Chinese soldiers lead blind-folded Japanese prisoners (above) away from the front after their capture in Burma. Elsewhere in that remote country, a GI (left) coaxes a mule with 350 pounds of equipment across a stream. Americans used 3,000 mules to move 7,000 men and weapons through the jungle during the monsoon and retook the vital overland connection known as the Burma Road.

ABOVE: CORBIS
LEFT: CORBIS / BETTMANN

RUSH HOUR

Chinese refugees squeeze onto every available space on a train (above) — even the dangerous undercarriage of a passenger car (right) — in a desperate effort to get away from 350,000 Japanese troops attacking the provincial capital of Kweilin in October. The assault was meant to split China and capture General Clair Chennault's main Fourteenth Air Force base. Chinese Nationalist forces joined the millions of fleeing peasants, and the city fell a month later.

ABOVE: UNDERWOOD PHOTO ARCHIVES
RIGHT: WIDE WORLD

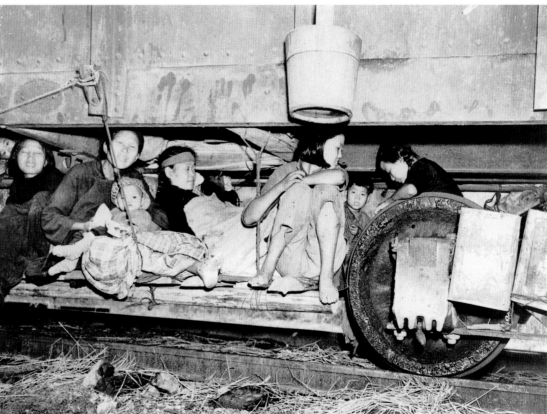

GERMANY

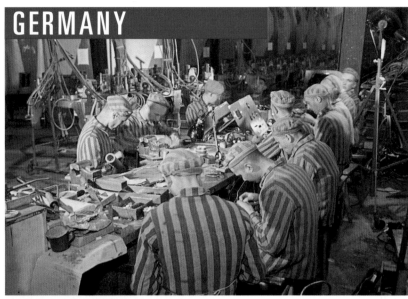

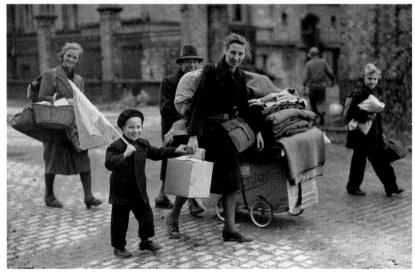

NEAR THE END

Slave laborers build V-2 missiles (left) in the Mittelwerk plant, near the Nordhausen camp. About 60,000 inmates were used to carve an enormous tunnel system in a mountainside to protect V weapons' production. Some 20,000 of them died during the project.

Joseph Goebbels, Minister of Propaganda, shakes hands with a childlike recruit (middle left) while reviewing the *Volkssturm*, the civilian militia. Hitler was scraping the bottom of the manpower barrel. By November, German losses totaled 1.2 million dead and wounded.

The first German city taken by the Allies was Aachen, and civilians began streaming out, bound for a refugee camp in Belgium. This family (bottom left), whose little son is carrying a cautionary white flag, had been living in an air-raid shelter.

LEFT: WALTER FRENTZ / ULLSTEIN BILD; MIDDLE LEFT: GLOBE PHOTOS; BOTTOM LEFT: UNDERWOOD PHOTO ARCHIVES

>

FAITHFUL EVA

A pensive Eva Braun, 32, Hitler's mistress (right), endures a serenade. Rarely seen in public with the Führer, she spent her days exercising, reading popular novels and worrying about her looks. After the failed plot to kill Hitler, she wrote him: "From our first meeting I swore to follow you anywhere — even unto death — I live only for your love."

RIGHT: PRESSEILLUSTRATIONEN HEINRICH R. HOFFMANN, MUNICH

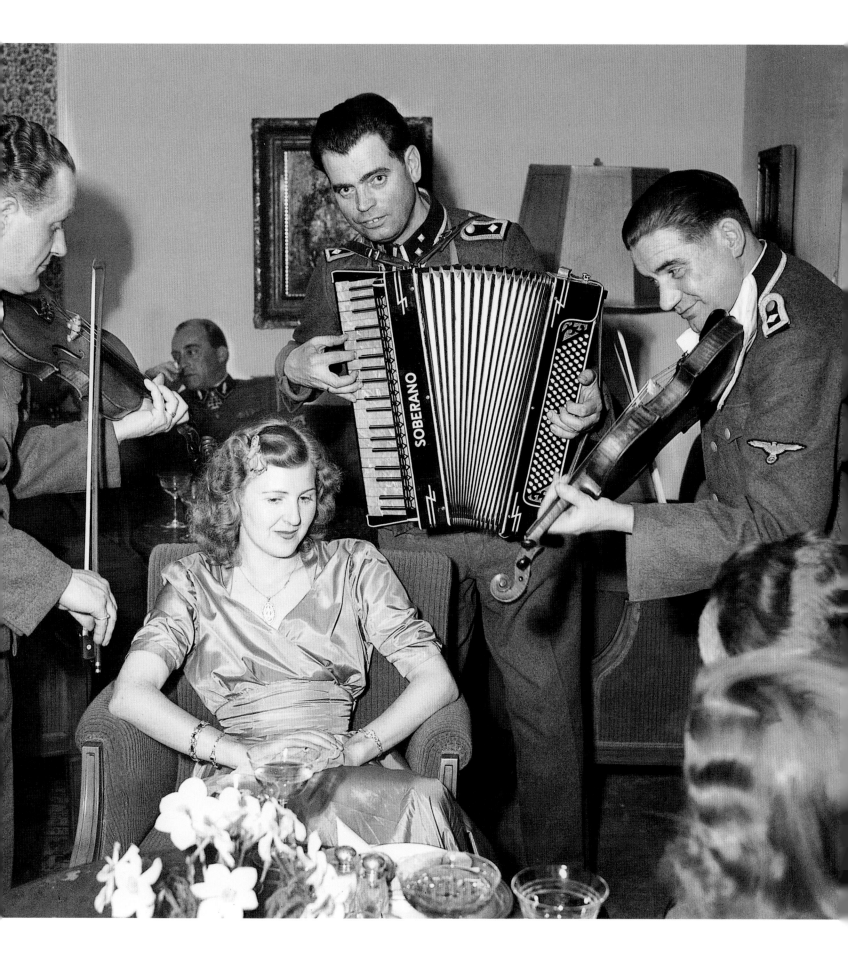

HALLOWED GROUND

A Yank kneels before a Catholic shrine in a Saipan cemetery after the Marines and Army captured the island. It was a time for prayer. The 25-day battle ended only after the most devastating banzai attack of the war. Overall, some 32,000 Japanese were killed, and hundreds of civilians, taught to fear the Americans, committed suicide.

PETER STACKPOLE / LIFE / TIMEPIX

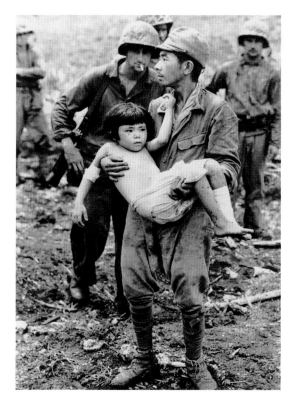

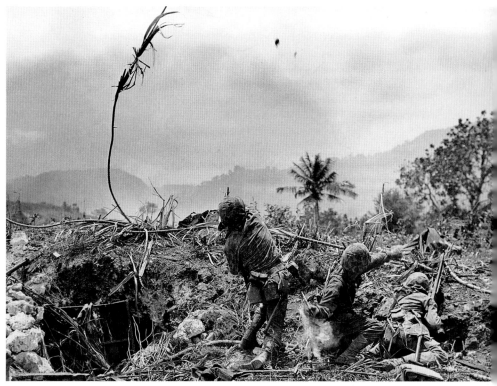

USE OF ARMS

A Japanese soldier — one of the few who surrendered — helps evacuate a wounded child on Saipan (above). The jungle fighting was close enough for grenades. One Marine (above right) throws, and another takes aim. Though the island was secured by mid-July, a few pockets of enemy resistance continued to hold out even after the war ended, in August 1945.

ABOVE: IMPERIAL WAR MUSEUM NYF 75247; ABOVE RIGHT: U.S. MARINE CORPS

MAC'S MOMENT

Filipino guerrillas (right) stalk a house on Leyte, searching for Japanese. Conquest of the island was accomplished only after ferocious battles on densely forested ridges. General MacArthur declared victory in December. Though Japan occupied other islands in the chain, the Philippines campaign was all but over.

RIGHT: UNDERWOOD PHOTO ARCHIVES

RICHARD SORGE

Seductive Spy

He was a master of modern Soviet espionage, his network providing Stalin with secret information that if heeded could have changed the war. Born in Russia of a Russian mother and German father, Richard Sorge served bravely in the Kaiser's Army in World War 1; he left it with a limp and, after reading Karl Marx, a dedication to Communism. He was a gifted actor, and his credentials as a news correspondent (below) in China and Japan were believable. He warned that Germany would invade the Soviet Union and the Japanese would strike in the Pacific, probably Hawaii. He was ignored. Arrested in 1941, Sorge, 49, was hanged in late 1944.

DOOMED ACCOMPLICE

An irreverent, hard-drinking charmer, Sorge (above) recruited Japanese journalist Hotsumi Ozaki (right) as his top agent. With ties to the military high command, Ozaki passed on secrets until arrested and tortured. Sorge was unmasked. Tokyo offered to exchange him for a Japanese prisoner in Russia; Moscow said it had never heard of Sorge.

ABOVE: SUEDDEUTSCHER VERLAG, BILDERDIENST
LEFT AND RIGHT: MAINICHI

DOUBLE BETRAYAL

Helma Ott, wife of the German ambassador to Japan (receiving a gift from a Japanese child, above), was one of Sorge's lovers. She was strikingly tall, elegant and reckless. Sorge's friendship with her husband, Eugen (above right, in 1938 with General Matsui), gave him access to state documents in the German embassy. After his arrest, however, Sorge never implicated Ott.

ABOVE LEFT AND RIGHT: ULLSTEIN BILD

<

TOOL KIT

After Japanese counterintelligence nabbed Sorge, they inventoried the spy tools (left) found in his house: a radio, coding equipment, a copying camera, developing equipment, two rolls of film of secret documents, a wallet containing $1,782, 16 notebooks of contacts with his agents — and two volumes of *The Complete Shakespeare*.

LEFT: MAINICHI

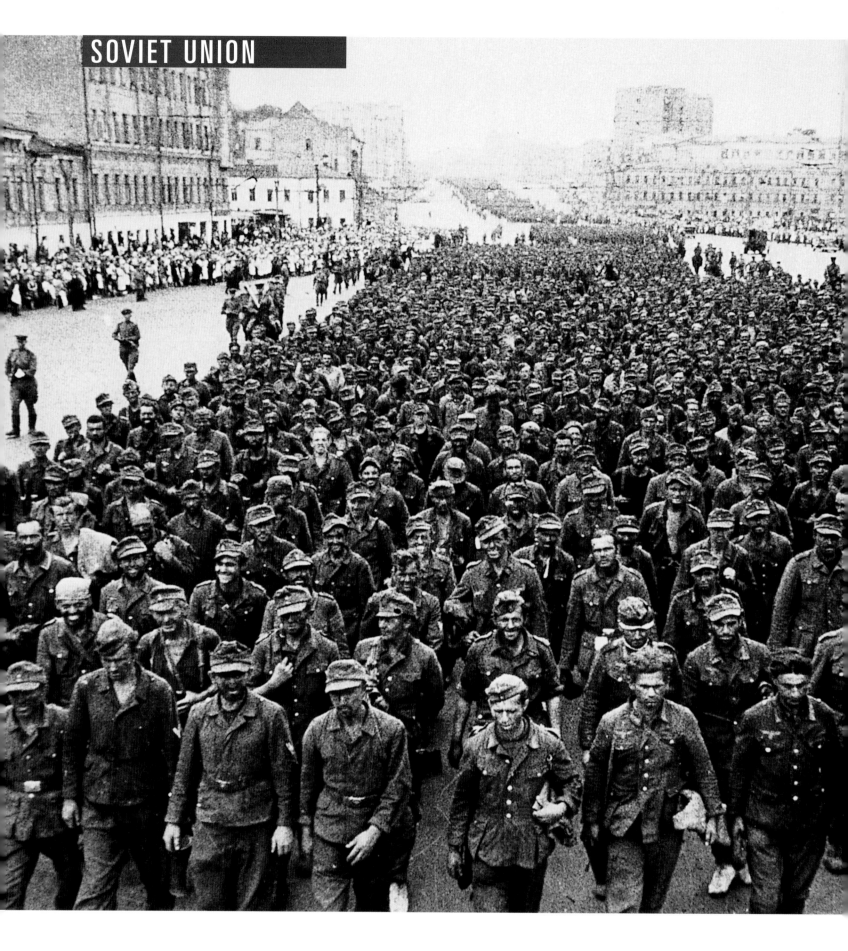

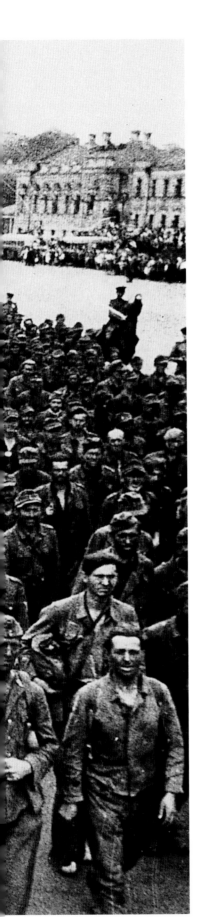

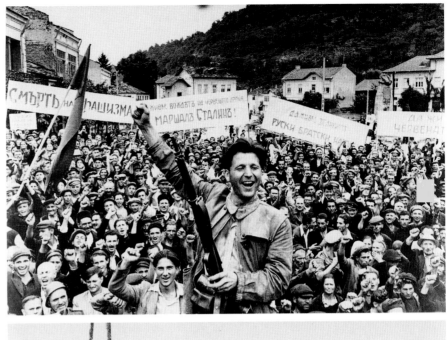

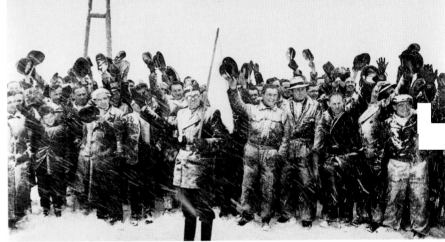

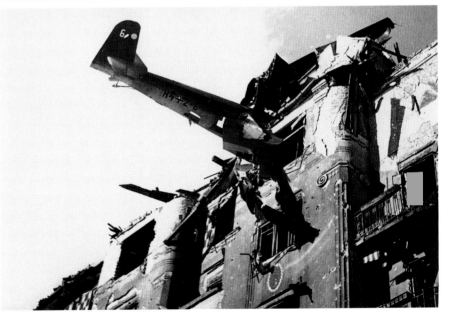

>
BELGRADE IS FREED

Belgrade celebrates its liberation in October 1944, after Soviet troops joined with Tito's Communist partisans to drive the Germans out. It paved the way for Tito to become Yugoslav premier, in 1945. Though Belgrade was declared an open city in April 1941, the Luftwaffe bombed it mercilessly, and the occupation that followed was harsh.

>
BUDAPEST IS NEXT

Hungary sued for peace with the Allies in October; German troops promptly occupied Budapest. But the Soviets had surrounded the city by December (right, a snowy welcome), and two months later the Wehrmacht abandoned it, leaving 10,000 wounded behind (and a Nazi plane embedded in a building, below right) as grim mementoes of their defeat.

<
MOURNFUL PARADE

The Germans finally got to Moscow but not the way they intended. This endless line of ragged prisoners was marched through the capital in July 1944. Millions of Axis POWs were treated brutally. Some were executed; most were sent to labor camps, where they faced almost certain death from starvation, exposure and disease.

ALL: DAVID KING COLLECTION

FINAL FANTASY

The young German soldier's confident look and necklace of bullets (above) tells much of the story. Hitler fantasized that his regrouped Army could punch through the thin American front in the wooded Ardennes plateau in Belgium and Luxembourg, retake Antwerp and split U.S. and British forces. It almost succeeded. One Panzer group encircled Bastogne (where two weary GIs await rescue, above right). But the Americans finally held, and Allied forces counterattacked from north and south. The "bulge" was slowly flattened out, and the Führer's last dream ended. But the sight of medics pulling wounded men across frozen fields (right) was far too common. The Allies suffered 77,000 casualties. Of those, 19,000 were American dead.

ABOVE AND OPPOSITE PAGE
FAR RIGHT:
JOHN FLOREA / LIFE / TIMEPIX
ABOVE RIGHT:
NBC / GLOBE PHOTOS
RIGHT: U.S. ARMY

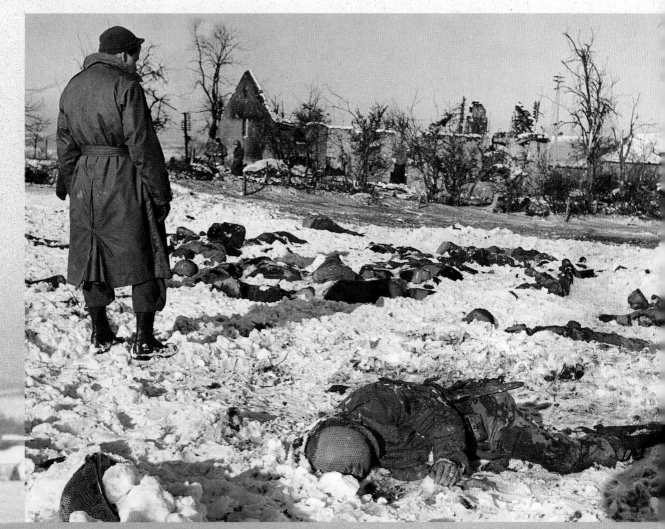

THE MASSACRE

On December 17 near Malmédy, American infantrymen threw down their rifles and surrendered to SS Panzer troops after a brief clash with tanks. The Nazis shot the GIs as they stood unarmed in a snowy meadow. Eighty-six Americans died (right). After that, some U.S. units vowed they would take no prisoners in SS uniforms alive.

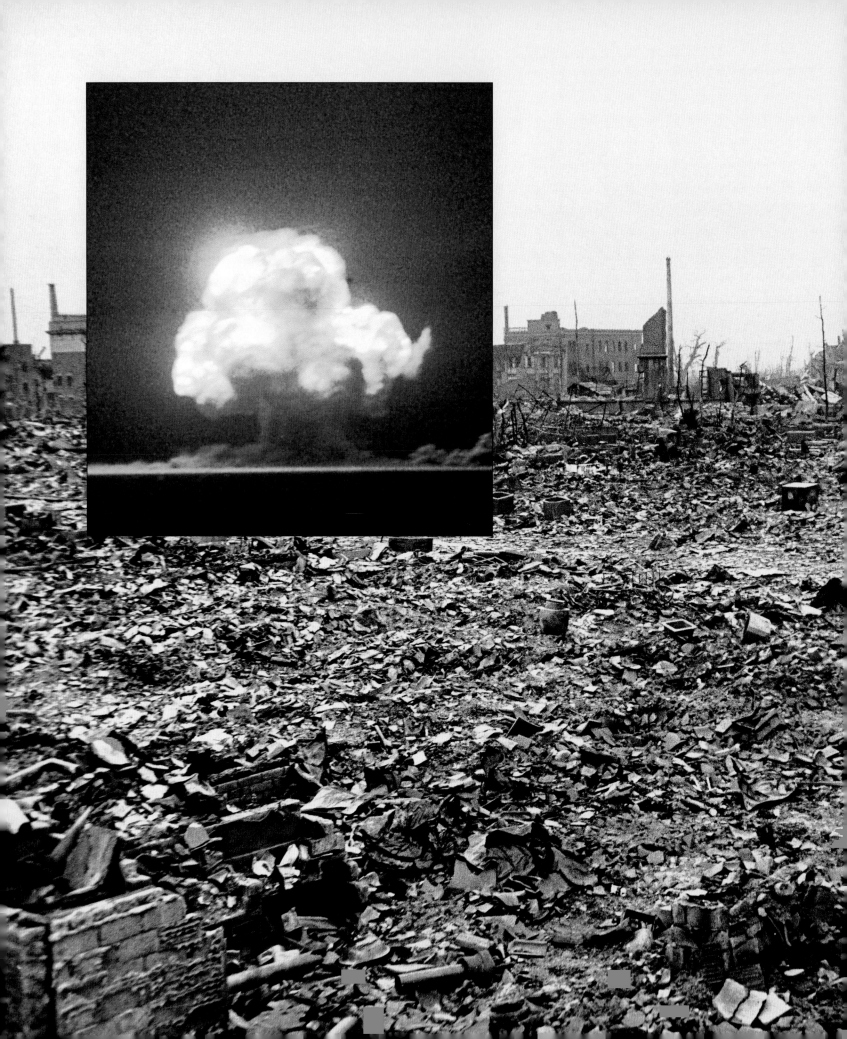

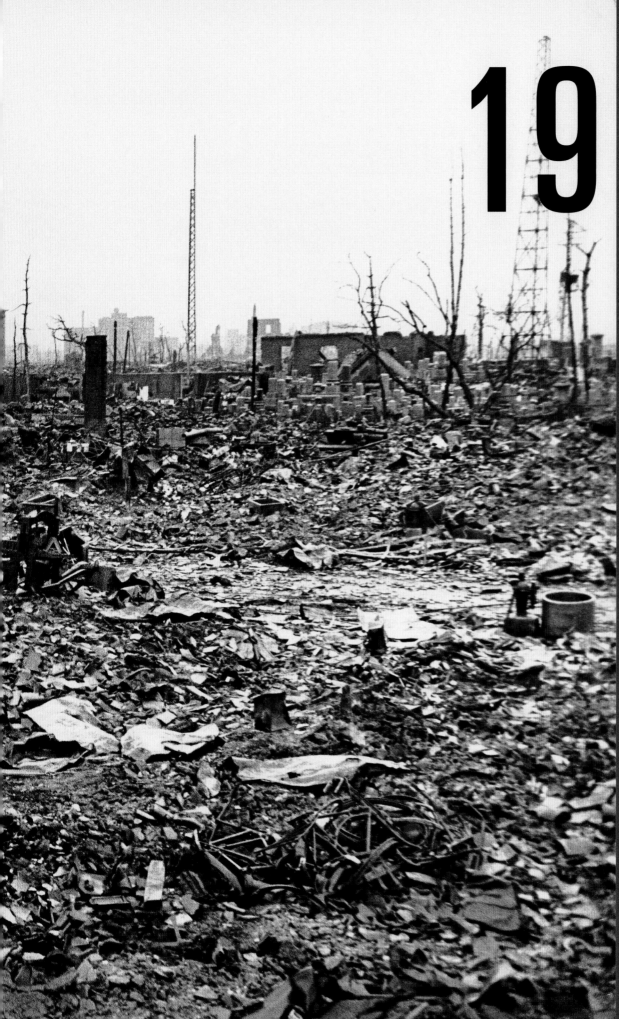

19 45

SPLITTING ATOMS END THE WAR

It was the flash seen round the world: a gigantic fireball above a mushroom cloud, so familiar today but seen for the first time in an American desert in July (inset). The Atomic Age was born. Eventually it would produce peaceful energy, but first the atom would be used as a weapon of war, to end a war. A U.S. B-29 named *Enola Gay*, for the pilot's mother, dropped an atomic bomb on Hiroshima, an industrial port, on August 6 (left). With a destructive force equal to 12,500 tons of conventional explosives, it leveled five square miles of the city and killed 80,000 people.

BERNARD HOFFMAN / LIFE / TIMEPIX
INSET: JACK W. ABEY

The Invasion That Never Was

by John S. D. Eisenhower

As 1945 opened, victory for the Western Allies in Europe was assured. The successful landing in Normandy, on June 6, 1944, followed by the destruction of much of the Wehrmacht in the Normandy campaign had placed the British, Americans and French on the German border by September of that year.

Adolf Hitler's gigantic Ardennes offensive, in December — the Battle of the Bulge — had resulted, in the long run, only in virtually destroying what fighting power the Wehrmacht still had. The German V-1 and V-2 weapons (pilotless aircraft and embryo ballistic missiles) had caused damage to the Belgian port of Antwerp and to southeastern England but had not altered the strategic situation. Only Hitler's iron control over the German people caused the war to drag on needlessly for another four months.

On February 6, 1945, I arrived at Le Havre, France, as a Lieutenant in the 71st Infantry Division. I was soon transferred to a unit that General Omar Bradley took a special interest in. Its mission, to keep the General apprised of the latest developments on the front, allowed me to witness sights that have remained indelibly in my memory.

I was near Torgau, Germany, where, on the Elbe River, an American patrol pushed out ahead of its forward limits and made a celebrated juncture with Soviet forces coming from the east. On the banks of the Mulde River, the limit of the American advance,

I contemplated a road sign that Berlin was only about 75 kilometers away, pondering the Allied decision to stop short and let the Russians take Berlin. Above all, I experienced the horror of visiting the notorious labor camp at Buchenwald. (If anyone needs a witness to the reality of the Holocaust, they can call on me.) I ended up the war, on May 8, 1945, as a member of the vaunted 1st Infantry Division, with headquarters in Cheb, Czechoslovakia.

Compared with the riotous celebrations that greeted the end of the First World War, V-E day (Victory in Europe) was a quiet time for the troops involved. My father, Supreme Commander Dwight D. Eisenhower, set that tone. On April 30, a week before the end, Adolf Hitler had committed suicide in a Berlin bunker, succeeded by Admiral Karl Doenitz, as head of the crumbling German state.

In the early hours of May 7 the German High Command, General Jodl and Admiral Friedeburg, signed an instrument of surrender in a red schoolhouse in Reims, France. Eisenhower held these Nazi officials in such contempt that he refused to sit at the table with them. He spent only a moment in their company. Standing rigidly behind his desk, he merely demanded assurances that the Nazis knew what they had signed in the presence of his Chief of Staff in the adjoining room. He then scribbled a telegram to the Combined Chiefs of Staff: "The Mission of this Allied force was fulfilled at 0241, local

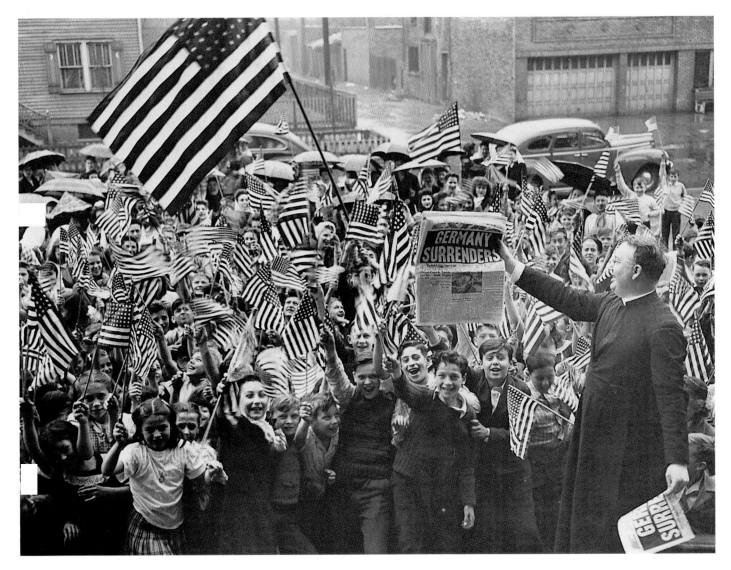

Students at St. Columkille school in Chicago (above) greet the news of Germany's surrender. But the reaction in America was somewhat subdued. Everybody realized the war was only half over.

CORBIS / BETTMANN

time, May 7th, 1945." The procedure was hardly a media event.

The reaction in the frontline divisions was much the same. It was a relief, of course, that the war in Europe was over, but the troops were tired. Furthermore, we realized that the war against Japan was far from won.

Until the European war ended, those of us involved gave little thought to the great events transpiring in the Far East. We can be excused, I believe, for my Navy friends who fought there assure me that they were equally ignorant of what was happening in Europe. A cross-check of the dates of events in both places in 1945 may therefore be of some interest.

The war was moving swiftly toward an end in both theaters. On January 9, as the American First and Third armies in Europe were reducing the last remnants of the German penetration brought about by the Battle of the Bulge, the Sixth Army in the Pacific was landing on Luzon, at the Lingayan Gulf, in the Philippines.

A month later, as Eisenhower's forces were beginning their attacks to clear the left bank of the Rhine River, the Fifth Marine Amphibious Corps landed on the eight-square-mile western Pacific island of

"I have a terrific headache," President and Commander in Chief Franklin D. Roosevelt complained on April 12 and, at age 63, died. The nation listened to his Washington funeral (above) on the radio.

ED CLARK / LIFE / TIMEPIX

Iwo Jima to begin a grim and costly campaign to secure a forward base for support of the bombing campaign against Japan. On March 9, the day the First Army unexpectedly seized a bridge over the Rhine at Remagen, General Curtis LeMay launched the first of his devastating fire-bombing raids against Tokyo. That series of attacks eventually resulted in some 260,000 civilian deaths, with nine million people left homeless from incendiaries alone.

On April 1 the American armies in Germany sealed off the Ruhr Pocket. On that same day, General Simon Bolivar Buckner's Tenth Army, under the overall command of Admiral Chester Nimitz, landed on Okinawa, in the Ryukyus. It was then that the Japanese resorted to their desperate kamikaze suicide-bombing attacks against the supporting U.S. Navy. That Okinawa campaign was not quite finished by the time the war in Europe ended.

As a relatively late arrival on the Continent, I

was slated, as soon as redeployment schedules permitted, for transfer to the Far East, where General Douglas MacArthur's headquarters was busily planning the first landings in Japan, code-named Operation Olympic. The prospect was exciting but not very cheery. If the Japanese, including civilians, put up the resistance we expected, American casualties might greatly exceed those we had incurred in Europe (578,220, including 139,380 dead).

During the weeks that I was awaiting orders to the Far East, I served as an aide to my father on a couple of trips. One of them took us to Potsdam, Germany, in July 1945. At that meeting he first learned of the development of the atomic bomb. Though he shared that confidential information with me, I gave it little thought until early August, when the air forces in the Pacific dropped an atomic bomb on Hiroshima, followed by another bomb three days later on Nagasaki.

My reactions were mixed. Nobody — certainly none of the soldiers scheduled for the invasion of Japan — protested President Harry S. Truman's order to use the bomb on Japanese civilians. Nor have I entertained second thoughts on the matter. The decision was consistent with the temper of the times, and in the long run it doubtless saved many Japanese as well as American lives. Nevertheless, I personally felt a bit let down, because it now appeared that the high adventure I had anticipated would probably not come to pass.

Only a couple of days after the dropping of the Nagasaki bomb, I again accompanied my father on a trip, this one a very elaborate affair to Moscow. As an American, I could not help feeling a little smug when talking with the somewhat overweight Soviet generals, resplendent in their white tunics and glittering decorations. At dinner in the Kremlin these generals predictably downplayed the importance of this superweapon, and I, as a Lieutenant, would have been impolitic to gloat.

The next night, in the middle of a dinner given for the Russian generals in the American embassy, word arrived of Japan's surrender. The spirit of camaraderie that evening was sincere and raucous, lasting into the wee hours of the morning. Three weeks later, in an elaborate ceremony aboard the American battleship *Missouri*, General MacArthur presided over the formal Japanese surrender. The Second World War, the most destructive in the history of the human race, was over.

Wars, unfortunately, do not end neatly, like athletic contests or motion pictures. Though the bullets stop flying, the residue of the immense destruction remains. In Europe, therefore, problems abounded. Homeless families, many of them fleeing the Russians, choked the road net. Vast numbers of German prisoners had to be disarmed, organized and most of them sent home as soon as possible. On May 7, 1945, Germany was our implacable enemy. On May 8 she was a prostrate nation. The occupying powers were now responsible for housing the population, providing them with coal for the coming winter and, above all, rescuing them from the specter of starvation. It was a trying time, yet hardly mentioned in history books.

But the lasting effects of the year were political. At the Yalta Conference in February, Prime Minister Winston Churchill and President Franklin Roosevelt had reluctantly acknowledged the de facto status quo, which gave at least temporary hegemony to the Soviets over Eastern Europe despite the fact that Hitler's invasion of Poland had been the cause for the start of the war. But by the late summer the rapport between East and West had evaporated, and both sides simply consolidated power where they had troops. Although Russia and the Western Allies had fought as cobelligerents against Hitler, the matters of fundamental disagreement that had been swept under the rug during the fighting reasserted themselves. The 45-year period of tension known as the Cold War began.

Civilians could not escape the artillery battles inside Manila in February. This woman, wounded in the leg (above), is comforted by her husband as she is taken by jeep to an American aid station.
CARL MYDANS / LIFE / TIMEPIX

The world was now deprived of the true, lasting peace for which all had yearned and so many had died. Winston Churchill observed the devastating disappointment by naming the last of his six-volume account of the war "Triumph and Tragedy." Though Churchill's point was well taken, I think it is overstated. The end of the hot war, with the death of Adolf Hitler and the democratization of Japan, was a triumph for the human race far greater than the tragedy that ensued.

John S. D. Eisenhower, an Army Reserve Brigadier General and former Ambassador to Belgium, is the author of eight books. The most recent is Yanks: The Epic Story of the American Army in World War I. *He is the son of former President Dwight D. Eisenhower.*

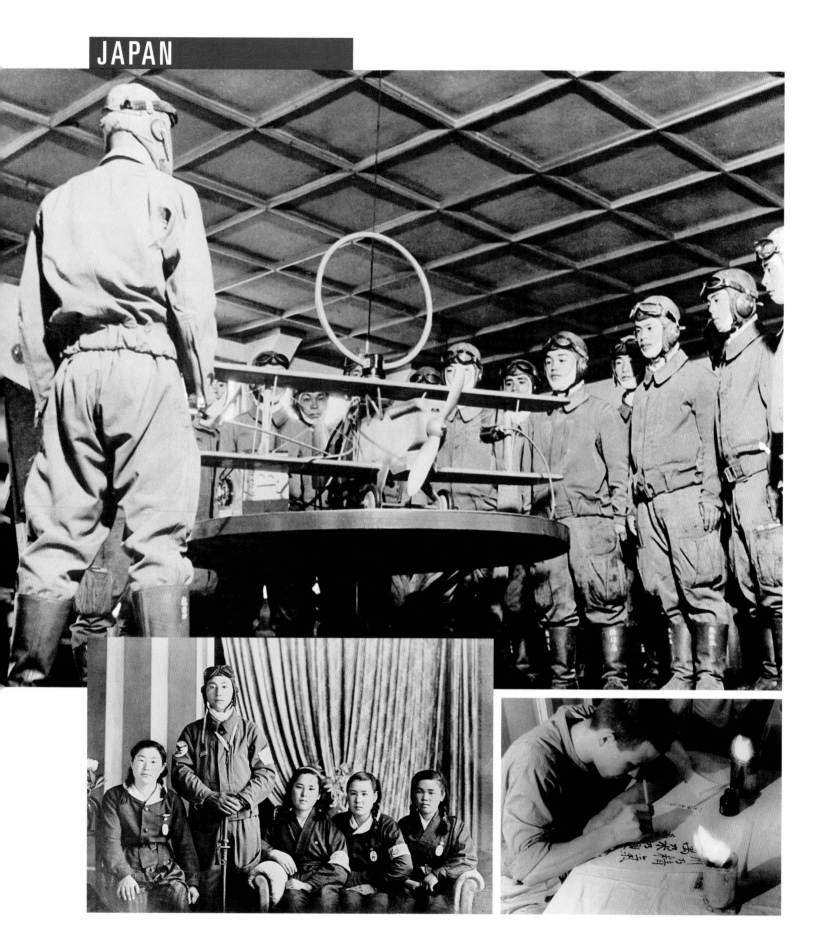

KAMIKAZE CORPS

In a final, desperate effort to slow the American advance, Japan launched the suicide air corps called kamikaze, or "divine wind," after the miraculous typhoons that shielded the country from Mongolian assault in the 13th century. The strategy was chillingly sound. With Japanese planes and fuel in dwindling supply, crashing individual aircraft filled with explosives into U.S. ships would inflict great damage and high casualties.

Kamikaze flights held appeal in a nation with a long tradition of ritual suicide. Two or three pilots volunteered for every available plane; especially ardent applicants filled out their forms in blood. Most were young and inexperienced (top left), and their training sometimes as brief as seven weeks. More seasoned airmen were still better used as escorts for bombers.

Japanese schoolgirls idolized the doomed heroes, such as these groupies at Ozuki air base (bottom far left). Before a fatal mission, pilots wrote valedictory letters (near left) and shared a round of sake (top right) at the airfield. A successful mission is seen vividly at right: The flaming remains of a shot-up Japanese plane manages to hit the carrier *Intrepid*.

TOP LEFT AND BOTTOM NEAR
LEFT: CARL MYDANS / TIMEPIX
BOTTOM FAR LEFT:
T. TANUMA / TIMEPIX
TOP RIGHT: AUSTRALIAN
WAR MEMORIAL
RIGHT: HULTON / ARCHIVE

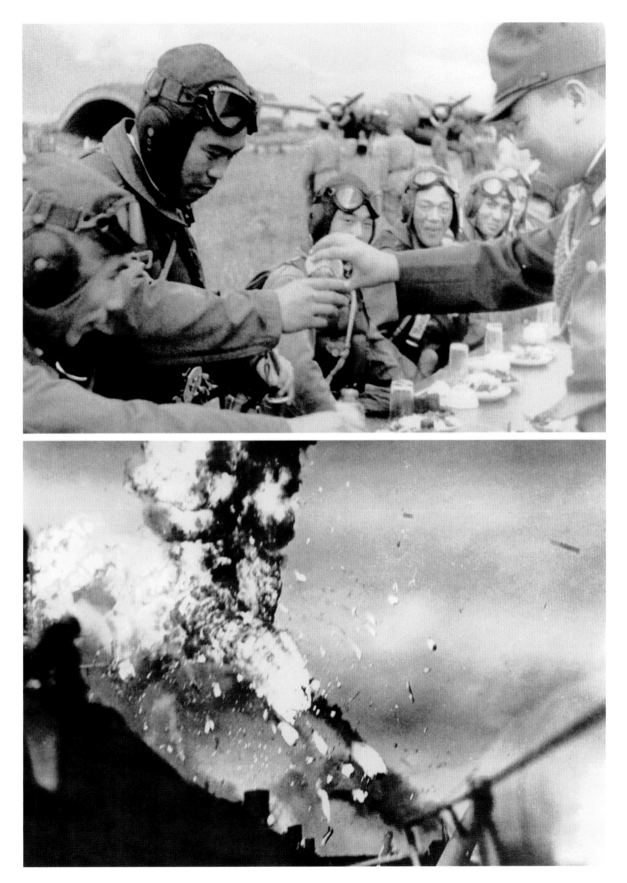

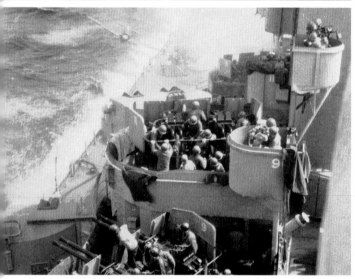

THE GHASTLY TOLL

American aircraft carriers were particularly vulnerable to kamikaze attack because of their combustible wooden flight decks (the British used thick steel). The ships also were packed with ordnance and aircraft fuel and became virtual floating bombs. After several attacks the *Saratoga* (top left) was aflame, and 123 crewmen died. The *Hancock* (bottom left) was remarkably able to receive planes within four hours after being hit.

The battleship *Missouri* (middle left) was more fortunate than most. The Zero banking toward its main deck caromed off, but the pilot's body was catapulted into a gun mount with enough force to damage it.

The *Bunker Hill* (right) barely survived its Pacific tour. Attacked by two kamikazes in 30 seconds, the carrier was turned into a deadly junkyard when planes on the flight and hangar decks blew up. The disaster killed 396 men and injured 264. The ship was repaired and returned to duty just in time to bring servicemen home after the war ended. Kamikaze attacks went on for 10 months, sinking 38 ships and killing 4,907 American sailors, by far the worst Navy casualties in the Pacific war.

TOP LEFT: U.S. NAVY
MIDDLE LEFT:
NATIONAL ARCHIVES
BOTTOM LEFT: U.S. NAVY
RIGHT: U.S. NAVY

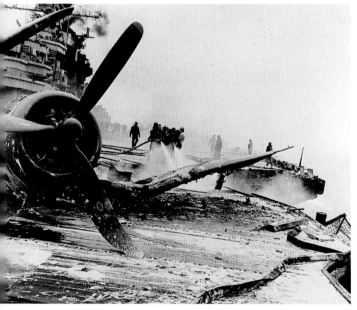

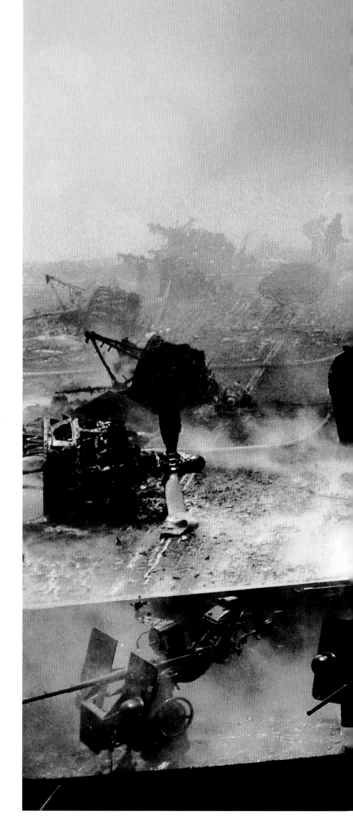

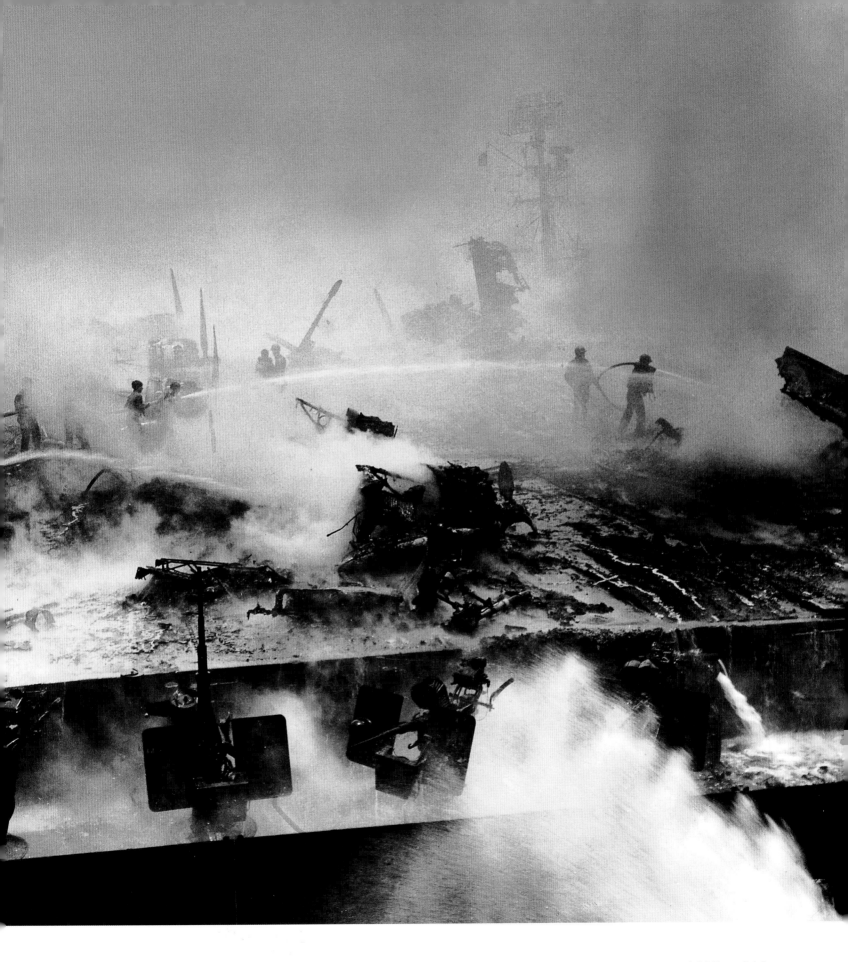

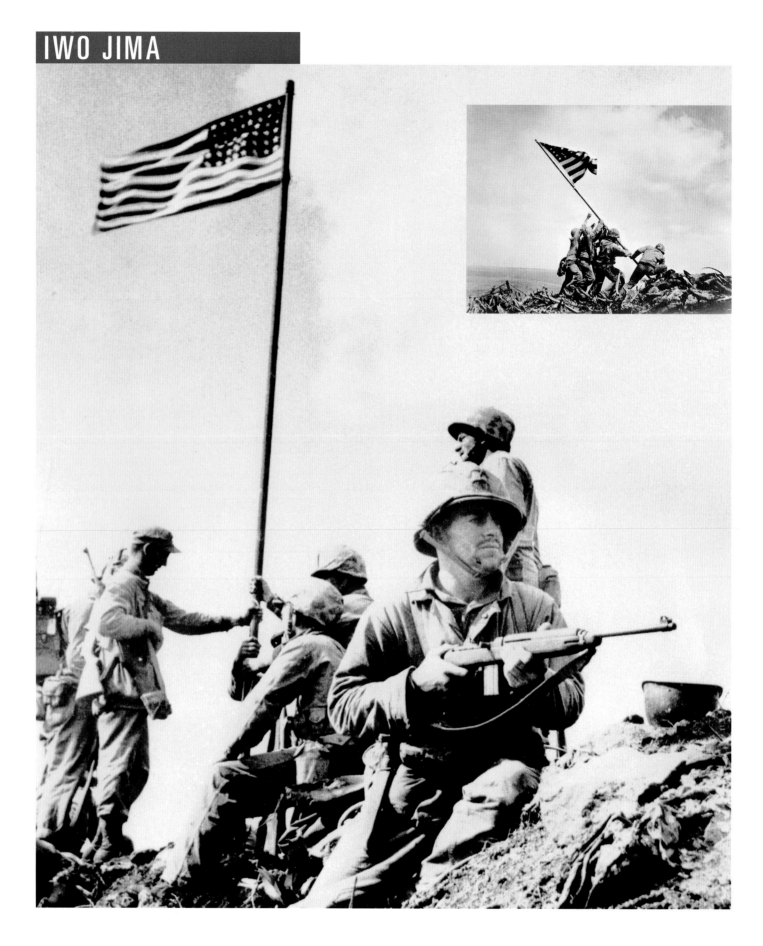

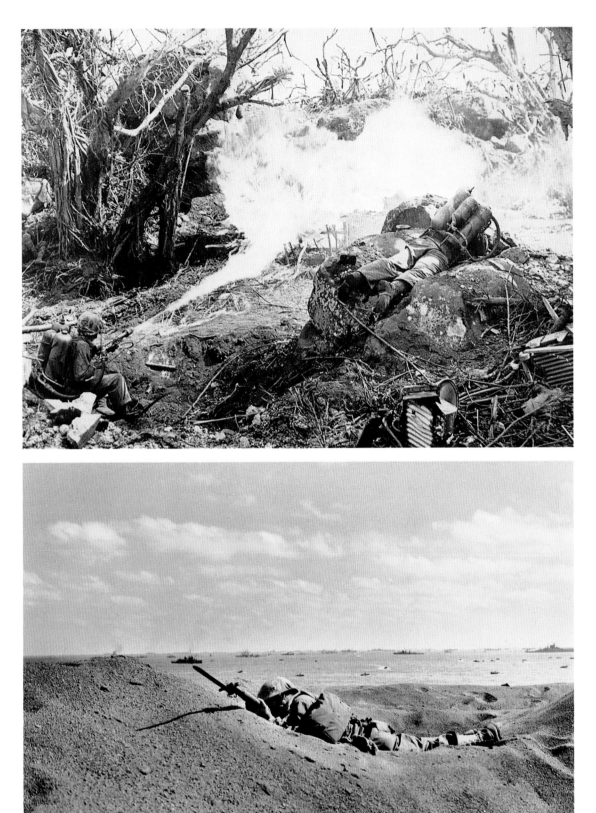

FIRST FLAG ON IWO

On February 23, four days into the invasion of Iwo Jima, 40 Marines reached the summit of Mount Suribachi and raised a small flag (far left). An officer said it should be bigger. So a flag was borrowed from a Navy ship; the resulting Associated Press photograph of the second raising (inset, left) is probably the best known of World War 2. But it did not signify final victory. That would take three more awful weeks.

Prolonged bombing before the invasion had done little to dislodge an enemy hidden in tunnels deep under the volcanic island's powdery soil. Amphibious tractors floundered in it. Trenches collapsed as soon as they were dug. Marines crawled across the 12-square-mile island's blasted landscape yard by yard, wiping out bunkers with flamethrowers (top right).

Their losses were horrendous. The man stopped on the beach by a bullet to his head (right) was one of 6,800 killed on Iwo. Another 20,000 were wounded. It was the first island battle in which total U.S. casualties were greater than the enemy's. But even though the cost in lives was extremely high, Iwo was invaluable as an emergency airfield for crippled B-29s returning from Japan.

FAR LEFT: WIDE WORLD
INSET, LEFT: JOE ROSENTHAL /
AP / WIDE WORLD
TOP RIGHT: HULTON / ARCHIVE
RIGHT: SERGEANT ROBERT
COOKE / U.S. MARINE CORPS

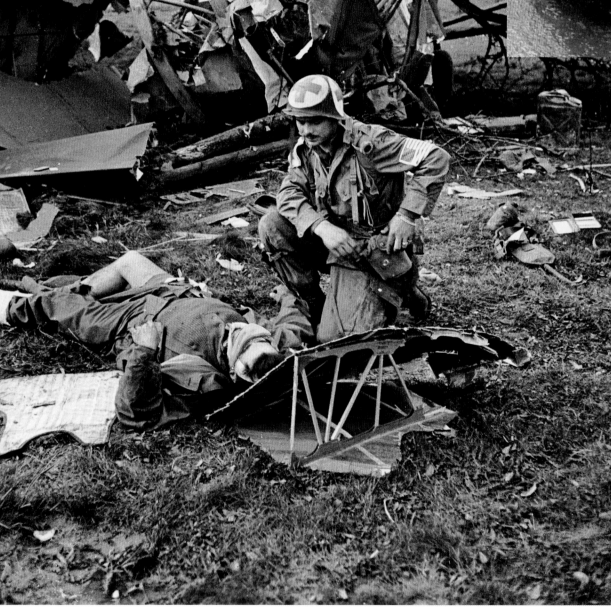

TRAVELING LIGHT

As the Allies advanced, weary German civilians took flight, occasionally (and perilously) crossing enemy lines to avoid mandatory evacuation within the Third Reich. One of them, this elderly woman (above), her meager possessions piled in her lap, hitches a wheelbarrow ride to a refugee shelter run by the British at Bedburg, near Cologne.

IMPERIAL WAR MUSEUM
B 14737

<

HUMAN WRECKAGE

The ruins of a glider near the Rhine River indicate the pounding the wounded trooper's body has taken (left). The Germans first conducted research into the feasibility in combat of motorless aircraft, and the U.S. made frequent use of them in Europe. Gliders could take soldiers behind enemy lines quickly, land in virtually any field — but were highly vulnerable to anti-aircraft fire.

ROBERT CAPA / MAGNUM

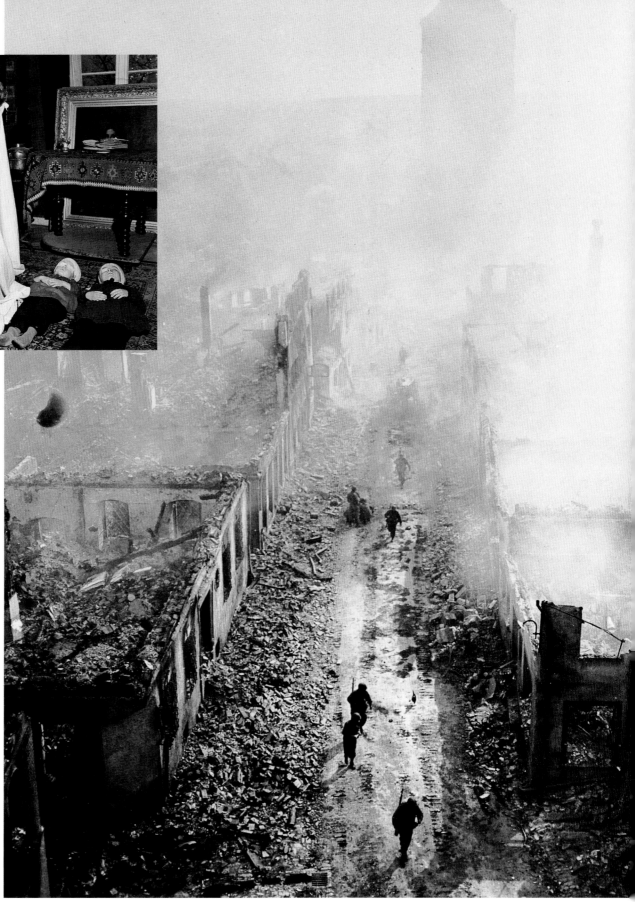

A FAMILY GONE

Lying under a sheet held by a stunned neighbor were two tiny victims of Hitler's war. The boys were poisoned by their distraught mother, who had just learned of her husband's death in the defense of their Main River hometown, Schweinfurt. After dutifully arranging her sons' bodies, the poor woman took her own life — a sacrifice admired in Nazi ideology.

MARGARET BOURKE-WHITE / LIFE / TIMEPIX

>

OUT OF THE NIGHT

The streets of war had rarely seemed gloomier or more hazardous than in Waldenburg, Saxony. Artillery and tank fire had knocked down its buildings, but then German snipers holed up in the rubble. For the infantry, the drill was familiar: Move cautiously, weapons at the ready; don't bunch up, and watch for buckling walls.

IMPERIAL WAR MUSEUM
EA 63143

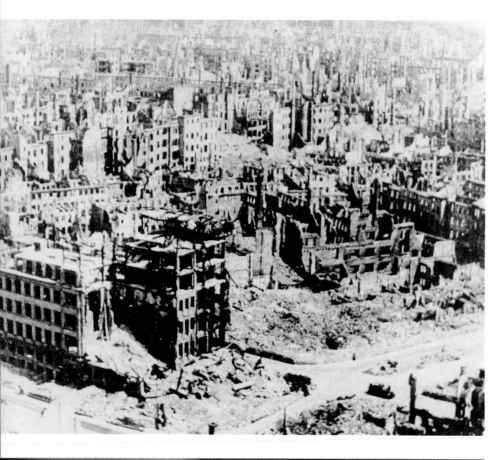

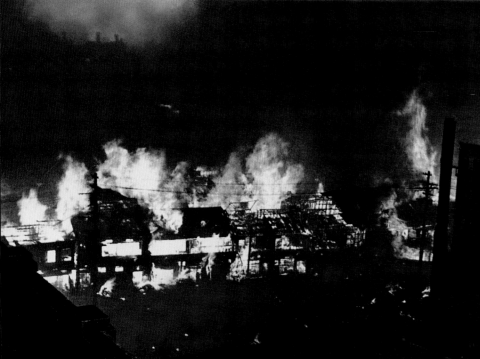

<

DRESDEN DEVASTATED

A beautiful baroque capital of scant military importance, Dresden was spared heavy bombing, which was why the Germans moved hordes of evacuees there, as well as Allied POWs. Then to demonstrate support for Russian action in the East, British and American bombers saturated the city (left) with incendiaries. The 1000-degree flames killed 135,000 residents.

IMPERIAL WAR MUSEUM 44924

>

A BOMBER CAUGHT

As Sakai's searchlights got a fix on one B-29, hundreds more flew undisturbed, showering the city with explosives on July 10 (right). Japanese authorities gave shell-shocked air-raid victims railroad tickets to any destination, causing a nationwide urban exodus. Meanwhile the emperor and family took up residence in a royal bomb shelter.

MAINICHI

<

OSAKA ON FIRE

None of the raids endured by Osaka, Japan's second-largest city, compared to the punishment it suffered in March. In one night U.S. bombers dropped 1,733 tons of napalm and oil, burning 135,000 wood-and-wallboard homes in minutes (left). Fire barriers helped reduce the death toll, but later attacks destroyed what was left of the city and its port.

WARTIME JAPANESE
GOVERNMENT PHOTO

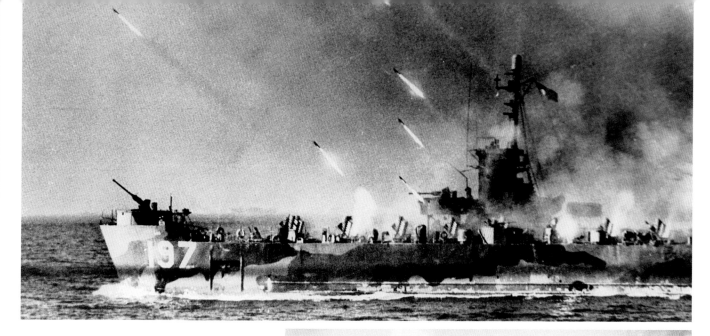

The Deadliest Campaign

Storming the beach of this mountainous island — owned, not simply occupied, by Japan — with little opposition on April 1, U.S. troops attributed their success to pre-invasion bombs and artillery, such as the rockets launched by a landing craft (above). Some April Fools'. In a new tactic the Japanese had withdrawn inland, where they mounted a vicious defense (the rip of incoming shells prompts one GI to hit the dirt, left). Meanwhile, offshore, clusters of kamikazes attacked the Navy until the defenders ran out of aircraft. The ground fighting continued. Okinawan civilians had been told that Americans shot their prisoners, so thousands hid in caves. Some gave up reluctantly, like this man wrapped in a towel against the smoke (middle right); but for others the caves became mass tombs.

Among the Japanese, a few chose surrender over suicide. These men (bottom right) waded nude to a Navy boat to become POWs. By the time organized resistance ended, in June, about 110,00 of their comrades on Okinawa, and as many as 160,000 residents, had died. American losses were 12,500 dead and 36,000 wounded, the highest toll of any Pacific campaign. Among the dead was the Tenth Army's General Simon Bolivar Buckner.

ABOVE: UNDERWOOD PHOTO ARCHIVES
LEFT: W. EUGENE SMITH / LIFE / TIMEPIX
MIDDLE RIGHT: U.S. MARINE CORPS
BOTTOM RIGHT: IMPERIAL WAR MUSEUM NYF 74287

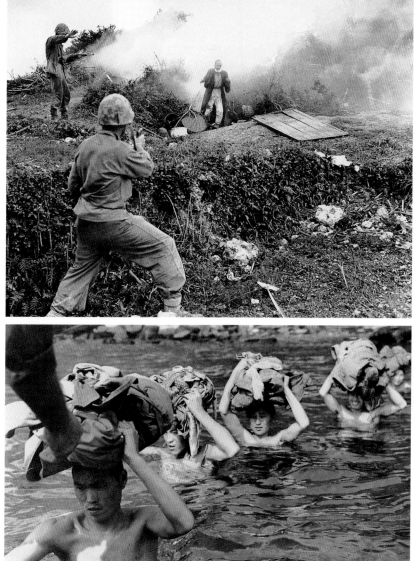

BERLIN

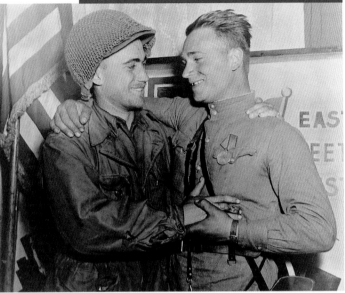

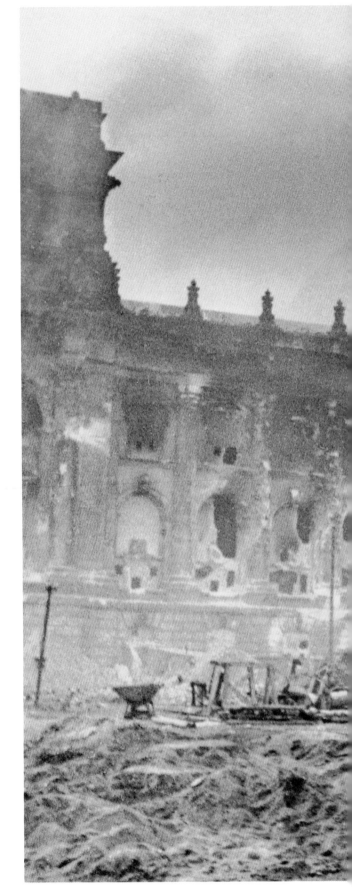

< >

THE TWAIN MEET

West embraced East on April 25 when U.S. Second Lieutenant William Robertson (left), a patrol leader, inched across the ruins of a bridge spanning the Elbe River to meet his Soviet counterpart, Lieutenant Alexander Sylvashko. Five days later the Reds were in Berlin in force, and a few soldiers approached the battered Reichstag (right) with the hammer and sickle flag they would unfurl from the roof.

LEFT: U.S. ARMY; RIGHT: DAVID KING COLLECTION

<

HITLER'S TOMB

PFC Richard Blust inspects the bunker under the Reichs Chancellery, where Hitler spent the last 15 weeks of his life (left). He married Eva Braun, and then they both committed suicide here on April 30. Blown up by the Russians, the ruins of the cramped cellar were uncovered by construction workers in 1999 and buried again lest they become a neo-Nazi shrine.

HULTON / ARCHIVE

<

ARMY SURPLUS

Stark evidence that the war was lost: this pile of German helmets, many with bullet and shrapnel holes in them. Berlin's finale was surreal. Loyal to the end, fanatical SS officers hanged deserters on the spot. Conditions in conquered areas of the city were just as frightening. Embittered Soviet soldiers went on a rampage of murder, looting and rape.

DAVID KING COLLECTION

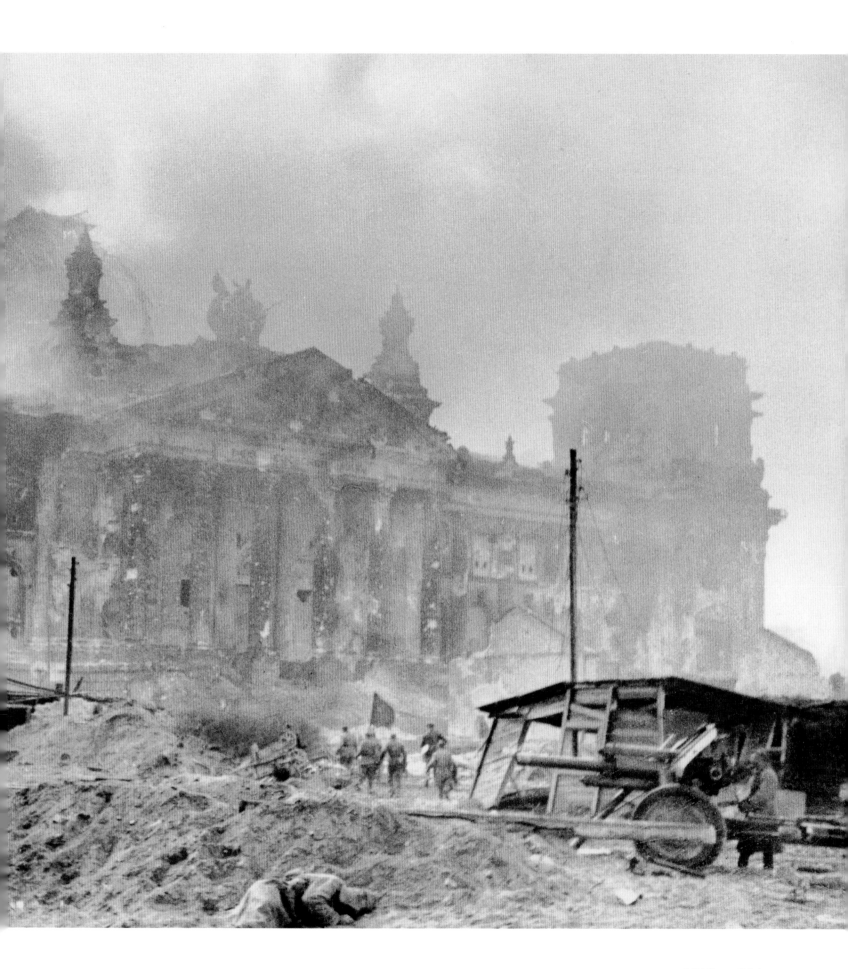

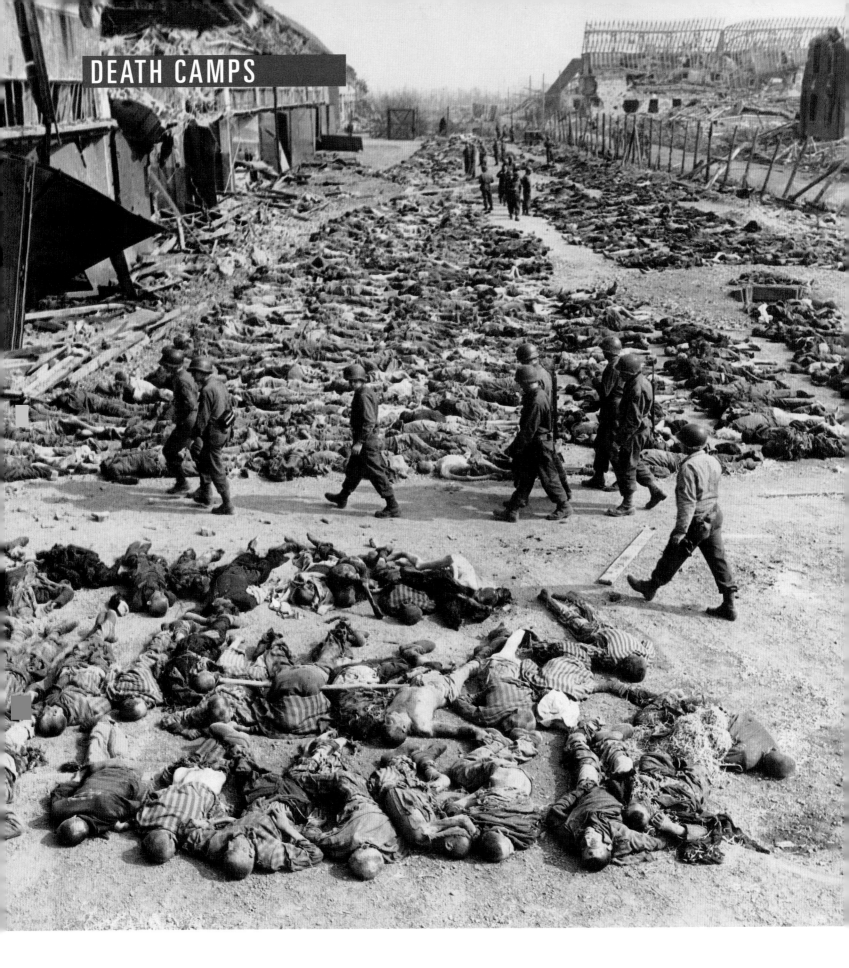

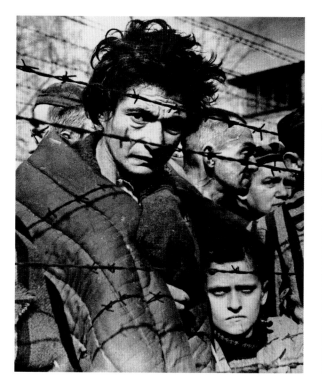

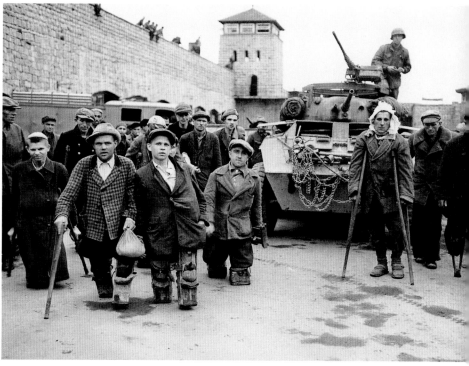

HELLS ON EARTH

Allied leaders had heard about Hitler's mass exterminations but decided the best way to help the Jews was to win the war quickly, and did not make the reports public. The scenes inside the camps were thus unimaginable, even to the battle-hardened soldiers who broke down their gates. At Nordhausen (left), American troops organized the bodies of nearly 3,000 slave laborers for burial. Caring for the survivors was more complicated. A mother and son are stranded at Auschwitz (above) until someone could take them in. These Mauthausen inmates (above right), crippled by double amputations, need physical rehabilitation. And a frail Wobbelin prisoner sobs when he is not among the first taken to the hospital (right).

LEFT: JOHN FLOREA / LIFE / TIMEPIX; ABOVE: VLADIMIR RYUDIN; ABOVE RIGHT: IMPERIAL WAR MUSEUM EA 65917; RIGHT: IMPERIAL WAR MUSEUM EA 66640

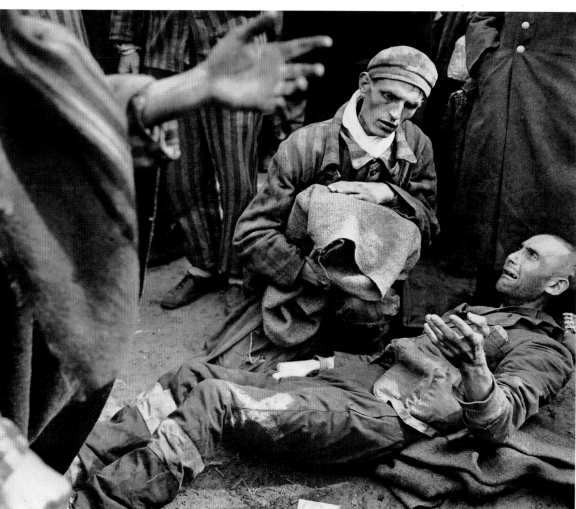

DEATH CAMPS

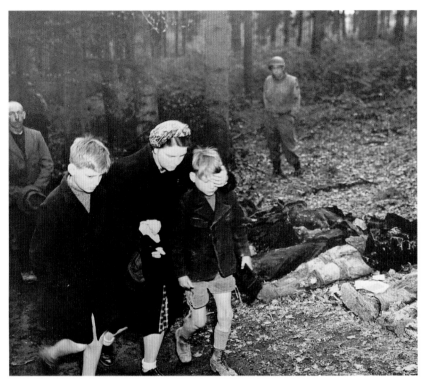

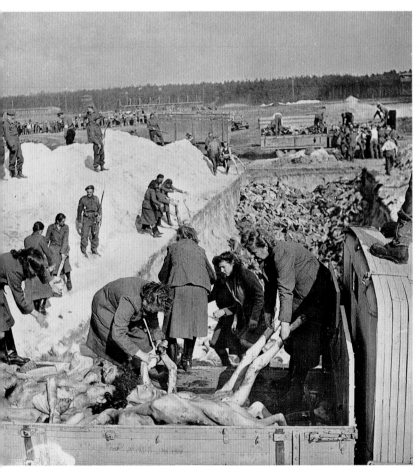

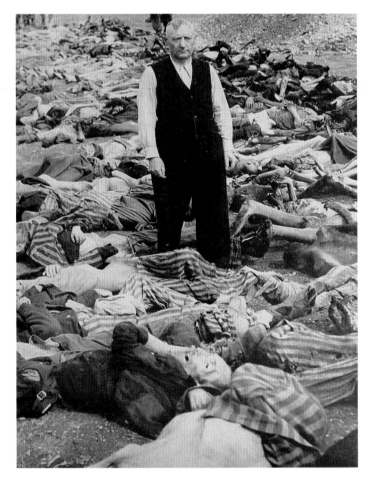

GERMANS AND GRAVES

To convince Germans of the full depravity of Nazi crimes, the Allies required townspeople to visit nearby camps. At Suttrop, where 57 Russians were murdered, civilians had to dig up the bodies. At top far left, a nattily dressed businessman holds an exhumed infant. A mother who brought her young sons to the camp (top near left) lowers her head and rushes through while trying to shield the eyes of one boy from the horror.

At right, the residents of Ludwigslust are pressed into service as pallbearers. In their Sunday best, they carry bodies away from Wobbelin. During the funeral service, one citizen was heard to say, "It is a disgrace to be a German."

The guards and staff at the camps, of course, lacked even the convenience of deniability, and were treated more harshly. The British compelled female guards at Bergen-Belsen (bottom far left) to put the shrunken corpses of prisoners into a mass grave to prevent disease. And the commandant of Kaufering IV, an SS officer named Eichelsdoerfer (bottom near left), was ordered to stand amid his handiwork for the photographic record.

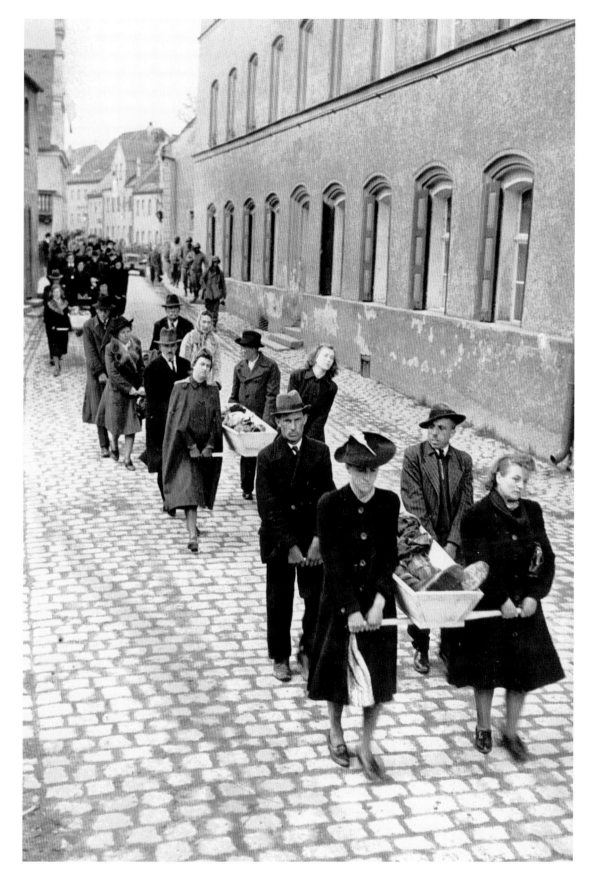

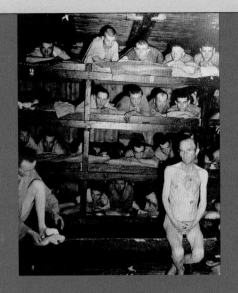

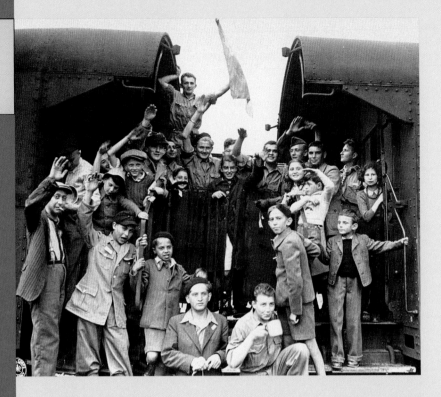

THE FOUNDING OF ISRAEL

Promised Land

Like these Buchenwald inmates (above) the Jewish communities they came from were in fragile condition at war's end. The great rabbinical centers of Eastern Europe and the rural Yiddish-speaking shtetls all had been razed. In cosmopolitan cities Jewish-owned shops and homes had been seized; there was little chance they would be returned. With repatriation impossible, many survivors became convinced they had to build their own nation. Zionism — a late-nineteenth-century movement founded by the targets of czarist pogroms — flowered in the collapse of Nazi Germany. Out of Zionism came Israel.

EUROPE'S ORPHANS

From a train taking them to France (top), Jewish children wave farewell to their friends at Buchenwald, which had been turned into a refugee camp. It was the beginning of a flood of Jews from Europe to British-run Palestine. London, diplomatically fearful that a growing Jewish population would provoke the Arab majority, ordered them stopped. Among the refugee ships that tried to sneak through the blockade in 1947 was the famous *Exodus* (right, in Haifa). British destroyers rammed it, put troops aboard and arrested the passengers. Deciding to make an example of them, the British sent the 4,500 men, women and children not to Cyprus, the usual destination, but to Germany.

TOP: NATIONAL ARCHIVES / COURTESY USHMM
RIGHT: THE ILLUSTRATED LONDON NEWS
TOP LEFT: MARY DICKINSON / COURTESY USHMM

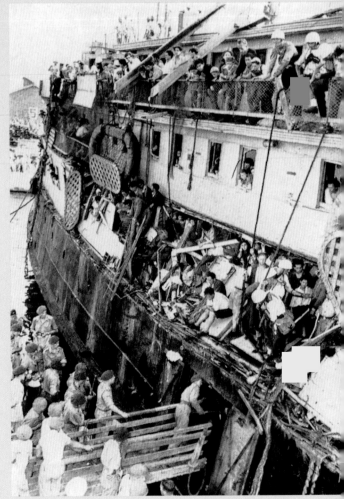

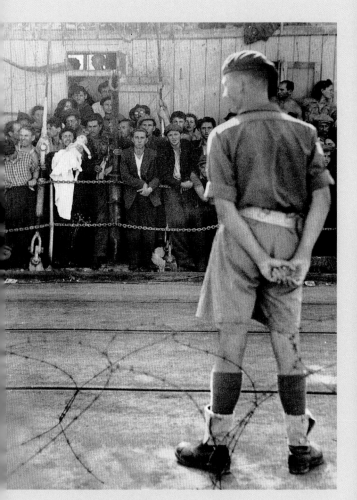

FATHER FIGURE

The Polish-born son of a Zionist, David Gruen settled in Palestine at the age of 20 and hebraized his name. Ben-Gurion entered politics as a secular Socialist. By adroitly balancing his people's priorities against international realities, he shepherded Israel to statehood and became its first elected prime minister (left) at the age of 62.

DMITRI KESSEL / LIFE / TIMEPIX

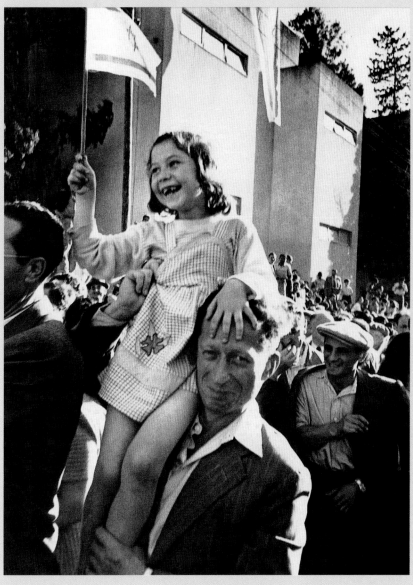

THE BRITISH FOE

With the help of Haganah, the Jewish underground army, thousands of European Jews made it to Palestine. Others did not. A British soldier watches a boatload of angry detainees (above), one of whom brandishes the body of a baby who was suffocated by tear gas fired when their ship was attacked. During the war, Zionists had not harassed the British; they were bitter at the payback.

CORBIS / BETTMANN

>

BIRTH DAY

Emigration never stopped despite the obstacles, and in November 1947 the UN approved partitioning Palestine into one nation for the Arabs, one for the Jews. At right, a girl waves the new blue-and-white flag to celebrate the birth of Israel, on May 14 in 1948. Six weeks later the British pulled out of the region.

ROBERT CAPA / MAGNUM

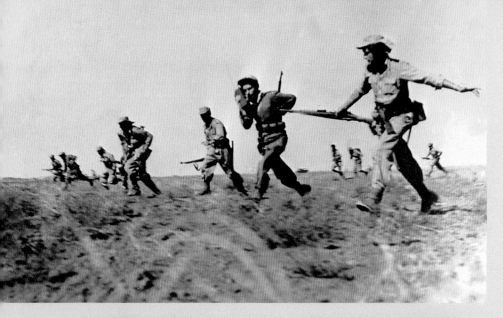

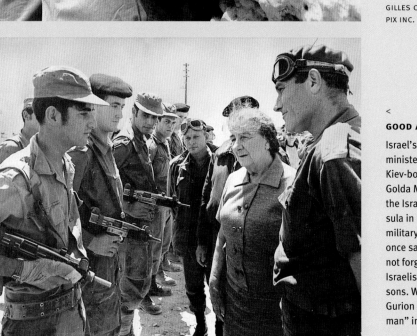

WAR FOR SURVIVAL

A few hours after Israel declared its independence, five Arab nations — Egypt, Jordan, Syria, Lebanon and Iraq — invaded. With World War 2 memories as motivation, the new nation fought back (left, advancing against Egyptian troops in the Negev desert). Its victory added 21 percent more land to its borders but cost 6,000 lives, almost one percent of the population.

HULTON / ARCHIVE

EMBRACE THE PAST

Expecting a new attack by Arabs, Israel struck first in 1967. The so-called Six-Day War took its troops into the hitherto inaccessible Arab quarter of Jerusalem, where a soldier kisses the Wailing Wall (left), revered as the last remnant of the Second Temple. The area is also sacred to Moslems, who believe Muhammed ascended to heaven from the nearby Dome of the Rock.

GILLES CARON / LIAISON / PIX INC.

GOOD AS GOLDA

Israel's fourth prime minister, at age 70, was the Kiev-born, Milwaukee-bred Golda Meier (left, touring the Israeli-held Sinai peninsula in 1969). She was a military hard-liner who once said her country could not forgive Arabs for forcing Israelis to kill their enemy's sons. While premier, Ben-Gurion called her "the only man" in his cabinet.

I. FREIDIN

ARAFAT EMERGES

The West considers him fierce and intractable; his Middle East rivals, too moderate. Yasser Arafat, a onetime engineer, runs the Palestine Liberation Organization within that delicate balance. He won the job (right) in 1969 and has kept it by using a shrewd mix of terrorism and diplomacy (like the Zionists before him). The Palestine state is largely his creation.

AUGUSTO MENESES

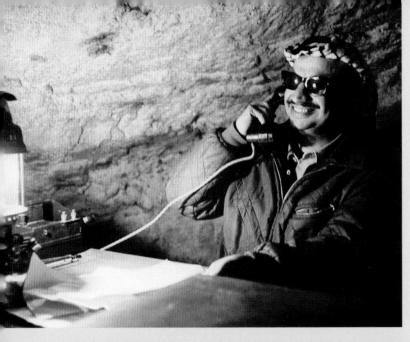

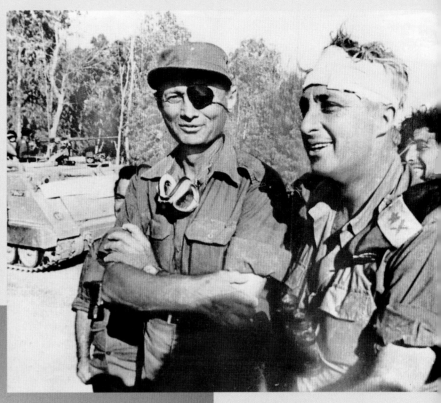

RETURNING FIRE

In 1973 on Yom Kippur — Judaism's most solemn holiday — the Arabs caught Israel offguard with a two-front attack. But Egypt and Syria failed to capitalize on their early successes. Soon Israeli troops, under Defense Minister Moshe Dayan and Major General Ariel Sharon (above, from left), had crossed into Egypt. Artillery was pounding Syria (left) to support an invasion that threatened its capital, Damascus. The UN stepped in and negotiated a ceasefire. The bittersweet victory proved that the Jewish state could fend off its enemies but would have to dedicate much of its human and financial resources to the task.

ABOVE: CORBIS / BETTMANN
LEFT: G. MELET / AGENCE FRANCE MATCH

PEACE, THEN DEATH

In 1978 President Jimmy Carter (right) helped Egyptian President Anwar Sadat (at left) and Israeli Prime Minister Menachem Begin agree on the region's first treaty — and win the Nobel Peace Prize for their courage. The pact gave the Sinai, occupied by Israel since 1967, back to Cairo. Egyptian Muslim fundamentalists were not happy; they assassinated Sadat in 1981.

DAVID HUME KENNERLY

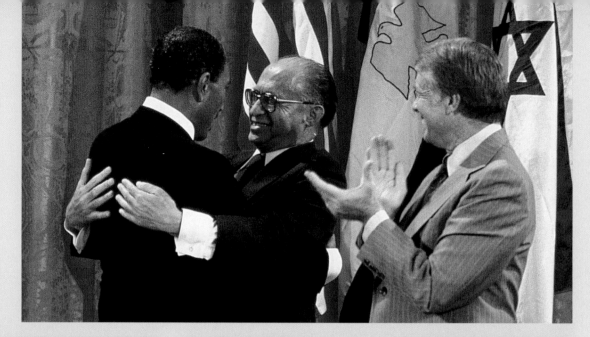

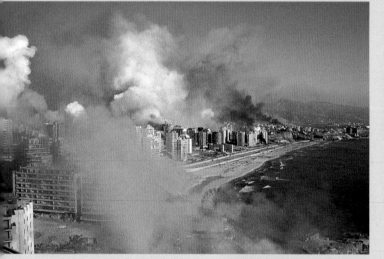

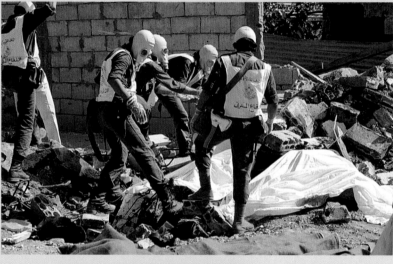

LUCKLESS LEBANON

Split by a 1975 civil war Lebanon suffered even more seven years later, when Israel invaded in an effort to drive out Arafat's PLO. Beirut was in flames (above). In the internal struggle that followed, Palestinian refugee camps were overrun, and hundreds of civilians slaughtered. Lebanese police wore gas masks (above right) to remove the decomposing bodies.

ABOVE: DIRCK HALSTEAD / TIMEPIX; ABOVE RIGHT: RUDI FREY / TIMEPIX

<
ANOTHER LEADER DOWN

Assassinating government officials has become a Middle Eastern way of death. A decorated Army veteran, Prime Minister Yitzhak Rabin was anything but a dove. Yet his meetings with Arab leaders and his willingness to trade territory for peace prompted a right-wing Israeli nationalist to murder him in 1995. Mourners set up this informal shrine outside parliament (left).

CHRISTOPHER MORRIS / BLACK STAR

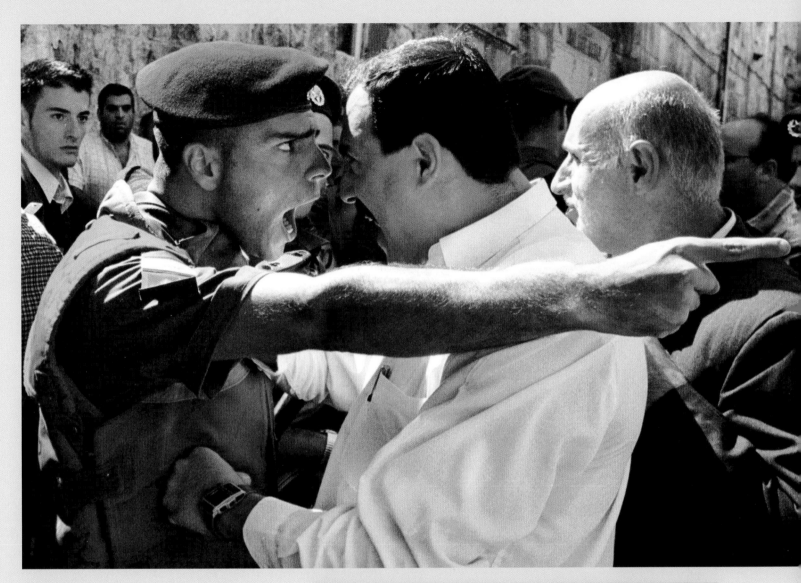

HOT HEADS

In 2000, renewed and bitter violence derailed peace talks between Tel Aviv and the PLO. Palestinian terrorism escalated; Israeli counterattacks against suspected terrorist leaders were brutal. The tension was dramatically illustrated (above) when an Israeli policeman refused to let an Arab worshiper enter al-Aqsa mosque in Jerusalem for Friday prayers.

AMIT SHABI / REUTERS / TIMEPIX

>

SHAKE, DON'T STIR

The fresh round of violence meant a new Israeli prime minister: war hero Ariel Sharon, 72. He had a tough-guy reputation but said he wanted peace. George W. Bush, the President of Israel's staunchest ally, has sent diplomats to the Middle East to encourage the process. The two men met in Washington in March 2001 (right). The killing continues.

CORBIS / REUTERS NEWMEDIA

BUILDING THE BOMB

Before the war, both Allied and German physicists knew the power of a nuclear reaction. In 1939 a race began to build an atomic bomb. The Nazis lost, not least because of the scientists who had fled west to escape Hitler. The code-named Manhattan Project built a huge, secret plant in Oak Ridge, Tennessee (below), and another in Washington State. Although most employees weren't sure what they were working on, they were ordered to keep quiet (right). In December 1942 the first self-sustaining atomic pile was set off; that meant a bomb could be made. British and American scientists did it in two-and-a-half years.

ED CLARK / LIFE / TIMEPIX (BOTH)

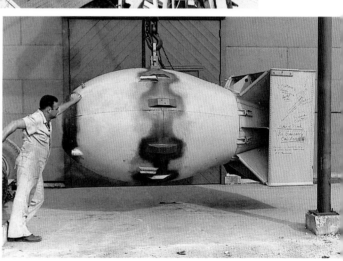

Testing the Bomb

Making sure the bomb that was built would work was the responsibility of the men at left: physicist Dr. Robert Oppenheimer and Manhattan Project director General Leslie R. Groves. It did. The two are standing at the remains of the tower on which it was detonated, on July 16, near this staging area in New Mexico (at top). Two bombs were subsequently made. Above is number 2, nicknamed Fat Man, a few hours before it was dropped (next page). The morality of the bombing is debated now. Not then. President Truman did not hesitate, and Churchill wrote of the decision: "There was unanimous, automatic, unquestioning agreement."

LEFT: CORBIS / BETTMANN
TOP: LOS ALAMOS NATIONAL LABORATORY
ABOVE: NATIONAL ARCHIVES

NAGASAKI

The Second Attack

Three days after Hiroshima, the U.S. dropped a second atomic bomb on Nagasaki (it was an alternative target; first choice was Kokura, but it was obscured by thick clouds). Though the damage was less than at Hiroshima, because of Nagasaki's surrounding hills, and the death roll (40,000) about half, the scene at ground zero was equally horrific: blackened bodies (below), burned children brought to an aid station by a father and a brother (both near right) and dying residents (far right).

ALL: YOSUKE YAMAHATA / G. T. SUN CO., TOKYO

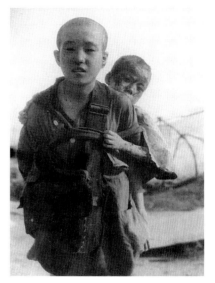

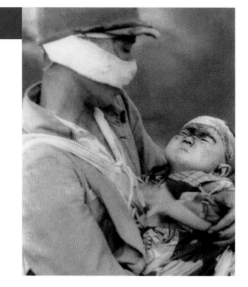

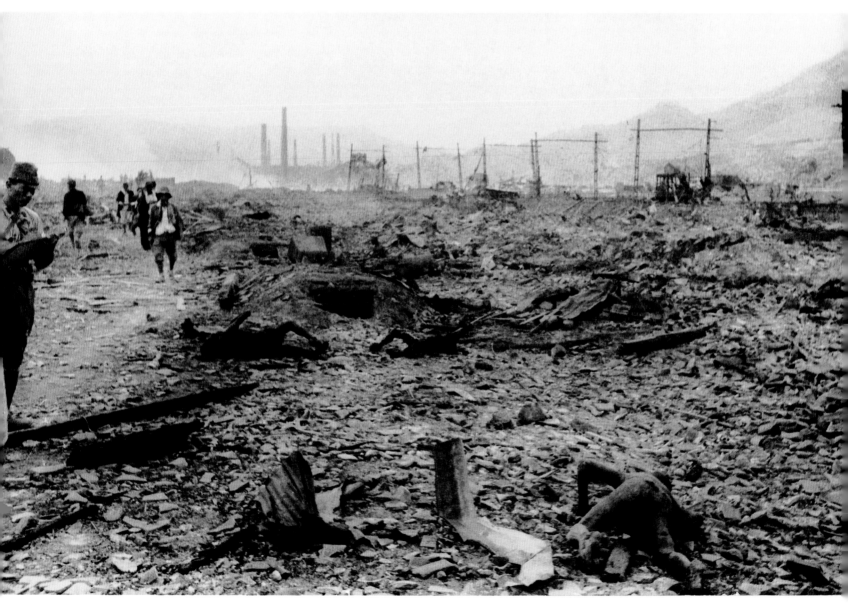

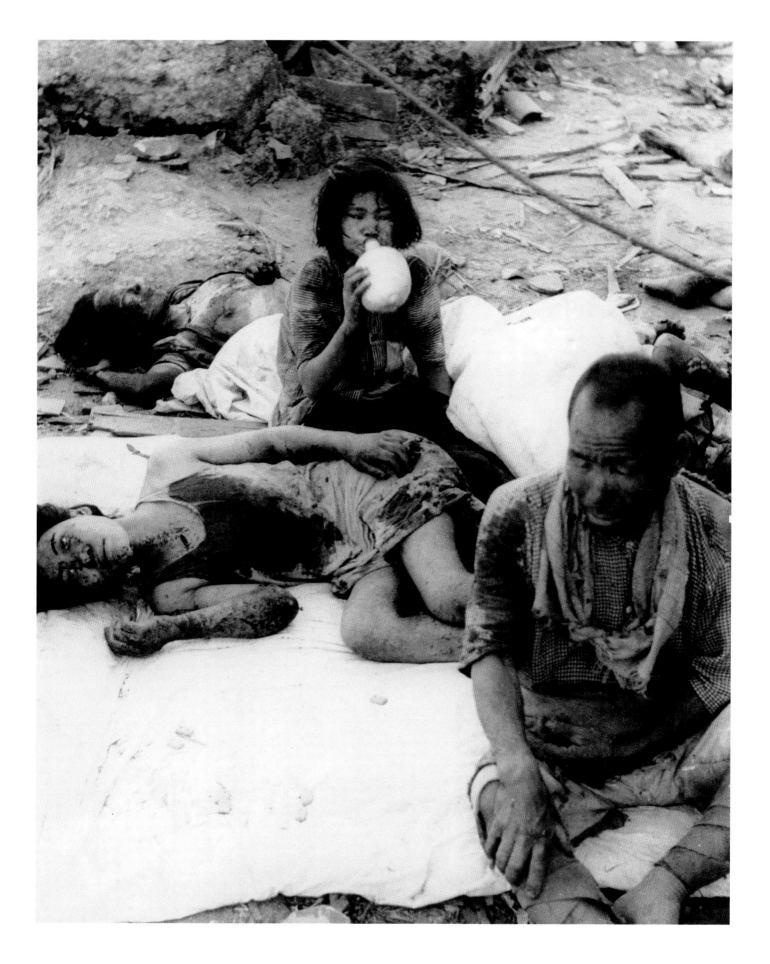

SURRENDER

SURRENDER BY PEN . . .

The end came quietly on the deck of the battleship *Missouri*, in Tokyo Bay, on September 2 (above). Japanese foreign minister Mamoru Shigemitsu signs the document of Japan's official capitulation. Looking on are General Douglas MacArthur, far right; the Japanese delegation; officers from all the Allied nations, foreground; and the ship's company crowding the main deck and a 16-inch turret.

UNDERWOOD PHOTO ARCHIVES

. . . AND BY SWORD

Around the Pacific, local Japanese commanders surrendered with the ritual of turning over their swords: to an Indian Major in Saigon (top left); to an American Lieutenant Colonel on Saipan (bottom left), which took place December 1, after 47 Japanese soldiers and sailors had hidden in the island's jungle and coral caves for 17 months; to another Lieutenant Colonel at the Kurihana Naval base in Japan (top right). In Manila things were not so polite. A U.S. Colonel indicates what the Japanese Lieutenant General can do with his handshake (below).

TOP LEFT: IMPERIAL WAR MUSEUM SE 5690; BOTTOM LEFT: U.S. NAVY; TOP RIGHT: CARL MYDANS / LIFE / TIMEPIX; BELOW: GEORGE LACKS

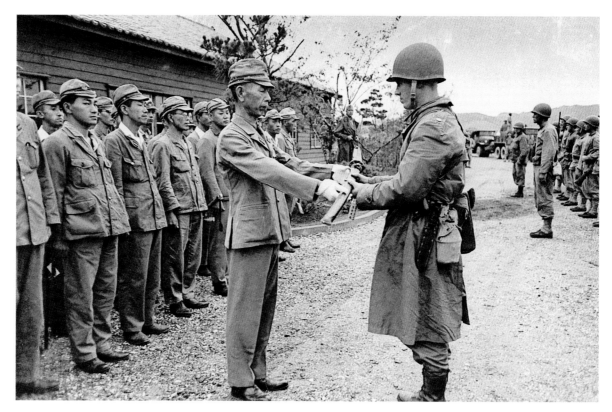

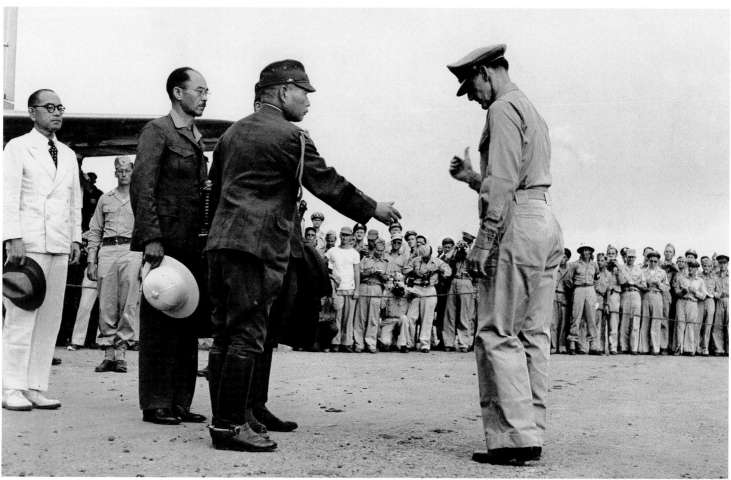

CELEBRATION

HOORAY, V-J DAY

The most famous kiss of
World War 2 was caught by
LIFE photographer Alfred
Eisenstaedt in Times
Square (bottom near right)
after Japan surrendered.
But as these pictures show,
there was a whole lot of
smoochin' goin' on all over
the world — (this page,
clockwise) in Washington,
New York City, Miami,
Kansas City, Chicago;
(opposite page top) Paris,
London, Hollywood and
Boston. But perhaps the
most poignant embraces of
all took place at St. Albans
Naval Hospital, in Queens,
New York (opposite bot-
tom). Grievously wounded
Marines and sailors kiss a
nurse and raise their
crutches in triumph. For
them the struggle to heal
would go on for quite
a while.

THIS PAGE, CLOCKWISE:
CORBIS / BETTMANN; TONY
LINCK / TIMEPIX; MIAMI
HERALD; EARL HENSE / KANSAS
CITY STAR; GORDON COSTER /
LIFE / TIMEPIX; ALFRED EISEN-
STAEDT / LIFE / TIMEPIX

OPPOSITE PAGE, CLOCKWISE:
U.S. ARMY; HULTON / ARCHIVE;
WALTER SANDERS / LIFE /
TIMEPIX; JAMES COYNE; NEW
YORK DAILY NEWS

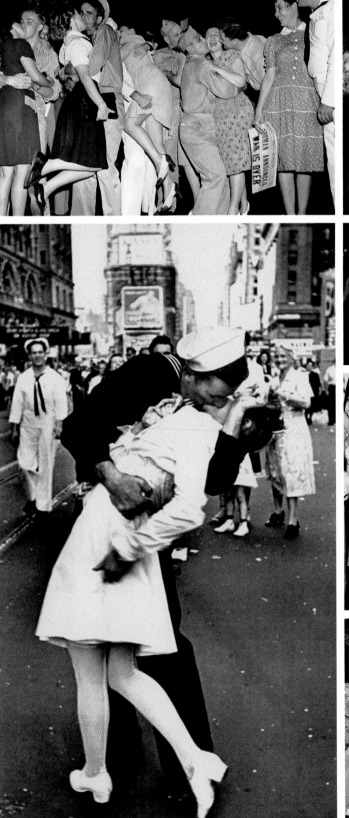

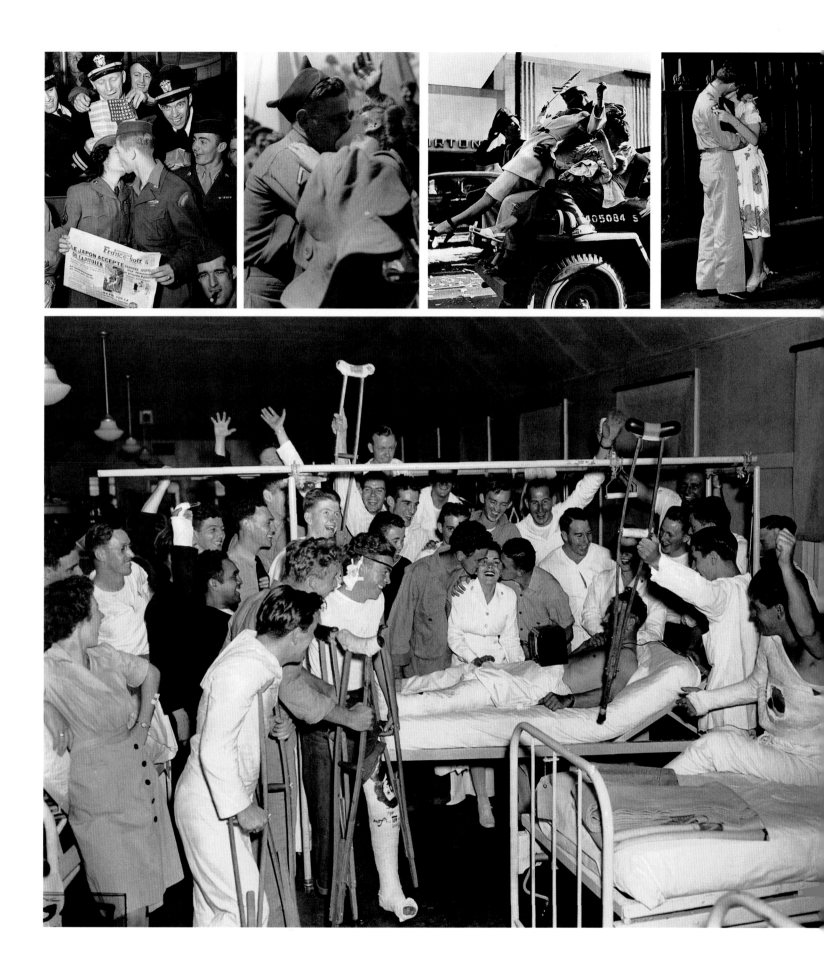

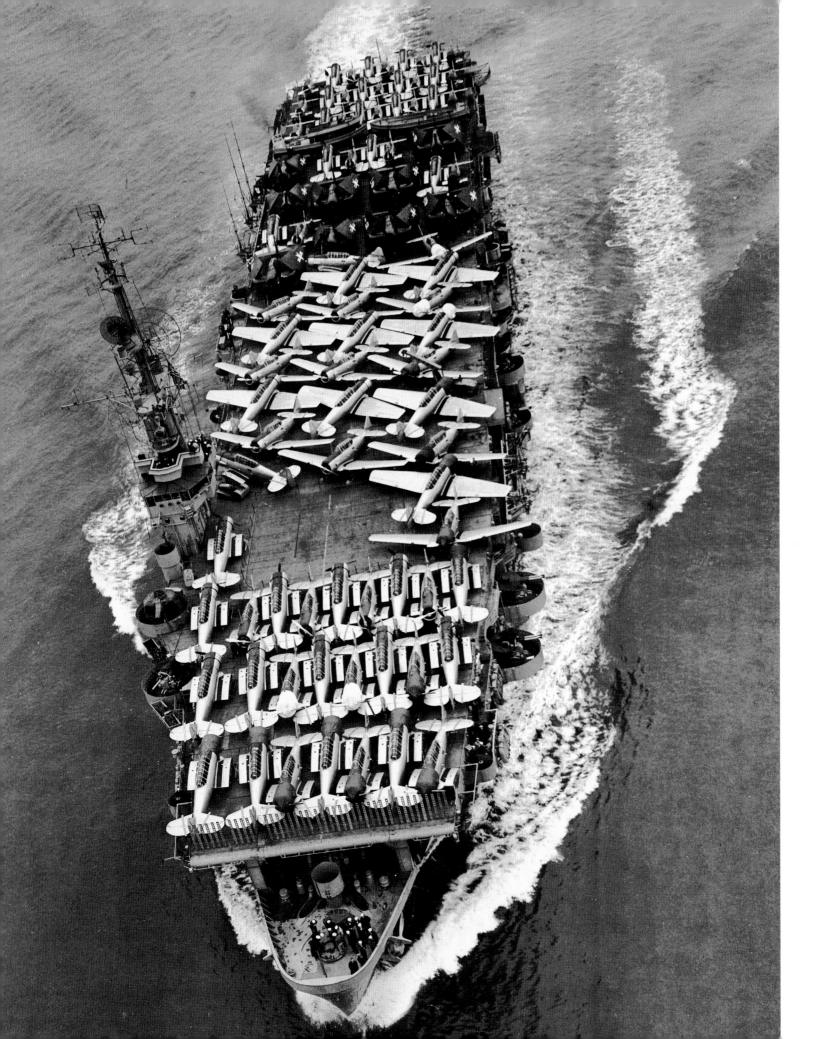

The War's Aftermath

Red scares, baby harvest, fatter paychecks and learning to pull together

by William L. O'Neill

OVERSEAS almost nothing turned out as expected after Japan surrendered. Americans had believed that the end of World War 2 would bring about world peace because the Allies, or perhaps the United Nations, would enforce it. President Franklin D. Roosevelt had hoped peace could be ensured by keeping the Big Three — Britain, the Soviet Union and the United States — together, with each policing its own part of the world. Although FDR disowned the term, this was "spheres of influence" diplomacy, and would have been a good solution to the peacekeeping problem had it worked.

Roosevelt's plan failed because the war had altered the global balance of power by reducing the great nations from six to two, the U.S. and the Soviet Union, the latter a predator nation that was taking advantage of the newly created military vacuums in Europe and Asia. In violation of treaty agreements, Joseph Stalin and the USSR turned the occupied countries of Eastern Europe into Soviet-style police states.

America's new role became clear in 1947, when London abruptly informed Washington that Britain

was pulling out of the eastern Mediterranean because it could no longer afford costly foreign operations. Since a Communist-led insurrection was raging in Greece and the Soviets were pressuring Turkey, President Harry S. Truman asked Congress to aid the two countries, which it did, saving both. Truman then announced that any state threatened by outside aggression could count on American help, a policy soon named the Truman Doctrine. He aimed to restore the balance of power in Europe and Asia by containing Soviet expansion, an all important task that only America could undertake. Thus, victory in World War 2 produced not peace but the Cold War.

The Marshall Plan (1947) was a vital feature of Truman's policy, providing goods and money for rebuilding the economies of Western Europe and Japan. In 1949 Truman capped his Cold War strategy by forming the North Atlantic Treaty Organization (NATO), a military alliance that included most of the Western democracies. In a few short years, the President had mapped out the course America would pursue for decades to come.

The Truman Doctrine's greatest test came on June 25, 1950, when Communist North Korea, which had been heavily armed by the Soviets, invaded the Republic of Korea, headed by Syngman Rhee. Korea had been occupied and partitioned along the 38th parallel at the end of the war by the Soviets and the Americans. However, both had with-

<

Under the Truman Doctrine of aid to Greece and Turkey to help resist Communist pressure, the U.S. carrier *Rendova* sailed in April 1948 from San Francisco with 80 AT-6 trainers for the Turkish Air Force.

CORBIS / BETTMANN

drawn their garrisons before North Korea struck. Within days it became clear that South Korea's weak Army could not withstand the invaders. Truman courageously intervened, supporting that country with naval and airpower, and soon with troops.

Although NATO and the UN endorsed Truman's decision, America did most of the fighting because its European Allies had not yet recovered from World War 2. After nearly being driven into the sea, U.S. forces took the offensive and by September had liberated South Korea. Flushed with victory, Truman authorized Supreme Commander General Douglas MacArthur to occupy North Korea, disregarding warnings from Communist China that it would resist what it saw as a threat to its borders.

The subsequent invasion of North Korea eventually prompted an armed Chinese response, which drove the UN troops back into South Korea. After a series of attacks and counterattacks, the front stabilized roughly along the 38th parallel in the spring of 1951. Fruitless peace talks alternated with outbreaks of trench warfare until 1953, when newly elected President Dwight D. Eisenhower secured an armistice.

The Korean War took 54,000 American lives, including 33,000 killed in action (others died of injuries and disease). Although a costly tactical draw, the war was a strategic victory for the United States because it saved South Korea and, in doing so, drew a symbolic line in Europe and Asia that was never crossed again — except, arguably, in Vietnam.

Moreover, Korea fundamentally changed the Cold War. Before it, American policy had relied mainly on economic assistance to achieve its goals, but from 1950 on, the United States would more often use military means. Another result was that

<

After Germany surrendered, Europe was awash with refugees. This was a street scene in bomb-damaged Munich, where hungry looters were stealing food from the ruins of a warehouse.

DAVID E. SCHERMAN / LIFE / TIMEPIX

The Cold War produced near hysteria about Communist influence in Washington. It was exploited by Wisconsin senator Joseph McCarthy (above), who promised to "sweep" the government clean of Reds.

HULTON / ARCHIVE

Truman began supplying aid to the rump Chinese Nationalist government in Taiwan, a decision that still hampers Sino-American relations, and to the French in Indochina, starting a process that would drag America into the Vietnam War.

Thus, by way of the Cold War and the Korean War, World War 2 shaped American foreign policy until 1991, when the Soviet Union collapsed. It shapes America's oversize military to this day, which has taken on a life of its own that is often unrelated to national security requirements.

Domestically World War 2 provided enormous benefits to the great majority of Americans who emerged unscathed from it. The war ended the Great Depression, which had lingered on until 1942. Full

The baby-boom generation was drawn into politics by its opposition to the Vietnam War. In April 1971 one of 200,000 demonstrators in Washington, D.C., climbed the Peace Monument to wave a Vietcong flag.

retool, consumers bought their goods. A severe housing shortage began in 1945, when veterans started coming home to a country that had not expanded its basic housing stock for 15 years. The shortage was over by 1950 thanks to shrewd developers like William Levitt, who learned to mass-produce housing, and to the GI Bill. Its mortgage guarantees enabled veterans to buy homes cheaply, often for less per month than their previous rentals.

Thanks also to the GI Bill millions of veterans completed their schooling, becoming the best educated and, therefore, the best paid generation yet. Millions of them astonished the country by simultaneously going to college and starting families, and they had many more children than previous generations. The birthrate rose by about a third between 1940 and 1957, the peak year of the "baby boom," when 4.3 million infants were born (compared with fewer than 4 million births in 1997, after 40 years of population growth).

As the boomers were much more numerous than any generation before them, they changed the nation at every stage of their lives, straining public schools in the Fifties, doubling the college population in the Sixties, and then swelling the work force. Early in the 21st century they will start making heavy demands on the Social Security system.

The baby boom was the most durable result of World War 2 at home, but an immediate and startling effect was the ardent domesticity of the war generation. As the birthrate rose the divorce rate fell, reaching its lowest postwar point in 1958. Housing developers, construction companies, manufacturers, retailers and the entire service industry celebrated the war generation's demographics. A magazine coined the word "togetherness" to describe its attachment to home and family.

But the war generation also provoked a strange body of social criticism. Looking at America's spreading suburbs and growing families, critics detected

employment arrived a year later, and, since consumer goods were in short supply, a large measure of personal income wound up as savings. These cushioned the transition to peacetime despite several years of inflation, the loss of millions of defense jobs and the return to civilian life of 10.5 million veterans between 1945 and 1947. Congress and President Roosevelt helped out, not by planning an orderly conversion, which they didn't, but by enacting the GI Bill in 1944. It offered immediate assistance to veterans in the form of subsidies for education, guarantees for home and business loans and other benefits.

Instead of a return to hard times, which many Americans had feared, the economy boomed, after a shaky start. As fast as defense manufacturers could

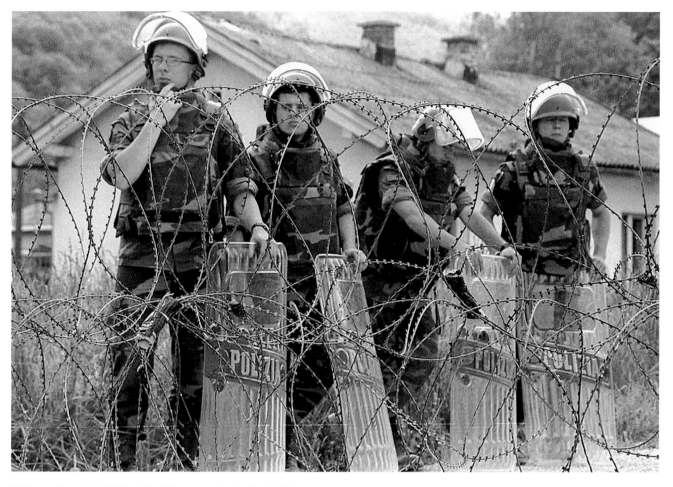

NATO was formed in 1949 to defend Europe against the Soviet Union, but by 2001 its troops — like these Italians in Bosnia — were trying to maintain order in the volatile remnants of the former Yugoslavia.

DANILO KRSTANOVIC / REUTERS / TIMEPIX

not bliss and prosperity but a sinister mutation in the national psyche. Books like William H. Whyte's *The Organization Man* (1956) accused young fathers of being timid conformists, eager to get along rather than get ahead, unlike the independent thinkers and risk-takers of the past.

These stereotypes, which persist even today, had little basis in fact. Previous generations had also exalted home and family, were mostly employees rather than entrepreneurs and consumed as much as they could. Later generations resembled the veterans as well but with one important difference: They held marriage and family in much lower regard, as evidenced by rising divorce and illegitimacy rates, falling birthrates, growing numbers of single-parent families, lower marriage rates and later marriage ages of the boomers and their children.

By 1990, 60 percent of women with youngsters under the age of six would be partly or fully employed — often out of necessity, to be sure. Even so, when it comes to family values the war generation cannot be matched. Critics in the 1950s failed to understand that what made these young mothers and fathers different was not some failure of nerve but World War 2. Veterans had spent on average three years in the service, which most regarded as lost time when they should have been finishing school, getting jobs and starting families. This explains why they were in such a hurry after the war. They treasured domestic life because they had spent so much time crowded together in ships, barracks, tents and foxholes. In addition, living cheek by jowl with men from all over the country, every walk of life, every

religion and every white ethnic group (the military was racially segregated in WW 2) had forced them to put prejudice aside and learn to pull together.

Their wives and future wives lost three years as well. Like the men, if to a lesser degree, they learned to share housing and scarce goods, to carpool and to work cooperatively with others, often in defense plants. Inevitably, these values carried over into the postwar era. There is no hard evidence that the war generation was especially conformist or that it feared risk — business starts, for example, grew during the 1950s in step with the population. Ironically, social critics at the time attacked what is now called the "greatest generation" for its virtues, completely missing the point that the war had made it different from earlier generations, and in some ways better.

To many Americans the worst effect that World War 2 had at home was the Red Scare. The Cold War, the spread of Communism and the Korean War — all aroused fears that created opportunities for demagogues. Senator Joseph McCarthy of Wisconsin enjoyed the most fame, or notoriety, but the House Committee on Un-American Activities, among other bodies, had been looking for subversives years before McCarthy first charged in 1950 that the government harbored Communists.

Beginning almost immediately after the war, right-wingers accused President Truman of being soft on Communism, though in 1947 he had issued a Loyalty Order so draconian that parts of it were later found unconstitutional. Even without the Loyalty Order, Truman's aggressive foreign policy and decision to fight in Korea should have established his credentials as an enemy of Communism.

Truman's record did not protect him, because Republicans wished desperately to regain power, and used scare tactics to make many Americans believe that the period of Democratic rule constituted, as McCarthy had said, "20 years of treason." Richard Nixon, while a senator, called Truman, Secretary of State Dean Acheson and Adlai Stevenson, the Democratic presidential nominee in 1952, "traitors" to American principles. McCarthy also declared Secretary of Defense George C. Marshall to be a subversive.

Smear and slander helped Eisenhower win the presidency in 1952. But McCarthy lost sight of the Red Scare's partisan objective and continued to search for disloyalty in what was now a Republican government. In 1954 his subcommittee's televised hearings on alleged subversives in the Army enabled the nation to witness his bullying, arrogance and lack of proof. This weakened him enough for the Senate to censure him in December. The censure destroyed his power and McCarthyism as a movement, both having outlived their political usefulness.

During the Red Scare, federal agencies dismissed more than 1,700 employees, and about 12,000 more resigned under fire. The military discharged some 2,250 servicemen and -women for disloyalty or as security risks. On a much smaller scale local and state governments, school districts and higher education underwent similar purges. Hollywood blacklisted hundreds of film-industry workers for their political beliefs and associations, while radio and television similarly deprived 1,500 people of their livelihoods. In the United States, these victims of McCarthyism were the last casualties of World War 2.

William L. O'Neill is Professor of History at Rutgers University, having also taught at the universities of Pittsburgh, Colorado, Pennsylvania and Wisconsin. His most recent books are American High: The Years of Confidence, 1945–1960, *and* A Democracy at War: Americans Fight at Home and Abroad in World War II.

Index to Pictures

LIFE: WORLD WAR 2
HISTORY'S GREATEST CONFLICT IN PICTURES

Editor: Richard B. Stolley
Designer: Susan Marsh
Picture Editor: Christina Lieberman
Research Coordinator: Brenda Cherry
Editorial Production Manager: Carol Mauro-Noon
Writers: Leslie Jay, Bruce Frankel, Jamie Katz
Picture Researchers: Joshua Colow, Christine Hinze (London),
George Hogan, Angelika Lemmer (Bonn)
Researchers: Evelyn Cunningham, Joan Levinstein, Robert Paton,
Annette Rusin, Melissa Wanamaker, Carol Weil

Special thanks to:
Sheldon Czapnik, Patricia Clark (research), Ruth Cross (index),
Kim Ellerbe (administration), Sally Proudfit, Ismael Reina (imaging)

Produced in cooperation with Time Inc. Editorial Services
Director: Claude Boral
Research Center: Lany McDonald
Picture Collection: Kathi Doak, Daniel Donnelly
Photo Lab: Tom Hubbard, Tom Stone, Daniel Chui

Time Magazine
General Manager: Andy Blau

Published by Time Warner Trade Publishing
Chairman: Laurence J. Kirshbaum
President: Maureen Mahon Egen

Bulfinch Press / Little, Brown and Company
Publisher: Carol Judy Leslie
Senior Editor: Terry Reece Hackford
Associate Editor: Stephanie V. W. Lucianovic
Production Manager: Sandra Klimt
Production Associate: Allison Kolbeck
Production Assistant: Tracy B. Shaw

Bulfinch Press is an imprint and trademark
of Little, Brown and Company (Inc.)

FIRST EDITION
ISBN 0-8212-2771-8
Library of Congress Control Number: 2001093633
PRINTED IN THE UNITED STATES OF AMERICA

Extended Picture Credits
While every effort has been made to give appropriate credit for
photographs reproduced in this book, the publishers will be pleased
to rectify any omissions or inaccuracies in the next printing.

Page 38 (inset): Otto Hagel / © 1998 Center for Creative Photography,
University of Arizona Foundation

The *Queen Mary* takes American troops back home in 1945.

WIDE WORLD

LIFE: WORLD WAR 2

DESIGNED BY SUSAN MARSH

PICTURES EDITED BY CHRISTINA LIEBERMAN

COMPOSED IN META, ADOBE GARAMOND AND UNIVERS BY CAROL MAURO-NOON AND SUSAN MARSH

SEPARATIONS BY PROFESSIONAL GRAPHICS INC., ROCKFORD, ILLINOIS

PRINTED AND BOUND BY R. R. DONNELLEY & SONS COMPANY

IN WILLARD, OHIO